PICTURE WORLDS

PICTURE WORLDS

STORYTELLING ON GREEK, MOCHE, AND MAYA POTTERY

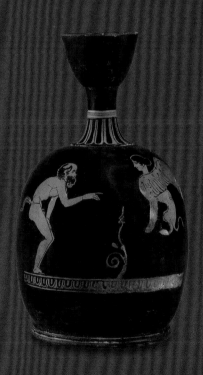
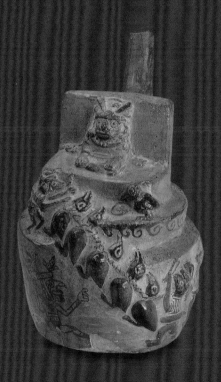
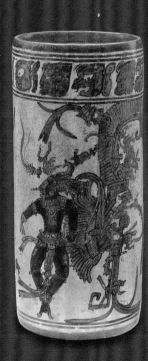

EDITED BY DAVID SAUNDERS
AND MEGAN E. O'NEIL

J. PAUL GETTY MUSEUM
LOS ANGELES

CONTRIBUTORS

DAVID SAUNDERS is associate curator of antiquities, J. Paul Getty Museum.

MEGAN E. O'NEIL is assistant professor of art history, Emory University.

OSWALDO CHINCHILLA MAZARIEGOS is associate professor of anthropology, Yale University.

IYAXEL COJTI REN is assistant professor of anthropology, University of Texas at Austin.

GUY HEDREEN is Amos Lawrence Professor of Art, Williams College.

ULLA HOLMQUIST is director of the Museo Larco, Lima, Peru.

STEPHEN D. HOUSTON is Dupee Family Professor of Social Sciences, Brown University.

KATHLEEN M. LYNCH is professor of classics, University of Cincinnati.

JOANNE PILLSBURY is Andrall E. Pearson Curator of Ancient American Art, The Metropolitan Museum, New York.

JEFFREY QUILTER is the former director, Peabody Museum of Archaeology & Ethnology, Harvard University.

CARLOS RENGIFO is lecturer, National University of Trujillo, and research director, Huacas de Moche Archaeological Project.

JULIO RUCABADO YONG is curator of pre-Columbian art at the Museo de Arte de Lima.

MARK STANSBURY-O'DONNELL is professor of archaeology and art history, University of St. Thomas.

ANDREW D. TURNER is senior research specialist, Getty Research Institute.

ELENA VEGA is director, Huacas de Moche Archaeological Project.

DIRECTOR'S FOREWORD

Among the many societies that have produced painted pottery, the ancient Greeks (700–323 BCE), the Moche of northern Peru (200–850 CE), and the Late Classic Maya in Central America (550–850 CE) stand out for the compelling figural imagery that adorns the surfaces of their vessels. Often potted and decorated with extraordinary finesse, these vessels are animated by lively depictions of capricious divinities, epic adventures, and ritual performances, providing an unparalleled means for understanding the ways in which these peoples visualized their societies, myths, and cosmos.

The three traditions of figure-decorated pottery were distinct in both place and time, and each has been studied on its own terms, through careful analysis of typology, imagery, and techniques of manufacture, as well as the contexts of their production and use. But bringing Greek, Moche, and Maya ceramics together allows us to learn more about each, for surprising similarities may arise, and the questions we ask of one culture may prompt different responses for the other two. Why decorate utilitarian shapes with complex scenes of mortal or mythical activity? What social practices did these painted vessels—made for feasting, for drinking, for ritual or funerary purposes—make possible? What narratives, beliefs, or ideas did the scenes convey? How might they relate to written or verbal forms of communication? How did painters convey place, or the passage of time, on the curving surface of a pot? And how did users engage with these painted scenes?

These are just a few of the lines of inquiry that arise through the juxtaposition of Greek, Moche, and Maya painted pottery. This volume and its accompanying exhibition—generously supported by Jeffrey P. Cunard and the Getty Patron Program, and by Charles and Ellen Steinmetz in honor of Professor Christopher B. Donnan—encourage the exchange of methodological approaches across the traditional structures of university departments or curatorial specialisms. The three cultures differ substantially—not only in terms of their political and social organization, and the existence, if any, of textual sources, but also through modern histories of study, collecting, and display. Faced with such diversity, definitive answers may prove elusive, but—as is manifest in the collaborative approach of this volume—it is in the process of exploration, curiosity, and willingness to engage with other perspectives that new understandings emerge. Readers may be unfamiliar with one, two, or maybe all three of these ancient cultures, but this project provides multiple points of entry, celebrating their rich pictorial and narrative traditions and offering a framework that invites and fosters engagement. The topics considered here not only sharpen our comprehension of the Greeks, Moche, and Maya but inform broader conversations about how images are used and how stories and worldviews are shared. As visual media continue to shape our own lives, these are topics that retain profound significance today.

Timothy Potts
Maria Hummer-Tuttle and Robert Tuttle Director
J. Paul Getty Museum

ACKNOWLEDGMENTS

David Saunders and Megan E. O'Neil

This volume and the exhibition it accompanies are predicated upon communication and collaboration, and it is a great pleasure to acknowledge the support, insight, and guidance we have received from friends and colleagues, old and new, over many years. From the outset, Mary Miller has provided us both with advice and assistance, and we are profoundly grateful for her generosity and expertise. Timothy Potts, Jeffrey Spier, Richard Rand, and Carolyn Marsden-Smith have been steadfast in their commitment to our project, and we are indebted to them for their leadership and counsel. We are delighted that the exhibition will travel to the Michael C. Carlos Museum at Emory University following its display at the Getty Villa, and deeply appreciate the work of Henry Kim, Bonna Wescoat, Elizabeth Hornor, Renée Stein, Todd Lamkin, and Ruth Allen, who have done so much to make this possible.

An informal session of short presentations over Zoom in June 2020 proved especially valuable in shaping the project, and we owe special thanks to those who took part: Alyce de Carteret, Oswaldo Chinchilla Mazariegos, Christopher Donnan, Mary Louise Hart, Stephen Houston, Bryan Just, Kathleen Lynch, Claire Lyons, Mary Miller, Joanne Pillsbury, Jeffrey Quilter, Matthew Robb, Mark Stansbury-O'Donnell, and Andrew D. Turner. Many participants subsequently served as members of our advisory committee, and their instructive suggestions and questions have informed many aspects of our own thinking and writing.

The exhibition would not be possible without the generosity of the museums and institutions that have allowed their works of art to travel, and we sincerely thank our many colleagues. In Mexico, Juan Manuel Garibay López, Itzia Naidee Villicaña Gerónimo, Alejandra Barajas Moreno, and Laura Elena del Olmo Frese at the Instituto Nacional de Antropología e Historia; and Daniel Juárez Cossío at the Museo Nacional de Antropología. In Guatemala, Felipe Amado Aguilar Marroquín, Obdulio Alberto Ramos León, and Aramiz Fernando Rivera Robles at the Ministerio de Cultura y Deportes; Cristopher Martínez, Rosaura Maribel Ramírez Rodríguez, and especially the late Daniel Aquino Lara at the Museo Nacional de Arqueología y Etnología; and Mellyn García Castellanos at the Museo Regional Mundo Maya. In Peru, Carlos Roldán del Águila Chávez, Leslie Urteaga Peña, Sonia Valentina Molina Gonzales, and Gerardo Sabino Moreno Arias at the Ministerio de Cultura; Ulla Holmquist and Rocío Aguilar at the Museo Larco, Lima; Elena Vega Obeso and Carlos Rengifo at the Proyecto Arqueológico Huacas de Moche; Ingrid Claudet Lascosque, Augusto Bazán Peréz, and Rubén Buitrón at the Fundación Wiese; and Mónica Bazán and her colleagues at N. Leigh Transporte de Arte.

In the United Kingdom, Hartwig Fischer, Alexandra Villing, Thorsten Opper, Danny Zborover, and Ian Taylor at the British Museum, London. In the United States, Martha Tedeschi and Susanne Ebbinghaus at the Harvard Art Museums; Matthew Teitelbaum, Phoebe Segal, and Laure Marest at the Museum of Fine Arts, Boston; Thomas Cummins, Juan Antonio Morro, and Frauke Sachse at Dumbarton Oaks Research Library and Collection, Washington, DC; James Rondeau, Andrew Hamilton, and Kate Weinstein at the Art Institute of Chicago; James Steward and Bryan Just at the Princeton University Art Museum; Max Hollein, Joanne Pillsbury, Laura Filloy Nadal, Seán Hemingway, and Alexis Belis at the Metropolitan Museum of Art, New York; Ashley Hammond, Charles Spencer, Sumru Aricanli, and Kristen Mable at the American Museum of Natural History, New York; Adam Levine and Andrea Gardner at the Toledo Museum of Art; Gary Tinterow and Rex Koontz at the Museum of Fine Arts, Houston; Michael Govan, Diana Magaloni, Alyce de Carteret, Megan Smith, and Chiara Barlow at the Los Angeles County Museum of Art; and Silvia Forni, Matthew Robb, Jeanette Saunders, Rachel Raynor, and Christian de Brer at the Fowler Museum, UCLA. We also thank Camilo Luin at the Museo Popol Vuh, Melissa Badillo at the Institute of Archaeology in Belize, Jaime Awe and Christophe Helmke of the Central Belize Archaeological Survey Project, Caroline Fernald at the Phoebe A. Hearst Museum of Anthropology, Bernadette Cap at San Antonio College, Seth Pevnick at the Cleveland Museum of Art, Sanchita Balachandran at the Johns Hopkins University Archaeological Museum, Simon Martin at the Penn Museum, Dorie Reents-Budet, and Marc Zender at Tulane University.

The professionalism and creativity of our colleagues at the Getty Museum have been truly inspirational. Susan McGinty has overseen the coordination of the exhibition project with clarity

and care, supported by Erin Minnaugh and Marisa Weintraub. In the Registrar's office, Stephanie Baker handled loan documentation and negotiations with exemplary proficiency, aided by Kanoko Sasao, Naomi Abe, Jackie Burns, Cherie Chen, Lynette Haynes, and Debby Lepp. In Conservation and Mountmaking, Susanne Gänsicke, Jessica Arista, Erik Risser, Richard Hards, and Tim Skornia conceived of innovative ways to display the vessels and ensure their safety, while the installation of the objects was ably accomplished by our preparators, Marcus Adams, Dan Manns, and Cesar Santander. Julie Garnett, Chaya Arabia, Asja-Melina Schenk, and Jes Harden brought fresh perspective and sensitive design to the exhibition's layout and graphics, and the didactic materials benefited substantively from the dedicated attention of our editor, Sahar Tchaitchian. Many other colleagues in Interpretive Content and Public Programs invested time, passion, and energy to foster engagement, both in and out of the galleries, and we thank Tasia Johnson, Laurel Kishi, Laura Hubber, Shelby Brown, Nia Robertson, and Lisa Adey. Through Ralph Flores and Anna Woo, we collaborated with Theresa Chavez, Eddie Ruiz, and their colleagues at About … Productions, and the curiosity and commitment of the teenagers developing performances inspired by the myths of ancient Greece, Rome, and Mesoamerica were wonderful to encounter. For their endeavors to promote the exhibition and foster community support, we are also grateful to Janet McKillop, Kim Uyttewaal, Alicia Rhymes, John Giurini, Shannon Iriarte, Brittany Saake, Maria Velez, Yasmine Vatere, Emily Cregg, and Noelene Gacis. We are also grateful for the contributions of our Carlos Museum colleagues in the execution of the exhibition at Emory University, including Brittany Dolph Dineen, Joseph Gargasz, Dave Armistead, Bruce Raper, and Ciel Rodriguez.

It has been a pleasure to produce this book with our colleagues at Getty Publications, under the leadership of Kara Kirk. As we initiated the project, we benefited greatly from the enthusiastic support of Karen Levine and Nola Butler, and the book's development owes much to the adept proficiency of Rachel Barth, who has worked ceaselessly to bring it to publication, and to Tori Gallina, who has overseen its production. Nancy Rivera gathered and organized the images with efficiency and aplomb, and Dani Grossman's keen eye and ingenuity have shaped the volume's design and layout. We are indebted, too, to Jane Bobko for her careful scrutiny and rigorous inquiry in copyediting the manuscript, and to Juliana Froggatt for proofreading. We thank Rose Vekony for her translation of Spanish texts, the three anonymous peer reviewers for their comments and suggestions, and David Fuller for making the maps. Finally, we express our lasting gratitude to our co-authors, not only for their written contributions, but for their enthusiastic participation and insightful correspondence. We have learned a great deal from each of them and look forward to further conversations.

In closing, David acknowledges the members of the Antiquities department, past and present: Jeffrey Spier, Claire Lyons, Mary Louise Hart, Ken Lapatin, Jens Daehner, Sara Cole, Nicole Budrovich, Judith Barr, Paige-Marie Ketner, Roko Rumora, Sierra Schiano, Paula Gaither, Yusi Liu, Skylar Masuda, and Opal Lambert. They have provided critical support throughout the development of this project, and he is privileged to call them colleagues. He also thanks his family for their ongoing love and encouragement, without which none of this would be possible.

Megan is grateful for the support of colleagues at Emory University, both in the art history department and the Carlos Museum, and to many friends and colleagues in Belize, Guatemala, Mexico, and Peru with whom she has shared many conversations and visits to archaeological sites, museums, and conferences. She also is indebted to her friends and family, especially to Kevin Cain and Pascal Cain-O'Neil, for their patience, love, and inspiration during the development of this project. May we all continue to share our stories.

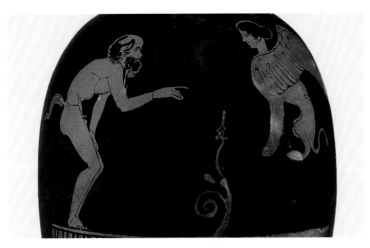

FIGURE 1 Oil Jar with Satyr and Sphinx. Greek, made in Athens,
425–420 BCE (detail, plate 16)

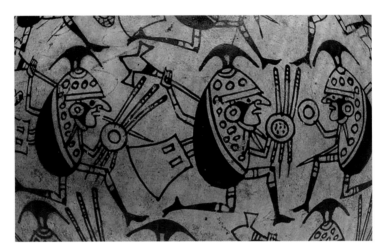

FIGURE 2 Stirrup-Spout Vessel with Lima Bean Warriors.
Moche, made in northern Peru, 650–800 CE (detail, plate 22)

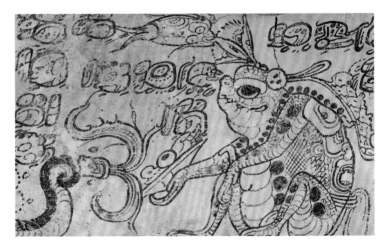

FIGURE 3 Cylinder Vessel depicting Otherworldly Toad,
Jaguar, and Serpent. Maya, made in southern Campeche,
Mexico, or northern Peten, Guatemala, 650–800 CE
(detail of a rollout photograph of plate 37)

INTRODUCTION

Megan E. O'Neil, David Saunders, and Andrew D. Turner

A balding satyr, identifiable as such by his equine tail and ear, points an inquisitive finger toward a primly perching sphinx (fig. 1). Helmeted bean warriors, their legs in an energetic run, brandish maces as they clash (fig. 2). A corpulent toad whose head is topped by a water lily and fish holds out a dish containing disembodied eyeballs and a severed hand (fig. 3). The identities of these creatures differ wildly, as one might anticipate when encountering objects from three unrelated traditions of painted pottery—Archaic and Classical Greek (700–323 BCE), Moche (200–850 CE),[1] and Late Classic Maya (550–850 CE), respectively. But these figures are all made visible, brought into being, on the curving surfaces of clay vessels created for storing, pouring, or drinking liquids. Each of these painted pots is a picture world, a stimulus for storytelling.

What lies behind the impulse to decorate functional vessels with figural imagery? We could ask this question with respect to many societies, past and present, for pottery production has been virtually universal in human history, and image making almost so. But the Greeks, Moche, and Maya are exceptional in the premodern world for the hybrid creatures, capricious divinities, epic adventures, and ritual activities that animate their painted pottery. Though these cultures are distant from one another in space and time, and distinct in their beliefs, rituals, and social structures, each produced large quantities of terracotta (fired clay) vessels bearing scenes drawn from life and imagination and incorporated them in lived experience—whether at convivial gatherings and funerary rituals, as gifts and votive offerings, or through trade and political networks. These vessels were versatile and dynamic, and were used in many different social settings. By bringing the Greek, Moche, and Maya traditions together we seek to explore what these painted pots made possible—be that as prompts for storytelling and the sharing of common values; as expressions of religious beliefs, political ideologies, or assertions of cultural identity; as windows onto imagined realms or as enduring records of past events; as immersive sensory experiences, animated by their beholders; as manifestations of craft and labor by artisans named or as yet unknown; or as possessions that were valued, sometimes far from their place of production, as markers of status. By no means do all these possibilities pertain equally to Greek, Moche, and Maya figure-decorated pottery, and applying a single interpretive approach will both mislead and misread. In fact, it is the painted pots' diversity that drives our project, for it fosters both new questions and the querying of assumptions.[2]

COMMON PRINCIPLES

Given the substantial differences among the three societies—indeed, each one was itself composed of many communities and social groups, often in conflict or competition—we begin with some propositions that apply to Greek, Moche, and Maya painted pottery and support their juxtaposition. This outline of commonalities is made all the more necessary because of the profound disparities in the evidence that we have today to study each of these cultures—most notably in terms of textual sources, including when they were written and by whom.

In all three societies, figural imagery appeared across a range of media, but whereas textiles might fray or fade, metalwork corrode or be melted down, and organic materials degrade, painted pottery lasts. Though vulnerable to breakage, chipping, or wear, terracotta is fundamentally durable. The painted images could be seen and experienced over time, and even when the vessels were ritually broken or disposed of, fragments remain, and can often be pieced together. These characteristics of fired clay account for the ubiquity of terracotta vessels in archaeological excavations and museums, and, in turn, for why they offer such a rich resource for study.

Another factor behind these vessels' survival is that clay is not inherently rare or valuable, and so these objects have largely avoided the depredations of later generations looking for materials, such as marble, jadeite, or metals, that were at times repurposed or deemed precious.[3] This is not to say, however, that painted pottery in these societies was cheap or widely accessible. Not only do some vessels incorporate rare materials, such as the mother-of-pearl inlay on the Moche Warrior Duck vessel (plate 1); the contexts or consequences of their manufacture and subsequent movement also created value. Finely painted Maya vessels, for example, were produced within royal contexts by elite artists, and they maintained associations with their origins as they circulated at feasts or were given as gifts.[4]

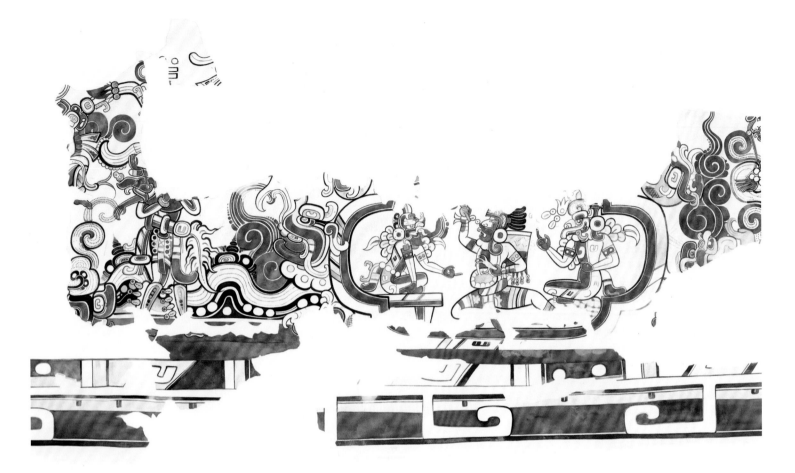

FIGURE 4 The Maya Maize God dances inside the turtle-earth. Scene from reconstruction of the west wall mural, Las Pinturas Sub-1A, San Bartolo, Guatemala, Late Preclassic period (ca. 100 CE). Detail of watercolor copy by Heather Hurst

The portability of these vessels provides a third significant point of connection. While Greek potters and painters did, on occasion, produce monumental examples (such as the ceramics that served as grave markers in the eighth century BCE), the painted pots in all three cultures tend to be portable. Indeed, as vessels for feasting, drinking, or ritual activity, they must be handled—whether raised to the mouth for consumption, inverted for pouring, turned for viewing or demonstration, or deposited in a tomb or shrine. Far from being static adornments to communal activity, these pots were frequently moved, and with scenes that wrap around their surfaces or are juxtaposed across different faces, they invite manipulation. Furthermore, these vessels circulated not only within the communities that made them but across time and space—passed down through generations or exported. And once the pots left their place of production, the images could acquire new resonances, be reinterpreted, or lose their significance altogether.

Beyond their shared material qualities, these vessels—and their makers and users—existed within a much broader landscape of imagery and expression.[5] In all three cultures, figural imagery appeared across a range of media, from the miniature or personal, such as jewelry, adornments, and clothing, to the monumental and public, such as murals and architectural decoration (fig. 4). These images might be encountered daily or only on specific occasions, scrutinized at close range or glimpsed from afar. Furthermore, life events (birth, marriage, death) and communal rituals could involve allusion to, or even reenactment of, mythical narratives and divine actions. The deeds of divinities, heroes, and supernatural beings explained, embodied, and enlivened eternal rhythms of seasonal change, human and agricultural fertility, and many cultural practices. In the Greek, Moche, and Maya cultures, as elsewhere in the world, stories and narratives were part of the fabric of

society and circulated through performance and recitation. This is difficult to recapture today, but the significance and ubiquity of oral traditions in premodern societies cannot be overstressed. Tales were shared through song, exposition, and conversation in formal or ritual contexts (such as feasts, symposia, diplomatic visits, and funerary ceremonies) as well as informally—with a restless child on a grandparent's knee. Drawing from a communal understanding, these tales did not belong to a single composer or orator. They could be related by many, and in part because of this were mutable, open to elaboration and adjustment as they passed from person to person. There are some fixed points— the Greek hero Theseus always defeats the Minotaur, the Moche Warrior Priest always receives a goblet of blood, and the Maya Maize God is always reborn—but parents, priests, and poets (and painters of ceramic vessels, too) could extemporize and toy with expectations. These narratives were a cultural bedrock upon which people could build, and were subject to adaptation; they were fresh with each new telling or digression.

Today, one of the biggest obstacles to appreciating the significance of oral traditions is the prevalence—or even privileging—of the written word in our globalized society, and particularly in art historical scholarship. This emphasis on text has many ramifications for the contemporary study of ancient art and material culture. One motivation for selecting Greek, Moche, and Maya painted pottery for a three-way juxtaposition is that the character of literacy (and survival of evidence for it) in these societies allows for different yet complementary approaches to their pictorial imagery.

There was no writing among the Moche, which renders the representations on their pottery and other media even more powerful as a means of communication.[6] Both the Greeks and the Maya, by contrast, recorded their languages in phonetic writing systems, and stories and myths were preserved as texts. A significant volume of Greek prose and poetry survives to this day, and so it is possible, for example, to cite the account in Homer's *Iliad* of Achilles's abuse of Hektor's

corpse,[7] and compare it with scenes on ancient vessels, such as an Athenian storage jar (plate 2). The same approach cannot, however, be taken for the Maya. While inscriptions endure on stone sculptures, painted pottery, and other media (though the work of decipherment—an achievement of the past seventy years—remains ongoing), we do not have direct access to other literature that might have been in existence during the Late Classic period (550–850 CE), when the terracotta vessels considered here were produced. There certainly were many bark-paper books made during this period, but these do not survive—in part owing to the conditions of the tropical environment, but also because Spanish religious authorities burned many Maya books in sixteenth-century campaigns against idolatry.[8] However, the *Popol Vuh*, an epic recorded in highland Guatemala by K'iche' Maya people, in the K'iche' language, in the sixteenth century, after the Spanish invasion, may preserve versions of some of the stories that had been in earlier circulation. And in all three fields, scholars have turned to later sources, folktales, and surviving material culture for help in comprehending the ancient imagery.

But even calling attention to the relationship between images and texts highlights a division that we seek to move beyond. The distinction is deeply rooted in Western art history and has tended to treat images as dependent on—even subordinate to—texts.[9] The combined weight of the Classical (Greco-Roman) and Christian traditions has elevated the written word as the more authoritative medium of communication, providing stability and fixity. Yet this word-image distinction is far from self-evident. Maya glyphs can denote syllables and words while permitting intricate visual complexity, even playfulness, such that we should think of text and image as poles on a spectrum of communicative practice.[10] Furthermore, the word-image distinction may stand at odds with ancient perspectives. For both Greek and Maya, one verb denotes writing *and* painting. In Greek, the verb *graphein*— used by painters when they signed pots— conveys the method and technique employed for the marking of signs.[11] Likewise, for the

Maya, the root *tz'ihb* (write/paint) concerns not what is being rendered (whether word or image) but the method or technique of painting, as opposed to incising or sculpting.[12] We should emphasize, too, that the very act of making something visible through writing/drawing can bring it into being. In Greek, the verb *idesthai*, "to behold," shares its root with that for *oida*, "I know,"[13] while, as Allen Christenson points out regarding the *Popol Vuh*, "The authors of the manuscript described the text as an *ilb'al* (instrument of sight) by which the reader may 'envision' the thoughts and actions of the gods and sacred ancestors from the beginning of time and into the future."[14] In short, images and texts alike make stories manifest, recording and giving more permanent form to what otherwise existed only when uttered, sung, or heard. All of which encourages us to move away from efforts to determine whether the elements of a particular scene are consistent or "correct." As Lisa Trever has noted in regard to Moche painted pottery, "What might be perceived as an unsettling din of competing interpretive voices may be precisely what the bottle *wants*. It drives people to tell tales that are … flexible and adaptable (as oral narratives are), not closed and certain (as written texts are thought to be). That is, the modern desire to decipher a single master narrative from a painted vessel may be misdirected from the outset."[15]

The painted pottery of these three cultures also forces us to consider how we think about time. The scenes on many vessels have been classified as "mythical" or "supernatural," either because figures are identifiable as such by inscriptions or through their attributes, or because the imagery is otherwise set apart from the contemporary world of the vessels' production. Scenes that do not meet these criteria are often classified, variously, as "historical," "daily life," "generic," or "everyday."[16] It is possible to identify clear examples of both types, but imposing this binary opposition exposes a number of methodological problems.

First, "generic" or "daily life" scenes should not be taken as snapshots of lived experience. Granted, painters depicted many quotidian features of the worlds

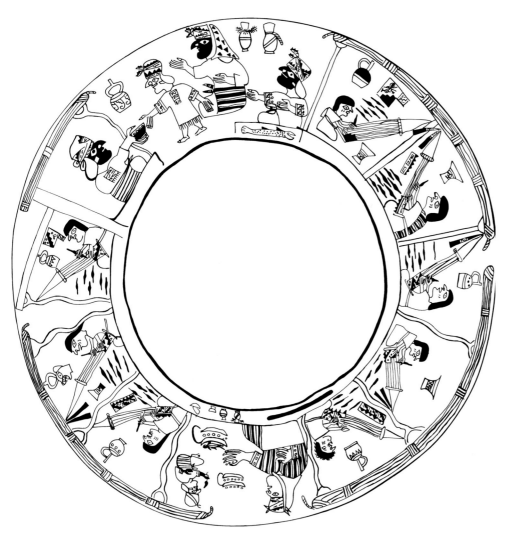

FIGURE 5 Flared Bowl with Weavers.
Moche, made in northern Peru, 500–800 CE
(see plate 30). Drawing by Donna McClelland

they inhabited—clothing, furnishings, foodstuffs—but their intent generally was not documentary. Rather, these are scenes that are constructed, often drawing on stock motifs, and arranged to highlight particular aspects or normative values. An Athenian cup with a symposium scene (plate 3), for example, does not offer a record of a particular drinking party, but presents an assemblage of elements that evoke the experience of such an event—erotic encounters, a serving boy, cups raised for toasts. Depicted on a drinking vessel, the painted decoration anticipates the pleasures and excesses of the night ahead. To follow the phrasing of Mary Beard, "this is not a *picture of*, but

a *statement about*" the symposium.[17] Likewise, the Moche flared bowl (fig. 5) that portrays several weavers alongside depictions of flared bowls and other vessels may not simply represent a quotidian "snapshot" of a workshop, but could instead invite us to consider the possible relationship between the act of transforming loose thread into finely woven textiles and the mixing and serving of ritually consumed drink that occurred within the vessel itself. For the Maya, some palace scenes are labeled with specific names and even dates, almost certainly depicting individuals in a specific event (plates 4, 5), but others do not have such labels and may present more generic palace scenes.[18]

Second, for all three cultures, where many aspects of lived experience were shaped and infused by divinities and heroes, natural and supernatural forces, and ancestors and future generations, the distant past or imagined realms of what we might call "myth" were not separated from more recent events or locations closer to home. In Maya inscriptions and imagery, for example, events and actors in the past, even in deep time (what may otherwise be called "mythical time"), as well as events in the future, are not clearly distinguished from those in the present or more recent past. In addition, narratives regarding the actions of deities, ancestors, and the living are told using the

O'NEIL, SAUNDERS, AND TURNER

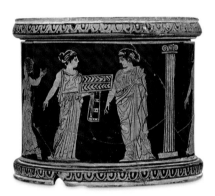

FIGURE 6 Container, attributed to the Manner of the Meidias Painter. Greek, made in Athens, 420–410 BCE. Terracotta, H: 8.3 cm (3¼ in.); Diam: 10.2 cm (4 in.). New York, The Metropolitan Museum of Art, Rogers Fund, 1909, 09.221.40a, b.

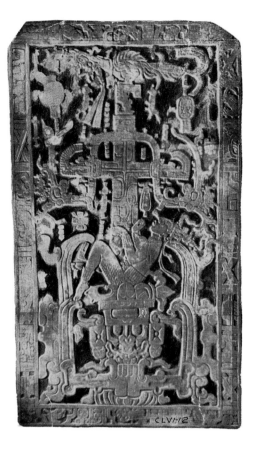

FIGURE 7 Lid from sarcophagus of K'inich Janahb Pakal, Temple of the Inscriptions, Palenque, Chiapas, Mexico, 683 CE. Limestone, L: 379 cm (149³⁄₁₆ in.); W: 220 cm (86⅝ in.)

same calendar and verbal systems. The living may repeat actions of ancestors and deities, and both ancestors and deities may be conjured or called into the here and now.

Finally, even if we persist in distinguishing the "mythical" from the "everyday," scenes remain that elude such definitive classification. Indeed, in all three cultures' painted ceramics, there are compositions that oscillate between these two poles, allowing for the present to be identified in myth or the distant past, and vice versa. For example, in Athenian painted pottery of the second half of the fifth century BCE, there are many depictions of female adornment and preparations for marriage. Where figures are named

by inscriptions, some can be identified as mythical characters, divinities, or personifications of abstract ideals, such as Good Repute and Good Order (fig. 6). But even where the figures are unnamed, they retain the *potential* to be seen in such mythical or at least idealizing terms.[19] And for the Moche and Maya, images or events from the past and present can be merged or made analogous, so that a scene depicting one or more living persons can also be a manifestation of ancestors or deities. In Peru, discoveries at Sipan and San José de Moro of high-ranking Moche individuals entombed with the accoutrements of deities that appear in the Presentation Theme (or Sacrifice Ceremony)

pottery scenes challenge facile distinctions between myth and lived reality,[20] suggesting instead that Moche public ritual was charged with mythical and supernatural presence, or at the very least that the identities of certain Moche elites were fused with those of deities either before or after death. Similarly, on the lid of the sarcophagus of K'inich Janahb Pakal (fig. 7), a Maya ruler of Palenque, the depicted figure is both that historical individual and a manifestation of maize, solar, and lightning deities as he emerges from the underworld after his death; and the ancestor's body, in death, was adorned with jadeite ornaments characteristic of maize and solar deities.[21] The interplay of narrative scenes

and ritual reenactment in these examples reciprocally invested existing power structures with supernatural legitimacy and lent a sense of immediacy to mythical depictions on pottery and other media. Another proposal for understanding these ambiguities is that scenes of the divine, heroic, or supernatural provide models for human behavior.[22] Calling, narrating, impersonating—and, crucially, depicting—ancestors and deities are ways to bring them into the present. As a K'iche' Maya elder responded to Christenson as he read part of the *Popol Vuh* aloud to him, "These are the words of my ancient fathers? … You make them live again by speaking their words."[23]

PRECEDENTS AND PREVIOUS SCHOLARSHIP

We bring these three cultures' ceramics together in order to explore similarities and differences. Individual Greek, Moche, and/or Maya vessels have occasionally been presented together under broad thematic rubrics,[24] but in general the three pottery traditions have been displayed and studied separately.[25] Much of this is due to classifications long inherent in the organization of university faculties and museum departments (as well as the art market), which set "Western" art apart from "non-Western," distinguish "high art" from "primitive art," or separate the fields of art history, archaeology, and anthropology from one another. Furthermore, studies of the three cultures and their pottery have developed at different times, under different conditions, and with different priorities, and only now are chronological, typological, and stylistic classifications in place to support a project that brings them together. Crucial, too, are advances that have been made in both documentation and accessibility. Preparing a project of this nature would be unfeasible without the Beazley Archive Pottery Database and *Lexicon Iconographicum Mythologiae Classicae* for the Greek material, Christopher B. Donnan and Donna McClelland's archive of drawings of Moche

painted pottery, and Justin Kerr's corpus of rollout photographs of Maya vessels (distributed first in a series of books, and then released online at a much broader scale).[26] We are thus indebted to generations of scholars, and owe much to an international advisory committee that has helped to shape our thinking and selection of objects. We have also sought to work closely with colleagues in countries of origin to foster an exchange of ideas and cultivate partnerships, not least in the development of this publication and through the inclusion of vessels with documented findspots or from museums in those countries.

This undertaking is, we hope, a beginning, and a stimulus to future inquiries. Yet we make no claims to originality in bringing the three cultures together.[27] Around twenty years ago, the Getty organized a roundtable that considered Greek, Maya, Moche, and also Mimbres pottery (from the American Southwest). But when we survey the scholarship, it remains striking that scarcely any publication on Greek painted pottery acknowledges the Maya or Moche material,[28] whereas numerous books and articles on the ancient Maya and Moche make reference to the Greek tradition.[29] Progress in rectifying this imbalance is apparent in an interdisciplinary project at the University of Chicago that forms the basis of the Visual Conversations in Art and Archaeology series, published by Oxford University Press. One volume was dedicated to vessels,[30] with chapters on Greek, Roman, Maya, and Chinese material. But as we have developed our project, we want to capitalize on the unique opportunity that a museum exhibition affords: bringing objects together in a shared space, so that they can be seen side by side by diverse audiences. Furthermore, the display of vessels allows us to address their physical forms. For all the benefits provided by image archives and rollout photographs, the painted scenes that prompt our interest adorn the curving surfaces of portable objects that were made to be handled.

ORGANIZATION OF THIS BOOK

Recognizing that readers may not have equal familiarity with the ancient Greeks, Moche, and Maya, we intend this book to provide an accessible, concise introduction that can serve both as a springboard to deeper engagement and as a solid foundation for meaningful juxtapositions and the sharing of ideas. The first part thus offers overviews of the three societies, in chronological sequence (Greek, Moche, Maya), beginning with a general survey for each, describing geography, chronology, religious practices, and political organization. These are followed by essays dedicated to the production of painted pottery, each in turn accompanied by brief studies that look more closely at the contexts in which some of these vessels have been found. Following those considerations of society and culture, the second part of the volume turns to the imagery, outlining some methods and approaches for interpretation. In "Understanding the Imagery," our survey essay addressing the three cultures together, we acknowledge distinct histories of study and sources of evidence, but also draw attention to some shared facets. Three mini-essays provide detailed analyses of specific subjects—for the Greeks, the Trojan War; the Moche deity Wrinkle Face; and the Maya Maize God—and three sidebars highlight hybrid figures (satyrs, bean warriors, and *wayob*), the beings with which we began this essay.

Bringing together material from different and unconnected cultures—and particularly cultures for which surviving textual traditions are incomplete or altogether lacking—demands sensitive assessment of the character of surviving evidence, and careful reflection on the approaches we apply. Through this juxtaposition of Greek, Moche, and Maya painted pottery, we hope to foster a productive framework within which to query, explore, and refine our understanding not only of these visually rich and dynamic traditions but of human practices, such as image making and storytelling, that continue to endure.

NOTES

1 In this volume, we use the term "Moche" rather than "Mochica."

2 Fricke and Flood 2022 provide an instructive overview of the opportunities and challenges inherent in moving beyond disciplinary traditions.

3 On more recent looting, see O'Neil and Saunders, "Modern Histories of Ancient Vases," this volume.

4 On elite Maya vessels, see O'Neil, "Maya Vase Production and Use," and Houston, "Maya Gift Giving," this volume; see also Reents-Budet 1998 and Callaghan 2014. On the value attached to Greek ceramics, see Saunders, "Greek Painted Pottery," this volume.

5 As outlined by Martin 2006b.

6 See Martin 2006b, 68–75; Jackson 2008; Trever 2022, 1–31.

7 Homer, *Iliad* 22.395–404; 24.14–18.

8 Chuchiak 2006.

9 Squire (2009, 1–193) offers a detailed investigation of this topic. See also Taylor 2008b and Knight 2013.

10 As discussed by Martin 2006b, 63–64.

11 But see Neer (1998), who highlights a shifting relationship between word and image in fifth-century BCE Greece.

12 Houston 2016.

13 See Squire 2016, 10–13.

14 Christenson 2007, 11.

15 Trever 2022, 26.

16 See Topper 2012a, 146, discussing Greek painted pottery: "In fact, it has recently been observed that the category we call 'scenes of contemporary life' is defined not by knowledge of what Athenian life looked like but by the modern inability to connect the scenes to myth." See also Ferrari 2003.

17 Beard 1991, 20.

18 For example, Los Angeles County Museum of Art, M.2010.115.505 (K5940).

19 On this topic, see Beard 1991, 20–21; Junker 2012, 50–59; and, most fully, Giuliani 2013.

20 These scenes are discussed in Saunders, O'Neil, and Turner, "Understanding the Imagery," this volume.

21 Filloy Nadal and Martínez del Campo Lanz 2010.

22 As discussed by Miller and Martin 2004, 50–91.

23 Christenson 2007, 6–7. As Christenson explained, "The word he used was *k'astajisaj*, meaning 'to cause to have life,' or 'to resurrect.'"

24 For example, in the exhibition *Sights and Sounds of Ancient Ritual* (New Haven, Yale University Art Gallery, November 9, 2018–March 3, 2019) and in the recently reinstalled galleries of the Santa Barbara Museum of Art in California.

25 For exhibitions focused on Greek painted pottery, see: *The Amasis Painter and His World* (New York, Toledo, and Los Angeles, 1985–86); *Le peintre Darius et son milieu* (Geneva, 1986); *Euphronios* (Arezzo, Paris, and Berlin, 1990–91); *Colors of Clay: Special Techniques in Athenian Vase Painting* (Los Angeles, 2006); *The Berlin Painter and His World* (Princeton, NJ, and Toledo, 2017–18); and *Exekias hat mich gemalt und getöpfert* (Zürich, 2018–19); for Moche: *Moche Art of Peru: Pre-Columbian Symbolic Communication* (Los Angeles, 1978); *Ceramics of Ancient Peru* (Los Angeles, 1992); *Moche Fineline Painting of Ancient Peru* (Los Angeles, 2001); *Sex, Death and Sacrifice in Moche Religion* (Paris, 2010); for Maya: *The Maya Scribe and His World* (New York, 1973); *Lords of the Underworld: Masterpieces of Classic Maya Ceramics* (Princeton, NJ, 1978); *Painting the Maya Universe: Royal Ceramics of the Classic Period* (multiple US venues, 1994–95); *Dancing into Dreams: Maya Vase Painting of the Ik' Kingdom* (Princeton, NJ, 2012); *Revealing Creation: The Science and Art of Ancient Maya Ceramics* (Los Angeles, 2016–17).

26 In referring to Greek vessels in this volume, we use, where available, the Beazley Archive Pottery Database (BAPD) number (see https://www.beazley.ox.ac.uk/carc/pottery). For the Donnan and McClelland archive of Moche material, see https://www.doaks.org/resources/moche-iconography. For Maya vessels, we use K numbers, after Justin Kerr's Maya Vase Database (http://research.mayavase.com/kerrmaya.html; https://www.doaks.org/research/library-archives/icfa/collections/justin-kerr-maya-archive-1966-2012-1; see Kerr and Kerr 1989–2000), or their museum accession numbers.

27 For a comparative approach to studying narrative imagery in different cultures, see, recently, Wagner-Durand, Fath, and Heinemann 2019. More broadly, see Abe and Elsner 2017.

28 Boardman 2001, 180, is a notable exception.

29 So much so that Dorie Reents-Budet (1994, 34n17) critiqued comparisons of Maya and Greek vase painting.

30 Brittenham 2019.

MODERN HISTORIES OF ANCIENT VASES

Megan E. O'Neil and David Saunders

In embarking upon this project, we recognize the complex histories that account for Greek, Moche, and Maya vessels being objects for study and display. Over the course of centuries, they have entered collections that are often far from their places of production or discovery. Some come from archaeological investigations, accompanied by documentation about their context. Others were acquired through the art market, and their source is unrecorded. It is important, therefore, to provide a brief overview of these modern histories.

In accordance with their distribution in antiquity, Greek vases are found widely around the Mediterranean. The earliest collections were formed in Italy, where evidence for painted pottery can be traced back to the fifteenth century.[1] Notable assemblages were already in existence by the eighteenth century, and with the flourishing interest in (Neo)classical art across much of Europe, Greek vases provided a means of engaging directly with ancient craft. These finds predated, or ran parallel with, the gradual formalization of archaeological practice (with the excavations at Herculaneum, starting in 1738, and Pompeii, starting in 1748, being key to the discipline's development), although governing authorities tried repeatedly to restrict the movement and export of antiquities. In the late 1820s, rich sources of Greek pottery were discovered in central Italy, notably at the Etruscan site of Vulci. These formed the basis of many new collections, and dealers, collectors, and scholars (in some cases, the same individuals) flocked to Rome. The market became increasingly international, particularly once well-resourced museums and collectors

from the United States emerged during the closing decades of the nineteenth century, and the often-fragmentary nature of the material meant that individual vessels could be dispersed across collections and even continents.

Some nineteenth-century excavations were documented, although not always to the standards of today's archaeological fieldwork. Others were little more than private prospecting for treasure. Today, archival research can be a means to reconstruct lost tomb groups, or track the movements of a particular pot on the market.[2] Nevertheless, the findspot (provenience) of many a Greek pot may remain lost or frustratingly vague (consisting, for instance, only of the phrase "said to be from Vulci"), even if it has resided in a collection for generations. Furthermore, despite renewed legislative measures in countries of origin, illicit digging persisted during the twentieth century, with material pouring into a market that—with exceptions—turned a blind eye to where and how it surfaced. In 1970, UNESCO produced its Convention on the Means of Prohibiting and Preventing the Illicit Import, Export and Transfer of Ownership of Cultural Property, but it took years for many state parties to ratify and implement this convention.[3] In the 1990s and 2000s, however, the seizure of warehouses' worth of looted antiquities drew attention to an international network of dealers, restorers, curators, and collectors.[4] With this evidence, Mediterranean countries of origin recovered illicitly obtained works from numerous individuals and museums, including the Getty Museum. Even so, in most cases, specific information about these objects' findspots has been lost.

Early extractions of ancient Moche material culture can be traced to the sixteenth century, when invading Spaniards dug or diverted water into large mud-brick temples such as the Huaca del Sol to access their interred goods, primarily in search of gold.[5] Later in the colonial period, in the eighteenth century, individuals conducted what they perceived to be scientific excavations in those buildings, modeled after ones carried out at Pompeii and elsewhere in Europe.[6] In the early twentieth century, collectors in Peru included the archaeologist Rafael Larco Hoyle, who shaped the study of Moche pottery. Acquiring both individual objects and whole collections, he and his family members assembled an array of Moche ceramics and other media that today makes up the Museo Larco in Lima.[7] Later in the twentieth century, illicit digging grew significantly, as casual diggers or professional looters cut into buildings and dug holes across the landscape.[8] Such depredation gained attention when items from a multilayered burial mound in Sipan, in the Lambayeque Valley, appeared on the international art market. Local authorities eventually shut down the illicit digging at Sipan, and the Peruvian archaeologist Walter Alva subsequently undertook a major archaeological project to recover the physical and cultural contexts of the tombs in that burial mound.[9] These recent excavations at Sipan and other sites like El Brujo have provided a more informed view of the chronology of Moche pottery, as well as of Moche religion and social structures.

Late Classic Maya ceramics were collected as early as the nineteenth century. These were derived both from casual finds

and from excavations, such as those carried out by the German immigrant E. P. Diesel-dorff at Chama, in highland Guatemala, and by Harvard University's Peabody Museum at Copan, Honduras, in the last decade of the nineteenth century. Systematic excavations in the early and mid-twentieth century, conducted by archaeologists, universities, and museums, uncovered Maya ceramics from sites in Guatemala's department of Peten, such as at Uaxactun (excavated by the Carnegie Institution of Washington), which enabled scholars to place the vessels within chronologies and begin to understand their social contexts.[10] However, most of the ancient Maya painted polychrome vessels known today came from illicit digging, primarily in Peten after 1970, largely because of political instability in this region as a result of the Guatemalan Civil War (1960–96), during which many Maya people were massacred. In 1972, the United States passed the Regulation of Importation of Pre-Columbian Monumental or Architectural Sculpture or Murals law, which was intended to protect monumental sculpture but left ceramic vessels and other portable objects vulnerable. A 1970 treaty between Mexico and the United States, designed to protect ancient Mexican artifacts, seems to have encouraged professional looters to shift their activities to Guatemala, where some operations grew to massive scales, as at Río Azul, which was heavily looted from 1976 to 1981, when huge tunnels were cut into the pyramids to seek pottery and other items.[11]

The purchase of painted Moche and Maya vessels by private collectors and museums, both in countries of origin and outside, heightened interest in owning these objects, with competition to acquire them increasing their value in the international art market. Legislation in countries like Guatemala, Mexico, and Peru and other international agreements, however, have attempted to respond to these activities; for example, in 1991, in reaction to a Guatemalan plea, the United States prohibited importation of Maya archaeological artifacts from Peten through an emergency action, which was formalized with a memorandum of understanding in 1997.[12] In addition, improved oversight and education, both in countries of origin and outside, have helped reduce such trade. All parties must remain vigilant to protect these materials and Indigenous peoples' ancestral heritage. Furthermore, Indigenous scholars and activists have advocated for allowing more Indigenous people in the Americas to make decisions about the fate of the cities and objects that their ancestors made, and to work to prevent and repair the harm of looting and other forms of extractive colonialism.[13]

All of the above has informed our decisions in selecting objects for the exhibition, many of which are illustrated in this volume. First, we have avoided vessels in private collections, selecting only those that are in museums and accessible to the public. Second, we have made a determined effort to display objects that have secure archaeological contexts. For a project that seeks to explore what painted pots made possible, it is vital to base our interpretations on examples that come from documented excavations, for these offer a solid basis on which to propose how a vessel was used, who might have handled or owned it, and what else might have been seen alongside it. Third, we are collaborating with museum curators and government officials in Guatemala, Mexico, and Peru to highlight the essential nature of international partnerships, both in learning about and in protecting the cultural heritage of these regions. Nevertheless, we have also included vessels without documented provenience. We both have worked extensively with collections of antiquities that lack findspots, and remain convinced that such objects—while substantially and often irrevocably deprived of critical information about their use and biography—still have plenty to tell. Our project considers how images are constructed, and the relationships among written, pictorial, and oral sources. For these topics, even vessels whose histories are incomplete can offer information about artists, images, and basic human desires to share and communicate with one another and the divine.

NOTES

1 On collecting Greek vases, see Nørskov 2002.

2 Well demonstrated by Bundrick 2019. See also the online tool developed by the Institut national d'histoire de l'art in Paris: https://ventesdantiques.inha.fr/.

3 See further Gerstenblith 2013; La Follette 2017; Gerstenblith 2019.

4 Discussed in Elia 2001; Watson and Todeschini 2007; Silver 2009; Felch and Frammolino 2011; Gill 2018.

5 Zevallos Quiñones 1994.

6 Pillsbury and Trever 2008, 197–98.

7 On Rafael Larco Hoyle, see Evans 1997.

8 Weismantel 2012, 303, 309.

9 Alva 1988; Coggins 1998, 62–63.

10 Miller 1989, 128–33.

11 Coggins 1998, 54–55, 60–62; Adams 1999, 3–7.

12 Valdés 2006, 96.

13 See, for example, Cojtí Cuxil 1996; Cojti Ren 2006; Montejo 2022.

MAKERS
AND
USERS

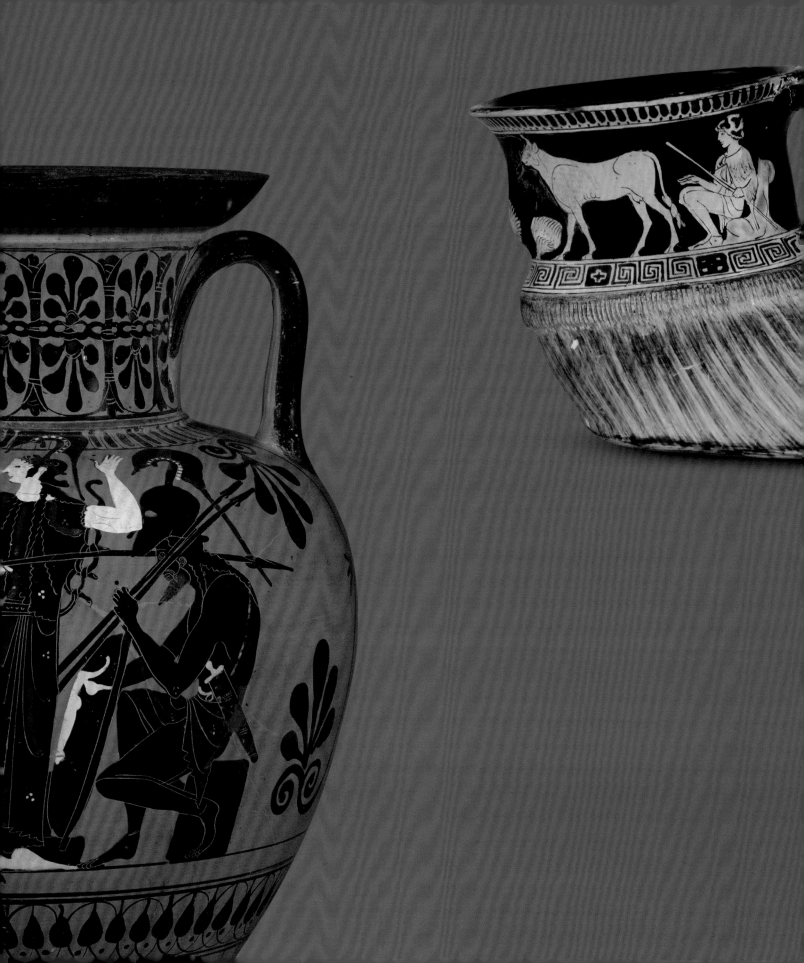

GREEK

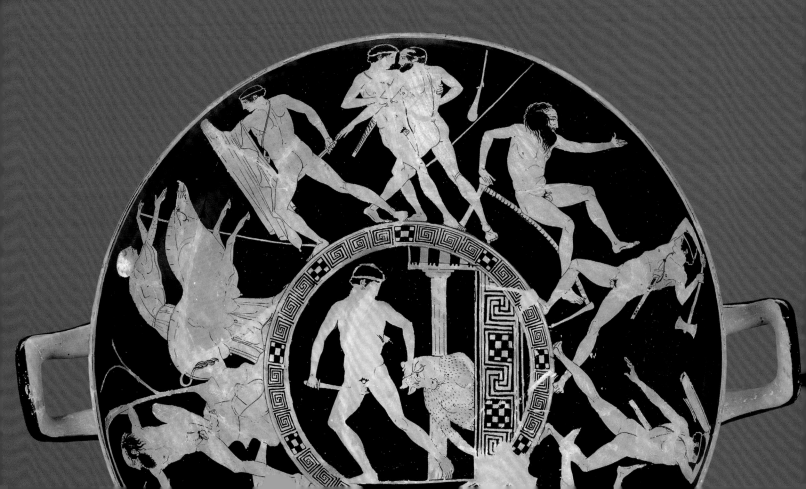

ANCIENT GREECE, 700–323 BCE: AN OVERVIEW

David Saunders

TIME

Following the Bronze Age (ca. 3000–1200 BCE), the practice of decorating pottery vessels with figural imagery reemerged in Greece from around 800 BCE and became widespread in many locations. By around 600 BCE, Athens began to dominate the market, and over the next two hundred years, its black- and red-figure pottery was widely used within Greece and exported across the Mediterranean. Its production thus falls within what are today termed the Archaic (700–480 BCE) and Classical (479–323 BCE) periods, the division between the two being the second Persian invasion of Greece in 480–479 BCE. Greek victory over this foreign foe proved decisive in fashioning Hellenic identity, but would also sow seeds of dissension, for Athens's assumption of leadership against future threats shaped a series of shifting alliances and long-running hostilities among the Greek city-states throughout the fifth and fourth centuries BCE. These internal struggles also ensured that Persia continued to play a part in Greek affairs, and after the Macedonians took control of Greece during the second half of the fourth century BCE, Alexander the Great returned to fight the old enemy. Alexander's death in 323 BCE marks the traditional end date of the Classical period, by which time the production of figure-decorated pottery in Athens had substantially diminished, although it flourished during the final decades of the fourth century BCE in Sicily and southern Italy.

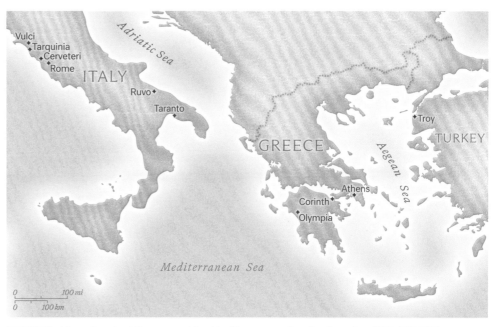

FIGURE 8 Map of ancient Greece and the Mediterranean showing key sites, 700–323 BCE

PLACE AND POLITICS

As this rapid sketch suggests, ancient Greece was not a unified state but, rather, comprised many poleis (city-states). Their distribution and diversity were shaped by the country's terrain—a mountainous landscape, interspersed with a few fertile plains—and its extensive coastline dotted with islands (fig. 8). Furthermore, the Greek world extended beyond the confines of the modern nation-state, and Plato's analogy of "frogs around a pond"[1] makes clear how important the Mediterranean and Aegean Seas were to commerce and communication. There were numerous settlements on what is today the west coast of Turkey, and from the mid-eighth century BCE, colonization—spurred by trade opportunities and the need for habitable land—spanned locations around the Black Sea, northern Africa, Sicily and southern Italy, and even the Mediterranean coast of modern-day France and Spain. Within this context, individual poleis waxed and waned, and each found its own means of structuring society. Some form of aristocracy was, initially, the prevailing model, but during the seventh and sixth centuries BCE,

many poleis experienced rule by a tyrant. The term "tyrant" was, in origin, more neutral than it is today, simply denoting an individual who overthrew the established aristocracy, achieving power with the support of the hoplite class (those who could afford armor). Rule by a tyrant could be beneficial, with substantial investment in architectural projects and cultural life, but tyrants' attempts to maintain control and pass it on to their heirs were typically met with resistance. This often augured a return to jockeying for power among the highborn or wealthy, but at Athens, reforms by Kleisthenes in 508 BCE reshaped the structure of society. According to the principle of *isonomia* (equality of law), all citizens could vote and participate in civic life. However, those with wealth and status still found ways to wield political influence, and there were short-lived periods of oligarchic rule. Furthermore, the democratic principles of participation and equality were fully available only to free male adults—and from 451/450 BCE, Athenian citizenship required not one but two Athenian parents.

Given that so much of the painted pottery considered in this volume was produced in sixth- and fifth-century BCE Athens (fig. 9), there is a danger of focusing on that city too much when making general assessments of ancient Greek culture. It bears stressing, therefore, just how exceptional Athens was during the Archaic and Classical periods—not only for its political organization but also for its size, wealth, material culture (and the efforts taken to rediscover this in recent centuries), and the array of literary texts that survive. Yet for all that Athens should be treated as a special case, and despite the fact that different Greek poleis might have their own calendars, coinages, or forms of government, a common Panhellenic identity can be inferred from a shared language, religion, and set of customs.[2]

LANGUAGE AND LITERACY

Ancient Greek was an Indo-European language, and existed in a number of dialects, although these would have been largely understandable to their different speakers. Foreigners were identified as such because they did *not* speak Greek: the word *barbaroi* (from which comes the word "barbarians") evoked the *bar-bar-bar* of their incomprehensible tongues. Evidence for writing—lost since the end of the Bronze Age—begins by around the mid-eighth century BCE. The alphabet was adapted from Phoenician script, and quickly found poetic uses—one of the earliest extant Greek inscriptions is a metrical verse incised on an Athenian jug. Yet this new technology emerged within a deeply rooted tradition of oral recitation, exemplified by the *Iliad* and *Odyssey* (perhaps written down by the end of the eighth century BCE, but achieving their established form only by the end of the sixth). These epic poems were part of a much larger cycle that recounted the exploits of Greek gods and heroes, and that had evolved over centuries. Performance and memorization remained key components of Greek culture, and it was not until the fifth century BCE that reading became a widespread means of conveying and acquiring information. Furthermore, there was doubtless a broad spectrum of literacy, and the range and variety of words and phrases that can be found on Athenian painted pottery provide one means of gauging the wider facility with the written word. Examples range from illegible blobs to carefully composed metrical phrases, and an individual painter—sometimes on a single vessel—might write both meaningful phrases and nonsensical strings of letters. All this suggests an environment in which some—but by no means all—could write (and read), and often only to a limited degree. This diversity, however, makes evident that literacy was not confined to a group of specialists.

RELIGION

Religion was another connection among Greek peoples. At its heart was a pantheon of twelve major divinities, resident on Mount Olympos, who were immortal and typically imagined in human form. For mortals, day-to-day religious practice sought primarily to obtain the gods' favor, and devotion manifested itself at an individual or family level (a votive offering in anticipation of a vow fulfilled, for instance), as well as at public rituals—most obviously the cycle of sacrifices and festivals that, for Athens, are estimated to have composed up to half the calendar year.

Each god and goddess had their own domain, although often with some overlap—Hephaistos, for example, was the god of fire, and so associated with metalwork and forges, but Athena's powers also extended to craft, and she was the subject of particular attention from Athenian potters and painters. Furthermore, individual divinities might have multiple aspects and cult sites, even in a single polis. In Athens and its vicinity, for example, Aphrodite could be worshipped as Aphrodite *Ourania* (heavenly), Aphrodite *Pandēmos* (of all people), Aphrodite *en kēpois* (in the gardens), and Aphrodite *Euploia* (good voyage)—each of these being a different manifestation of the goddess. Besides the twelve Olympians, there were divine personifications of both natural phenomena and abstract concepts; "new" divinities, such as Asklēpios; and a catalogue of heroes and semidivine beings. A number of the Olympians were themselves children of the primordial Titans, and Hesiod's *Theogony* (ca. 700 BCE) provides the earliest account of the generations that were believed to have preceded the gods. But for all the complex genealogies and narrative episodes, there was no canonical, immutable text in which doctrine was enshrined.

The most important act in Greek religious practice was sacrifice, and while temples housing cult statues and countless votive offerings could be imposing structures, the altar was the focus of a Greek sanctuary (fig. 10). Animals were butchered, their thighbones wrapped in fat and burned,

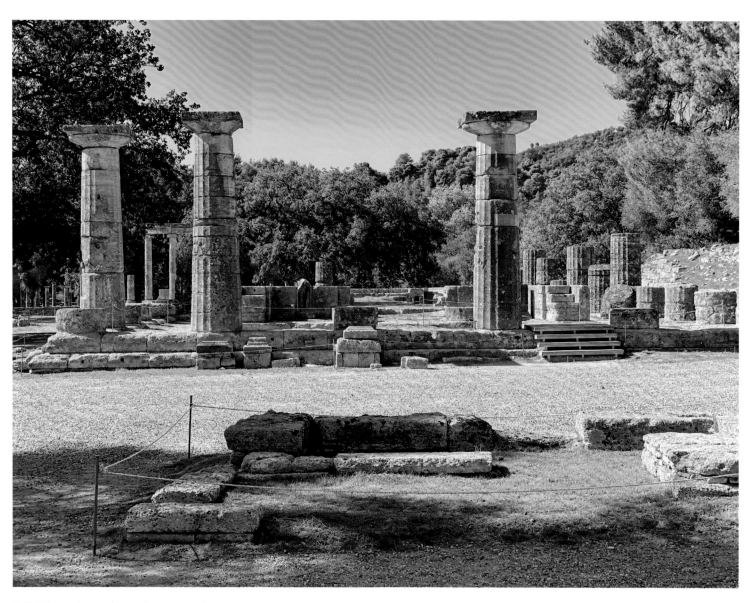

FIGURE 10 Altar and Temple of Hera, Olympia, Greece, built ca. 600 BCE

with the aroma ascending to satisfy the gods above, while the flesh was cooked and eaten by the worshippers. These and other offerings, such as libations (liquid offerings), were officiated by priests and priestesses, whose positions might be hereditary, elected, appointed, even bought. Each local community had its own calendar of festivals, but there were certain rites that assumed prominence across the Greek world—most notably the Panhellenic festivals at Delphi and Olympia (both performed every four years), and at Nemea and Isthmia (every two). All four were rooted in the worship of individual gods, and, not to be outdone, Athens established its own for Athena (the Greater Panathenaia). These festivals lasted days, and beyond processions and sacrifices, offered the spectacle of games. Athletic and equestrian events (and also some involving music and song) provided individuals and their poleis with the opportunity to win glory and renown (*kleos*) in the most public of settings. This culture of competition—and of being recognized for one's virtue—is apparent already in the *Iliad*, where the battlefield offered the ultimate stage for achieving *kleos*. This is expressed succinctly by Achilles:

> … if I stay here and fight beside
> the city of the Trojans,
> my return home is gone, but my
> glory shall be everlasting;
> but if I return home to the beloved
> land of my fathers,
> the excellence of my glory is gone,
> but there will be a long life
> left for me, and my end in death
> will not come to me quickly.[3]

THE SYMPOSIUM

Ideals such as these—masculine and aristocratic—found further expression in another aspect of life that was distinctly Greek: the symposium (see plate 3). This "drinking together" was a private, male-dominated event that was initially the purview of the leisured elite. Following a meal, drinkers reclined on couches, enjoying one another's company through song, conversation, and jokes. Central to the proceedings was the consumption of wine—or, rather, diluted wine. Drinking unmixed wine was deemed a foreign practice, and—at least at the outset of the evening—behavior was carefully orchestrated. A symposiarch would determine the proportion of wine to water, and following libations to the gods, the drink would be distributed from a large mixing vessel. Beyond the participants' own wit and erudition, entertainment might come from dancers or musical performers, and the evening could conclude with sex and a drunken procession in the street (*kōmos*).

RELATIONSHIPS, GENDER, AND SOCIAL STATUS

The symposium served, alongside the gymnasium, as a principal setting for the celebration and pursuit of male desire. Relationships between a youth in his early teens and an older male were central to elite masculine society in Greece. These partnerships were not only sexual but a valued component of a young man's upbringing, the lover providing guidance and education during the beloved's formative years.[4] A man's relationship with his wife was framed somewhat differently, being directed primarily at the raising of children,[5] but the chauvinistic tone encountered in some written sources should not overshadow expressions of love and care that can be found on funerary monuments. Nevertheless, there were substantial disparities in social status, with women generally unable to participate in civic affairs as men did. Married at fourteen or fifteen to someone who might be twice her age, a bride would be relocated to her husband's home, where her primary responsibilities were running the household, preparing food, weaving, and raising offspring. These realities were reiterated in ritual and myth, notably in the story of Persephone, who was playing with her friends when she was seized by Hades and taken down to the underworld to be his bride, leaving her mother, the goddess Demeter, broken in grief. Young girls could be described as "fillies," and the notion that they needed taming was an abiding theme in male-female relations in ancient Greece.[6] But while there are many texts—invariably written by men—that suggest that women were expected to conform to high standards of modesty,[7] this was probably unfeasible for any but the most wealthy, and the gap between expressed social norms and lived experience would have been substantial. Moreover, girls and women could participate publicly in religious practices, be it in processions at festivals, performing funerary rituals, or making dedications to the gods.[8] Some served as priestesses, and could accrue significant standing in doing so.[9]

Classified separately from the wives of citizens were *hetairai*. Desired for their wit, musical skill, and beauty, they could in some cases acquire great wealth. But as speeches given as part of legal cases attest, the distinction between a *hetaira*—who might be enslaved, a freedwoman, or a freeborn immigrant (see below)—and a *pornē* (sex worker) could be in the eye of the beholder.[10] This underscores the fact that all aspects of Greek life involved enslaved people. Most households would have had at least one or two slaves, and, without excluding the possibility of good relations at an individual level—slaves could be granted their freedom, and a nursemaid or *paidagōgos* (tutor) might be a trusted member of the *oikos* (household)—the enslaved were considered chattels, excluded from participating in political life.

Situated between the enslaved and citizens were metics—freeborn immigrants or freed slaves, who enjoyed certain legal protections but lacked political rights and could not own land.[11] At Athens (where, as so often, our evidence is richest), they were required to pay a special tax, but could accrue substantial wealth. As the city developed, it offered numerous opportunities for business, and metics constituted a significant percentage of the skilled workforce—not least the potters and painters considered in this volume.[12]

NOTES

Introductions to ancient Greece are numerous. See Dillon and Garland 2013; Sansone 2017; Pomeroy et al. 2020; and multiple volumes in the Wiley-Blackwell Companion series. For an introduction to ancient Athens, see Neils and Rogers 2021. Two recent textbooks on Greek art situate the material culture within broader social and political contexts: Neer 2012; Stansbury-O'Donnell 2015.

1 Plato, *Phaedo*, 109b.

2 Facing Persian attack in 479 BCE, the Athenians assured the Spartans of their commitment to defending Greece by invoking "the kinship of all Greeks in blood and speech, and the shrines of gods and the sacrifices that we have in common, and the likeness of our way of life" (*Herodotus* 8.144, in *Herodotus*, trans. A. D. Godley [Cambridge, MA: Harvard University Press; London: W. Heinemann, 1920–25], vol. 4, 153).

3 *Iliad* 9.411–16, in *The Iliad of Homer,* trans. Richard Lattimore (Chicago: University of Chicago Press, 1951), 209; compare also Sarpedon's speech to Glaukos, *Il.* 12.322–28.

4 See Lear and Cantarella 2008.

5 See Oakley and Sinos 1993, 9–10.

6 Compare the myth of Pandora, explored in Reeder 1995.

7 For instance: "Great is your glory if you fall not below the standard which nature has set for your sex, and great also is hers of whom there is least talk among men whether in praise or in blame" (Thucydides 2.45.2, in *History of the Peloponnesian War: Books I and II*, trans. Charles Forster Smith [Cambridge, MA: Harvard University Press; London: William Heinemann, 1980], 341); "Thus for the woman it is more seemly to stay indoors than to be outside" (Xenophon, *Oeconomicus* 7.30, in *Memorabilia; Oeconomicus; Symposium; Apology,* trans. E. C. Marchant and O. J. Todd, rev. Jeffrey Henderson [Cambridge, MA: Harvard University Press, 2013], 451).

8 See Kaltsas and Shapiro 2008. For funerary rituals, Garland 2001; Stampolidis and Oikonomou 2014.

9 See further Connelly 2007.

10 See Davidson 1997.

11 For a valuable study of metic women, see Kennedy 2014.

12 In the preserved accounts for the building of the Erechtheion on the Athenian Acropolis, around three-fifths of the named workers are metics (Stansbury-O'Donnell 2015, 271).

GREEK PAINTED POTTERY: PRODUCTION AND USE

David Saunders

Any survey of Greek pottery production should begin by acknowledging that figure-decorated ware constitutes just one component of the overall ceramic output. Undecorated vessels were used for cooking and storage, and workshops produced substantial quantities of plain black-gloss ware. Moreover, the thousands of figure-decorated vases and fragments that survive today are a tiny proportion of what was once produced, just one percent or less.[1] Painted pottery was, in other words, a ubiquitous medium, and modern market values are misleading in this regard. A few vases bear markings indicating their ancient prices, and these suggest that a medium-size vessel, such as a hydria or amphora, might have cost around a drachma, which is generally taken to be an average daily wage. For all but the most impoverished households, therefore, a small number of painted vessels would have been within reach.

Athens in the sixth and fifth centuries BCE will dominate our discussion here, but painted pottery was produced throughout the Greek world, notably at Corinth, Sparta, and a range of sites on what is today the west coast of Turkey, as well as in southern Italy and Sicily. Workshops would have served a substantial market, with storage and serving vessels (*amphorae, hydriai, oinochoai*), large mixing bowls (*kraters, dinoi*), drinking cups (*kylikes, skyphoi*) used at the symposium, perfume jars (*aryballoi, lekythoi, alabastra*) and small containers (*pyxides*) for personal adornments, and specific shapes designed for ritual or funerary practices (*phialai,*

loutrophoroi).[2] All these could also serve as religious offerings or grave gifts, and might be repurposed to these ends after years of use. But by no means was all pottery produced for local consumption. Corinthian workshops manufactured thousands of oil vessels that are found throughout the Mediterranean, and starting from the sixth century BCE, Athenian pottery was exported in copious quantities, in particular to Etruria, southern Italy, and sites around the Black Sea. Furthermore, potters and painters might relocate, and we can trace Corinthian artisans in Athens, and Athenians in Boeotia (central Greece) and southern Italy.

POTTING AND PAINTING TECHNIQUES

Greek painted pottery was made on the wheel, and is thus fundamentally different in method from Moche and Maya vessels. Some components, such as the handles, were formed by hand, while molds were used to produce sculptural elements.

The painted decoration was achieved using a slip (clay mixed with water) obtained through levigation: mixing the clay with water, allowing the heavier particles to sink, and siphoning off the more refined liquid. Pots were painted before they were placed in the kiln, and evidence for preliminary sketches can sometimes be seen. No written account of the firing process survives from antiquity, but detailed study—of excavated test pieces and misfires, for example—and

two centuries of attempts at replication have led to the consensus that the pots were fired once, but in three stages. The clay used by Athenian potters was rich in iron, and the distinctive orange and shiny black of their vessels is the result of a carefully controlled firing process, rather than the addition of any special pigments.[3]

Initially, air would circulate in the kiln, and the pot turned a reddish color. With the temperature rising to around 800 degrees Celsius (about 1,470 degrees Fahrenheit), the vents in the kiln were closed, so that all the oxygen was used up. The entire pot turned black, and the areas that had been decorated with slip vitrified, forming an impenetrable glassy layer. After the temperature increased to around 950 degrees Celsius (about 1,740 degrees Fahrenheit), the vents of the kiln were reopened, allowing oxygen to circulate again and the temperature to decrease. During this third and final phase the undecorated areas of the pot oxidized a second time, turning from black to orange. However, because the decorated areas had vitrified, and thus were no longer porous, they experienced no further chemical exchanges. The result was that they remained black, distinct from the unpainted areas.

The Geometric pottery of the eighth century BCE exhibits a silhouette technique, and this was gradually embellished to permit greater detail and some additional color (purplish red and white, derived from other clay types). The fully developed black-figure technique occurs first in Corinth by the early seventh century BCE and involves

FIGURE 11 Wine Cup with Symposium Scene. Greek, made in Athens, ca. 480 BCE (detail, plate 3). The potter's signature along the edge of the handle reads, "Hieron made [it]."

the delineation of features such as drapery folds, eyes, and musculature with a sharp tool. The practice of incising finds parallels in metalworking and engraving and was incorporated by Athenian workshops about 630 BCE. Around a century later, a period of technical experimentation in Athens gave rise to the red-figure technique,[4] which is a reversal of black figure: the background is painted black, leaving figures and ornament the color of the clay. Features that were previously incised were now rendered with a brush (perhaps composed of one or a few animal hairs), and painters employed a variety of dilute and relief lines to articulate details. They also embellished figures with applied clay, gilding, and, starting in the mid-fifth century BCE, additional colors (such as pinks, blues, and greens) obtained from minerals that were added after firing.

POTTERS AND PAINTERS

Pottery production—dirty, smelly, and laborious—was scarcely celebrated in antiquity,[5] and what we know of the makers comes from three sources: archaeological evidence of manufacture;[6] ancient depictions of potters and painters; and signatures. The last provide names of painters—who typically sign "[so-and-so] painted [it]," using the word *egraphsen* (compare the

Maya *utz'i[h]b*)[7]—and also of potters, who typically sign "[so-and-so] made [it]" (fig. 11), although here the word employed, *epoiesen*, can sometimes indicate both potting and painting, or, as in the case of Nikosthenes (fig. 13; plate 6), something more general, such as ownership of a workshop. The motivations to sign seem as various as the makers themselves, but these signatures have proved to be a critical tool for modern scholars in organizing the mass of material. Upon compiling vessels signed by a particular hand, it is possible to recognize the same painter's unsigned work, and Sir John Beazley (1885–1970) developed this method to its fullest in his studies of Athenian black-and red-figure pottery. By identifying what he called a "system of renderings" through detailed study of drapery folds, anatomical features, and ornamental details, he was able to recognize an individual painter's style and track its evolution.[8] Crucially, Beazley attributed unsigned vessels not only to painters whose names were known but also to painters whose names do not survive. This gave rise to the many nicknames that remain in use today, referencing a distinctive visual trait, such as the Affecter (plate 7), or the modern location of a particular example, such as the Harrow Painter (plate 8). Beazley's lists of attributions continue to serve as an organizational framework for the study of Athenian painted pottery, especially since dating these vessels still depends primarily on stylistic assessments.[9] Subsequent research has applied the same approach to pottery produced at other centers (and by other cultures, such as the Moche),[10] and led to additions to or revision of Beazley's lists. Similar steps have been taken to identify potters, relying on details of shape and form, although these are less fully advanced. To some extent, this reflects a privileging of the painter's craft that is deeply rooted in Western art history, but it stands at odds with the ancient Greek evidence. More than twice as many potters as painters are named on Athenian vases, and they seem to have had primacy in the workshops. The potter was, after all, rooted to the wheel and kiln, while painters could be more mobile, and we see a variety of potter-painter relationships.

The red-figure painter Makron, for example, worked consistently with the potter Hieron (plates 3, 9), but other painters collaborated widely. Judging by signatures and attributions, Epiktetos painted vessels for at least eleven different potters (and painted at least one pot he made himself), while the potter Nikosthenes (fig. 13; plate 6) collaborated with thirty-three painters and at least three other potters.[11] These networks can sometimes be traced over decades, and skills could be passed down through the family—in one case, signatures that include a father's name allow us to track three generations of potters: Ergotimos, his son Eucheiros, and a grandson whose name is lost.[12]

Evidence for buildings and installations is invariably incomplete, and the term "workshop" is frequently used to denote networks of artisans who—judging by signatures or stylistic attributions—appear to have worked together. In some instances, however, excavated finds do support these associations.[13] Kilns are sometimes preserved, but often the clearest markers are deposits of waste material and test pieces. At Athens, many pottery workshops were concentrated in an area to the northwest known as Kerameikos.[14] This was close to the city's burial ground and transport routes, with access to material supplies, but sufficiently distant to keep the smoke and smell away from the town. Pottery production, at least at anything other than a domestic scale, was likely to have been seasonal, and the size of the workforce remains subject to debate.[15] But if solid numbers are hard to come by, there are glimpses of a close-knit community. As noted, skills could be transmitted within a family, and in the decades around 500 BCE, a cluster of artisans even name one another on their vases.[16] Pottery making also appears to have been a masculine domain. All the names known from signatures are male, and the same holds for Athenian depictions of potters and painters at work, except for a workshop scene on a red-figure hydria of the mid-fifth century BCE, which includes a woman decorating a volute krater.[17] This leaves open the possibility that women participated in aspects of production, but their involvement is not easily traced in the material record. Signatures do, however, convey a degree of social diversity. One painter explicitly signs as a slave,[18] and a portion of those working in the Athenian Kerameikos may have been noncitizen metics (freeborn immigrants) or enslaved. Names such as Brygos, Skythes, Syriskos, and Kolchos could suggest foreign origins, as does the Etruscan name Metru,[19] while Epiktetos (meaning "newly acquired") could indicate (once-) enslaved status. But three potters, Teisias, Xenophantos, and Phintias, each sign as "Athenaios" (Athenian), and others are clearly citizens.[20]

Some Athenian workshops were situated on thoroughfares leading out of the city, so it could have been possible to buy pottery directly at the place of production. It is likely that there were also stalls in the Agora, and probably in the city's port at Piraeus,[21] but the ways in which potters and painters catered to their customers are difficult to reconstruct. The clearest evidence comes from the very few instances in which a text on a vessel names the individual for whom it was made.[22] Much more prevalent are *kalos* names, which have long been thought to praise highborn youths, who were celebrated in Athens. These inscriptions, in which the adjective *kalos*, meaning "beautiful" or "fine," was attached to a personal name, could indicate that a vessel was produced for the named individual, or—more likely—that the maker or user had (or hoped to have) some familiarity with that person. But recent scholarship highlights that *kalos* names could function in playful ways, and need not always reference elite young men.[23] Prefired inscriptions that designate vessels as dedications to a deity are a more reliable, if more general, basis for identifying pottery produced for an intended market.[24] Scenes that lie outside a painter's usual run of subjects could also indicate production for a specific purpose (particularly when the vase's findspot is known, and the scene can be associated with a place or individual).[25] But all these categories are dwarfed by the vast bulk of material, for which we can only speculate about the painter's motivation or intent. Nevertheless, the selection of imagery was not entirely arbitrary, and

a vessel's function was an important factor. A category of oil jar (white-ground lekythoi) was made for funerary purposes, and often with imagery to match,[26] while Dionysos and his entourage, or images associated with the symposium and its preparations, would always prove suitable subjects for drinking vessels or kraters. Painters were responsive to their markets, and we can identify shifting fashions over the long term. Some scenes endured for centuries, but others emerged suddenly or flourished only briefly. For much of the sixth century BCE, for example, the Athenian hero Theseus was primarily depicted defeating the Minotaur. But in the years prior to 500 BCE, new scenes appear, which show him defeating a variety of opponents (also seen some decades later on the drinking cup illustrated in plate 10, datable to about 430 BCE), or depict other episodes in his life (see plate 8). When this development is seen alongside contemporary literary sources and other visual media, it appears that Theseus was promoted as the new democracy's leading hero, and the vase painters responded to—and shaped—this interest in his exploits.[27]

Broadly speaking, therefore, figured-decorated pottery was produced to satisfy the market, and what was familiar, or of current interest, was what sold.[28] This aspect of Athenian pottery production takes on further weight when we turn to the large volume of material that was exported to non-Greek communities around the Mediterranean.[29] Shapes that imitate foreign vessel types demonstrate an attempt to cater to external tastes or ritual practices, and traders and middlemen must have played a critical role in communicating what might sell. Some evidence for their activity comes from markings (graffiti), usually a symbol or a letter or two, often under the foot of a vessel. In some cases, the same trademark occurs on pots by painters who have been connected stylistically, suggesting an association with a particular workshop. But did knowledge of a specific market overseas determine the choice of imagery? By and large, many painters seem to have operated in a pictorial middle ground, depicting subjects that could be viable at home or abroad. Clear cases of targeted imagery, such as elaborate vessels that have been found in Persian territory with scenes of Persians prevailing against Greeks are rare,[30] but study of Etruscan contexts increasingly suggests that certain themes were understood to have local appeal or adaptability. In the case of an Athenian black-figure amphora (see plate 7) that ultimately served as a container for ashes in a burial at Tarquinia, the mourners could have identified the depictions of Greek gods as their related Etruscan counterparts, and so recognized Hermes as Turms, a guide of souls.[31] Such compositions may not have been conceived with the export market in mind, but Etruscan consumers incorporated them in their own cultural practices, and—via traders and intermediaries—this stimulated production back in Athens.

NOTES

For detailed consideration of many of the topics discussed here, see Boardman 2001; Papadopoulos 2003; Williams 2009; Sapirstein 2013; Williams 2013; Langridge-Noti 2015; Bundrick 2019; Hasaki 2021; Rotroff 2021. Lynch 2011 provides an instructive consideration of the pottery of a single Athenian household. On depictions of potters and painters, see Hasaki 2021, 179–226, and on signatures, Hurwit 2015, 71–96. On potting and painting techniques, see Noble 1988; Schreiber 1999; Cuomo di Caprio 2017; Balachandran 2019.

1 The figure is obtained by calculating how many Panathenaic amphorae (awarded as prizes at the Panathenaic Games every four years) should have been produced, and comparing that number to surviving examples.

2 Most shape names are ancient, although their modern usage does not always reflect their original application; see Richter and Milne 1935.

3 First proposed by Richter 1923. Recent technical analyses have reopened the possibility that some pots underwent multiple firings; see Saunders, Trentelman, and Maish 2021.

4 The advent of the red-figure technique is conventionally dated circa 525 BCE, but for suggestions to downdate or extend the careers of some of its early practitioners, see Rotroff 2020. For other decorative techniques, such as white ground, that were introduced in the late sixth century BCE, see Cohen 2006; Lapatin 2008; Bentz, Geominy, and Müller 2010, 42–59.

5 One text suggests Athenian pride in the city's ceramic tradition: the fifth-century BCE politician and author Kritias asserted that Athens "invented the potter's wheel and the child of clay and the oven, most glorious pottery, useful in housekeeping" (Athenaios, *Deipnosophistae* 1.28c; see Neer 2002, 212–13).

6 More than 250 Archaic and Classical sites from across the Greek world are known. Stissi 2012 assesses what can be known of workshop organization and scale; see further Bundrick 2019, 33–37; Hasaki 2021, 227–78.

7 See O'Neil, "Maya Vase Production and Use," this volume.

8 See Arrington 2017.

9 The Beazley Archive Pottery Database (https://www.beazley.ox.ac.uk/carc/pottery) collates and augments this information.

10 See further Turner, this volume.

11 Makron signs once, but Hieron signs nearly sixty vessels, and all but two have been attributed to Makron (Hurwit 2015, 85–86; Williams 2017, 168). On Epiktetos, see Paleothodoros 2004, 55–56; on Nikosthenes, Tosto 1999, 1–13, 172–206.

12 Williams 2009, 309.

13 For example, a deposit containing fragments attributed to painters associated with the potter Brygos (see Williams 2017, 168), or another with fragments attributed to the Painter of the Athens Dinos and contemporaries (Bentz, Geominy, and Müller 2010, 150–69).

14 During the Early Iron Age and into the sixth century BCE, potters worked in what would become, in the Classical period, the Agora (Papadopoulos 2003).

15 Sapirstein (2013, 508) concludes that "the whole population of potters, painters, and assistants engaged in the production of Attic pottery was below 100 for much of the sixth century BCE and is unlikely to have risen much above 200 at its maximum." See further Sapirstein 2020, responding to arguments for much larger numbers proposed by Stissi 2016 and Stissi 2020.

16 On "potter portraits," see Neer 2002, 87–134; Topper 2012b, 147–54; Hedreen 2016a, 22–58.

17 Vicenza, Banca Intesa, 2 (C278) (BAPD 206564). The early fifth-century BCE painter Douris is presumed to be male, but the spelling of the name leaves open the possibility of a female artisan (Buitron-Oliver 1995, 1). Hasaki (2021, 206) discusses the depiction of a woman on a Corinthian votive plaque. On women as potters or painters during the eighth century BCE and earlier, see Murray, Chorghay, and MacPherson 2020.

18 "Lydos the enslaved" is written on a late sixth-century BCE black-figure kyathos (Rome, Museo Nazionale di Villa Giulia, 84466; BAPD 6247). The rest of the inscription has been read as "from Myrina," a site near Izmir on the Turkish coast.

19 On Metru, see Williams 2013, 47–48; see also Pevnick 2010, who argues that Syriskos (meaning "the little Syrian") sometimes signed as Pistoxenos ("trustworthy foreigner").

20 See Williams 2009, 310. A fifth-century BCE potter, Nikias, signs with both his father's name and the name of his deme, indicating his citizen status (London, British Museum, 1898.7-16.6; BAPD 217462). See also the fourth-century BCE potter Bakkhios, of the deme Kerameis, whose two sons won a contract to produce pottery at Ephesos, where they were awarded citizenship (Hurwit 2015, 96).

21 Boardman (2001, 156) notes an anecdote of around 300 BCE that indicates that pottery could be hired.

22 Williams (2013, 41–43) discusses four examples. Dedicatory texts on Maya vessels are comparable, albeit within a very different political and social structure; see O'Neil, "Maya Vase Production and Use," this volume.

23 The possibility that these names provide evidence for special commissions was key to a proposal that many Athenian painted pots were used once and then exported (Webster 1972). This secondhand-market hypothesis has found few followers (see further Bundgaard Rasmussen 2008). For recent considerations of *kalos* names, see Lissarrague 1999; Slater 1999; Mannack 2014; Mannack 2016; Pevnick 2021. On *kalē,* the female equivalent, see Hedreen 2016b.

24 See, for example, the Athenian black-figure fragment with a dedication to Apollo, Museum of Fine Arts, Boston, 03.852 (BAPD 300379). See also Iozzo 2018 for discussion of rare instances in which words pertaining to a vessel's decorative subject have been inscribed and subsequently overpainted or overwritten.

25 See, for example, two Parian Geometric amphorae with battle scenes (Zaphiropoulou 2006) and an Athenian black-figure skyphos with figures wearing unusual headgear (Lynch 2011, 110–18).

26 On white-ground lekythoi, see Oakley 2004.

27 On the deeds of Theseus and his iconography, see Neils 1987; Neer 2002, 154–68; Servadei 2005.

28 See further Lynch, this volume.

29 Villing (2021, 277–80) provides an excellent overview. Bundrick (2019, 47–49) discusses the exceptional case of a boat that was en route to Massalia (Marseille), the Pointe Lequin 1A wreck (ca. 520–500 BCE). Of the cargo recovered, ninety-four percent was fine-ware pottery.

30 Williams (2013, 49–50), discussing Museum of Fine Arts, Boston, 21.2286 (BAPD 209548), and Paris, Musée du Louvre, CA 3825 (BAPD 275887). Villing (2021, 278) also notes Thracian-style mugs decorated in red figure with Thracian imagery, and vessels found in Egypt with Egyptian motifs.

31 See Bundrick (2019, 168–70), whose study employs the term "Etruscanization" in discussing the ways in which Etruscans incorporated Athenian painted pottery into local practice and ritual.

Wine Cup with the Suicide of Ajax (plate 15, detail)

ATHENIAN FIGURED POTTERY AT HOME AND ABROAD

Kathleen M. Lynch

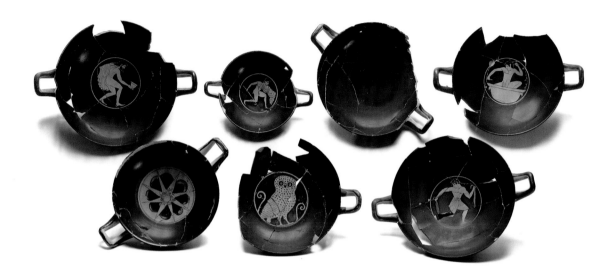

FIGURE 12 Selection of wine cups (500–480 BCE) recovered from an Athenian household. Ephorate of Antiquities of Athens-Ancient Agora. Ancient Agora Excavations/American School of Classical Studies. From left to right and top to bottom: P 32420, P 32411, P 32470, P 32419, P 32421, P 32422, P 32417. After Lynch 2011

Thin-walled and decorated with vibrant black or orange figures, Athenian figured pottery stood out from contemporary pottery throughout the Mediterranean. Most ancient settlements had access to clay beds and could create practical vessels for daily use. But these utilitarian forms lacked the exceptional aesthetics of Athenian figured pottery; thus, it is no surprise that consumers around the Mediterranean imported Athenian pottery as a complement to local pottery production. In fact, the structural strength of Attic clay permitted extraordinary pottery shapes, such as the kylix, with its broad, almost horizontal bowl, that make much more sense in metal (plate 10). The exceptional quality of the clay combined with unusual narrative figural decoration appealed to Greeks and non-Greeks alike.

The potters of sixth- and fifth-century BCE Athens were not only technically savvy; they were also master marketers of their products. Athenian pottery from known findspots reveals some differences between the modest shapes and decoration of vessels used at home, by Athenians themselves, and the more elaborate shapes and decoration of vessels designed for the export market. Archaeological evidence from the Archaic and Classical periods confirms that Athenian households bought decorated and plain black pottery for private use. This domestic use overwhelmingly favored specialized drinking equipment for the symposium, the quintessentially Greek wine-drinking event. The Greeks mixed their wine with water, and every guest had his own cup, which he held while reclining on a couch (plate 3). Ceramic sympotic equipment included a mixing bowl (plates 8, 11), a storage jar (plates 2, 7, 12), a water jar (plate 13), a wine jug (oinochoe), and individual stemmed cups (plates 3, 6, 10, 14). Indeed, the krater and the kylix played such specific functional roles in the symposium that it is hard to imagine their use in other social contexts. We can be confident that an ancient Athenian household that possessed a krater or kylikes hosted symposia.

The imagery on sympotic equipment from the homes of ancient Athenians strikes us as very modest compared to the decoration

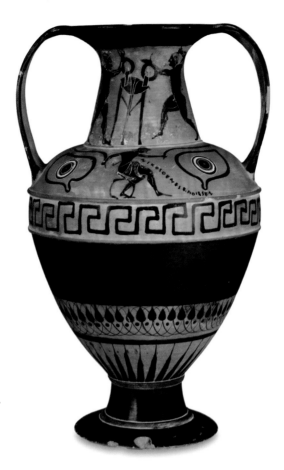

FIGURE 13 Storage Jar with Boxers, signed by Nikosthenes as potter, attributed to Painter N. Greek, made in Athens, ca. 520 BCE. Terracotta, H: 31 cm (12 3/16 in.); W: 19.5 cm (7 11/16 in.). Malibu, J. Paul Getty Museum, Villa Collection, 68.AE.19

on the same shapes produced for export. For example, a late Archaic house near the Athenian Agora owned a set of kylikes, some plain black but six with red-figure decoration (fig. 12).[1] Of the six, all but one had decoration only on their floor, in the tondo of the cup. The exteriors remained totally black. Four of the tondo scenes feature single figures performing everyday chores and activities: a bearded man carrying a drinking cup (skyphos); a youth carrying strips of meat; another youth treading grapes in a vat; and a third youth running with a throwing stick. None bear mythological subjects—a trend seen in the remains of other Athenian household cupboards.

Athenian homes also occasionally owned figure-decorated wedding vessels, which bore imagery appropriate to their cultural function, though surviving examples are much less widespread than sympotic vases. Other figure-decorated shapes, such

as the lekythos—an oil container—may have served a variety of functions, from holding a condiment for the snacks at the symposium to storing perfumed oil for personal adornment (plate 16). Popular in the late Archaic period (ca. 520–480 BCE), black-figure lekythoi feature a range of imagery that does include Dionysos, satyrs, and maenads, suggesting that some did have a role in the symposium. Unlike kylikes, the lekythoi used at home in Athens are very similar in imagery to their counterparts sent to consumers around the Mediterranean.

We know little about the physical setting of pottery production in ancient Athens, although scholars have hypothesized artistic associations among painters based on stylistic similarities.[2] We know even less about the logistics of the export trade in Athenian pottery: who placed orders, what was the relationship between the pottery producer and the transporter, and how did customer

feedback reach the Athenian producers? Like a smoking gun, findspots of vases outside Greece and patterns of customer preference provide the best evidence for trade. For example, the presence of Athenian figured vases in tombs of several cultures in Italy, including the Etruscans, validates the existence of structured and sustained trade between Athens and Italy during the Archaic and Classical periods. In fact, pottery production for the export market probably exceeded that for the domestic Athenian market. The Athenian potters were businessmen, after all, so they met a profitable demand for their products.

The Etruscans, a culture in central Italy active during the Archaic and Classical periods, are the best-studied market for Athenian figured pottery. Excavations of settlements show that Etruscans used figured Athenian pottery in their everyday lives, and, more dramatically, some

Etruscan city-states buried their dead with grave gifts including Athenian pottery. The tombs, whether rock-cut chambers or pit graves, preserved the pots complete. As early as the seventeenth century of our era, Italian nobles discovered these tombs on their property and extracted the vases for their private collections. These personal collections eventually found their way to major museum collections around the world, although the find locations of the vases were often lost along the way. Nevertheless, if we see complete Athenian vases with elaborate mythological narrative scenes in museums, there is an excellent chance they came from Italian graves (see, for example, plates 7–10).

The Etruscan taste for Athenian vases, however, allows us to see how the savvy Athenian potters and painters marketed to these non-Greek consumers. The style of the paintings remained uniquely Athenian, but occasionally Athenian potters produced shapes never used in domestic Athenian contexts, like a wide-handled, narrow amphora called the Nikosthenic amphora (fig. 13) or a ladle with a loop handle called a kyathos. These vessels, though unmistakably Athenian in production, echo indigenous Etruscan pottery forms. Greek sympotic shapes, however, found a ready use in Etruscan banquet culture. The Etruscan banquet had very different cultural objectives than the Greek, but as in the symposium, Athenian pottery helped to distinguish the event as beyond the ordinary. In some cases, the placement of Athenian pottery in a grave probably happened after its use in a funeral feast.

More interesting for us is how Athenian vase painters selected imagery to appeal to their customers. Scholars have shown that certain figural decoration, such as large eyes on cups (plates 6, 14) or heterosexual erotic scenes, found more customers abroad than at home. Other times we can see patterns of preference but cannot always explain them. In general, the Athenian vases from Etruscan and other Italic contexts feature more elaborate mythological narratives than the vases from Athens itself. Multifigured scenes illustrate moments from Greek myth, but they do not teach the myths: the scenes on these vases require the viewer to know the story to recognize the moment. Perhaps the owner of the vase gained prestige through knowledge of this foreign imagery. Some Etruscan mythology echoed the Greek, so the popularity of the Greek hero Herakles matches that of the Etruscan hero Hercle.[3] Later sources explain that a good afterlife was something of a party, and thus images of Dionysos and his retinue take on an eschatological meaning in Etruscan or Italic funerary settings. Nevertheless, Athenian potters happily modified their products— through non-Attic shapes and more elaborate imagery. These figure-decorated vases, then, may tell us more about the interests and concerns of their Etruscan users than about their Athenian creators.

Athenian pottery has been found in nearly every site excavated around the Mediterranean, from Portugal and inland France to northern Africa, the Levant, and the Black Sea. For most of the sixth and fifth centuries BCE, the trade to these areas did not reach the structure or quantity of that to Italy. But in the fourth century BCE, trade shifted away from Italy, and Athenian potters found new non-Greek customers to the west, in Iberia, and on the northeastern coast of the Black Sea. Again, we can see patterns of preference: Iberians favored kraters, to be used as cinerary urns, and customers in the Crimean area of the Black Sea liked shapes with added color and even gold details. Production for each area was not exclusive, but the trade patterns remind us that even as the Attic pottery industry neared its end, Athenian potters remained savvy businessmen catering to their consumers.

All Athenian pottery was made in Athens, regardless of where trade took it. Even when the painters depict images that residents of Athens would never choose, the style and artistic concept remain distinctly Athenian. As we examine pottery produced by the Greeks, Moche, and Maya, it is important to ask why these cultures developed narrative imagery on such a modest medium. For our Athenian businessmen-potters, the export market may have been the prompt.

NOTES

1 See Lynch 2011.

2 See Saunders, "Greek Painted Pottery," this volume.

3 See Bundrick 2019.

MOCHE

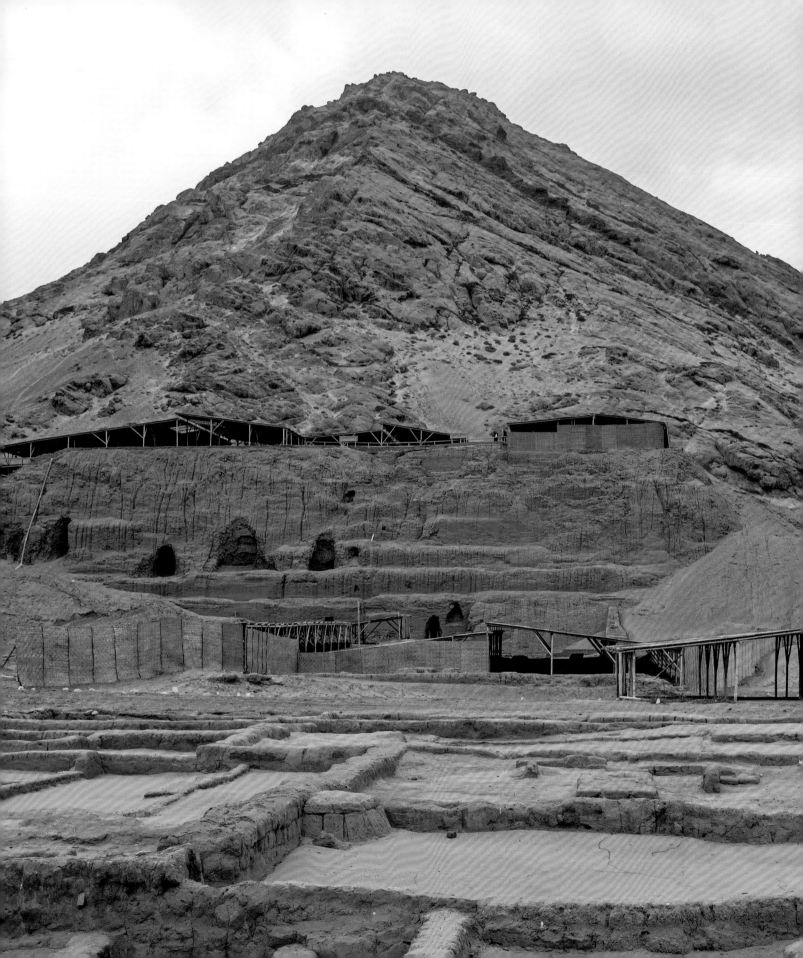

THE MOCHE, 200–850 CE: AN OVERVIEW

Ulla Holmquist

TIME AND PLACE

About two thousand years ago, the inhabitants of the northern coastal valleys of what is today Peru began to dedicate their time and energy to cultivating the lands they had conquered in the desert, consistently improving the hydraulic technology that enabled them to make efficient use of the water that ran through their irrigation canals only seasonally (from November to March). The people who had adapted to this territory over millennia intensified agricultural production, improving the crops, fertilizing the soils, administering the distribution of water, and gaining a better understanding of natural cycles.

Archaeologists have identified three different cultures occupying the valleys of the north coast during these years: the Vicus culture (in the modern Piura region), the Salinar (in La Libertad and north of the Ancash region), and the Viru (in the Lambayeque, La Libertad, and Ancash regions). The variety in the material culture of these communities could suggest a basic ethnic diversity, and also a complex history of alliances, conflicts, and sociopolitical changes. This diversity of cultural expression faded over time, however.

In this region (fig. 14), between the Huarmey Valley, to the south, and the Piura Valley, to the north, Moche culture developed around 200 CE, and underwent a process of disintegration around 850 CE. Following the research of Rafael Larco Hoyle (1901–1966), this culture was thought to be the expression of the north coast's first state, with a capital at Huacas de Moche (in the Moche Valley), and a core area (the Moche and Chicama Valleys) from which it expanded to the south

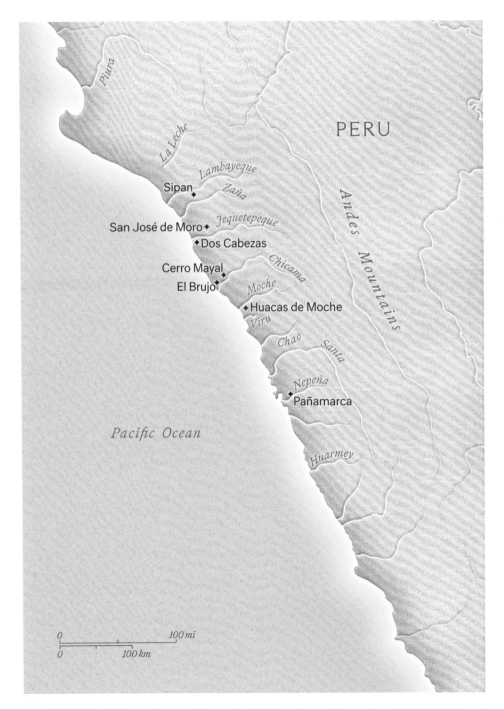

FIGURE 14 Map of the north coast of Peru, showing key sites and river valleys, 200–850 CE

FIGURE 15 View of Huaca de la Luna at Huacas de Moche, Peru, with Cerro Blanco in the background

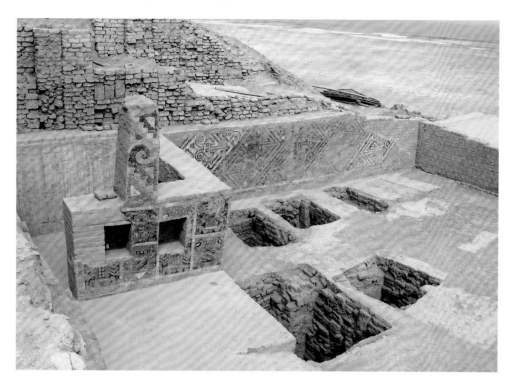

FIGURE 16 Tomb of the Señora de Cao and accompanying burials, Huaca Cao Viejo, El Brujo, Peru, 400–450 CE

(the Viru, Chao, Santa, and Nepeña Valleys). Later, other scholars suggested that a second state developed north of the Chicama Valley (in the Jequetepeque, Zaña, Lambayeque, and La Leche Valleys), and that this "northern Moche" state was politically independent from the "southern Moche" state.[1] In Piura, the presence of Moche materials alongside Vicus cultural expressions would imply the existence of some sort of Moche colony. More recently, scholars have discarded the idea of a unified Moche state in the northern region in favor of the existence of various polities in the valleys north of Chicama.

For some researchers today, understanding the Moche phenomenon requires examining it from multiple centers and considering the formation of cultural identities in the context of ethnic diversity.[2] Moche culture was not the homogenous cultural phenomenon that it was thought to be decades ago; nor did it correspond to a single expansive state or lordship. Rather, it was more a political ideology, embodied in an elite material culture that had a substantial religious component. The elaboration of these symbolic expressions was based

on a cultural tradition that had great continuity in the region, and that was already present in the earlier Cupisnique culture from around 1200 BCE.[3]

We could also view Moche culture as a religion shared by various ethnic groups living on the north coast,[4] recognizable in its material manifestations, such as ceremonial and funerary furnishings, and ritual performance spaces with similar stylistic traits. These traits express the shared symbolic, mythological, or ideological background of the political-religious leadership of the north coast communities, which, until the rise and adoption of Moche culture between 200 and 850 CE, had developed distinctive local cultural traditions.

POLITICAL ORGANIZATION

The adoption of an Andean perspective in interpreting pre-Hispanic sociopolitical phenomena—the avoidance, that is, of theoretical models based on Western historical realities—has generated alternatives to the Moche "centralized-state" model.

In assessing contrasting ethnohistorical models and the archaeological evidence from pre-Hispanic north coast towns, some have suggested that the social organization of the early Moche communities during the Early Intermediate period (from roughly the beginning of the common era to 650 CE) consisted of autonomous political units in the form of groups organized by kinship and by territory.[5] Such groups would have been patrilineal, with territories organized around lands irrigated by a main canal. Possible alliances and conflicts between groups could explain, for example, the stylistic variability in their material culture and different stylistic evolutions. These communities interacted with their highland neighbors—the Recuay (in the Ancash region), Huamachuco (La Libertad region), and Cajamarca (Lambayeque region)—and their relations were likely not only political or based solely on trade or mutual dependencies, as in the case of water management; they must also have generated mixed ethnicities. Over five hundred years or more, from one generation to the next, the various alliances among communities in the extensive

territory of Moche culture would have occasioned movements of producers (including potters, builders, and ritual specialists), marriage exchanges, and fluctuation in the transmission routes of cultural knowledge and practices.

CEREMONIAL CENTERS

The architectural design of the ceremonial centers and mausoleums in the northern coastal valleys is not homogeneous, though all were built in adobe and the great majority feature ceremonial courtyards and platforms with attached entrance ramps. In several cases, the builders of these platforms progressively built over them, sealing off entrances and filling spaces with mold-made adobe bricks. This occurred at events associated with the burial of the buildings and the symbolic regeneration not only of those spaces—which were considered huacas, or sacred beings—but also of ruling lineages.

The most emblematic buildings, which were also the settings for the main Moche rituals, were Huaca de la Luna (adjacent to Cerro Blanco and part of the Huacas de Moche complex, which includes Huaca del Sol and the residential structures between it and Huaca de la Luna) (fig. 15) and Huaca Cao Viejo (part of the El Brujo complex, built close to the sea, fig. 16), in the Moche and Chicama Valleys, respectively. The mountain, which was a sacred entity guarding the water that flowed down its flanks to irrigate the fields, and the sea, which was the origin of life and a world associated with the ancestors, would have been the complementary sacred entities personified by these two huacas. Decades of sustained archaeological work at these archaeological complexes have yielded hundreds of scientific essays and books that allow for a general understanding of both sites.[6]

Both huacas served as burial places for political-religious leaders and pilgrimage sites where leaders of the neighboring communities convened. They were centers for all manner of meetings and exchanges, including the processes of legitimizing power and hierarchical positions among the participants. Religious messages, ritual practices, and mythological stories were disseminated mainly from here. The impact of these centers can be seen in the ceramics of other local substyles, artifacts carved in wood, woven tunics, metal artifacts, and other locally produced objects that were not widely distributed. All these objects, though adapted to the conditions and needs of the elites and the local ritual practices, share a certain artistic canon.

The influence of the liturgical centers can also be seen in how other ceremonial centers and mausoleums were constructed, how their ceremonies were performed, and how the elites in other valleys of the Moche cultural-religious sphere were buried. It may have been that builders, painters, and, probably, religious specialists from Huaca de la Luna traveled to other valleys to build and establish other ceremonial centers. Besides Huaca de la Luna and Huaca Cao Viejo, Moche monumental sites like Pañamarca (Nepeña Valley) reveal the importance of mural painting and reliefs, which served to situate shared Moche mythological narratives in the places where the rituals were performed. Throughout the time of the Moche phenomenon, various Moche huacas (Pampa Grande, Galindo, Pampa la Cruz, El Castillo de Santa, Guadalupito) present mural art related to ancestral deities, martial culture, warrior processions, and sacrificial offerings.[7]

In Huaca Cao Viejo, the tomb of the Señora de Cao stands out, as do the tombs of various ritual specialists in Huaca de la Luna. Other Moche sites with mausoleum buildings or cemeteries associated with congregation areas are Sipan (Lambayeque Valley), Ucupe (Zaña Valley), San José de Moro (Chaman Valley), and Dos Cabezas (Jequetepeque Valley). There, rituals of consumption, feasts, and funeral rites were held for community leaders, providing them with the proper treatment to assure their transcendence and their conversion into ancestors.

The men and women buried in these places held leadership roles, such as community chiefs; they may have been lords and ladies who descended from ruling families and exercised hereditary power, or persons who filled priestly roles in high-level rituals. Most of these tombs are rich in grave goods. Clothing, adornments, coffins, and funerary design reveal the great community effort devoted to converting these people into ancestors; in some cases, these practices may be seen as rituals deifying the rulers. The processes are not homogeneous, since each community, group, and political entity developed in its own way, and changes unfolded at their own pace.

ART

The collective memory of the towns that had certain religious commonalities in the Moche epoch retained the histories of past events as well as processes, legends, and myths. These were not only shared orally—in conversation, song, stories, and prayers—but also modeled, painted, carved, and woven. It is important to note that all that is known of the Moche beliefs and rituals derives from the study of visual creations, and not from written texts. If we define writing as the registering of spoken language in visible phonetic signs, it can be said that no written stories, legends, myths, or ritual instructions exist in the Andean region in pre-Columbian times.

Mythological narratives were portrayed on the walls of buildings that received locals and pilgrims for ritual performances, and the bodies of political-religious leaders in the places reserved for them as mausoleums, so that participants in ceremonies were surrounded by stories. The sophisticated ceramics, metal ornaments, woven tunics, and mantles rich in visual imagery came to life with the objects' use and participation in diverse activities: containing water, adorning sacred bodies in splendor, and shrouding ancestors. Their materials, techniques, and images summoned the forces needed to interact and satisfy the demands of the Moche way of being in the world, a way sustained by the reciprocity between communities and their ancestors or divinities. This is probably the

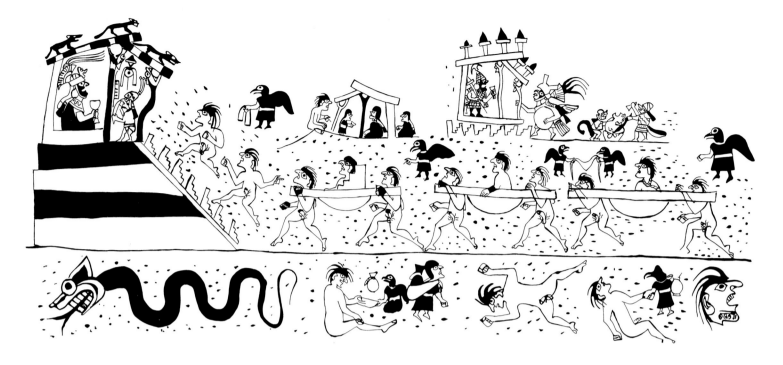

FIGURE 17 Rollout drawing of Stirrup-Spout
Vessel with Sacrifice and Presentation Scenes.
Moche, made in northern Peru, 600–850 CE
(see plate 23). Drawing by Donna McClelland

most widespread characteristic of Andean religions: the constant collective offerings to sacred beings, or huacas, to propitiate them, to "feed" them, so that they could continue to be active and powerful, assuring the circulation of life, one of the main concerns of Andean cosmologies.

Moche fine ceramics were reserved for the social elites and used at festivals and ceremonies. After years of research, scholars have recognized the internal heterogeneities of the Moche style, and even differences previously seen as chronological variations are recognized today as local substyles.[8] Furthermore, the stylistic diversity of Moche pottery is no longer equated with ethnopolitical diversity, for which other evidence is lacking.

A common stylistic trait of Moche ceramics is the preferential use of two colors (cream and red ocher), though some substyles vary (orange or dark brown replaces red ocher). Another characteristic is the large number of stirrup-spout bottles (plates 1, 17–29). Some were employed in ritual activities and then buried as offerings, while others were made solely for use in funerary rituals, after which they would be included among the grave goods.

Certain types of ceramic ceremonial vessels are prevalent in specific regions. The so-called portrait vessels, which depict priests, artisans, and warriors, both local and foreign, were made only in the southern Chicama Valley and not in the "northern Moche" region. Also absent from the north are the flared bowls that are among the most characteristic types of Moche fineware and usually depict complex iconographic scenes (see fig. 5).

Moche metallurgy stands out for its expert handling of alloys, and metalworkers created sophisticated gold, silver, and gilded-copper ornaments with different sheens and colors that echoed the sacred celestial bodies in their varied appearances. The sun, moon, and stars, in their brilliance and subtle color variations, were manifested in ornaments such as earspools, nose rings, funerary masks, necklaces, backplates, bracelets, and crescent-shaped feathered headdresses. Cups and bowls reserved for ceremonial use were also made in these metals, and bear great symbolic power, as do ceremonial knives, scepters, spear throwers, and other priestly or elite paraphernalia. The metal workshops were very closely linked to the main liturgical centers, since their production was intended both for the ceremonies performed there and for the clothing and grave goods of the elite.

RELIGION

Moche religion has been studied through analysis of the rich iconography present in Moche artifacts and buildings. For decades, scholars have dedicated themselves to identifying personages and their activities, distinguishing their different natures, and to recognizing the existence of human beings, deities, and ancestors (the dead) as the main actors of myths and rituals depicted in Moche art.

Here, we mention some of the most relevant contributions in the last fifty years to the examination of Moche religion. The thematic approach proposed by Christopher B. Donnan in 1975 made it possible to distinguish actors and compositions in the vast Moche iconographic universe, and was an argument for the nonsecular nature of Moche art. A decade later, Anne Marie Hocquenghem, applying a structuralist approach, considered the possibility of understanding the Moche iconographic system in relation to the Andean ceremonial calendar. Jeffrey Quilter has explored a narrative approach to analyzing Moche iconography, and in his reconstruction of some Moche mythological narratives, Jürgen Golte emphasized the need to "read" the iconography by considering the shapes of the ceremonial ceramics and the distribution and organization of the images on the vessels as part of the communication system. Most recently, Krzysztof Makowski has stressed the importance of a close and careful iconographic description of personages, actions, and episodes, adopting a contextual and semiotic approach that has enriched our knowledge of the Moche pantheon.[9]

The consensus among scholars today is that Moche art is narrative in nature—that is, it depicts elements, figures, or episodes from mythological narratives and from the ritual practices shared by the northern coastal towns between 200 and 850 CE. Ceremonial and funerary ceramics, ritual objects made of metal, the funerary attire of leaders and priests, and monumental public art in the major Moche ceremonial centers offer a rich visual corpus that can be organized into autonomous elements (items of clothing, animals, fruits, single figures, and perhaps an architectural structure), actions (involving two figures), and simple or complex scenes in which several figures interact. Different episodes from the same mythological narrative are sometimes even presented in a single object.[10]

These scenes show us not only human figures—including ritual celebrants, characters with zoomorphic traits, and ancestral warriors—but also figures with supernatural aspects that we might consider divinities, or huacas, and that make up the pantheon of Moche gods. Men and gods appear in mythical episodes that probably correspond to rituals performed in the earthly realm at specific moments of the ceremonial calendar of the epoch. Without attempting to enumerate the diverse types of complex scenes depicted in Moche art, we note the frequent occurrence of ritual combats between richly attired warriors that culminate in a blood offering (fig. 17).

As happens with myths shared over an extensive territory, local or regional versions develop; nonetheless, we can identify certain figures and episodes so often portrayed that they may be considered "Pan-Moche." Among these is a mythological cycle, probably an epic—visually expressed as an element of Moche identity—relating the exploits, combats, and travels of a legendary deity who is today often referred to as Ai Apaec or Wrinkle Face.[11] We can also identify another cycle, whose protagonist is a goddess of the moon and sea, who has the characteristics of a weaver. A stirrup-spout bottle in the San José de Moro style presents successive episodes of this cycle painted in a spiral sequence on the globular vessel (fig. 52). Given the lack of written sources on Moche religion, iconography is the main source for Moche stories, figures, and rituals, all of which require a semiotic-contextual analysis to enable us to identify and interpret them correctly.

NOTES

Translated from the Spanish by Rose Vekony.

1 For an overview of the Moche, see Castillo and Uceda 2008; Quilter 2010b; Benson 2012.

2 On Moche sociopolitcal organization, see Shimada 2010.

3 See further Bawden 1995.

4 As proposed by Quilter 2010a.

5 See Rosas 2017.

6 For richly illustrated overviews of these sites, see Uceda, Morales, and Mujica 2016 on Huaca de la Luna, and Mujica 2007 on Huaca Cao Viejo.

7 On Moche murals, see Trever 2022.

8 See Turner, this volume.

9 See Donnan 1975; Hocquenghem 1987; Quilter 1997; Golte 2009; Makowski 2022.

10 See further Makowski 2022.

11 On Wrinkle Face, see Rucabado Yong, this volume.

MOCHE CERAMICS: ARTISTS, WORKSHOPS, AND TECHNIQUES

Andrew D. Turner

Much of what we believe to be true about the ancient Moche has been the direct result of close analysis of their finely decorated ceramics. Modern scholars have privileged the study of pottery for understanding what the Moche believed and valued, how Moche societies were structured, and how they changed over time. Subtle changes in form, particularly among stirrup-spout vessels, served as the basis for Rafael Larco Hoyle's five-phase chronology for the Moche phenomenon, a system published in 1948 and still widely employed today.[1] Vessels with painted and low-relief scenes offer vivid glimpses of otherwise lost mythical narratives and ritual practices. Vessel construction and execution suggest that technical accomplishment and artistic expression were highly valued. And yet, despite what the vessels themselves tell us, very little is understood about the potters and pot painters and their relationships to the social, religious, and political forces that structured Moche societies.

The five-phase chronology that Larco developed was shaped by his belief that the Moche ceramics were the product of an expansive and centrally administered Moche empire. It later became clear that entire ceramic phases were absent in some areas, and that the chronological sequence was more applicable in the southern part of the Moche region than it was in the north. Although most known Moche decorated vessels were looted, and thus the contexts and locations in which they were encountered are lost, systematic excavations over the last several decades have begun to demonstrate that variations in vessel form and painting style not only were the result of stylistic changes over time but also reflected local and regional traditions and tastes. In tandem with these discoveries, scholars now recognize that the Moche phenomenon was not an empire but, rather, a collection of smaller polities and city-states that shared certain cultural traits,[2] but were at times unified by alliances or divided by rivalries, much like the ancient Greeks and Classic-period Maya.

Greater sensitivity to regional distinctions within the larger corpus of Moche ceramics has led to the identification of several substyles, each with its own aesthetic trajectories and aims. Christopher B. Donnan has described four regionally based Moche substyles, some of which overlapped chronologically: a Huacas de Moche substyle, which is roughly equivalent to Larco's Phase IV and was widely distributed among the Moche, Viru, Chao, and Santa Valleys; a Dos Cabezas substyle, dating to 300–600 CE and primarily associated with the sites of Dos Cabezas and La Mina in the Jequetepeque Valley; a Huancaco substyle, linked to a site of the same name in the Viru Valley that was occupied between 550 and 680 CE; and a Moro substyle, closely tied to the site of San José de Moro in the Jequetepeque Valley, dating to roughly 650–800 CE and displaying traits most closely associated with Larco's Phase V.[3] Fineline painting—delicately rendered bichrome figures and scenes, considered a hallmark of Moche ceramics—was most widely practiced in the Huacas de Moche and Moro substyles, but is notably absent from the Dos Cabezas tradition, which instead focused on three-dimensional and low-relief vessels.[4] The fineline traditions of Huacas de Moche and Moro differed in execution, with Huacas de Moche presenting a greater visual clarity and Moro displaying a higher degree of stylization, often obscuring its subjects with dots and circles in otherwise undecorated space.[5] Although both substyles shared iconographic conventions and casts of characters, they elicit different viewer responses: Moro-style painting demands effort on the part of the viewer and rewards the eye that can extract recognizable forms from densely decorated backgrounds (e.g., plate 26), whereas Huacas de Moche painting is more immediately legible and seems to aim at minimizing visual ambiguity (e.g., plate 21). As might be expected, these traditions also emphasized different themes and subjects. The Presentation Theme, for example, is found only in Huacas de Moche pottery, whereas the Burial Theme is nearly unique to the Moro substyle.[6] The Huacas de Moche substyle presents, overall, a broader variety of subject matter, and the Moro substyle places greater emphasis on nautical themes, including boat scenes and confrontations between the deity Wrinkle Face and sea monsters.[7]

At present, only two Moche ceramic workshops have been excavated. A workshop at Cerro Mayal, which was active between 550 and 800 CE and likely received patronage from the nearby site of Mocollope, contained numerous molds for making figurines, musical instruments, and ritual vessels.[8] The other workshop, suited for

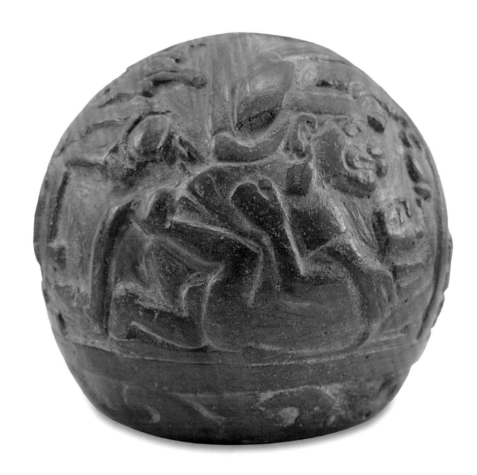

FIGURE 18 Probable mold matrix. Moche, made in northern Peru, 500–800 CE. Terracotta, H: 9.8 cm (3⅞ in.); W: 12.1 cm (4¾ in.). Lima, Museo Larco, ML004363. The matrix could be used to produce stirrup-spout vessels, jars, and other types of vessels.

large-scale production, was found at Huacas de Moche, in the area between Huaca de la Luna and Huaca del Sol. In the workshop, teams found "some 1,000 whole and fragmentary molds of figurines, trumpets, stirrup-spout bottles, face-neck jars, and appliqués, and numerous matrices (both fired and unfired) for making molds."[9] The multiroom complex contained separate spaces for manufacture, firing, and water storage,[10] and underwent three phases of construction.[11] Although pottery workshops at other sites have not been detected, the existence of one at Huacas de Moche is consistent with evidence from sites like Huaca Cao Viejo, Pampa Grande, and San José de Moro, where production facilities for other types of ritual and funerary goods were concentrated adjacent to large ceremonial architecture.[12] Presumably, the

placement of production areas within huaca centers allowed for greater elite control over the production and distribution of these goods and facilitated the sharing of techniques, materials, and thematic and iconographic conventions among artists working in different media.

Moche potters were among the most adept in the Andean region, employing a variety of techniques to produce works of considerable complexity (and, in notable contrast to Greek potters, without the wheel). They used four basic techniques—coiling, molding, modeling, and stamping, and most often at least two techniques were combined on a single vessel.[13] The creation of stirrup-spout vessels exemplifies some of the complex processes that Moche potters used in fineware production.[14] The chamber was usually produced by pressing clay into a

two-piece mold with an opening at the top or bottom that allowed for the inner seamline to be smoothed. After drying sufficiently, the chamber was removed from the mold and then sealed using additional coils of clay. The dual necks and spout were made by wrapping clay around tapered rods that were joined and attached to the vessel chamber. Vertical slits were then cut into the two necks of the stirrup to allow the interior passages to be reamed (allowing liquid to flow through the finished vessel), and were then resealed. This process stands in contrast to the later Chimu tradition (900–1470 CE), in which entire vessels, including stirrup spouts, were produced in two-piece molds. Potters at San José de Moro experimented with even more complex constructions to dazzling effect, in some instances by making false outer chambers that were perforated with holes or

by placing a hollow tube through the center of the chamber (plate 26) to playfully give the false impression that the vessel was not capable of holding liquid.[15]

The use of clay molds allowed Moche potters some flexibility and consistency in ceramic production. A probable matrix (a handmade original from which a mold was taken) of a globular vessel chamber exemplifies some of the advantages of using molds (fig. 18; compare figs. 37, 38): the detailed low-relief scene on the surface of the original could be easily reproduced, and a variety of spouts could be attached to the undecorated top of the chamber, allowing different types of vessels (such as stirrup-spout vessels, strap-and-handle vessels, and jars) to be produced from the same mold.[16] Moche vessels often incorporated three-dimensional figures and other subjects in their construction, usually placed on top of liquid-holding rectangular or globular chambers (plates 1, 28, 29). Detailed features such as heads and torsos were often made in separate molds and joined together, but freestanding elements in the round that would not release from a rigid clay mold, such as arms and legs, were often hand-built. However, despite the ubiquity of mold use in some Moche traditions, the practice was apparently absent from the Dos Cabezas tradition.[17]

Practical considerations aside, there may also have been symbolic value in using molds to produce duplicate vessels. Near-identical pairs of vessels with subtle differences in scale or in specific details hint at the concept of asymmetrical dualism, a widespread social and cosmological organizational principle in the Andes.[18] A similar concern, expressed materially, is evident in the pairing of gold and silver objects in the high-status tombs of Sipan.[19] Likewise, although there is typically no specific correlation that we can detect between vessel imagery and the identity of the deceased, similar ceramic vessels were often paired in Moche graves.[20] A parallel practice may be found in Inca gold, silver, and wooden drinking vessels,[21] pairs of which were often made from the same metal or block of wood.[22] Such vessels were used in drinking rituals, and pairs were divided between Inca elites and subordinates to solidify alliances and pacts of mutual obligation (compare Maya vessels that served as gifts).[23] An illustration from Felipe Guaman Poma de Ayala's *El primer nueva corónica y buen gobierno* (1615–16) shows Inca nobles pouring maize beer from paired vessels into a large container during a royal funeral.[24] Similar pairing of certain types of Moche finewares may account for both the production of duplicates and their eventual placement in tombs.

Moche fineware vessels were typically painted using red-ocher- and cream-colored slips, and then burnished before firing. Moche potters produced limited quantities of reduction-fired blackwares (see plate 1, for example), and polychrome painting, which is generally attributed to the influence of Wari (to the south, near modern Ayacucho), appears on some vessels made during the later centuries of the Moche phenomenon. The red slip was made from clay similar or identical to the clay used to make the vessels.[25] Although Moche vessels decorated with geometric designs are common, fineline painting is especially notable and distinct among Andean traditions owing to its expressive and communicative potential. Particularly in earlier phases, pot painters augmented fineline brushwork with different techniques, including incising and overpainting (in white), but these techniques are largely absent from Phases IV and V.[26] Although firing probably often took place in open pits that used llama dung as fuel,[27] a simple chamber kiln was found at Cerro Mayal,[28] and a kiln made of adobe bricks was found at Huacas de Moche.[29]

Moche pot painters left no signatures, but individual artists or groups of artists have been identified using connoisseurial techniques, similar to those developed by Sir John Beazley for the study of Greek pottery.[30] Identified artists are assigned names based on idiosyncratic treatments of anatomical features (for example, the Large Lip Painter) or proportions, the use of particular motifs (the Portable Dais Painter), subject matter preferences (the Burial Theme Painter), or the name or location of a vessel that is emblematic of their individual style, such as the Amano Painter (see plate 24). Although signatures on Greek vessels indicate that some painters were also potters, divisions of labor in Moche workshops are not clear. In at least one instance, two painters appear to have collaborated on the same vessel.[31]

Central questions remain about the role of potters and painters in Moche societies. Were they originators of Moche corporate imagery and ideological statements, or did they work under the close guidance of elites and religious specialists? How much liberty did they have to invent new types of imagery or introduce new scenes? Moche potters and painters often expressed individual stylistic innovations, but they nonetheless adhered to broader guidelines and iconographic canons that are fairly consistent across different media. Moche finewares were not produced for a market, unlike Athenian pottery, suggesting a closer relationship between pottery workshops and Moche structures of power. Moche potters may have attained relatively high social status or been members of a Moche elite, as some have surmised,[32] but available evidence is not as clear as it is in the case of some Classic Maya painters whose signatures link them to royal families. The relationship between Moche potters and Moche elites likely varied from place to place and over time. The two excavated workshops, at Cerro Mayal and Huacas de Moche, suggest different sets of relationships between artists and patrons. At Cerro Mayal, a share of production may have been owed to royal patrons at Mocollope for redistribution, whereas some of the workshop's output could have been exchanged for goods at different social levels.[33] The location of the workshop at Huacas de Moche, in the area between the site's two massive pyramidal structures, may indicate that artists had privileged status and a central role in the creation of Moche elite ideology,[34] or perhaps that the center's elites kept a close eye on their production. Although the value of Moche finewares is apparent from the care taken in their production and their ultimate placement alongside the deceased in tombs, a deeper understanding of their use and means of distribution by the living would help clarify the roles of potters, painters, and workshops in Moche societies.

NOTES

1 Larco Hoyle 1948.

2 See Holmquist, this volume.

3 Donnan 2011. For a well-illustrated survey of Moche painted pottery, see Donnan and McClelland 1999.

4 Donnan 2011, 107.

5 McClelland, McClelland, and Donnan 2007, 20.

6 These themes are discussed in Saunders, O'Neil, and Turner, "Understanding the Imagery," this volume.

7 McClelland, McClelland, and Donnan 2007.

8 On Cerro Mayal, see Russell and Jackson 2001.

9 Uceda and Armas 1998, 93.

10 Uceda and Armas 1998, 95.

11 Rengifo and Rojas Vega 2008, 338.

12 Quilter 2002, 176–77.

13 Donnan 1965, 117.

14 See Donnan 1965, 122–23; Donnan and McClelland 1999, 28–30.

15 McClelland, McClelland, and Donnan 2007, 11.

16 Turner 2015, 15.

17 Donnan 2011, 107.

18 Quilter 2010b, 42-43, 134.

19 See Alva 2001, 225.

20 Donnan 1995, 143.

21 Quilter 2010b, 134.

22 See Cummins 2004, 7.

23 See O'Neil, "Maya Vase Production and Use," and Houston, this volume.

24 Guaman Poma de Ayala 1615–16, 287 [289].

25 Donnan 1965, 125.

26 Donnan 1976, 58; Donnan and McClelland 1999, 30.

27 Benson 2012, 25.

28 Russell and Jackson 2001, 164.

29 Uceda and Armas 1998, 99.

30 See Donnan and McClelland 1999 (referencing Beazley at 306n1); McClelland, McClelland, and Donnan 2007. On Beazley's techniques, see also Saunders, "Greek Painted Pottery," this volume.

31 Donnan and McClelland 1999, 287.

32 Chapdelaine 2001, 83; Uceda and Armas 1998, 108.

33 Russell and Jackson 2001, 164.

34 See Rengifo and Rojas Vega 2008.

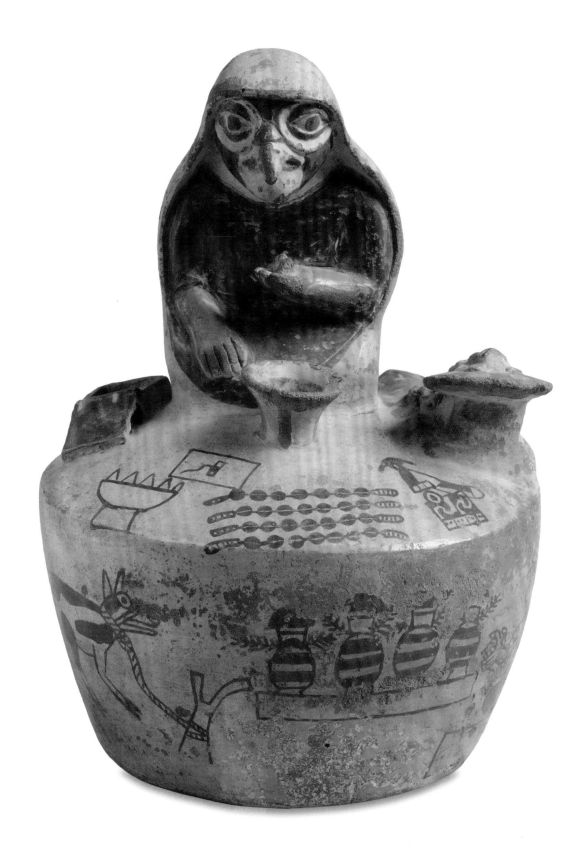

FIGURE 19 Stirrup-Spout Bottle Depicting a Curing Session. Moche, made in northern Peru, 500–800 CE. Terracotta and pigment, H: 20.9 cm (8 ¼ in.); W: 14.7 cm (5 ¹³⁄₁₆ in.); Depth: 14.3 cm (5 ⅝ in.). Cambridge, Massachusetts, Harvard Peabody Museum of Archaeology and Ethnology, Gift of Friends of the Museum, 1916, 16-62-30/F728

USES AND USERS OF MOCHE PAINTED VESSELS

Jeffrey Quilter

As is the case with so many things, we know much about some aspects of finely decorated Moche pottery (finewares) and very little about others. We know how vessels were made, their different shapes, the "hands" and schools of some painting styles, and the symbolism of images, yet who made them, how they were distributed and obtained, and their uses other than as grave goods are poorly known. Indeed, while the Maya and Greek vessels considered in this volume were mostly for serving or consuming food and drink, Moche finewares, or at least the stirrup-spout vessels, do not appear to have been regularly used for such purposes.

Our ignorance is due to a variety of reasons, chiefly the fact that the large collections of today were made without recording archaeological contexts and other useful information. In addition, Moche culture was for decades interpreted as a single state stretching over multiple river valleys and, consequently, all Moche art was interpreted as a single corpus with widely shared uses and meanings that persisted over several centuries. Recent scholarship, however, has shown that the story of Moche finewares is much more complicated than first thought.

To understand how finewares were used and who might have used them, we must begin by considering some of their basic features. Although decorative and symbolic motifs vary greatly, there are only four basic fineware forms: *cántaros*, flared bowls, *cancheros*, and stirrup-spout bottles. *Cántaros* are short-term-storage jars, usually less than forty centimeters (15¾ in.) tall and often

found in groups in tombs or in household contexts. The basic shape was widely shared in the ancient Andes, and these Moche jars were usually minimally decorated.

Flared bowls usually have small bases with wide, flaring rims (plate 30). One well-known stirrup-spout bottle shows a modeled bird-woman who appears to be conducting a curing ceremony for the Moche deity Wrinkle Face while sitting behind an empty flared bowl (fig. 19). It is tempting to suggest that these vessels were used like crystal balls, to contact deities or spirits to aid in curing or to foresee the future.

Cancheros (fig. 20) are the most enigmatic of the four basic vessel forms. As is the case with flared bowls, the only other culture that made and used *cancheros* is the Recuay, the Moche's contemporaries in the adjacent highlands. Although there are subtle differences in shapes, perhaps reflecting regional styles, Moche *cancheros* commonly have round biconvex bodies with a small central hole and a long, tapered handle. Those that have been scientifically excavated are strongly associated with robust adult men, suggesting that they were used by warriors.[1] The upper surfaces usually have little decoration, though the bases are often elaborately painted. Curiously, these vessels are almost always buried with the hole side down.

Stirrup-spout bottles are the best-known Moche vessel form. While found in earlier cultures in Peru and Ecuador, they became popular among the Moche and are rarely found among their contemporaries or in later cultures. They were so popular

that they were the primary vessel form for grave goods. It seems that if only one fineware vessel was placed in a burial, it was a stirrup-spout bottle. Yet, while popular, this form is the most awkward of the four to fill or empty of liquid, considering its small spout hole. It is not clear if stirrup-spout bottles were used only in mortuary rites or if they had social roles before burial. In either case, filling them would have been difficult. Perhaps a primary use as a burial good made pouring them out a moot point.

While we can assume that stirrup-spout bottles held liquids, determining what liquids they may have held, if any, has proved elusive. Examination of broken bottles in museum collections usually reveals no easily observed residues; analytical techniques are not yet refined enough to detect traces of former contents easily; and museum curators are reluctant to have finer examples damaged through probes. Water would leave no obvious traces once it evaporated, but *chicha* (maize beer) would presumably leave residues, yet none have been found. Surprisingly few studies to determine vessel contents have been carried out to date.

The range of stirrup-spout bottle styles is great, from sculptural representations of humans or deities (plate 1) to modeled scenes of rituals (plate 29) to serving as canvases for different painting styles, whether with a few images or densely composed scenes (plates 17–27). Many portrait-head vessels or modeled scenes (plate 28), from our perspective, could stand alone as representations, yet they commonly have stirrup spouts attached

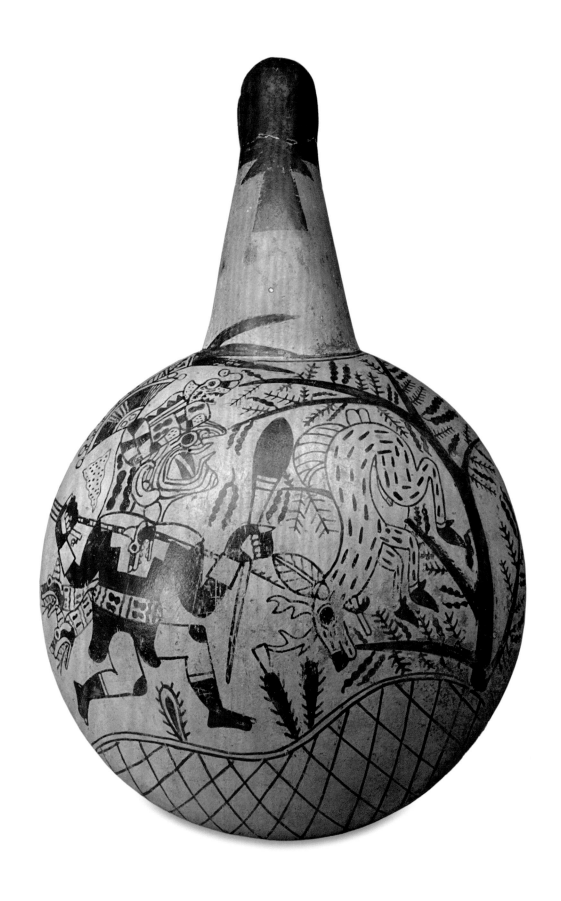

FIGURE 20 *Canchero* depicting Wrinkle Face Hunting a Deer. Moche, made in northern Peru, 500–800 CE. Terracotta and pigment, H: 29.9 cm (11¾ in.); W: 18.7 cm (7⅜ in.). Art Institute of Chicago, Kate S. Buckingham Endowment, 1955.2277

to them. This suggests that the vessel in question had to be a bottle and not simply a highly decorated vessel. The spout itself, with two parts joining into one, expresses a concept of duality, a fundamental principle in Andean thought, expressed in various ways throughout the past. A primary Moche way was through the stirrup-spout bottle.

Only two ceramic workshops have been excavated.[2] At Cerro Mayal, in the Chicama Valley, the assemblage of ceramic fragments discarded because of production flaws consisted primarily of small figurines, and none of the major forms discussed above were encountered. At Huacas de Moche, the extensive finds and workshop seem likely indicators that huaca, or temple, centers were the main places where finewares were made and from which they were distributed. Evidence also exists that contemporaneously distinct variants of fineware styles were shared by towns and huaca centers connected by irrigation canals, and it is likely that general to specific variants conformed to the same dendritic pattern as canal systems.

Future studies will likely show that variants of deities and other themes depicted on the vessels were favored by different social groups within the larger Moche world, and we already know that there were changes in symbolism through time. The representation of various individual scenes and themes served as cues to remind people of the extended myths with which they were associated, in the same way that representations of the Maize God or the Trojan War elicited recollections from Maya or Greek viewers, respectively.

Since the majority of finewares have been found in graves, we can infer that an important role for the pots was as burial offerings. Some evidence of wear on the bases of finewares suggests, however, that they may have been used in life, for a while, before they were interred with the dead. A study of fifty-nine Moche burials revealed that stirrup-spout bottles were the most popular grave good (183), followed by *cántaros* (142), flared bowls (11), minor vessel forms (26), and *cancheros* (25).[3] Old men (aged 45+) had the greatest quantity of bottles, flared bowls, and *cántaros*, and senior men (aged 30–45)

had the second-greatest amount of the same vessel forms. But adult men (aged 13–30) had more *cancheros*, and senior women (aged 30–45) had more flared bowls and *cántaros*, than any other age group except old men. There were only twelve females in the sample, however, compared to thirty males, so a larger sample of women might alter conclusions. Children, who generally could not be sexed, had fewer finewares with them than any other group.

The results of the study combined with other observations suggest that the number of finewares in graves is correlated with gender and age, with senior and old men and senior women buried with the greatest number of vessels. The highest-status Moche of whom we know, such as the Lord of Sipan and the Señora de Cao, are buried with relatively few finewares but with great quantities of gold and silver jewelry and regalia. While we focus attention on ceramics because of their beauty and their ubiquity in museum collections, and because of what they can tell us about ancient behaviors and beliefs, it appears that, for Moche lords and ladies, gold ornaments were valued more than pots as emblems of their "royal" splendor.

Scholars have long been puzzled about how the scenes on finewares may have related to the lives of the dead with whom they were buried. Only rarely does there appear to be a correspondence, such as a small vessel buried with the Señora de Cao depicting a woman curer attending a mother and child (plate 28) and the assumption that the Señora, too, had been a curer. If the vessels in a grave were brought by mourners, however, the fineware imagery may have had a relation to *them* and not to the deceased. Perhaps a mourner's bringing of a vessel as an offering was more important than the scene depicted on it.

The Moche did not use money, so how people obtained finewares from huaca centers or elsewhere is unknown. Perhaps participants in rituals at huaca centers or those performing services for them received vessels in exchange for their contributions of labor, or perhaps attendees at ceremonies received them as signs of a relationship between them and the ceremonial center. Perhaps the vessels were proofs of loyalty to a huaca center

and signifiers of identity with the priests and elites at such centers. Although research is at an early stage, pottery styles not only changed through time; there are also suggestions that styles were localized as well, with major centers differing in decorations and secondary centers, often on the same canal system, varying those styles.[4]

The enormous quantity of fineware vessels in museums and collections today suggests that production, consumption, and circulation of these pots occurred at a very high rate and in a relatively short period of time. Dramatic social, cultural, and political changes took place in the Moche lands starting in the second half of the seventh century. Within a century or less, many of the Moche forms and decorations considered here were no longer made. Moche culture did not end so much as radically transform. Late Moche styles, such as that associated with San José de Moro (for example, plates 24 and 26), stand out from earlier forms, and variations in styles among valleys were reoriented, in part because of outside influences from the central coast and various parts of the highlands, especially the Wari culture. Old rituals ceased and, apparently, only some of the old deities were maintained, in radically different forms, as Moche culture transformed into later cultures, Lambayeque in the north and Chimu in the south.

NOTES

1 See further Quilter 2021, 196–99.

2 See further Turner, this volume.

3 See Quilter 2020.

4 On Moche geopolitical networks, see Koons 2012.

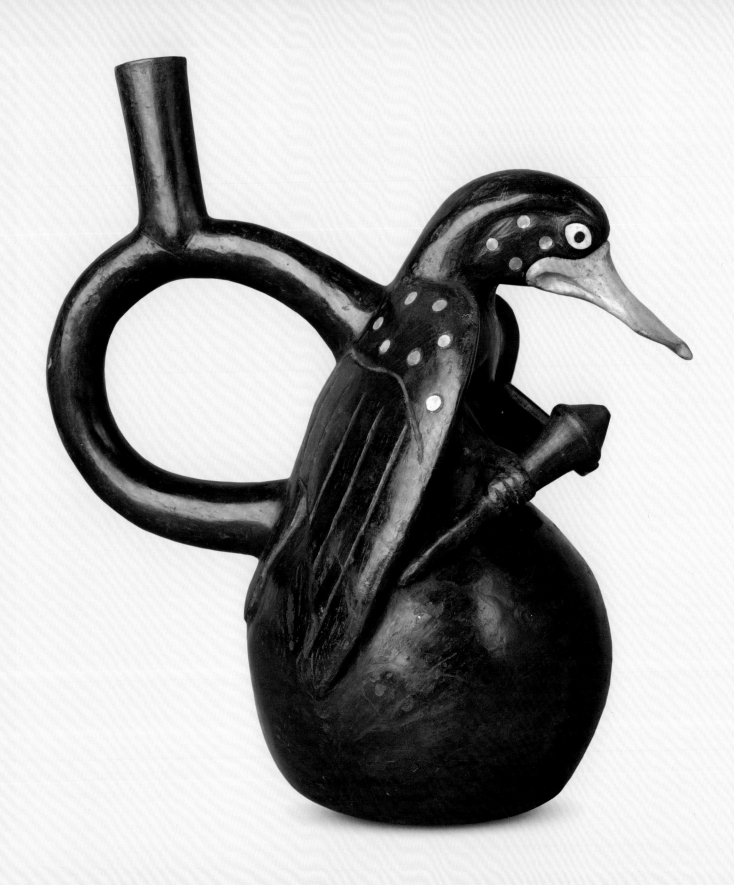

Stirrup-Spout Vessel in the Shape of a Warrior Duck (plate 1, profile view)

THE WARRIOR DUCK OF HUACAS DE MOCHE: FUNERARY RITUALS AND THE MASTERY OF MOCHE POTTERS

Elena Vega and Carlos Rengifo

Huacas de Moche is one of the most remarkable sites of ancient Peru, where decades of archaeological excavations have brought to light vital evidence of Moche communities' ceremonial world. At its heart is Huaca de la Luna, a monumental architectural complex that stands before the imposing peak of Cerro Blanco (see fig. 15). During the course of five centuries, its platforms and plazas were constructed and then, at intervals, ritually buried and built over, so that what survives today is a series of superimposed structures.[1] In the fill that covered the penultimate edifice of Platform I (the main platform) and that served as the foundation for the final building phase, a chamber tomb was found near the south wall of what is now known as the Patio of Rhombuses. This is one of the most sacred spaces of the temple.

This adobe-brick tomb contained a cane-made coffin in which the body of an adult male had been placed.[2] The man was wrapped in cloth, and folded copper sheets were positioned, as offerings, on his mouth, hands, and feet. On his chest were pierced copper disks and rectangular sheets, which could have adorned the individual's now-deteriorated clothing. Near the pelvis, a gilded-copper lime container and a knife were found, which may originally have been placed in the deceased's hands.

Twelve vessels were located outside the coffin, most of them stirrup-spout bottles, and five other ceramics were inside it, all of the latter manufactured especially for funerary purposes. One was an exceptional sculptural vessel that today is known as the Warrior Duck (opposite). Its intriguing shape, and its technical and aesthetic excellence, make this stirrup-spout bottle one of the masterworks of the Moche culture. The vessel is a representation of a web-footed bird with a spoon-like beak. The duck has a stern gaze and upright pose, and holds, with human hands that emerge from its chest, a squared shield and a war club, typical of Moche warriors. The body of this figure is entirely black because the vessel was produced by reduction firing, and then its surface was carefully polished. The duck's beak, fired in an open kiln and attached to the body using a vegetable resin, is an orange-cream color. Moche potters sought to depict the figure in a largely realistic fashion, and mother-of-pearl inlays were applied to the duck's shield, head, and feathers. The eyes were rendered with a white shell, with black stone for the irises.

The Warrior Duck bottle was produced during the heyday of the Moche IV ceramic style (as defined by Rafael Larco Hoyle),[3] possibly circa 500–650 CE. It attests to the mastery of molding and modeling techniques for pottery production attained by Moche artisans, and to the status of the deceased. The complexity of his funerary accoutrements and the inclusion of such a singular and prestigious object in his grave suggest that this individual was someone of great importance in his community. Even though there are aspects of the Warrior Duck's production and context that remain unknown, the vessel's features reaffirm the intriguing nature of Moche ceremonial imagery, which displays hybrid characters with attributes that may reveal the social role of the individuals who were buried with such special objects.

NOTES

1 For a well-illustrated overview of Huaca de la Luna, see Uceda, Morales, and Mujica 2016.

2 On the tomb and its finds, see Uceda 2008, 160–63, and Uceda, Morales, and Mujica 2016, 142–43.

3 On Larco's five-phase chronology for Moche pottery, see Turner, this volume.

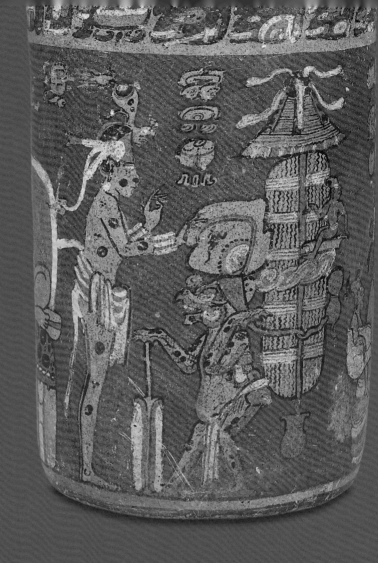

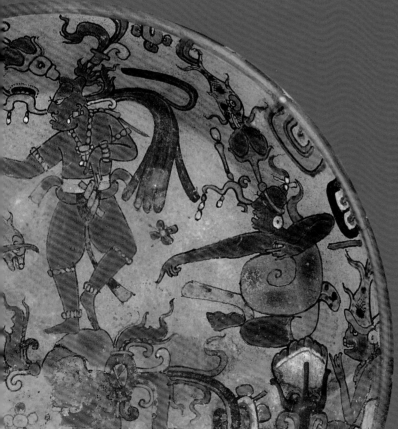

MAYA

THE LATE CLASSIC MAYA, 550–850 CE: AN OVERVIEW

Megan E. O'Neil

The ancient Maya civilization flourished in southern Mexico and Central America for two millennia before the arrival of Spanish invaders at the shores of Yucatan in the early sixteenth century CE. Upon the Europeans' arrival, Maya people were living in complex cities, creating painted books and ceramics, and writing in the Mayan hieroglyphic script.[1] The Maya in this region ultimately ejected those invaders, who proceeded to central Mexico, where they conquered the Mexica (Aztec) Empire in 1521. But the Spaniards returned to Yucatan's shores in subsequent decades, to invade again. By that time, Maya and other Indigenous peoples across Mesoamerica had been weakened by European diseases, collapsing trading routes, and economic disruption engendered by the fall of the Mexica Empire and Spanish invasions farther south, in Chiapas and the Guatemalan highlands.[2]

By 1542, the invaders had established the colonial city of Mérida on top of the Maya city of Ti'ho, in Yucatan, beginning a long period of domination, destruction, and oppression in this region. Colonial authorities, including Catholic friars, began to torture and kill Maya people, destroy their buildings, seize precious books and other sacred objects, and punish scribes for writing in hieroglyphs.[3] These practices eventually led to the dismantling of Maya political and power structures and the extinction of the writing system, though Maya people have over the centuries continued to fight for their autonomy and cultural preservation and renewal. In fact, artists such as Walter Paz Joj, in Panajachel, Guatemala, are

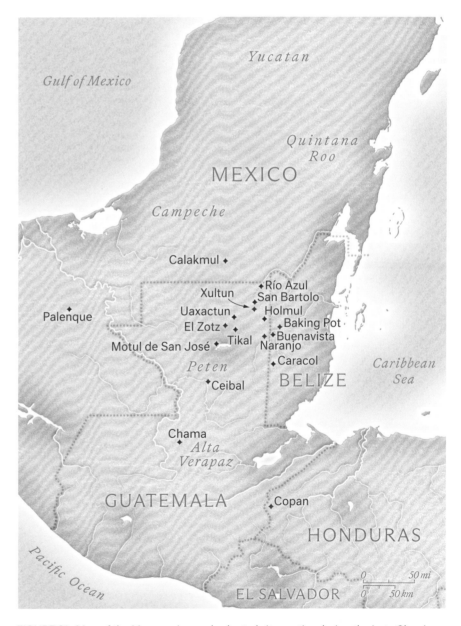

FIGURE 22 Temple I, Tikal, Guatemala, 734 CE

FIGURE 21 Map of the Maya region and selected sites active during the Late Classic period (550–850 CE)

writing in Mayan hieroglyphs once again, experimenting with new graphic signs for syllables and words to match their own languages and express contemporary ideas, and Patricia Martin Morales, in Muna, Yucatan, makes copies of ancient polychrome ceramics and innovates new designs.[4]

TIME

Scholars divide the ancient Maya civilization into the following periods: Middle and Late Preclassic (1000 BCE–150 CE), Protoclassic or Terminal Preclassic (150–250 CE), Early Classic (250–550 CE), Late Classic (550–850 CE), Terminal Classic (850–1000 CE), and Postclassic (1000–1521 CE).

Across these periods, Maya people sustained life through the consumption of maize, their staple food; beans, squash, and chiles; and luxury foods like *kakaw* (chocolate). They made pottery in all these periods, too, but we focus here only on the Late Classic, when artists most fully experimented with creating narrative scenes and inscriptions on polychrome painted vessels. In the Early Classic, ceramic artists excelled in creating lidded bowls portraying anthropomorphic forms or animals of the region. One bowl excavated by archaeologists from a royal tomb at El Zotz, Peten, combines artistic expression in two and three dimensions: a sculpted animated howler monkey is surrounded by flat painted flowers and deities like the Maize God, in order to situate this fantastic creature in the cosmos (plate 31).[5] During the Late Classic, ceramic artists shifted to a new shape, the cylinder vessel, generally without supports, in addition to bowls, plates, and other forms. The primary foci of our study are these cylinder vessels and artists' use of the cylinder's external surface to render a continuous scene that wrapped around the whole vessel.

PLACE AND POLITICS

This volume focuses on the southern Maya lowlands, encompassing southern Campeche, Mexico; Peten, Guatemala;

Belize; and western Honduras (fig. 21). In the Late Classic, this was a vibrant, dynamic region filled with independent polities or kingdoms that, though sharing many cultural aspects, did not ever unite under one political system. They did engage in many interpolity alliances, as well as conflicts. Furthermore, although the powerhouses of the Mutul kingdom, centered at Tikal, Guatemala, and the Kaanul kingdom, centered in the Late Classic at Calakmul, Mexico, tried to gain ascendancy by absorbing other sites in their respective dominions and attacking each other and their enemies' allies and subject states, neither established more widespread control. In fact, it may have been such alliances and competitions—as kingdoms strove to cultivate interpolity relationships, express their identities, and claim divine rights to power by demonstrating connections to deities and ancestors in deep time—that inspired artists to innovate. Moreover, these vibrant vessels, which were made by talented artists, conveyed wealth and status, and their production and use demonstrated each place's creative, economic, and political power and potential. Distinct regional styles were elaborated,[6] and the painted vessels depict diplomatic courtly visits and were exchanged across the geopolitical landscape.

The precious vessels were also valued for their depictions of deities and ancestors. Some were preserved and kept in circulation even after accidental breakage, as is evident from repairs with crack lacing (fig. 79), and others were intentionally broken to transform them into offerings.[7] Furthermore, vessels functioned as containers for food and drink to offer to deities and ancestors and to share in familial and diplomatic feasts, in order to lubricate social interactions and celebrate shared identities.

LANGUAGE AND LITERACY

The myriad Maya polities shared many cultural features, including a writing system that uses signs standing for syllables and words that are put together to express spoken language phonetically. Although in

the Late Classic, people spoke distinct Mayan languages in different regions (the Maya still do today), they wrote in a common language that scholars term Common Mayan, an ancestral language related to the Ch'orti' and Ch'olti' languages that circulated among court members and other elite individuals (one might compare the way Latin was retained in the Catholic Church for centuries).[8]

Mayan writing is inherently graphic, and artists appear to have favored creative expression in its rendering, continually innovating ways to write syllables and logographs (signs standing for words) and experimenting with the interplay between textual and pictorial expression. Mayan writing thus is quite complex, but many artists in the past excelled in its execution and innovation, undoubtedly the result of years of education, training, and practice. Literacy levels were likely quite low, though undoubtedly people achieved varying levels of literacy, able to read or recognize certain dates or names, for instance, or to read or copy texts but not create new ones.[9] It is clear that Mayan writing was prized, even by those who could not fully write it, for many painted vessels bear "pseudoglyphs" that are rendered as if writing, and may even copy particular glyphs, but do not form legible words or phrases.[10] Likely made by less elite artists or in peripheral regions, they emulated forms of writing on works that those artists may have glimpsed or even held.

Dedicatory inscriptions (also called the Primary Standard Sequence) frequently appear on polychrome painted vessels.[11] These may include a dedication verb, such as *t'abay* (raise up), as well as information about the type of vessel, its intended contents and owner, and even its painter.[12] Other texts may identify depicted figures, narrate action, or provide first- or second-person quotations (plate 39).[13]

In some cases, the dedication texts or the depicted events are dated. The ancient Maya developed a complex calendar system that enabled them to track dates over long periods of time, whether to record historical events or the actions of deities in deep time, thousands of years in the distant past, or

FIGURE 23 East Court, House C, Palace, Palenque, Chiapas, Mexico, 661 CE

in the future. The Calendar Round combined dates from two calendar systems, the 260-day *tzolk'in* ritual calendar and the 365-day *haab* solar calendar, which, working together, repeated every fifty-two years. The Long Count tracked time since the primordial event of Maya Creation, on the Calendar Round date 4 Ajaw 8 Kumk'u, in 3114 BCE, in deep time.[14] On a vase with a Supernatural Birth scene (plate 33), the text begins with the Calendar Round date 13 Muluk 17 Pax, followed by a birth verb, *sihyaj*. The Long Count is used much more rarely than the Calendar Round on ceramic vessels, though the Uaxactun Initial Series vase bears the Long Count of 7.5.0.0.0, from 256 BCE, which would have been in the distant past for this seventh-century CE vessel (plate 34).[15]

RELIGION AND RITUAL

The ancient Maya world was replete with supernatural entities that were manifestations of forces of nature such as storms, wind, lightning, and maize, and depicted as anthropomorphic, zoomorphic, or hybrid entities.[16] But these entities could also combine, in a process known as theosynthesis, and bear characteristics, for instance, of maize, sun, and lightning,[17] or multiply, with numerous manifestations at the cardinal directions and earth's center. There are both male and female deities, and deities whose gender is ambiguous or even multiple.[18]

These supernatural entities engaged in human actions, at times modeling behavioral ideals and otherwise creating conflict, and personified changes of season or other major events in the natural world or agricultural cycle.[19] Death and rebirth, or the loss and regaining of power, are common tropes of mythological narratives, as these supernatural entities rise and fall in tandem with annual cycles. Humans, in turn, emulated Maya deities and dressed as or otherwise transformed into them, seen particularly in images of rebirth as the sun or maize, promising new life after death. Places in the landscape like caves, mountains, and water features were potent locales, functioning as portals for descent into and resurrection from the underworld, or as sites for the primordial storage of precious goods like maize. Such potent places appear in imagery

on many painted vessels and were built into Maya cities (fig. 22), where pyramids and their superstructures were likened to mountains and sky caves, ballcourts were cave entries, and patios could be filled with water, from which rebirth could take place.[20]

People also engaged with deities and ancestors through ritual practice. They frequently performed rites to celebrate calendar anniversaries, for which a ritual participant might offer food, stoke fire, let blood from their tongue, ears, or genitals, or dedicate a monumental stone stela or altar. Such rites are depicted on some painted vessels,[21] and some vessels were dedicated during ceremonies to deities and ancestors, with expectations of creating or cultivating relationships and benefiting living humans. In short, whether through imagery, text, architecture, ritual, or other forms of expression, the ancient Maya found myriad ways to connect with other humans and the divine.

THE MAYA COURT

Maya polychrome painted vessels often depict courtly contexts and were frequently made for them. Both the physical spaces of palaces (fig. 23; plates 4, 5), including architecture and perishable decorations, and their social structures, including individuals performing roles in those spaces, are made visible on painted ceramic vessels. A kingdom's court was composed of the principal ruler, in many sites called the *k'uhul ajaw* (sacred lord), his or her family, other nobles, attendants, and visitors. A more powerful leader, called a *kaloomte'*, could rule one kingdom and subject polities; the leaders of other, less powerful places may have held titles such as *sajal* (regional governor) or *ajaw* (lord). Women were important members of Maya courts, whether as wives, mothers, and regents or, sometimes, as rulers; they, too, owned painted vessels and are portrayed as court members, attendants, or preparers of food and drink. Young elites, whom we might call princes, were known as *ch'ok* (sprout), with the vegetal metaphor implying future growth; they were also described as *chak ch'ok keleem* (great, strong youth), to

emphasize their physical power and juvenescence.[22] These young elites feature in many dedicatory inscriptions as vessel owners and appear in figural scenes.

Painted ceramic vessels were produced for local use, whether for living people or for tombs, and for gift giving, both within and across polities. As described earlier, cultivating alliances with other kingdoms was a significant form of political activity, as larger kingdoms conquered smaller ones, or smaller ones allied with more powerful polities, to gain wealth or earn protection. Marriages were significant means of alliance, particularly as princesses moved to other places, such as when the Kaanul kingdom sent princesses to marry rulers of smaller polities within the Kaanul political orbit, forging long-term alliances.[23] Vessels and other gifts were probably exchanged during such unions.

In short, Maya ceramic vessels truly were social media. Made by and for Maya courts, they lubricated and inspired social interactions. The vessels were among those used when food or drink was shared during palace feasts. They elicited surprise when they were shown, turned, or lifted (at times resulting in an unexpected rattle caused by the movement of ceramic pellets hidden inside them). And they inspired storytelling about deities, ancestors, or the living, allowing people to affirm and extend shared identities as Maya people or members of specific polities or larger alliances.

NOTES

1 Scholars generally use the adjective "Maya" to refer to the civilization, art, and architecture, and "Mayan" to refer to languages or the ancient writing system.

2 Díaz del Castillo 1928, 44–51, 60–67; Clendinnen 1987, 9–10, 16; Restall 1997, 3–5; Restall 1998, 6–7.

3 Karttunen 1994, 90; Chuchiak 2010, 89–90.

4 O'Neil 2022a, 232–33, 238.

5 Newman et al. 2015, 130–34.

6 These regional styles are described in O'Neil, "Maya Vase Production and Use," this volume.

7 Chinchilla Mazariegos 2011, 52; Arredondo Leiva, Auld-Thomas, and Canuto 2018, 320–22.

8 On the language of the inscriptions, see Houston, Robertson, and Stuart 2000.

9 On literacy among the Maya, see Houston 1994.

10 On pseudoglyphs, see Calvin 2006. On so-called nonsense inscriptions on Greek vases, see Saunders, O'Neil, and Turner, "Understanding the Imagery," this volume.

11 See further Stuart 2005.

12 See O'Neil, "Maya Vase Production and Use," this volume.

13 See Saunders, O'Neil, and Turner, "Understanding the Imagery," this volume.

14 Freidel, Schele, and Parker 1993, 61–65.

15 Carter 2015, 12.

16 See further O'Neil 2018.

17 Martin 2015, 210–18.

18 On Maya genders, see Looper 2002; Stockett 2005.

19 Miller and Martin 2004, 51–65.

20 On ritual caves, see Vogt and Stuart 2005.

21 A cylinder vessel from Naranjo or its vicinity (Los Angeles County Museum of Art, M.2010.115.871) portrays a ruler burning rubber as an offering. A cylinder vessel probably from southeastern Campeche (Washington, DC, Dumbarton Oaks Research Library and Collection, PC.B.568) depicts two elite figures letting blood from the tongue and the penis, respectively.

22 Houston 2018, 42–47, 157–158.

23 See further Martin 2008.

FIGURE 24 X-radiograph of Cylinder
Vessel depicting Otherworldly Toad,
Jaguar, and Serpent. Maya, made in
southern Campeche, Mexico, or north-
ern Peten, Guatemala, 650–800 CE
(see plate 37). Nonplastic inclusions
that are oriented horizontally (note
the dark horizontal lines) indicate that
this vessel was built with coiling.

MAYA VASE PRODUCTION AND USE

Megan E. O'Neil

Over the past seventy-five years, much has been learned about the production and use of ancient Maya painted ceramic vessels—through visual examination, studies of images and inscriptions, materials analysis and conservation science, archaeological excavation, and comparison of historical and contemporary Maya ceramic production. Together, these interdisciplinary approaches shed light on the makers, users, and life histories of these extraordinary works. One especially fruitful area has been the continuing decipherment of Mayan hieroglyphic writing, for vessels' dedicatory inscriptions, when present, name intended owners and uses. But vessels may have had a multiplicity of life histories: they may have been used by individuals, traded or gifted to other kingdoms, broken and tossed into trash middens, or buried in offering caches or tombs.

PRODUCTION: POTTERS AND PAINTERS

Ancient Maya potters crafted ceramic vessels with hand-building techniques such as coiling, slab building, and the use of molds. As with some Greek vases, we know the names the Late Classic Maya gave to certain vessel types, including the cylindrical drinking vessel (*uk'ib*) (e.g., plates 4, 5, 32–39, 42) and the rimmed plate (*lak*) (e.g., plates 40, 41, 43), which could have a flattened or curved bottom and ringed or pedestal support.[1] Potters or their assistants gathered clays locally and processed them through various means, including sedimentation or

levigation, to sift out grasses or other natural inclusions, or to separate for the finest grains. Like many potters across the world, they frequently added organic and inorganic nonplastic (or nonclay) inclusions, including sand, mica, shell, seeds, feathers, and crushed rock, such as limestone, to make clays less sticky and ceramic structures stronger. Archaeologists call those inclusions "temper," since they change the quality of the clay paste, which can be examined by looking at the edges of broken ceramics and by X-radiography.[2]

Coiling was the primary method of making cylinder vessels and plates, as revealed by the horizontal orientation of nonplastic inclusions seen in sherd edges and X-radiographs (fig. 24). To build a cylinder vessel with coiling, potters first formed the base, either by patting out a clay disk or by spiraling a clay roll into a flattened circle.[3] They built the vessel sides by spiraling clay rolls around the circumference and upward, or by setting rolls into stacked rings. They joined these rolls together and pulled them upward to thin the vessel sides, which could be further thinned or shaped with fingers or tools to form curves, flaring rims, or other design elements. The ancient Maya did not have access to the potter's wheel, which was employed in ancient Greece, but they likely used simple turning devices, such as an already fired plate or bowl, to turn vessels around while building them. Later Maya potters in Yucatan utilized a device called a *k'abal*, a wooden disk secured by a central pivot that is spun with the feet, but that likely was a later invention or introduction,

as there is no evidence for this tool in the pre-Hispanic period.[4] As with the Moche, Maya potters also used molds to create whole vessels or ornaments attached to vessels constructed by other means.

Artists painted the shaped clay forms with slip, generally with added clays or minerals for coloring, such as calcite for cream-hued slips, manganese for blacks and browns, and iron oxides for reds and oranges. They burnished the vessel surfaces, either before or after painting, with a pebble or piece of leather, to compact and polish them, often leaving the vessels shiny, without using glazes. The vessels were then fired at relatively low temperatures, within a range of approximately 500 to 700 degrees Celsius (about 930 to 1,290 degrees Fahrenheit), in bonfire or pit kilns, generally in an oxidizing environment.[5] Artists sometimes added post-fire pigment such as Maya blue, an inorganic-organic pigment using indigo that the Maya invented,[6] or they incised designs into fired clay.

Dedicatory or other inscriptions at times name the vessel's painter, using the phrase *utz'i[h]b* (his/her writing/painting).[7] This provides a point of comparison with Greek vases, where painters signed with the word *egraphsen* ([so-and-so] painted [it]), but no Maya inscription has yet been identified as paralleling the Greek *epoiesen* ([so-and-so] made [it]), which typically identified the potter. Although inscriptions on Maya vessels from the Chochola region in Yucatan name carvers, these are references to the decoration on incised vessels, and not to the shaping of the vessel. It is unknown whether

FIGURE 25 *Utz'i[h]b* (his/her writing/painting) phrases on Maya ceramic vessels

25A With the name of the painter Mo(?)-n Buluch Laj on Cylinder Vessel with *Way* Figures. Maya, probably made in Motul de San José, Peten, Guatemala, ca. 755 CE (detail, plate 38). After Just 2012, 131, fig. 64

25B With the name of the painter Kuluub on Cylinder Vessel with Palace Scene. Maya, probably made in Motul de San José, Peten, Guatemala, 650–750 CE (detail, plate 5)

25C With the name of the painter Lo' Took' Akan(?) Xok on Squared Vessel (Vase of the Eleven Gods). Maya, probably made in Naranjo, Guatemala, or environs, 755–780 CE (detail, plate 44)

potters and painters were different individuals or one and the same; but even if they were different individuals, it is highly likely that they labored in the same workshops or otherwise collaborated.[8] Furthermore, there is archaeological evidence from Xultun, Guatemala, that artists worked in multiple media, including mural and book painting and ceramics, in the Los Sabios building.[9]

Scholars have deciphered multiple painters' names and identified examples of more than one vessel painted by the same scribe, whether by locating their names on those vessels or by comparing painters' hands in imagery or calligraphy.[10] This volume features several vessels with painters' names, including the name of Mo(?)-n Buluch Laj, from the Ik'a' kingdom, centered at Motul de San José, Guatemala (fig. 25a); he is known to have painted two other ceramics besides the vessel included here.[11] Another vessel was painted by Kuluub, perhaps also from Motul de San José, whose name appears in the painted image above the kneeling

attendant who hands a bowl to the enthroned ruler (fig. 25b).[12] Finally, the name of Lo' Took' Akan(?) Xok, probably from Naranjo, Guatemala, appears amid deity names on the Vase of the Eleven Gods, perhaps to highlight that artist's importance as a creator (fig. 25c).[13] Although most of the known painters appear to have been male, there are a few known female painters, including one from the Ik'a' kingdom, who painted a cylinder vessel from the reign of ruler Yajawte' K'inich.[14]

Artists painted in the styles of their polities or regions, such as the styles of Holmul and Naranjo; a region encompassing southern Campeche and northern Peten (near Calakmul and El Mirador); Motul de San José; El Zotz; and Tikal and Uaxactun. Vessels in the Holmul-Naranjo style generally feature cream backgrounds with designs painted in orange and red slips (plate 35); so-called codex-style ceramics, from southern Campeche and northern Peten, have cream backgrounds with brown-black designs (the palette resembles that of Maya codices, hence

the ceramics' name) (plates 33, 36, 37); pottery from Motul de San José, called the Ik'a' style after the polity's Maya name, exists in several substyles, all of which use multiple colors and tonal gradations and nuance (plate 38); and vessels from El Zotz may bear red backgrounds painted around figures rendered on a buff or yellow base slip, with details added in black and white slip (plates 34, 39).[15]

But as with Greek and Moche vessels, regional styles are not simply about color or technique, for core narratives such as the Maize God's life cycle were rendered distinctly in different regions. For example, the Tikal Dancer style, from Tikal and Uaxactun, appears on plates, likely for holding tamales, and renders the Maize God dancing against a plain cream background, with a border of red and brown-black designs (plate 40). He dances alone, without other figures or imagery signaling his location, but the implication is that he dances after his resurrection in a setting comparable to the environments painted on cylinders and plates in other styles (for example, plate 41). Other

FIGURE 26 Owners of Maya ceramic vessels

26A Name of K'ahk' Ukalaw Chan Chahk, lord of Sa'aal, on Squared Vessel (Vase of the Eleven Gods). Maya, probably made in Naranjo, Guatemala, 755–780 CE (detail, plate 44)

26B *Chak ch'ok keleem* (great, strong youth) title on Plate with Hunters Shooting a Supernatural Bird (Blom Plate). Maya, made in Belize, Guatemala, or Mexico, and found in Río Hondo, Mexico, 600–900 CE (detail, plate 43)

ceramics portraying him dancing are in the Holmul-Naranjo style, in which two or more maize deities, often paired with a companion of short stature, dance around the exterior of a cylinder vessel (fig. 27). Each Maize God wears a large, elaborate back rack holding an animal seated on a stone mountain, making reference to the three throne-stones of creation, indicating that this is a world-creation dance that takes place in the distant past, on 4 Ajaw 8 Kumk'u, correlating with 9 September 3114 BCE.[16] In contrast, on one red-background vessel, probably made by an El Zotz artist, the Maize God appears three times in different forms, including as a baby and an adult (perhaps depictions of different phases of his life), progressing around the vessel's circumference (plate 39).[17] In short, artists' participation in regional styles is evident not only in the ceramics' technique or manner of rendering images or texts but also in the vessels' very content, as artists embraced their polities' versions of core narratives.

OWNERS AND USERS

Iconographic, epigraphic, and material evidence, and archaeological context, can help shed light on the owners for whom ancient Maya vessels were made and other users, and on how the vessels were utilized. As with Greek and Moche painted pottery, Maya images on pottery sometimes show vessels in use, mostly in palace or court settings, whether resting beneath rulers' thrones or in active use, in people's hands (plates 4, 5).

Indeed, although this volume focuses on their painted images, the vessels are containers that were made to hold food and drink or tribute, gifts, or ceremonial implements. Dedicatory inscriptions may reveal the intended foodstuff. Those on cylindrical drinking vessels mention *kakaw* (chocolate); *ixim* (corn); *ul, sak ha'*, or *sa'*, for atole, a corn-based drink, or *kakawal ul* (chocolaty atole); and *chi* (pulque, or fermented cactus).[18] At times, the type of cacao is specified, such as *ixiim te'el kakaw* (*iximte'* cacao, which may be cacao mixed with *iximche-*tree fruit) (plate 35), *tzih kakaw* (pure cacao), *ach' kakaw* (new cacao), *k'an kakaw* (ripe cacao), or *chab'il kakaw* (sweet cacao or cacao with honey).[19] Depicted vessels may show chocolate foam rising out of cylinder vessels or plates of *waaj* (balls of maize dough, like tamales) covered in dark sauces, perhaps containing cacao.[20] Residue analysis has found both chocolate and corn in vessels of different shapes, including a vessel from Río Azul whose lid, when turned, locked in place, to protect the foodstuff within.[21]

After use in a palace setting, a vessel may have been broken and deposited in a midden, as happened with many codex-style vessels at Calakmul,[22] or cached as an offering, as at El Achiotal.[23] Archaeologists have found many painted ceramics in tombs; given the intact nature of many unprovenienced vessels, it is likely that these, too, were found in tombs. Some vessels in burials show wear or repairs and appear to have been deposited secondarily. But others show no wear and were probably made as funerary offerings. At Tikal, some tombs contain sets of vessels

FIGURE 27 Rollout photograph of Cylinder
Vessel with Maize God Dancers and Companion.
Maya, made in Peten, Guatemala, 650–750 CE
(see plate 35)

FIGURE 28 Tahn Bijil Chamiiy (Crossroad
Death/Disease), on Cylinder Vessel with *Way*
Figures. Maya, probably made in Motul de San
José, Peten, Guatemala, ca. 755 CE (detail,
plate 38). From Grube and Nahm 1994, 704, fig. 36

FIGURE 29 Watercolor illustration (rollout) of Cylinder Vessel with Presentation Scene (Vase of the Initial Series). Maya, probably made in El Zotz and found in Uaxactun, Peten, Guatemala, 600–700 CE (see plate 34). Drawing by M. Louise Baker, after Smith 1932

with similar images that were painted by artists of different skill levels, perhaps within a funeral context, as offerings to the deceased.[24] People at times also modified vessels before burying them, by knocking off plates' pedestal supports or drilling or punching holes into their centers, or by punching holes into cylinders' or jars' sides, perhaps to transform them symbolically into offerings.[25] The Maize God Dancer plate from a burial in Uaxactun Structure A-1 is a prime example of this practice, with a single hole drilled into its center (plate 40).

The owners of vessels, who may have been the patrons who commissioned them or the recipients of the vessels as gifts, may be named in dedicatory inscriptions, often with their emblem glyphs, indicating their kingdoms of origin, and other titles. It seems

that some vessels were buried in the named owners' tombs, but others appear in the tomb of someone else, to whom the vessel may have been traded or gifted. Such was the case with the Buenavista Vase, which names a Naranjo ruler but was buried in Buenavista, Belize, a smaller site in the Naranjo sphere.[26]

Names, emblem glyphs, and other titles provide some social context for painted vessels, whether or not they have archaeological provenience. For example, the owner of the Vase of the Eleven Gods is K'ahk' Ukalaw Chan Chahk, lord of Sa'aal, a *k'uhul ajaw* at Naranjo (fig. 26a). But not all owners were rulers; many are named as *ch'ok* (young prince), as on the Plate with Hunters Shooting a Supernatural Bird (Blom Plate), which names the owner as *chak ch'ok keleem* (great, strong youth) (fig. 26b). The

owner of one vessel with a palace scene is also a young man, named as *itz'aat* (wise person), *pitz[iil]* (ballplayer), and the son of a *kaloomte'* from the Ik'a' kingdom (plate 5).[27] These are not unusual. Stephen Houston has observed that many owners were young elite men and hypothesizes that the making or gifting of painted vessels was an important rite of passage or status marker for them.[28] Although most named owners are male, some are female, such as Ixik We'om Yohl Ch'een, a royal woman bearing the Baax Witz (Hammer-Stone Mountain) emblem glyph associated with Xultun, who owned the small cup with Maize God dancers (fig. 27).[29] The information about diverse communities of ceramic vessel users made available by Maya painters' naming of owners is much harder to capture for Greek ceramics, and—on account

of the absence of writing—even more difficult to determine for the Moche.

Other titles in vessels' dedicatory inscriptions may indicate family lineage or another identity. Two such titles, which may appear together, are *chatahn winik*, "person of *chatahn*" (*chatahn* may have been the name of a place or a lineage), and *sak wayis*, "white *wayis*," with that name evoking the *way* figures (pl. *wayob*) related to sleeping or dreaming.[30] These titles, present more frequently on codex-style vessels than in any other regional style, are among those borne by the owner of the codex-style vessel from Tomb 1 of Calakmul Structure II-H (plate 36).[31] But they were not tied to a specific site or kingdom and instead appear in multiple places in southern Campeche and northern Peten, such as Calakmul, La Corona, and Uxul, where they were apparently associated with a lineage or other group identity within the larger Kaanul kingdom.[32]

At times, supernatural figures such as *wayob* painted on vessels are named in association with particular people, such as a polity's *k'uhul ajaw* (sacred lord). On one codex-style vessel (plate 37), the *way* figures are connected to Kaanul kingdom rulers, whereas one Ik'a'-style vessel names *way* figures connected to humans from Ceibal and Caracol (or a site with a similar toponym, as written in the inscriptions), and to elites bearing the *chatahn winik* title.[33] These anthropomorphic, zoomorphic, or hybrid creatures related to sleeping or dreaming may have been personified illnesses sent to harm rivals as part of supernatural warfare (fig. 28).[34]

Dedication texts, along with other evidence such as painted imagery and place of deposition, can provide essential social context for painted vessels and even help identify cross-kingdom collaboration or alliance. For example, the owner of the aforementioned vessel with a palace scene (plate 5) is an Ik'a' prince, son of the ruler Sak Muwaan, and the vessel is made in the Ik'a' style, but the central painted figure, an enthroned ruler, is from the Itzimte kingdom.[35] Nonetheless, the Ik'a' prince is depicted in the image, too, seated and facing the Itzimte ruler, apparently commemorating the prince's visit to the Itzimte court, likely a momentous event in his life.[36] A vessel found in a site that does not match its owner's named place of origin may indicate marriage, gift giving, or other alliance, which may align with other types of evidence about cross-polity exchange.[37]

The relationship between the painting style and the place of deposition can be informative. For instance, the Vase of the Initial Series is painted in an El Zotz style but was found at Uaxactun (fig. 29).[38] This indicates some kind of movement, but the situation is complex, for several figures on the cylinder bear Kaanul titles, and the scene, dated around a thousand years before the vessel's making, may have functioned as a foundational story for the Kaanul kingdom and allies, which included El Zotz.[39] Thus, this vessel was probably made at El Zotz to celebrate participation in the Kaanul kingdom but was moved to Uaxactun through trade, gift giving, or another transaction, even though Uaxactun was not part of the Kaanul sphere. Such complex movements are knowable only because vessels like the Initial Series Vase were recorded in scientific excavations that preserved information about where they were found, providing crucial insight into their producers and users. As with items from other cultures that were looted, Maya vessels that do not have archaeological provenience may allow us to reconstruct some aspects of their social lives, but we are limited in what we can learn about them.

NOTES

1 Houston and Taube 1987; Stuart 2006b, 187.

2 Shepard 1956, 25–27; Hirx and O'Neil 2022, 34–35.

3 Reents-Budet 1994, 210, 231n91; Shepard 1956, 57–59; Hirx and O'Neil 2022, 39–40; O'Neil and Hirx 2022.

4 Mercer 1897, 63–64, 69; Shepard 1956, 61–63; Brainerd 1958, 66–68; Arnold 2018, 138–40.

5 Reents-Budet 1994, 214; Rice 2009, 120–21, 138–39.

6 Arnold et al. 2008.

7 Houston and Taube 1987.

8 Reents-Budet and Bishop 2012, 293; O'Neil 2022b.

9 Rossi, Saturno, and Hurst 2015.

10 See, for example, Just 2012, 132–39; Doyle 2016, 53.

11 Just 2012, 132–39.

12 Houston 2012, 320; Just 2012, 18.

13 Houston 2022, 87; O'Neil 2022, 419.

14 K3054; see Reents-Budet and Bishop 2023.

15 See, for example, Reents-Budet 1994; Just 2012; Reents-Budet et al. 2012; Carter 2015, 6–7.

16 Looper, Reents-Budet, and Bishop 2009, 116, 122–24. Correlations of Maya dates with the Christian calendar use Simon Martin and Joel Skidmore's Modified Goodman–Martínez–Thompson (GMT) correlation constant of 584286 (GMT + 3) (Martin and Skidmore 2012).

17 Just 2009, 10; Burdick n.d.

18 Stuart 2006b, 187, 191.

19 Stuart 2006b, 193–99; Chinchilla Mazariegos 2011, 52.

20 Hull 2010, 236, 251.

21 Hall et al. 1990; Grant 2006.

22 García Barrios and Carrasco Vargas 2006.

23 Arredondo Leiva, Auld-Thomas, and Canuto 2018, 320–22.

24 Coggins 1975, 562–66; Miller 2022, 447–49.

25 Martínez de Velasco Cortina 2014, 71–74; Finegold 2021, 19.

26 Taschek and Ball 1992.

27 Houston 2012, 319.

28 Houston 2009; Houston 2018, 67–68.

29 Krempel and Matteo 2012, 163–64. See also Houston, this volume.

30 Aimi and Tunesi 2017; Velásquez García and García Barrios 2018, 39 ; Cojti Ren, this volume.

31 Velásquez García 2009, 5.

32 Grube 2004; Grube et al. 2012; Grube 2013; Velásquez García and García Barrios 2018, 52.

33 Grube and Nahm 1994, 690, 704, 710–11; Shesheña 2010, 17; Tokovinine and Beliaev 2013, 191.

34 Houston and Stuart 1989; Grube and Nahm 1994; Helmke and Nielsen 2009; Houston 2022, 89–92. See Cojti Ren, this volume.

35 Houston 2012, 319.

36 Houston 2012, 319–21; Just 2012, 74.

37 See Houston, this volume.

38 Carter 2015, 1.

39 Carter 2015, 6–7, 10–12.

MAYA GIFT GIVING

Stephen D. Houston

FIGURE 30 Rollout photograph of a Cylinder Vessel found in Burial PNT-007, Structure 5-49, Tikal, Guatemala, 750–790 CE. Guatemala City, Museo Nacional de Arqueología y Etnología, 11418 (K2697)

Every object made and valued by humans has its own "social life." It passes through networks of people, meanings, and intent before decaying or finding its way, like the ceramics in this volume, into a tomb or cache. A special subclass of these objects implies some future obligation or incurred debt.[1] A gift might be expected in return, or some other act of reciprocity could be entailed. In such cases, emotions surge, in a mix of gratitude and ambivalence should the debt seem too great to repay. A welcome gift may soon come to smack of dominance and long-term control.[2] Who is gifting and who is receiving also matters, in that age, gender, group affiliation, and relative social station tend to condition

gestures of reciprocity, a point touched on below. A gift from a parent to a child would not be the same, conceptually or emotionally, as a gift from a lower-ranking lord to an overlord. In a further subtlety, some of these offerings are "inalienable," meaning that they never lose their association with past owners or makers.[3] Maya vases are no different in this regard, if with an additional feature. Many bear the names of the persons who first owned them. Erasing or muting that association would be possible only by covering the name with some material, usually stucco, applied after the vase had been fired; another name might then be painted on the surface. Yet these modifications are rare.

A state of inalienability—a thing that exists only in relation to a larger whole: a hand to a body, a pot to its first owner—affects most Maya ceramics with texts, along with many other name-tagged things from the Early Classic (250–550 CE) and Late Classic (550–850 CE) periods, be they of bone, shell, limestone, or precious jade. They carry their pasts with them, yet the identities of later owners who did not inscribe their names may have been as obvious to ancient Maya viewers as they are opaque or unrecoverable today.

The task of an archaeologist or art historian is to sort out the "chain of custody" by which things move around. This helps to distinguish between a gifted and a purchased

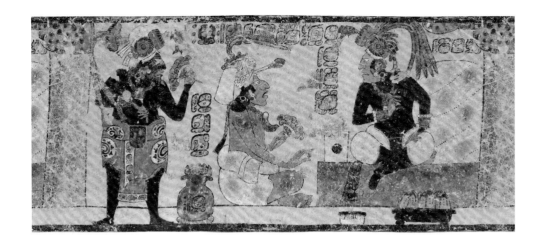

FIGURE 31 Rollout photograph of Cylinder Vessel with Palace Scene. Maya, probably made in Peten, Guatemala, 750–790 CE (see plate 4)

object, and usefully highlights the social setting of these transactions. Technical and stylistic studies may point to a particular region or city of production. But there is much more to consider. To take one example, an Early Classic bowl found in a royal tomb at El Zotz, Guatemala (plate 31), was probably made locally, to judge from its distinctive red hue, but its actual commissioning could have been complex. Perhaps it was created at the anticipatory behest of the person in the grave, the likely founder of the local dynasty. Or it might have been transferred to the dead from the world of the living, as part of a much longer chain of users. More than a few Maya vases have crack repairs or abrasions on rims from the lifting and dropping of lids. (Imagine, in a hot clime, the flies and bugs swooping down on food and drink in open containers—better to keep them out with a ceramic or a perishable lid of basketry or wood.) Another possibility is that tribute or capture in war may have brought the El Zotz bowl to the tomb. Potter wasps left nests in clay daub on the walls, showing that the tomb was left open for a time. Presumably, the wait was necessary in that it allowed funerary offerings to be assembled by willing or compulsory means. However pleasing the ceramics might be on display in a museum, there can be too much focus on them as such, without their onetime contents. Glyphic labels affirm that vases and bowls held costly drinks of chocolate or tamales and stews,

some laden with venison. These foods might have been valuable on their own, as beverages or dishes prepared to high standards of refinement.

Another kind of ambiguity marks a Late Classic vase showing a figure holding up a feline pelt for a named figure on a throne (fig. 30). Speech scrolls, some looping over glyphic records of these sounds, indicate active conversation between people on the vase. This evocation of sound, along with many other features of line, layout, color, and the image of the same enthroned figure ("Guardian [or Captor] of Akul Ajaw of Tikal"), confirm that the vase was made by Akan Suutz', the painter of a vase at the Los Angeles County Museum of Art (fig. 31). The vase with the pelt has an eroded and badly restored text that may once have explained the scene. The Los Angeles vessel provides a more legible main text, referring to a *ch'ahb* (fast) or related feast or ceremony with three participants. The focal figure, Guardian of Akul Ajaw, is labeled with a sign reading *baah*, which means both "body" and "image," a key label in Maya imagery that signals the presence and possibly the essence of important people. This figure presides over a person of lower rank who clutches a bouquet. Equipped with his own bundled flowers, a third male stands to the side, though it is unclear whether he is named; the seated underling certainly is, duly tagged as a *ch'ok*, a "sprout" or "youth." There are pots with food and drink, one with

macerated agave leaves to make or fortify an alcoholic beverage. Most have illegible texts on them, though a single label is readable, offering a nod to an important calendar date and perhaps a ceremony to commemorate it. Behind the enthroned figure is the name of the painter. The space behind a ruler is often occupied by retainers, so that the painter's caption in that space may stand for his physical presence in the scene.

But who has given what? The intended viewers of this vase would have known, but from our distant vantage, oblivious to context, we do not belong to that audience. The transmission or movement of pots must be inferred. Then there is a larger, terminological enigma. When discussed formally in hieroglyphic texts, "giving" and "receiving" are highly restricted in use. The glyphs are securely deciphered—*'ak* for "give" and *ch'am* for "receive"—yet when recorded, these acts involved not ceramics but deities and sacred regalia, flutes, or inebriating drink. Two other terms for "gift," *mayij* and *sij*, relate to a blood offering to deities and to a male child as a father's benefaction, respectively.[4] The aura is palpably ritual, supernatural, or metaphorical. Yet pots made by the same painter, or those depicting the same ruler, clearly moved around, having come from different findspots (when we have such information). Even if not mentioned in glyphic texts, some gifting or transfer must have occurred.

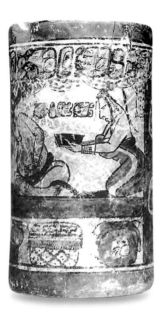

FIGURE 32 Cylinder Vessel belonging to a queen or princess from the city of Xultun, Guatemala, 700–725 CE. After De Smet 1985, pl. 16c

FIGURE 33 Rollout photograph of a painted ceramic vase once belonging to a young ruler of Naranjo, Guatemala, 550–600 CE. Found on the outskirts of Tikal, Guatemala (K2704)

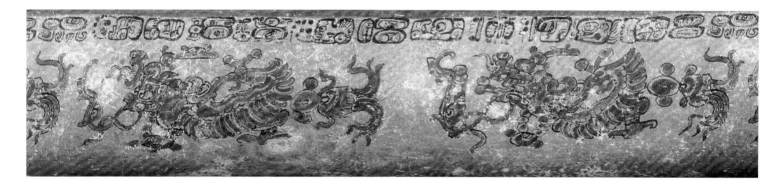

Some vases belonged to rulers, only a small number to queens or princesses. On one vase, the owner's name is neatly compacted as *ta Ixajaw* (for the royal lady); the possible depiction of that woman, as she offers a plate of food to a ruler on his throne, appears just below (fig. 32).[5] We also know that there was an apparent shift among the Late Classic Maya from ceramics that belonged to "ancestors" or elderly men known as *mam* to ceramics that were the property of a series of princes or nobles known as *ch'ok* or *chak ch'ok* (great youth). This change entailed some major reemphasis from the elders of society to the elders-to-come, the next generation of rulers or lords in active training to take power.[6] Seen in this light, the explicit ownership of ceramics by young lords is likely to mark rites of passage by which such gifts found their way to younger hands. One can imagine a process of toasting, the elevation of a vase in honor of a noble youth, but also a need to impart a certain polish in behavior, a knowledge of just how to act at a royal court. Several vases even specify that they are for the "first fast" of a lordly youth. It is surely relevant that the statements of ownership are on rim bands. Bringing the vase up to the lips to drink from would bring the eyes into close proximity. Users could see, read, and perhaps vocalize that text.

A surprisingly large number of drinking bowls are tied to a certain young lord, Aj Numsaaj of Naranjo (his name is not entirely pinned down, but this is the best approximation at present). Most lack documented findspots, though they are likely from distinct locations.[7] One with known provenience comes from a remote precinct of an enemy city, Tikal (fig. 33). Are these the result of a particular feast and subsequent gifting that dispersed them more widely? Aj Numsaaj came to the throne quite young, and the instability of that status may have endowed these pots with a special role. The large number of Maya "multiples"—ceramics attested in many copies or near copies—indicate, as Mary Miller has suggested, a wish for broader use but also particular occasions on which they were distributed.[8] To have such an object commemorated both that event and the owner whose name appears on the surface. From such ceramics and the gifts they imply came the principal motivation for these masterworks of calligraphic skill among the Early and Late Classic Maya.

NOTES

1 On the "gift" as an anthropological concept, see Yan 2002 for review and emphasis on distinctions in status, drawing on earlier work by Marcel Mauss and Georg Simmel, and later work by scholars like Pierre Bourdieu and Annette B. Weiner; the social life of things is well handled in Appadurai 1986. Fuller discussion of Maya evidence appears in Houston 2018, 82–91.

2 Such "obligation anxiety" is eloquently described in Davis 1971, 74.

3 For discussion of "inalienability" in Maya data, see Kovacevich 2017. For linguistic studies of inalienability in Mayan languages, see Kockelman 2009.

4 *Mayij* as "gift": David Stuart, personal communication, 2001. For discussion of these terms, see Houston 2018, 85.

5 On queenly pots, see Houston 2021. Such women moved around as part of exogamous marriages of alliance. A certain lack of generosity in dowries and bride wealth appears in some later sources from after the Spanish Conquest, but the sources are not always consistent on such portable goods. For vases owned by queens or princesses, see, in Kerr ca. 2000, K2695, K4463, K4996, K7055, K8007, K9072. Some involve queens from the large city of Xultun, Guatemala; see Rossi and Stuart 2020.

6 A curious feature, however, is the imagery on such pots. With few exceptions, they depict not dynastic events but an energetic set of supernaturals (Houston and Scherer 2020). As among the *way* pots described elsewhere in this volume (see Cojti Ren), figures float in some indeterminate "other time"; participants in the scenes are often wildly indecorous and curiously noninteractive. Most of these figures embody a combination of human attributes with characteristics of animals or other beings, yet contrary to most social beings, they show little awareness of one another's existence. A large question is why such images were clustered on pots said to belong to young men. Both amusing and raucous, the scenes may also have functioned as moral instruction or cautionary tales.

7 Such vases include, in Kerr ca. 2000, K774, K1288, K1558, K2704 (the example from Tikal's periphery, here fig. 33), K5042, K5362, K5462, K5746, K6813, K8245. Potsherds of close similarity have been found at trash dumps at Naranjo itself (NRB-003), and a full vessel at Holmul, Guatemala (Alexandre Tokovinine, personal communication, 2019).

8 On multiples and mass production, see Miller 2019. On mass production in general, see Houston and Matsumoto 2019.

STORIES
AND
PICTURES

UNDERSTANDING THE IMAGERY

David Saunders, Megan E. O'Neil, and Andrew D. Turner

Stories are not "told" by images. Stories are told from pictures, stories lie behind pictures.

— Stephen D. Houston and Karl Taube, "Meaning in Early Maya Imagery" (2008)

The first part of this book has provided a framework for approaching the ancient Greeks, Moche, and Maya, and their traditions of painted pottery. We now turn to the imagery. By dedicating our attention to pictorial narratives, or scenes that Mark Stansbury-O'Donnell defines as "open-ended, leading forward, backward, or to other actions or stories,"[1] we underscore the potential of painted pottery to prompt communication, and with that, the expression or perpetuation of shared knowledge.

But how can we comprehend the images and the stories that these ancient painted vessels portray or reference? Storytelling relies on a body of shared knowledge; it requires familiarity not only with characters, actions, and gestures, but also with a network of associations that each of these carries with them. In any type of narrative experience, therefore—be the narrative seen, heard, or read—not everything needs to be presented explicitly.[2] Centuries after the vessels were made, and with only incomplete and fragmentary evidence, what methods can we employ today to access these ancient traditions?

At the outset, we need to become familiar with pictorial conventions.[3] Although this may seem rudimentary, sustained looking and close description provide the basis for identifying objects, beings, and events. Many figures can be recognized by their particular appearance or attributes, such as the bull-headed Minotaur (plate 10); the Moche deity Wrinkle Face, with his distinctive visage and serpent belt (plate 19); or the lithe male Maya Maize God, with his characteristic sloping brow (plate 36). These features might be used over generations, and such stability permits identification even when only fragments survive. In other cases, visual cues or characteristics might be added, lost, or modified over time, so it may be necessary to consider clusters of traits that signify a certain being or entity.

With this preliminary iconographic analysis as our bedrock, we can then turn to broader contexts. Consideration of imagery in other media helps to elucidate what we see on the vessels; murals or other architectural decoration, for example, may present narratives more fully, filling in details or connecting scenes that appear in abbreviated forms elsewhere. We can also examine contexts of production. Was the scene of enduring popularity, or only of brief or local interest? Were there particular circumstances, such as a commission or shifting market forces, that motivated a painter to depict a specific theme? This leads us to consideration of the viewer(s). In what settings would a vessel have been seen and used? Do its shape and function point to

the circumstances in which an individual may have encountered its painted decoration? When we have documented evidence for an object's findspot, this proves critically important. For the Greek, Moche, and Maya alike, many of the painted vessels that survive today have been recovered from burials, and our knowing the identity of the individual with whom a vessel was deposited, or the other items that accompanied it in the grave, offers a concrete basis on which to consider the imagery's significance.

Beyond these material qualities and contextual considerations, which may be particular to the individual object, we can embed the painted scenes in religious beliefs and practices, political and social structures, and a wider framework of myths and rituals. Contemporaneous literary sources are hugely informative in this regard, but for the three cultures we examine here, these are incomplete or altogether absent. We can, nonetheless, consider archaeological evidence and make judicious use of later written sources. In the following pages, we address the methods and resources that have been employed to interpret Greek, Moche, and Maya imagery, considering each culture separately, in order to recognize distinct bodies of evidence and traditions of study. We then discuss the vessels collectively, calling on all three fabrics, to highlight pictorial strategies, many of which are shared—how, for example, painters organized scenes to convey different moments, and how a vessel's form could shape a viewer's engagement.

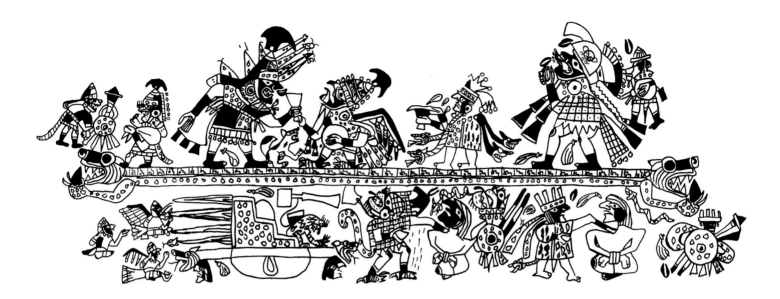

FIGURE 34 Rollout drawing of Stirrup-Spout Vessel with Presentation Theme. Moche, made in northern Peru, 500–800 CE. Museo Larco, ML010847. Drawing by Andrew D. Turner, after Donna McClelland

MOCHE

We begin with the ancient Moche, for whom there is no extant written literary tradition. Only their images survive. Despite the inherent difficulties of interpreting Moche painted pottery on its own terms, there are multiple approaches that can help us understand these complex images.

The bold and graphic pictorial style of Moche painted pottery is immediately engaging to modern viewers, and is notable among ancient Andean art traditions, which tend to eschew narrative and representationalism in favor of high degrees of stylization or abstraction. In fact, the visual legibility of Moche painting, unbound to language, may have been a pictorial strategy aimed at enhancing the communicative potential of ceramics in a socially and culturally diverse Andean north coast.[4]

Moche artists produced thousands of vessels with painted imagery over several centuries, but there is a relatively limited number of subjects that commonly appear. Given the high degree of repetition of individual scenes, careful comparison of known examples allows for the detection of additional details that may clarify meaning. Christopher B. Donnan developed the thematic approach,[5] which aims to systematically analyze all known examples of a given type of scene, and the individual characters that appear in them. Prominent themes identified by Donnan include the Presentation Theme, in which sacrificial blood from captives is collected in goblets and presented to a rayed deity (fig. 34), and the Burial Theme,[6] in which Wrinkle Face and his reptilian companion, Iguana, take part in the burial of a casket and present conch shells to a kneeling figure (fig. 35).[7] Although often repeated, these scenes are seldom reproduced in their entirety; painters instead focus on key sequences. The Presentation Theme, for example, is depicted in full only in rare examples. More often, artists selected a single element, such as the sacrifice of captives (plates 17, 23), relying on the viewer's understanding of a theme to fill in the gaps. Today, according to Donnan, these gaps can be bridged though application of his thematic approach, across a variety of media. The identification and investigation of prominent themes in Moche art has laid the groundwork for subsequent efforts to arrange them into sequential mythical narratives.[8]

Figures in Moche art may be depicted in landscapes, seascapes, and architectural settings, and painters often made use of formalized iconographic elements to provide additional context or allude to events not portrayed. "Locators," such as small hills of sand, certain types of plants, or waves, can serve as visual cues that convey whether a scene takes place in the desert, in a marsh, or at sea (fig. 36).[9] The inclusion of other pictorial elements may add further meaning; hummingbirds or falcons, for instance, may metaphorically allude to the speed or ferocity of warriors.[10] As defeated warriors in battle scenes are stripped nude, bound, and led

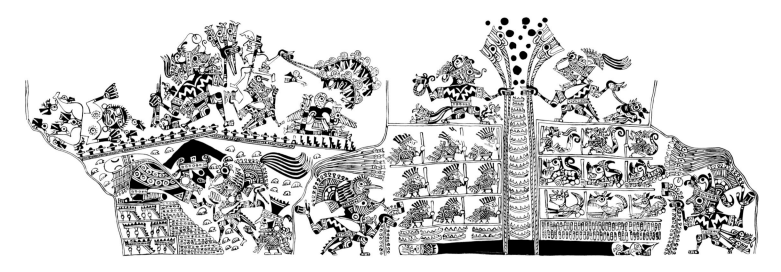

FIGURE 35 Rollout drawing of Stirrup-Spout Vessel with the Burial Theme. Moche, probably made in San José de Moro, La Libertad, Peru, 650–800 CE (see plate 25). Drawing by Donna McClelland

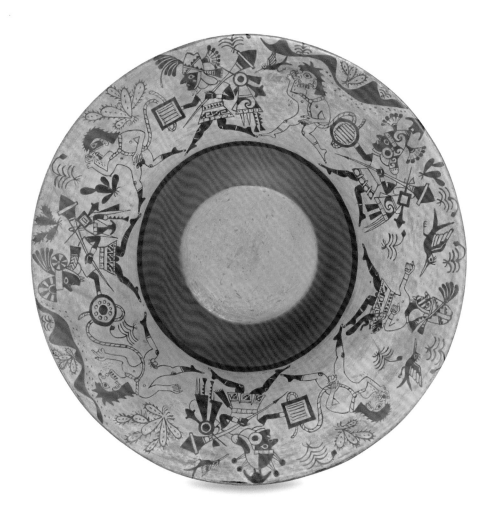

FIGURE 36 Flared Bowl with Combat Scenes. Moche, made in northern Peru, 500–800 CE. Terracotta. H: 19.5 cm (7¹¹⁄₁₆ in.); Diam: 38.5 cm (15³⁄₁₆ in.). Berlin, Ethnologisches Museum, Staatliche Museen zu Berlin, V A 48171. Defeated warriors are stripped and restrained by their captors. The captives' weapons and armor hang from the victors' maces. The desert setting is indicated by hills, dots that denote sand, cacti, and *Tillandsia* plants. Depth of field is achieved through vertical arrangement of pictorial elements.

SAUNDERS, O'NEIL, AND TURNER

FIGURE 37 Wrinkle Face Copulating with a Woman within a Roofed Structure. Detail (rollout drawing) of a relief vessel found in Plaza 1, Huaca de la Luna, Peru, 500–800 CE. Drawing by Andrew D. Turner, after Jorge Sachún

away, standardized bundles of weapons and armor allude to the decisive outcome of battle and the inevitable sacrifice of captives. Although many of these scenes ostensibly pertain to human warfare, the weapon bundles themselves may be personified, and nonhuman characters may take part in battle and captive-taking scenes.[11]

Although Moche artists did occasionally overlap images to convey perspective,[12] they most often used vertical placement of figures and locators to indicate depth of field. But possible affinities with Western art styles can also mislead modern viewers. A series of ten Moche vessels show the deity Wrinkle Face copulating with a woman within a roofed structure (see, for instance, fig. 37). On most examples, one of the vertical house posts intersects with Wrinkle Face's lower back. Following the common Western convention of pictorial overlay to convey spatial depth, we might read the placement of the house post as being *behind* Wrinkle Face's body. In other examples, however, the house post is visibly integrated into the back of Wrinkle Face's headdress, without

separation (fig. 38), suggesting that the post actually emerges from Wrinkle Face himself.[13] This small but crucial detail adds an important layer of meaning to the scene. Across the Andes, houses and house posts are widely considered metaphors for family lineages, and this mythical scene appears to cast Wrinkle Face as a foundational ancestor and perhaps, as suggested by the waves that appear beneath the groundline, the progenitor of coastal peoples.[14]

Moche vessels were generally used for storing and pouring liquid, and their function may have guided not just their form but even artistic decisions concerning the subject matter that was suitable for decoration. In many past and present Andean traditions, a convergence of two opposed forces, such as the conjoining of two rivers or a battle between two foes, is a symbolically and spiritually charged event known in Quechua (a widely spoken Indigenous language of the Andean highlands) as *tinkuy*. As Jeffrey Quilter notes, the form of the stirrup-spout bottle may embody a *tinkuy* convergence, as streams of liquid pass through the vessel's

two opposed tubes and conjoin at the spout when poured.[15] Consideration of important concepts like *tinkuy* not only helps us understand why Moche artists may have favored certain types of scenes (like combat between paired opponents or sexual intercourse); it also invites us to approach Moche vessels as potent ritual objects that were activated by handling, looking, and pouring.

Archaeological discoveries can further elucidate the imagery on the Moche pots. Direct visual analogues of narrative scenes on vessels have been revealed in other media, such as the dramatic murals found on temples at Huaca de la Luna, in El Brujo, and at Pañamarca (fig. 39).[16] The discovery of ritually dismembered individuals at Huaca de la Luna and the detection of human blood in goblets vividly demonstrate that scenes that had once been considered entirely mythical or symbolic in nature had startling real-life parallels.[17] However, no discoveries challenge us to scrutinize the relationship between representation and historical practice, and the very nature of Moche representation itself, more than a series of tombs unearthed

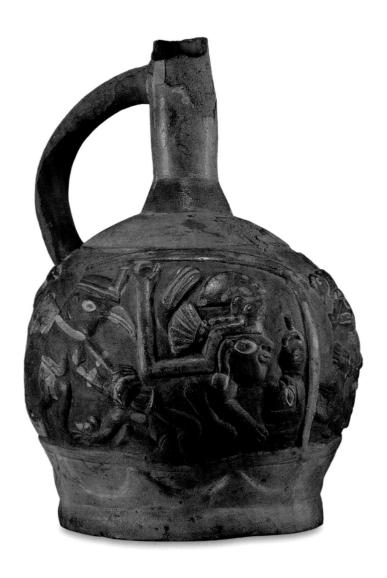

FIGURE 38 Relief Vessel with Wrinkle Face Copulating with a Woman within a Roofed Structure. Moche, made in northern Peru, 500–800 CE. Terracotta, H: 19.1 cm (7½ in.); W. 13.9 cm (5½ in.). Lima, Museo Larco, ML004358

at Sipan and San José de Moro in the late 1980s and early 1990s.[18] At both sites, richly ornamented high-ranking Moche people were entombed in the attire of figures that appear in Presentation Theme scenes. While these discoveries immediately suggested that some Moche pottery scenes might portray historical personages and events, doubts later began to surface.[19] First, the burials from the northern sites of Sipan and San José de Moro do not align chronologically with the vessels bearing Presentation Theme scenes, which were likely produced in southern centers. This slippage is all the more problematic given scholars' relatively recent realization that the Moche tradition was the product

not of a single centralized political system but, rather, of several peer polities that rose and fell over several centuries, much like the Maya and Greeks. In other words, though it contains commonalities and continuities that we recognize, "Moche-ness" was not expressed uniformly at all places and times. Second, it seems clear that the identities of the richly dressed people entombed at Sipan and San José de Moro were linked to those of the beings portrayed in the Presentation Theme, in death and perhaps also in life— it is likely that they performed ostentatious public rituals in the guise of the beings that appear in the Presentation Theme. Rather than directly representing individuals who

carried out rituals, however, both the pottery scenes and the burials may instead reference a common source: mythical narrative.[20] Representation animates and lends veracity to myth, and myth provides both structure and justification for ritual. Although the painted scenes are likely mythical in nature, the burials at Sipan and San José de Moro of people attired similarly to the beings who appear in the Presentation Theme suggest that such scenes were brought to life, or "animated," through public performance.

Finally, though we must exercise due caution and bear in mind the dramatic social transformations that affected life on the Andean north coast over the past

SAUNDERS, O'NEIL, AND TURNER

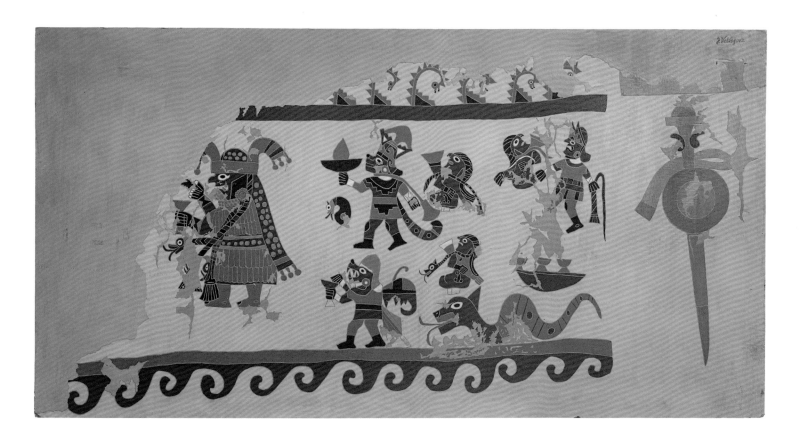

FIGURE 39 Replica of the mural of the
Sacrifice Ceremony discovered at Paña-
marca in 1958. Painting by José Velásquez,
after Félix Caycho. Ministerio de Cultura,
Museo Nacional de Arqueología, Antropo-
logía e Historia del Perú, Lima

millennium, we can in some instances enlist documentation of local practices or folktales (in later eras or in related societies) that may help clarify aspects of the Moche pictorial narratives. Scholars have frequently used modern and colonial accounts of practices and beliefs on the Peruvian north coast, especially involving healing, to understand some of the activities shown on Moche vessels.[21] In other instances, later sources have been employed to interpret individual characters,[22] or to reconstruct Moche rituals,[23] but scholars have generally stopped short of using these to reconstruct mythical narratives.[24] A notable exception is the Revolt of the Objects scene, known from a mural at

Huaca de la Luna and ceramic vessels (see plate 27), which Jeffrey Quilter has analyzed by utilizing colonial sources and widespread parallel myths in other Indigenous traditions of the Americas.[25] But in general, modern and colonial sources must be employed cautiously. No single approach or body of source material is sufficient for interpreting Moche narrative. Meanings and modes of representation were not stable, even throughout the duration of the Moche tradition, and different subjects could be invoked or modified by individual workshops depending on needs or desires. Full appreciation of the narratives requires careful evaluation of a variety of sources, thorough understanding

of Moche pictorial conventions, consideration of the social circumstances in which art was produced and used, and awareness that meanings of narratives can and do change over time or depending on the contexts in which they are presented.

MAYA

For Maya painted ceramics, just as for the Moche, we can pursue a purely pictorial analysis, but we are also able to study inscriptions written on the objects themselves and in other media recorded contemporaneously,

that may provide information about daily life, history, supernaturals, and other topics. Indeed, for ancient Maya painted vessels, there is significant interplay between the imagery and texts, indicating the Maya valuation of both these modes of expression, which together, as Simon Martin has written, "gave many Maya records their full communicative power."[26] Later written sources (such as the *Popol Vuh*, an epic recorded in highland Guatemala by K'iche' Maya people in the sixteenth century) recount narratives that may relate, even if distantly, to ones encountered on the much earlier painted pottery. In addition, other material evidence and archaeological discoveries help inform our interpretations.

Notably, the study of Maya painted vessels has lagged behind examination of other media because of insufficient access to the pottery.[27] Although some painted ceramics were found in archaeological excavations in the first half of the twentieth century, including in burials at Copan, in Honduras, and Holmul, Tikal, and Uaxactun, in Guatemala,[28] most of the painted polychrome ceramics known today come from illicit digging in the second half of the twentieth century.[29] Although many scholars have refused to write about those looted objects, because they had lost informational value and their publication might have encouraged more looting, several museum exhibitions have featured them, and in the exhibition catalogues and other publications, scholars primarily examine their imagery, particularly with regard to iconography, relationships to the *Popol Vuh*, or artistic styles.[30] However, more intense investigation ensued after Justin Kerr released his online database of rollout photographs (www.mayavase.com) around 2000, which facilitated international access, and also as epigraphers have endeavored to decipher the vessels' inscriptions. Furthermore, increased archaeological excavation in Peten in the 1990s and later has recovered more painted ceramics with documented findspots, allowing investigation of their images, inscriptions, and archaeological contexts simultaneously, which enables much richer analysis than does study of any one of these

areas alone. Also significant are research projects engaging in technical or scientific analysis of Maya painted pottery, studying, for example, residues of corn or chocolate, methods of manufacture, or clay chemistry to determine the objects' sites of origin.[31]

Late Classic Maya ceramic vessels feature a range of painted imagery, from geometric designs to complex pictorial narratives depicting the actions of humans and supernaturals. Common are palace or court scenes, set within building interiors indicated by pillars, ceilings, and thrones. The central focus of an exemplary palace scene painted on an Ik'a'-style cylinder (fig. 40) is a ruler seated on a stone throne furnished with a large pillow, amid five seated or kneeling individuals whose bodies overlap one another and the architecture to suggest their occupation of three-dimensional space. Ballgame equipment rests on the throne, and pottery containing food, drink, or ceremonial implements sit on and beneath the throne. A kneeling attendant presents a bowl to the ruler, while two seated figures appear to converse over a drinking cup. Each pair thus uses a ceramic vessel for social interaction. This extraordinary painting shows the physical and social spaces of the royal court, as well as activities like the ballgame that take place outside the time and space of the scene.[32]

Many other scenes refer to mythological stories by depicting a range of figures, including God L, a merchant deity and underworld denizen; the Maize God; storm deity Chahk; K'awiil, embodied lightning and deity of rulership; the Moon Goddess and male lunar deities; a supernatural baby jaguar; and a host of other anthropomorphic, zoomorphic, or hybrid creatures.[33] These entities, many of them manifestations of forces of nature, engage with one another in vibrant scenes that anthropomorphize patterns of the natural world, such as the first rains, seasonal changes, and agriculture, or emulate human social or political interactions.[34] The Maize God, for example, appears in a variety of scenes, whether alone or with other figures, in distinct but connected phases of his life cycle.[35] His rebirth is a key narrative highlight. He emerges from a turtle shell, mountain, or skull, frequently in

water (a reference to rebirth from the watery underworld), or he dances, as depicted in varying regional styles.[36]

Another core theme involves two young male figures, frequently depicted as hunters on Late Classic ceramic vessels, who battle underworld deities or other entities such as the avian Itzam Yeh (also called the Principal Bird Deity), who appears to be a false sun that must be defeated for the true sun to be born. These young males, named Juun Ajaw and Yax Bahlam on a plate that depicts them assisting the Maize God in his rebirth from a turtle shell (fig. 41),[37] may be Late Classic–period versions of the Hero Twins, called Hunahpu and Xbalanque in the *Popol Vuh*, which was recorded centuries later. Furthermore, some scholars suggest that the Classic-period Maize God is the same as Hun Hunahpu, the Hero Twins' father. Nonetheless, some of these aspects of the Late Classic stories are not articulated in the *Popol Vuh* and must be reconstructed from pre-Hispanic imagery.[38] Other Late Classic ceramics with painted scenes also appear to overlap with stories from the *Popol Vuh*, with some variations. For instance, painted on one cylinder (fig. 42) are three cacao trees, and replacing one cacao pod on each tree is the Maize God's head. Scholars have compared this scene with the *Popol Vuh* episode in which the severed head of Hun Hunahpu, which was hung in a calabash tree, spat into the hand of Xkik' (Lady Blood), an underworld maiden, rendering her pregnant with the Hero Twins, who later avenged their father's death.[39] Other scenes, such as that on the Plate with Hunters Shooting a Supernatural Bird (Blom Plate) (plate 43), which was found in a destroyed burial mound in Chetumal, Mexico, portray the two young hunters aiming their blowguns at the Principal Bird Deity, who is seated on a cleft head.[40] In a story of the *Popol Vuh*, the twins use blowguns to shoot Wuqub' Kaqix, or Seven Macaw, out of a nance tree, injuring him, and later remove his shiny teeth and eyes, thereby taking away his power.[41]

Granted, there are differences between the ancient images and the stories recounted in the *Popol Vuh*, indicating that such narratives were adapted and transformed in

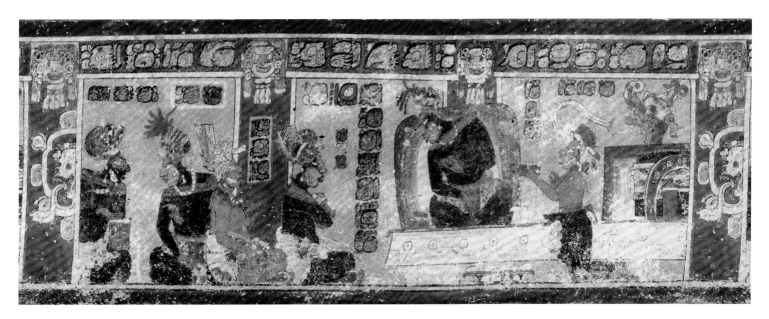

FIGURE 40 Rollout photograph of Cylinder Vessel with Palace Scene. Maya, probably made in Motul de San José, Peten, Guatemala, ca. 650–750 CE (see plate 5)

FIGURE 41 Codex-Style Plate with the Rebirth of the Maize God. Maya, made in southern Campeche, Mexico, or northern Peten, Guatemala, 680–740 CE. Terracotta and pigment, Diam: 32 cm (12 ⅝ in.). Museum of Fine Arts, Boston, Gift of Landon T. Clay, 1993.565 (K1892)

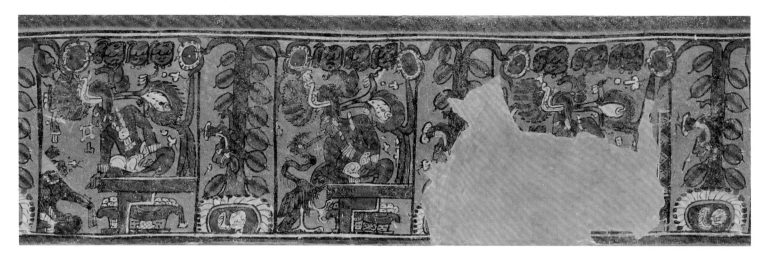

FIGURE 42 Rollout photograph of Cylinder
Vessel with Heads of the Maize God in Cacao
Trees. Maya, probably made in Alta Verapaz,
Guatemala, 600–800 CE (see plate 42)

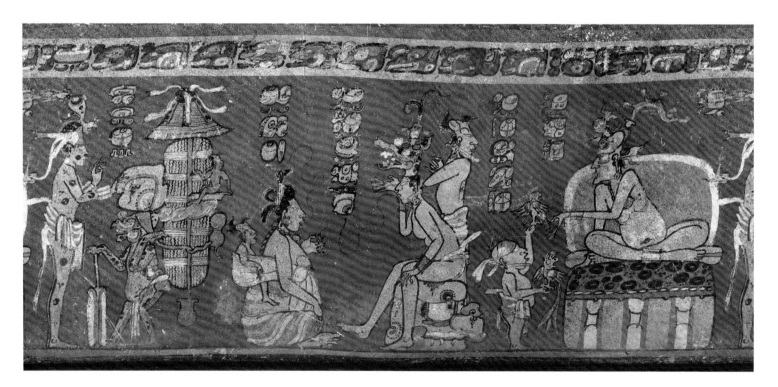

FIGURE 43 Rollout photograph of Cylinder
Vessel with the Maize God and other Super-
naturals. Maya, probably made in El Zotz,
Peten, Guatemala, 600–700 CE (see plate 39)

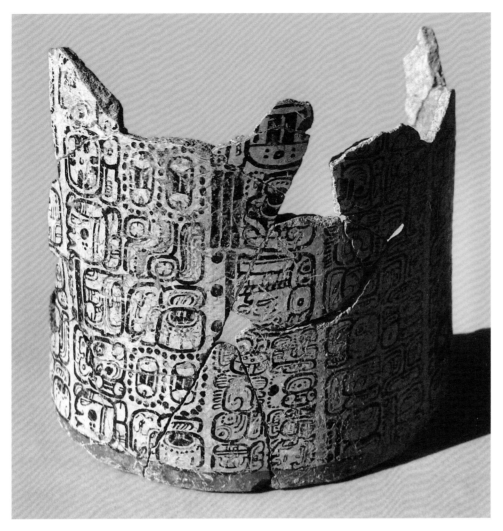

FIGURE 44 Komkom Vase. Maya, ca. 812 CE. Terracotta, max H: ca. 20.3 cm (8 in.). Found at Baking Pot, Belize. Institute of Archaeology, Belize, 28/190-001:173

narrating depicted scenes that even include dates and locales, whether historical or mythological. On the Vase of the Eleven Gods (plate 44), deities are seated in registers and face God L in his underworld palace, while the complementary text narrates the *tz'ahkaj* (it was put in order) of the gods on the day 4 Ajaw 8 Kumk'u—the Creation, in Maya time-keeping.[46] Further, some vessels bear first- or second-person quotations, bringing figures to life by giving them voice. On a red-background cylinder depicting the Maize God at various stages of his life cycle, including as a baby and an adult (fig. 43), the deity Itzam Kokaaj faces a small male figure wearing a headband.[47] The text between them begins with a version of the verb "to say," and includes the phrase "He said it," signaling that this is a quotative text, a conversation taking place between the two portrayed figures, whereas other dialogue is indicated by speech scrolls connecting inscriptions to individuals' lips.[48] Some vessels are painted with inscriptions alone, such as the Komkom Vase, discovered in Baking Pot, Belize (fig. 44), which bears a lengthy text recounting conquests, fire offerings, and other events, as well as information about the object's owner and family.[49]

Not all texts inscribed on Maya ceramics shed light on the associated images, for many simply dedicate the piece.[50] In rare cases, however, there may be some resonance between the images and the identity of the vessel's owner; for example, an unprovenienced vase in the Metropolitan Museum of Art, New York, portrays Chahk, who has struck open a stone house from which the Maize God emerges. The dedicatory text names the owner as a *jatz'oom* (striker), emphasizing a connection between him and Chahk.[51] Similarly, the owner of the Plate with Hunters Shooting a Supernatural Bird is named as a *chak ch'ok keleem* (great, strong youth; see fig. 26B), which resonates with the depicted young male hunters, who, because of their hunting prowess, guardianship of wealth, assistance to the Maize God, and obedience to deities like Itzam Kokaaj, were significant role models for young men.[52]

Painted images and texts on Maya ceramics are, therefore, best understood

different regions and time periods, both in the pre-Hispanic past and after the sixteenth-century Spanish invasion.[42] Indeed, Oswaldo Chinchilla Mazariegos observes that, unlike the Classic-period Maize God, Hun Hunahpu in the *Popol Vuh* is never resurrected, and the young twins in the *Popol Vuh* are solar and lunar deities.[43] He thus rejects calling them the Hero Twins and instead refers to them as Gods S and CH.[44] Furthermore, he argues that it may be more productive to emphasize these narratives' variability across time and space, rather than try to impose interpretations derived from the *Popol Vuh* or other later

sources.[45] Although these interpretations may still be debated, the overall message is clear: even as we use later texts and oral narratives to shed light on ancient imagery, we must be wary of assuming one-to-one correlations and instead be open to and even celebrate the diversity of expression in these core narratives across time and space.

The images painted on ceramics have been enormously revelatory with regard to ancient Maya mythology and courtly life, but analysis of painted texts has also been essential for interpretation. The texts may appear in various forms, including brief captions naming figures or longer texts

through multifaceted, interdisciplinary approaches that take into account any depicted stories and textual narrations, the social contexts of painters or owners, material qualities and means of manufacture, places of deposition, and material traces of use. Taken together, these allow us to reconstruct relationships to the people who made, owned, or used them, and the social lives of the vessels themselves, as they were experienced in palace courts or in tombs, used to inspire storytelling or make offerings to ancestors, or moved across the geopolitical landscape to cultivate alliances with other kingdoms.

GREEK

A wide array of scenes adorn Greek painted pottery,[53] encompassing domestic activities, social gatherings, weddings and funerary rituals, combat and battlefield departures, young men exercising, and women adorning themselves. Alongside these are depictions of the Olympian gods; satyrs[54] and other hybrid creatures; mythical episodes from the Greek army's ten-year siege of Troy and its aftermath;[55] and the adventures of heroes such as Theseus, Herakles, and Perseus. Many of the strategies that have been discussed for interpreting the imagery of the Moche and Maya material apply to Greek painted pottery—identification of figures by attributes; comparison with similar scenes and other pictorial media; and the judicious use of written sources. In the last case, the survival of literary texts from the period in which the pots were made, as well as the painters' use of inscriptions, demand particular attention.

Many inscriptions on Greek pottery serve as labels, naming figures in a scene.[56] Among the earliest examples is the Euphorbos plate (plate 45), made on the island of Kos at the end of the seventh century BCE, and discovered at Kameiros on the nearby island of Rhodes. Two warriors confront each other above a fallen figure. There is nothing in their appearance that suggests they represent specific individuals. But amid the dense ornamentation are three names, indicating that the Greek hero Menelaos stands at left

over the Trojan Euphorbos, against the advance of Hektor, prince of Troy. Through the addition of these labels, a seemingly nonspecific composition is identifiable as a mythical episode.[57]

At first glance, therefore, these labels are valuable tools, and their presence in one composition can be used to identify other, similar scenes that lack inscriptions. But the duel over a fallen warrior serves as an important caveat, for while there are many other examples of this composition, and most figures lack names (fig. 45), these "anonymous" warriors need not be Menelaos, Hektor, and Euphorbos. Not only do they lack attributes to support this identification; in the few cases where the scene is accompanied by legible inscriptions, other names occur, for instance, Memnon and Achilles fighting over Phokos, or Achilles and Hektor over an unnamed body.[58] These labels pin a standard composition to a specific episode, but their variability also demonstrates that the many nameless examples could evoke a multitude of stories. Uninscribed figures are not so much impossible to identify as possible to identify in many ways.

The slipperiness of inscriptions is apparent elsewhere. It is difficult, for example, to determine why a painter names figures on one pot and not on another, or only some figures even within a single scene. On a hydria in Boston (fig. 46), for example, Hektor and the tomb of Patroklos are labeled, but the protagonist of this episode—Achilles—is left unnamed. Furthermore, inscriptions that are spelled correctly can exist alongside so-called nonsense inscriptions (strings of letters that produce no meaningful Greek words) and mock inscriptions (for instance, dots and blobs that imitate the look of written words).[59] On an amphora that shows Priam, king of Troy, approaching Achilles to recover the body of his son Hektor (plate 2), a row of letters seems to incorporate the name of the messenger god Hermes, but other inscriptions on the pot look senseless, in some cases close to illegible. Some scholars have argued that the mere appearance of words added to a vessel's appeal, but more fruitful for our purposes is to consider the graphic aspect of these inscriptions, whether legible or

not.[60] They can guide the viewer's eye, even augmenting the narrative. On the amphora, the arc of letters surrounding Priam's head reinforces his supplication to Achilles. Even well-written labels can do more than simply identify. On the Boston hydria (fig. 46), Hektor's name—and thus his heroic reputation—hangs in empty space, Achilles trampling over it as he steps into his chariot, while Patroklos's name is marked for perpetuity upon his tomb.

These two depictions of Achilles's mistreatment of Hektor's corpse can be viewed alongside the relevant passages from the *Iliad*.[61] Literary works that might have existed at the same time as the potters and painters, in addition to copious later sources, provide a trove of material with which to study Greek art. Yet, as we consider Greek painted pottery alongside Maya and Moche, we should acknowledge the peculiarities—and even drawbacks—of this heavy reliance on literary sources.

The *Iliad* and the *Odyssey* belong within a sequence of tales describing the Greek siege at Troy and its aftermath, which in turn was just part of a constellation of interlinked stories involving gods and heroes. These had long circulated orally, but with the spread of the Greek alphabet during the eighth and seventh centuries BCE, could also be written down, and the Archaic and Classical periods (700–323 BCE) witnessed an efflorescence of poetry, prose, and drama. Texts ensured that particular narratives achieved a fixed form, but tales continued to be reinterpreted—most obviously in the competitive staging of mythical stories by Greek tragedians. Literature augmented—rather than replaced—the oral tradition, and performance and recitation remained fundamental. We should not presume that painters (whose literacy levels varied widely) enjoyed ready access to texts, and the papyrus scrolls on which these would have been recorded seem to have become accessible only by the final decades of the fifth century BCE.[62] The written word brought substantial cultural change, but as with any new technology, this was gradual and often uneven. To return to the two black-figure depictions of Hektor discussed above, we would be mistaken to imagine that

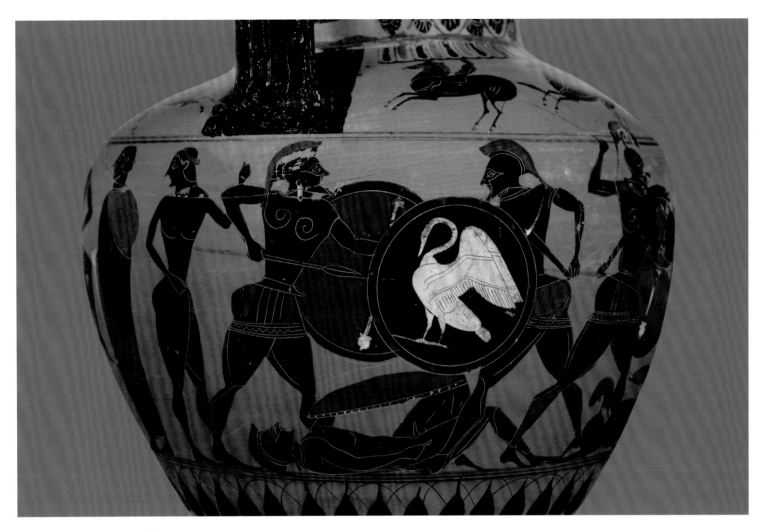

FIGURE 45 Storage Jar with Battle Scenes, attributed to Group E (near the Painter of London B174). Greek, made in Athens, ca. 540 BCE. Terracotta (detail). Malibu, J. Paul Getty Museum, Villa Collection, 86.AE.73

their painters were checking details against a text as we might today.

Our library of ancient Greece is also profoundly incomplete, and some tales, such as the life and deeds of Theseus (see plate 10), are most fully preserved by later Hellenistic or Roman-era authors—which, as in the case of the Maya *Popol Vuh*, requires us to consider how these may have changed over time. Other works are known only from fragments quoted in later texts, or through digests and summaries. But beyond the challenges of working with such scattered material, by concentrating on literary sources we

diminish the importance of *hearing* these tales, and risk treating the scenes on painted pottery as mere "illustrations." Familiarity with ancient Greek and Roman texts has long been a cornerstone of Western education, shaping expectations that images should align with written sources. But this fails to do justice to the different ways in which pictorial narratives—and the objects that bear them—functioned. Furthermore, considering these scenes to be illustrations risks fostering the sense that they are dependent on—and potentially inferior to—texts. This notion goes back to Gotthold Ephraim Lessing's

Laocoon: An Essay on the Limits of Painting and Poetry (1766), in which poetry is deemed superior to painting because it can convey the passage of time and describe a character's feelings or motivations. Much can be gleaned from examining the different ways in which writers and painters conveyed narrative (discussed below),[63] and many interpretive methods deployed for the study of literature have been applied fruitfully to Greek iconography. But rather than point to the things that painted pottery cannot do, we advocate for what it makes possible. To do so, it is necessary to approach the material on its own

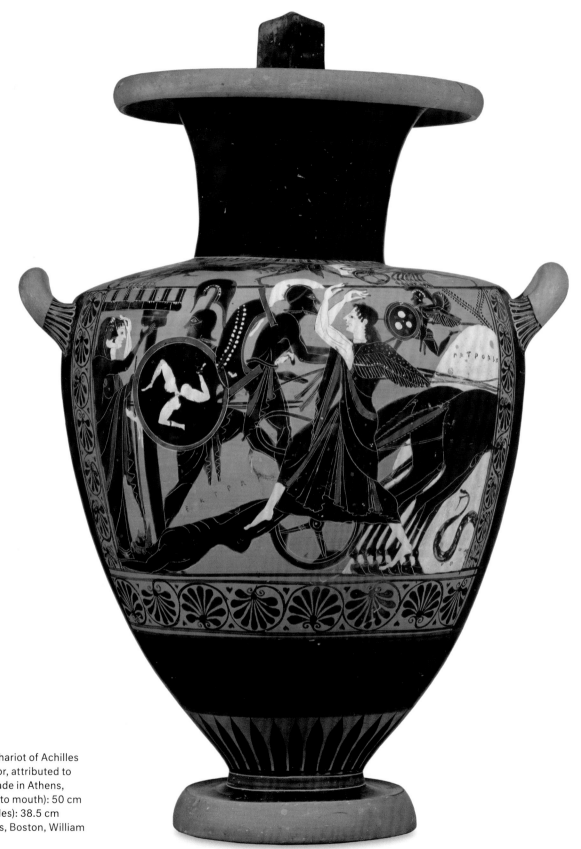

FIGURE 46 Water Jar with Chariot of Achilles
Dragging the Corpse of Hektor, attributed to
the Antiope Group. Greek, made in Athens,
520–500 BCE. Terracotta, H (to mouth): 50 cm
(19 11/16 in.); W (including handles): 38.5 cm
(15 1/8 in.). Museum of Fine Arts, Boston, William
Francis Warden Fund, 63.473

SAUNDERS, O'NEIL, AND TURNER

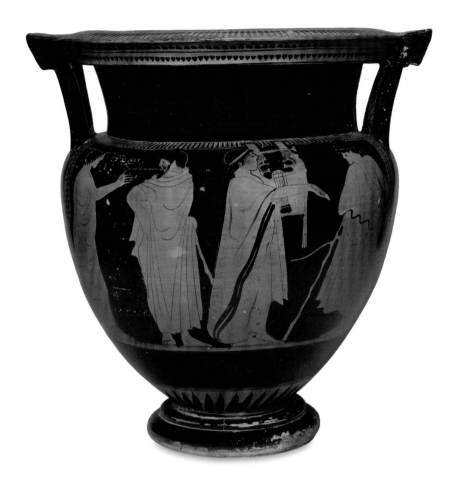

FIGURE 47 Mixing Bowl with
Men Listening to a Lyre Player.
Greek, made in Athens,
480–470 BCE (plate 8, reverse)

terms—as image-bearing vessels encountered in social settings, and as prompts for exposition and engagement. A case in point is the red-figure mixing bowl with Theseus—a model for Athenian male youth—greeting his divine father Poseidon at his home under the sea (plate 8).[64] Around the time the vessel was made, Athens established the Delian League, a naval alliance that sought to protect Greece from the Persians, so this scene, which asserts the Athenian hero's intimate association with the god of the sea, may have been especially meaningful.[65] The krater, designed for mixing wine and water, could have been placed at the heart of a symposium, and the sight of Theseus shaking hands with Poseidon might have prompted drinkers to expound upon the hero and the city he represented. The other side (fig. 47) celebrates the value of oral expression. A young

man plays a lyre (*kithara*), watched—and heard—by other men. There is no indication of what is being sung, but a celebration of Theseus's accomplishments would be apposite. Recounting the exploits of mythical figures not only entertained and inspired but also ensured that their memory and glory continued to resound, and this krater plays an active part in this cultural practice.

PICTORIAL STRATEGIES

Having identified approaches to comprehending and interpreting the images on painted pottery, we turn to consider the ways in which ancient Greek, Moche, and Maya painters organized their scenes to convey the passage of time and utilized the physical form of a vessel to create a narrative experience.

Despite very different subjects, visual vocabularies, and vessel shapes, certain practices occur or find parallels in all three civilizations. No less important is the part played by the viewer. The pots existed within what Simon Martin calls "interpretive communities,"[66] made up of those who encountered them, who needed not only to call on their own familiarity with stories and motifs but, in many cases, to engage actively with the vessels, be it by rotating them or tracing connections across multiple images.

Consideration of pictorial narratives—and in particular, how they compare to texts or recitations—has given rise to detailed analysis of the ways in which artists depict action. How, for example, do they convey the consequences of an event, or its motivations? Which point in a narrative is the most visually effective—its climax, or a tense moment

FIGURE 48 Rollout drawing of Stirrup-Spout Vessel with Wrinkle Face and Iguana. Moche, made in northern Peru, 500–800 CE (see plate 18). Drawing by Donna McClelland

FIGURE 49 Rollout drawing of Stirrup-Spout Vessel with Wrinkle Face and Iguana. Moche, made in northern Peru, 500–800 CE (see plate 19). Drawing by Donna McClelland

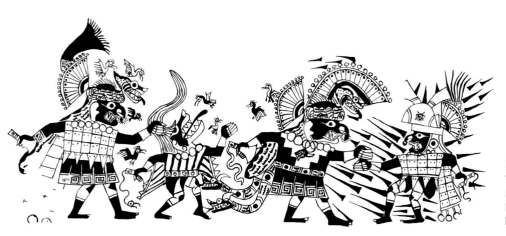

FIGURE 50 Rollout drawing of Stirrup-Spout Vessel with Wrinkle Face Fighting Anthropomorphized Creatures. Moche, made in northern Peru, 500–800 CE (see plate 20). Drawing by Donna McClelland

SAUNDERS, O'NEIL, AND TURNER

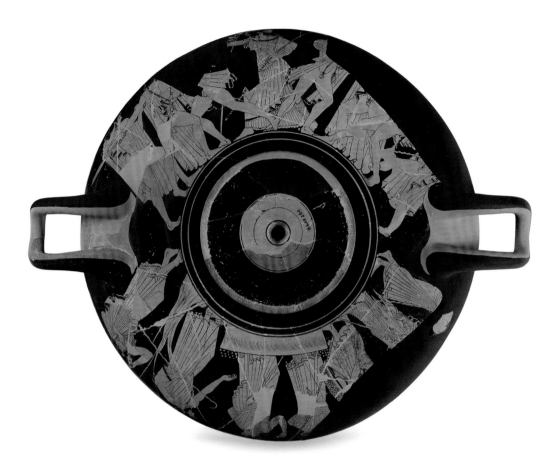

FIGURE 51 Exterior of Wine Cup with the Suicide of Ajax. Greek, made in Athens, 490–480 BCE (see plate 15). Above: Agamemnon intervenes in the dispute between Ajax and Odysseus; below: the ballot

beforehand? There are many vessels that are *monoscenic*—they show just a single moment (see, for instance, plates 11, 21, 43), though additional figures or settings or other pictorial details might look ahead or back to other facets of the story. Alternatively, painters may combine different moments and actions within a single picture field, essentially collapsing the passage of time (variously termed *synoptic*, *synchronous*, *simultaneous*, or *polychronic* narrative); on the Boston hydria (see fig. 46), for example, Achilles drags Hektor's body before Hektor's grieving parents, while the messenger goddess Iris descends to bring an end to Achilles's actions. A third strategy is to depict a character multiple times, in distinct episodes (*cyclic* or *continuous* narrative)—for example, Wrinkle Face and Iguana in the Moche Burial Theme (plates 25, 26), Theseus and his deeds (plate 10), or the rebirth of the Maize God (plate 32). These classifications—and others that have been

proposed—offer fruitful ways to examine how pictorial narrative functions, and can be applied across Greek, Moche, and Maya imagery.[67] But they also import assumptions about storytelling—as linear and time-bound—that may not apply to visual media, or the occasions at which these painted pots were encountered.

Furthermore, narrative considerations should be indivisible from the physical form of the vessel. Although photographs and illustrations are valuable tools for study, painted pots are not flat canvases. Their figural zones may constitute just a small part of the vessel, or extend over its curving surfaces. Painters imposed borders, sometimes serving as architectural forms (fig. 40), or cutting off scenes in an illusionistic play of space (plate 10, tondo).[68] Moche stirrup-spout bottles might be relatively consistent in form, but across different places and periods of their production, they demonstrate diverse

methods for organizing figural scenes. The pot may be treated as two-sided, with the same or similar scenes on the front and back (figs. 48, 49), or two different ones (fig. 50), enabling juxtaposition, comparison, or the linking of related episodes. The two sides of a large Athenian drinking vessel span ten years of fighting at Troy, from Paris's abduction of Helen to Menelaos's recovery of her (fig. 59), while a contemporaneous cup depicts a crisis in the Greek camp: on the exterior, the dispute between Ajax and Odysseus over whom should receive the arms of the deceased Achilles, and its resolution with a vote (fig. 51), and, on the interior, the horrific aftermath—the suicide of Ajax (plate 15).

In other cases, a single composition might span a vessel's surface (plate 21), or, in the case of the Maya Vase of the Eleven Gods (plate 44), all four of its sides, while a frieze spiraling around a pot allows for multiple episodes in a narrative (fig. 52). The surface

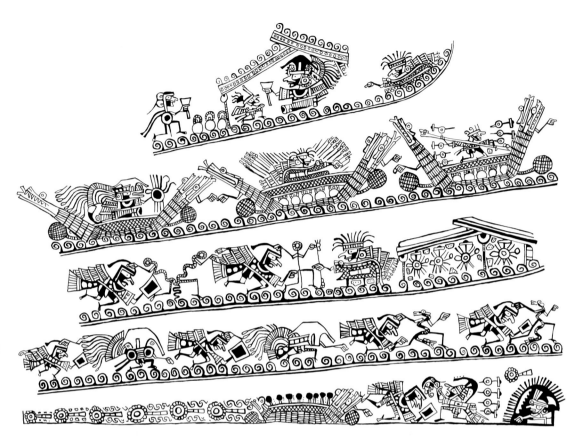

FIGURE 52 Rollout drawing of Stirrup-Spout Vessel with Combat, Boats, and a Presentation Scene. Moche, probably made in San José de Moro, La Libertad, Peru, 650–800 CE (see plate 27). Drawing by Donna McClelland

can also be articulated into sections, with even the underside providing a field for figural decoration (fig. 53). The dense patterning of this last example also calls attention to the interplay of figure and ornament, which is especially apparent in the San José de Moro substyle of Moche painted pottery, but can also be found on Greek vessels—for instance, eye cups (plates 6, 14) and the Euphorbos plate (plate 45).[69] Similarly, Moche vessels that combine painted and low-relief imagery with three-dimensionally rendered figures playfully and jarringly break narrative picture planes and bring characters into the viewer's space (plate 29). Disrupting and embellishing the painted surface, these figures remind us that assessing the images on these vessels solely in narrative terms is to underplay their full experiential value.

Pots might contain pellets that rattled when moved,[70] and certain types of Moche vessels with three-dimensional figures on the tops of their chambers were sometimes equipped with hidden internal whistling mechanisms.[71] "Figural" or "plastic" vases—such as an Athenian hoof-shaped mug (plate 46) with a bucolic scene around its rim,[72] or the cosmic howler monkey's head that serves as the handle to the lid of the bowl from El Zotz (plate 31)—are especially effective in their combination of form, function, and decoration. Moche pottery is particularly rich in examples that invite multiple forms of user engagement, beyond the purely visual. Several San José de Moro–style vessels were constructed with either perforated false outer chambers or chamber-piercing tubes (plate 26) that give the impression that they

would not be capable of holding liquid. Their construction, along with the dense painting style that seems to obscure figures and other details, suggest that these vessels were intended to be held, turned, and examined slowly and with care.

In short, these painted works invite both the eye and the hand. This is neatly visualized on the Ik'a'-style vessel (see fig. 40, left) where two figures sit in conversation, one holding a cylinder vessel, gesturing as though talking about it. The uninterrupted exterior of many Maya cylinders encourages their rotation, to animate a Maize God dancer (plate 35),[73] or to follow the curving, serpentine form of K'awiil's leg around a bare-breasted woman (fig. 54); glances among the figures, too, encourage a user to twist these vessels back and forth. In other

SAUNDERS, O'NEIL, AND TURNER

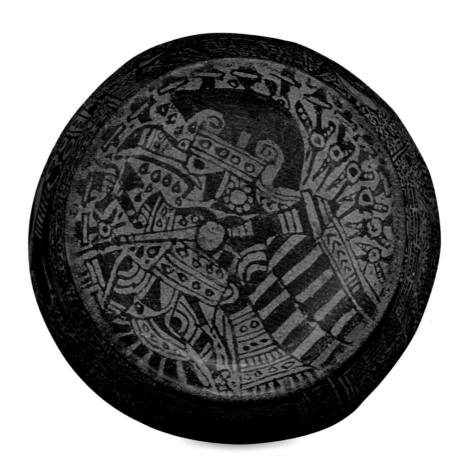

FIGURE 53 Underside of Stirrup-Spout
Vessel with the Burial Theme. Moche,
probably made in San José de Moro,
La Libertad, Peru, 650–800 CE (detail,
plate 26)

cases, multiple connected scenes may be experienced by rotating the vase. On the red-background cylinder with scenes of the Maize God at different ages (see fig. 43), the stories appear to proceed linearly, from left to right, suggesting that one needs only to turn it to follow the composite narrative.[74] Many Greek pottery shapes, by contrast, are sharply articulated, be it at the junction of body and shoulder, or by the presence of handles.[75] But here, too, there is value in engaging with the pot in the round.[76] Scenes on the fronts and backs of amphorae, or the exteriors and interiors of cups, are sometimes directly linked, but even when they are not, there are often meaningful connections to be made—for instance, between distinct mythical episodes, such as Achilles dragging Hektor (see fig. 46) and Herakles fighting

Kyknos (fig. 55), or thematically related scenes, such as Ajax and Achilles playing their boardgame on the body of another water jar, and a warrior-departure scene on its shoulder (plate 13).[77] So, too, on Moche vessels: on one side of a stirrup-spout bottle (see fig. 48), Wrinkle Face sits before Iguana with a spear in his arm; on the other side, the scene is similar but the spear is not shown.[78] Furthermore, moving the pot in one's hands can foster tension and surprise. On a vase in Princeton (fig. 56), a woman in God L's palace looks backward, and concernedly taps her companion on the back of the heel.[79] Rotating the cylinder to follow her gaze reveals two males in elaborate masks killing a bound victim. In similar fashion, tamales taken from a shallow bowl may bring the Maize God into view (plates 40, 41), reenacting

his birth, while Ajax's dead body (plate 15) is revealed to a drinker only as the cup is drained of wine. In such cases, decoration and function are intimately connected, and this link—and the viewer's role—can involve more than just holding and seeing. The hole that was made in the dish found in a tomb at Uaxactun (plate 40) penetrates the midriff of the Maize God depicted on it, perhaps reenacting the first emergence of maize from the earth, as well as ritual bloodletting.[80] Alternatively, when Maya people drilled such a hole and placed the plate on the head of the deceased, they transformed it from a vessel for eating to one that may itself have nourished the dead. For Moche figural vessels, user interaction was assumed, and meanings might change when the liquid contents sloshed inside, or when the user drank from

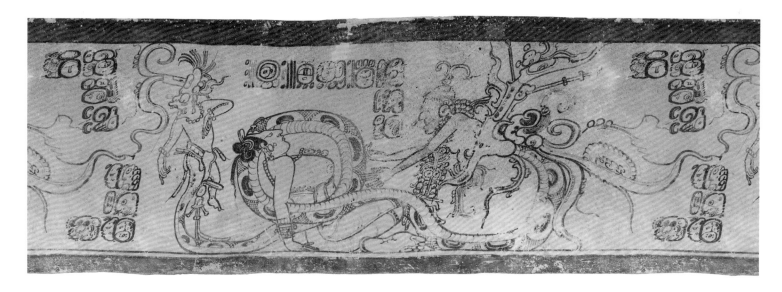

FIGURE 54 Rollout photograph of Cylinder
Vessel with Supernatural Birth Scene.
Maya, made in southern Campeche, Mexico,
or northern Peten, Guatemala, 650–800 CE
(see plate 33)

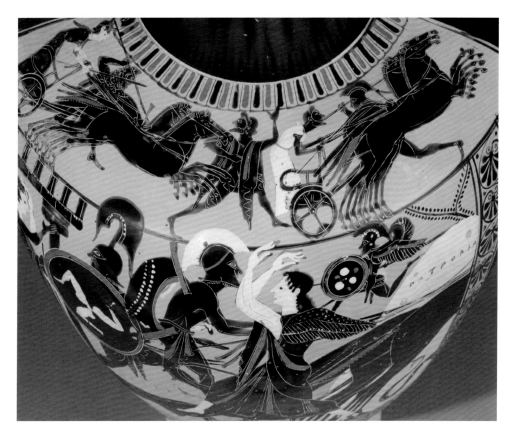

FIGURE 55 Shoulder of water jar (see
fig. 46), with Herakles fighting Kyknos

SAUNDERS, O'NEIL, AND TURNER

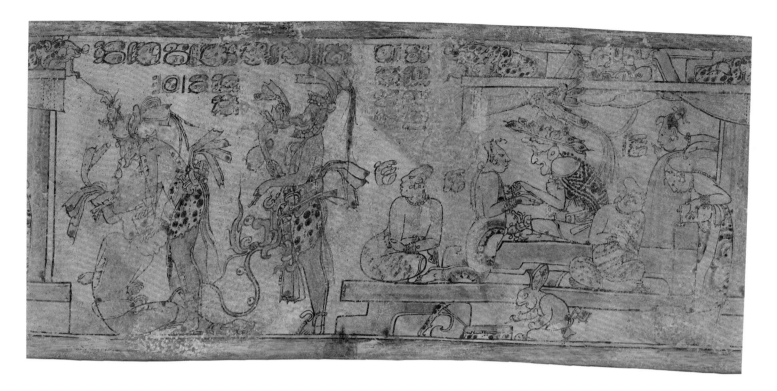

FIGURE 56 Rollout photograph of the Princeton Vase. Maya, 670–750 CE. Princeton University Art Museum, Museum purchase, gift of the Hans A. Widenmann, Class of 1918, and Dorothy Widenmann Foundation, y1975-17

the spout.[81] Seemingly inanimate pots were thus brought to life through human engagement. Furthermore, when painted ceramics moved from their places of production, they could obtain different meanings or functions in new contexts. Painted Maya vases, for example, could function as a treasured gift or as an index of an important social or political relationship, particularly when the image or text made reference to its original owner or polity of origin (for example, plates 4, 34).[82] Among Greek examples, a black-figure drinking cup (plate 14) with warriors around the eyes and handles and Menelaos reclaiming Helen at the fall of Troy fits well within the masculine realm of the Athenian symposium. But under the foot, an inscription added after the cup was fired reads, "I am Melōsa's victory prize; she defeated the girls at carding." Was the transformation of this cup, reportedly from the Greek colony of Taranto in southern Italy, into a girl's prize for wool working solely the consequence of its being an import, or could it also have owed something to the depiction of the legendarily beautiful Helen and her carefully rendered garments?[83] And while we may contemplate how the decoration of the krater with Theseus and Poseidon (plate 8) was perceived in the context of Athenian symposia and local politics, its final resting place—in a sarcophagus, reportedly of a woman, at the site of Ruvo in Apulia (southeastern Italy)[84]— demands other interpretations. In a funerary context, might the depiction of a brave hero in the watery depths, welcomed by a god, have served as a consolatory metaphor in the face of death?

That images might be read differently, or to different ends, once they left the potter's workshop reinforces the dynamic interplay among figure-decorated vessels, their makers, and those who encountered them. And this holds true in the present. By bringing together the painted pottery of the Greeks, Moche, and Maya, we celebrate traditions of storytelling and image making that continue to resonate today. Despite their distance in space and time, the pots reveal common practices that speak to shared human needs—to articulate ideals, to foster recollection, to amuse and delight. Yet they also bring forth fascinating and meaningful differences that prompt us to query our assumptions, and to be attentive to the specificities of every painted vessel.

NOTES

The epigraph is taken from Houston and Taube 2008, 132.

1 Stansbury-O'Donnell 1999, 14. Definitions of pictorial narrative can be highly variable, and often culturally or materially specific; see Wagner-Durand, Fath, and Heinemann 2019 and Giuliani 2013, who defines "narrative iconography" as "only possible in the context of a widespread tradition of storytelling in which stories are circulated in a more or less standardized form" (Giuliani 2013, 248). Stansbury-O'Donnell's definition is sufficiently broad for our purposes.

2 Martin 2006b, 91.

3 The following paragraphs draw on the three-stage approach outlined by Erwin Panofsky (1939) in relation to European Renaissance art. However, his methodology entails a heavy reliance on written sources, which does not extend to the ancient cultures that we consider here; see further Chinchilla Mazariegos 2017, 9–22. Although specific to Greek art, Stansbury-O'Donnell 2011 provides an accessible introduction to many interpretative approaches discussed in the following pages.

4 Martin 2006b, 86; Turner 2015, 67; Quilter 2022, 152–54. See also Holmquist and Turner, this volume.

5 Donnan 1976, 117; Donnan 1977.

6 On the Burial Theme, see Donnan and McClelland 1979.

7 On these and other themes, see "Narrative Themes [of Moche Iconography]," Dumbarton Oaks Research Library and Collection, Washington, DC, https://www.doaks.org/resources/moche-iconography/narrative-themes; this online archive also features more than ninety iconographic subject categories devised by Donnan and Donna McClelland, with McClelland's drawings (https://www.doaks.org/resources/moche-iconography/donnan-mcclelland-categories). For more on scenes involving Wrinkle Face, see Rucabado Yong, this volume.

8 Golte 1994; Quilter 1997.

9 Donnan and McClelland 1999, 59.

10 Donnan and McClelland 1999, 62.

11 See further Pillsbury, this volume.

12 See Donnan and McClelland 1999, 56.

13 Turner 2015, 45.

14 Arnold 1991; Turner 2015, 62.

15 Quilter 2010b, 43. See also Quilter, this volume.

16 On Moche murals, see Bonavia 1985; Trever 2022.

17 On Moche sacrifice rituals, see Bourget 2001.

18 On the royal tombs at Sipan, see Alva and Donnan 1993; on the tomb of a Moche princess at San José de Moro, see Donnan and Castillo 1992.

19 See Quilter 1997; Quilter 2002, 162–66.

20 See Quilter 1997.

21 Sharon and Donnan 1974; Donnan 1976, 95–115; Dobkin de Rios 1977. For a more cautious view on this approach, see Trever 2022, 20–28.

22 Donnan 1976, 82–85; Cordy-Collins 1977; Donnan and McClelland 1979.

23 Hocquenghem 1987; Bourget 2006.

24 Cordy-Collins 1983; Quilter 1997.

25 Quilter 1990; Quilter 1997.

26 Martin 2006b, 91.

27 See Miller 1989.

28 Gordon and Mason 1925–43; Merwin and Vaillant 1932; Smith 1932; Coggins 1975.

29 See O'Neil and Saunders, "Modern Histories of Ancient Vases," this volume.

30 Coe 1973; Coe 1978; Reents-Budet 1994.

31 Hall et al. 1990; Bishop 1994, 15–16; Nunberg 2012; Reents-Budet and Bishop 2012; Magaloni and O'Neil 2022.

32 Houston 2012, 314–21.

33 On hybrid creatures, see Cojti Ren, this volume.

34 O'Neil 2018; Chinchilla Mazariegos, Doyle, and Pillsbury 2022.

35 See Chinchilla Mazariegos, this volume.

36 See O'Neil, "Maya Vase Production and Use," and Chinchilla Mazariegos, this volume.

37 Museum of Fine Arts, Boston, 1993.565 (K1892).

38 Taube 1985; Miller and Martin 2004, 54–58; Chinchilla Mazariegos 2011, 70–71.

39 Miller and Martin 2004, 63; Martin 2006a, 164; Christenson 2007, 77–83.

40 Blom 1950.

41 Christenson 2007, 35–41.

42 Chinchilla Mazariegos 2017, 4, 183; Chinchilla Mazariegos 2022a, 66–67.

43 See Chinchilla Mazariegos, this volume.

44 Chinchilla Mazariegos follows an alphabetical system initially developed by Paul Schellhas (1904).

45 Chinchilla Mazariegos 2022a, 63.

46 Grube and Kerr 1998.

47 This deity has long been known as Itzamnaaj, but a proposed alternative, Itzam Kokaaj, is preferred, although this remains a tentative reading. See Martin 2015, 209n35.

48 Just 2009, 10, 12; Martin 2015, 199.

49 Helmke, Hoggarth, and Awe 2018.

50 See O'Neil, "Maya Vase Production and Use," this volume.

51 New York, The Metropolitan Museum of Art, 2014.632.1; Doyle 2016, 54–55.

52 Grube et al. 2022.

53 For an overview and suggestions for further reading, see Oakley 2013 and Oakley 2020.

54 See Hedreen, this volume.

55 See Stansbury-O'Donnell, this volume.

56 Snodgrass 2000 gives a succinct overview of inscriptions on Greek vases. In rare cases, they provide a title to the scene, or denote direct speech.

57 Discussed further in Stansbury-O'Donnell, this volume.

58 Private collection (BAPD 19721; *LIMC* Phokos V 1); Paris, Musée du Louvre, CA 4201 (BAPD 7661). On labels as invitations to identify figures, see Dietrich 2018.

59 See Chiarini 2018.

60 See especially Lissarrague 1992.

61 *Iliad* 22.395–404; 24.14–18 (Dragging of Hektor); 24.468–676 (Ransom of Hektor's Corpse).

62 See Giuliani 2013, 116, 207–8. On depictions of papyrus scrolls and writing slates, see Oakley 2020, 103–6.

63 Giuliani 2013 provides the most sustained exploration of this topic, undertaking a survey of Greek art from the eighth to the second century BCE. See also Hedreen 1996; Hedreen 2001, 3–12; Small 2003; Squire 2009 (especially 122–30, on illustrations); Junker 2012. Particularly lively debates surround the earliest figural scenes on Greek pottery of the eighth and early seventh centuries BCE and how these might relate to the Homeric poems (see, for example, Snodgrass 1998), and images on South Italian painted pots of the fourth century BCE potentially inspired by Greek drama (see Taplin 2007, 22–26).

64 Some have seen a poem by Bacchylides (ca. 518–ca. 450 BCE) that includes an account of Theseus's descent into the sea (Bacchylides 17, 96–113) as a direct influence on the painter of the krater. But there are other vessels that show the scene or related episodes that may be earlier than this poem; see Neils 1987, 8–11, 90; Shapiro 1994, 117–23; Servadei 2005, 84–91.

65 See Pollitt 1987, 9–13.

66 Martin 2006b, 59.

67 See Stansbury-O'Donnell (1999, 1–8), listing eight categories. See also Reents-Budet 1989; Quilter 1997, 116–20; Martin 2006b, 64–67; Jackson 2008, 133–49; Giuliani 2013, 131–39, 249–50; Chinchilla Mazariegos 2017, 15–19.

68 See Neer 2002, 54–77.

69 For a detailed study of the Euphorbos plate, see Squire 2018.

70 For example, the Moche flared bowl, Lima, Museo Larco, ML018882; the Maya vessels, Los Angeles County Museum of Art, M.2010.115.1, M.2010.115.430, and M.2010.115.13 (Magaloni and O'Neil 2022, cat. nos. 2, 17, 18); and the Greek kantharos, Los Angeles, J. Paul Getty Museum, 86.AE.702.

71 See McEwan 1997.

72 On Greek "plastic" vessels, see Cohen 2006, 240–90; Ebbinghaus 2018.

73 See O'Neil 2022b.

74 Burdick n.d.; Just 2009, 10.

75 On decoration in handle zones, see Kéi 2018.

76 See Lissarrague 2015 for a succinct overview.

77 Stansbury-O'Donnell (1999, 118–57), discusses two types of pictorial narrative: paradigmatic (different stories are linked thematically or symbolically) and syntagmatic (scenes follow one after the other in a sequence).

78 Christopher B. Donnan (in Boone 1996, 129–31) notes that the spear is shown on both sides of the similar vessel in Chicago (fig. 49).

79 Princeton University Art Museum, y1975-17 (K0511).

80 See Finegold 2021.

81 Weismantel 2021.

82 See O'Neil, "Maya Vase Production and Use," and Houston, this volume.

83 See, most recently, Plant 2022. Since carding (disentangling and straightening the wool fibers) can entail the exposure of a leg, others have suggested that this "carding contest" was really a sympotic striptease, and that Melōsa was a *hetaira* or prostitute.

84 Montanaro 2007, 211–12.

THE TROJAN WAR

Mark Stansbury-O'Donnell

At the time of the *Iliad*'s composition during the eighth century BCE, Greece was emerging from the long period following the collapse of the Bronze Age palaces. There had been a modest tradition of figure-decorated Mycenaean pottery, limited mostly to marching warriors and chariot processions, but figural representation had essentially vanished from Greek art. In the eighth century, Greek, and especially Athenian, potters began making monumental vases, some a meter (ca. 39 in.) or more in height, to stand as grave markers for the elite (fig. 57). On these, they revived figural decoration using silhouette figures in scenes of a heroic nature, such as ship and land battles, chariot processions, and the *prothesis*, a lying in state of the deceased mourned by members of the family and community. Most of these scenes are too schematic to be effective in conveying specific narratives like episodes of the Trojan War, but they capture the heroic ethos found in the *Iliad* and other epic songs.

The development of new pottery-painting techniques in the seventh century BCE gave artists across the Mediterranean an opportunity to experiment and create specific narratives with scenes of Troy and its heroes. Among these are three nearly contemporary examples of Odysseus blinding the cyclops Polyphemos during his journey home from the war: an amphora from Eleusis near Athens, a krater fragment from Argos in southern Greece, and a krater found in Cerveteri in Italy and signed by a Greek painter, Aristonothos.[1] The widespread findspots of these three works demonstrate that Trojan War stories were well known and appealing to a broad audience, but each is a unique representation of the general story of Odysseus and Polyphemos. The Eleusis amphora (fig. 58), dating to around 670 BCE, shows Polyphemos as a giant, crouched against the picture frame as if it were a cave

FIGURE 57 Mixing Bowl with Funerary Scene, Battles on Ships, and Marching Warriors, attributed to the Workshop of New York MMA 34.11.2. Greek, made in Athens, ca. 770 BCE. Terracotta, H: 99.1 cm (39 in.); Diam: 94 cm (37 in.). New York, The Metropolitan Museum of Art, Fletcher Fund, 1934, 34.11.2

wall, on eye level with the striding Odysseus and his sailors, who hold a long, thin trunk that they plunge into his eye. Their faces are now detailed by line, and the foremost figure is further distinguished by added white and a sketchier line, marking him as their leader, Odysseus. Polyphemos holds the cup that Odysseus offered him to make him drunk and pass out, but in the picture, he acts as if he were still drinking as he reacts to the attack, conflating different moments of the action into a single picture (what is known as a synoptic narrative). Indeed, representing time and action will be the challenge for pottery painters, who often have only a single panel for telling a complex story and must choose characters, moments, and actions that will be recognizable and decipherable for a viewer. There are, then, sufficient cues in this picture, such as the unique action of plunging a stake into the eye of a giant, for the viewer to identify and recall the main story quickly.

A plate from the end of the seventh century BCE shows two warriors fighting over a body (plate 45). The painter now uses added colors of white and brownish red with outlining in black to depict the helmets, cuirasses, skirts, greaves, and spears; the standing warriors are posed like mirror images of each other at an inflection point in the battle. There is no unique action here like the blinding of Polyphemos to inform the viewer of a specific story, but inscriptions that are placed within the gaps of the decoration identify the protagonists as Menelaos (left) and Hektor (right), fighting over the corpse of the Trojan warrior Euphorbos, who was killed by Menelaos after Hektor had slain Patroklos, the companion of Achilles. As often recounted in epic poetry, the armor of a fallen warrior becomes a trophy to be captured, and his body an object to be desecrated by his enemy, so there is a moral imperative for his allies to protect and retrieve both from the battlefield. While it may at first glance appear that Menelaos is trying to protect the fallen warrior, who looks as if he fell back in the attack of the figure labeled Hektor and who has a helmet of the same color as Menelaos's, in fact Menelaos is fighting to drag the body and armor from the field to despoil Euphorbos. That Euphorbos still

has his armor on contrasts with the account in the *Iliad*, in which Menelaos has already stripped the corpse when Hektor arrives to defend his fallen comrade and protect his body.[2] Since artists must typically compress multiple moments of an episode into a single picture, they use their own formulas to convey the drama, which here includes keeping the armor on the corpse to signify he is equivalent in warrior status with the two other figures. This formulaic battle scene epitomizes the heroic ideal and sacrifice, but without the inscriptions, a viewer could have matched the picture with other episodes of battle.

In the sixth century BCE, Athenian painters used the black-figure technique to depict more complicated and detailed compositions and began exporting these narrative vases throughout the Mediterranean in large quantities, particularly to Etruria in Italy. We can see the widespread importance of honoring the fallen warrior in another Trojan War scene that depicts the opposite action, Achilles dragging the body of Hektor (see fig. 46). After killing Hektor before the walls of Troy in retribution for the loss of his beloved Patroklos, Achilles ties the body of Hektor to his chariot and drags it around the city to brutalize it completely. In this scene we see Achilles leaping into the chariot in a formula that painters used to signal a hero leaving his home for war—with the unique addition of the corpse tied behind the vehicle. In another divergence from departure scenes, the figures to the left, in front of the architectural frame, are not the parents of the departing warrior; they are Hektor's parents, Priam and Hecuba. Their gestures are typical of funerary rituals, in which women tore their hair and men saluted. In one sense, the picture is about the earlier heroic departure of Hektor to his death. To the far right is the burial mound of Patroklos, with a small, winged warrior above it who represents his soul (*psyche*) and watches the vengeance of Achilles. Finally, we see a winged woman, the messenger goddess Iris, flying in toward Achilles, bringing a message from Zeus that Achilles should relent. To Achilles's frustration, Zeus had protected Hektor's body from harm so that he could eventually receive an

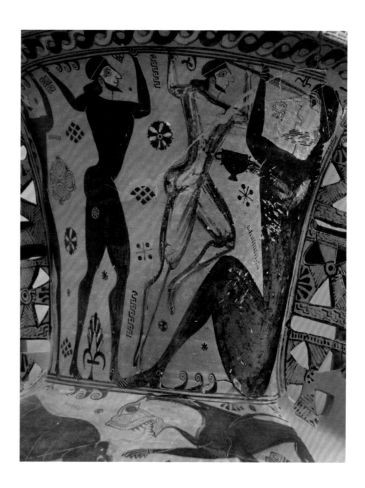

FIGURE 58 Neck of Storage Jar with Odysseus and Sailors Blinding Polyphemos, attributed to the Polyphemus Painter. Greek, made in Attica, ca. 670 BCE. Terracotta (detail). Found at Eleusis, Greece. Eleusis, Archaeological Museum

honorable burial. In this picture, the painter has combined several different actions in the same composition to cue the different elements of the episode, and its eventual resolution in Hektor's heroic burial. Hektor, in many ways, is the true hero of the *Iliad*, dying in an effort to save his city.

Another black-figure vase (plate 2) shows Priam's recovery of the body of Hektor. A beardless man reclines on a *kline* (couch), with his armor hanging in the background and a table of food beside him. That he feasts alone indicates that this is not a symposium. The balding, white-haired man at the left, pleading by reaching for the chin of the young man, can be identified as Priam asking Achilles to relinquish Hektor's body, which lies beneath the couch. Behind Priam, a slave bears ransom offerings; at the far left is Hermes, identified by his winged helmet, boots, and *kerykeion* (staff), who has escorted Priam safely through enemy lines

to Achilles's tent. Achilles holds out an offering bowl (phiale), pointing to the eventual success of Priam's entreaty and hero's burial for his son.

The Trojan War episodes of the *Iliad* discussed above, which took place at the beginning of the tenth year of the war, were not as popular in art as scenes from the end of the war. These events were recounted in two lost epic poems known as the *Little Iliad* and the *Ilioupersis* (The Sack of Ilios—Ilios was another name for Troy), preserved only in summaries and fragments, but vase painters had their own repertory of scenes, some of which are not extant in the surviving literature. On a cup from the third quarter of the sixth century BCE (plate 14), we see variations on warriors fighting under both handles and on the back side. Nothing in the picture allows them to be identified as Trojan, or even mythical. It is the pair of figures on the front of the cup that becomes a clue for the

viewer to consider these as Trojan scenes. Between the eyes, a warrior with drawn sword leads rightward a woman dressed in an elaborately patterned chiton and mantle. She pulls one hem of the mantle forward to reveal her face (once painted, like her feet and hands, in added white). Her gesture is well known from wedding scenes, when the bride unveils herself to the groom at her house before being led away by the wrist through the town to his home. The gesture, called the *anakalypsis*, is a clear visual signal about the bridal status of the woman, but here, with a warrior with drawn sword for the groom, it is out of place. Whereas women are described and sometimes depicted as victims of war, this particular pairing is unique and triggers in the viewer's mind the reunion of Menelaos with Helen at the end of the Trojan War. As the drawn sword reminds us, he had at first threatened to kill her, but upon seeing her face and beauty he took her back as his wife.

STANSBURY-O'DONNELL

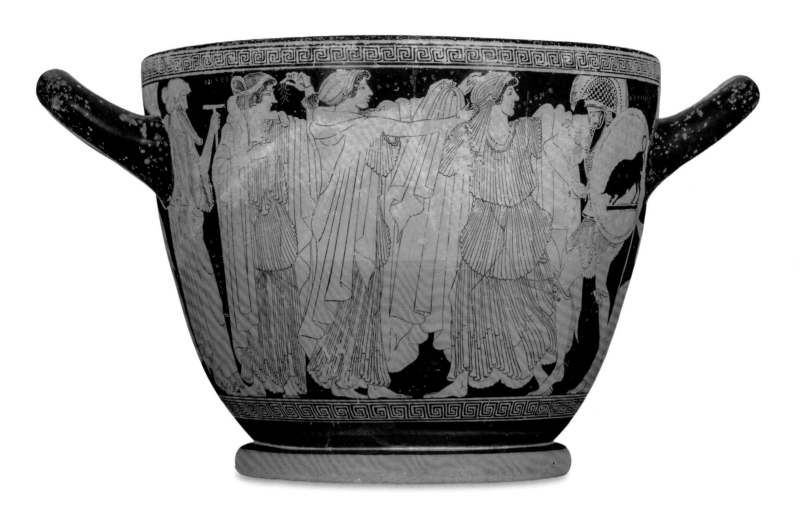

FIGURE 59 Drinking Cup with the Departure
and Recovery of Helen (reverse). Greek,
made in Athens, ca. 490 BCE (see plate 9)

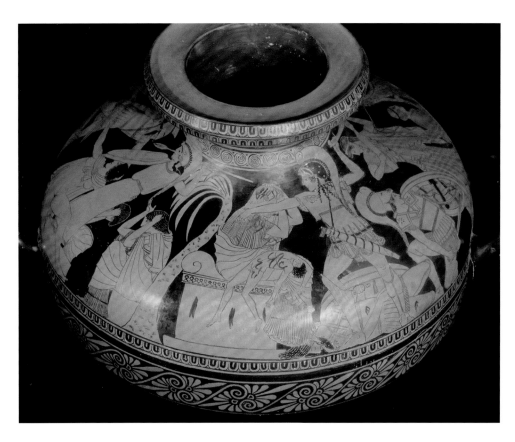

FIGURE 60 Water Jar with the Sack of Troy (the Vivenzio Hydria), attributed to the Kleophrades Painter. Greek, made in Athens, ca. 475 BCE. Terracotta (detail). Found at Nola, Italy. Naples, Museo Archeologico Nazionale, 81669

With this identifiable scene, the viewer can deduce that the other scenes on the cup represent fighting at the fall of Troy.

The new red-figure technique that began in the last quarter of the sixth century BCE provided more opportunities for Athenian artists to show subtleties of actions and emotions in the many subplots of the destruction of Troy. The recovery of Helen appears again on the back of an early fifth-century drinking vessel (fig. 59), and the interactions of the characters are more complex than on the cup discussed above. Menelaos is at the far right, drawing his sword as Helen flees from him. Behind her, the goddess Aphrodite, identified by inscription, pulls Helen's veil aside to reveal her face. Menelaos looks down, but when he looks up after drawing his sword, he will see Helen's face and the sight of her beauty will change his course of action. The painter, Makron, uses the front of the skyphos to show Paris's abduction of

Helen ten years earlier (plate 9), juxtaposing the beginning and the end of the tale. In this scene, Paris leads a veiled Helen by the wrist, as a bride would be led from her father's home. Eros adjusts her crown and Aphrodite her veil, making the abduction appear at first glance to be a marriage. Indeed, one might first think that the warrior is Menelaos, as on the black-figure cup, but inscriptions clarify that he is Alexandros, another name for Paris. On this drinking vessel, Helen becomes a prize or pawn in the Trojan story.

A contemporary artist, the Brygos Painter, used the exterior and interior of a drinking cup to unfold a sequence of three scenes leading to the suicide of the Greek hero Ajax just before the sack of Troy. Ajax and Odysseus had rescued the body and armor of Achilles when the hero died. Both heroes laid claim to the armor as a prize and drew weapons against each other as they argued (see fig. 51). A figure with a scepter,

probably Agamemnon, stands in the center to separate the antagonists as others move to restrain them. The Greek leaders decided to put the decision to a vote, and we see the Greek warriors on the other side of the cup, placing their markers on a platform with their vote for Odysseus or Ajax.[3] The pair observe from the sides, but Ajax on the right bows and tears at his hair in an emotional gesture of mourning, signifying that he will lose the vote. The end of the story appears on the interior of the cup, viewable only to the drinker (plate 15). We see a sword planted upright on a sandy beach and Ajax lying naked and impaled on it. He has fallen on his sword after going mad in anger; his war-trophy slave, Tekmessa, has found him and covers his body with a mantle. Ironically, the sword had been Hektor's, given to Ajax by Hektor himself after a duel (*Iliad* 7.301–12). In accounts of the Trojan War, suicide was extremely unusual (and a unique visual

STANSBURY-O'DONNELL

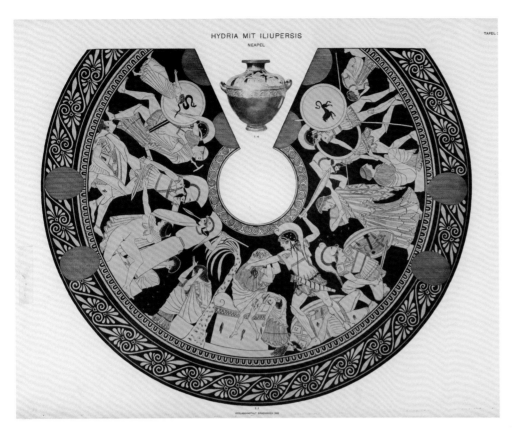

FIGURE 61 Rollout drawing of the shoulder of the water jar (fig. 60). After Fürtwangler and Reichhold 1904, pl. 34. Clockwise from top right: Akamas and Damophon recovering Aithra; Andromache attacking a Greek warrior; Neoptolemos killing Priam; rape of Kassandra; escape of Aeneas carrying Anchises

formula of this story), but, for Ajax, it was the only option left to him for a hero's death.

Five *Ilioupersis* scenes can be seen in an exceptionally vivid and complex picture on a hydria by the Kleophrades Painter, now in Naples (fig. 60).[4] Placed on the shoulder of the vessel, the five scenes are arranged like a panorama (fig. 61) that would be seen by everyone seated in the symposium when the water pitcher was set on the ground, or by a gathering of mourners when the jar was used as a funerary offering, or during a funeral when the vessel was employed, as it was in this case, as a cinerary urn (many Athenian vases found in Italy served this purpose). At the center we see an old man seated on an altar with a boy on his lap. This is Priam, attacked at his household altar by Neoptolemos, the son of Achilles, who has already killed Priam's grandson Astyanax, the son of Hektor. In contrast to the scene on the Boston hydria (see fig. 46), here Priam expresses his

grief by tearing at his shorn head, causing himself to bleed. It is unusual to see a man in such desperation in Greek art (recall his wife Hecuba's pose on the black-figure hydria discussed above), but the gesture and pose convey his extreme grief at the death of his family and fall of his city. Sorrow and despair are also apparent in the next scene to the left, where two women pull out their hair, huddled in the sanctuary of Athena, signified by her cult statue on a base. Clutching the statue is a nude woman with a mantle over her shoulders, being assaulted by a warrior with drawn sword. Even without inscriptions, the visual clues and artistic tradition identify this scene as the rape of Kassandra, daughter of Priam, by Ajax the Lesser (distinct from the Ajax whose suicide we saw earlier). While she pleads with her upturned right hand, his outrage on her will destroy the statue from which she seeks protection. Ajax's action is a double violation, and the

desecration of Athena's sanctuary will bring the goddess's vengeance upon him on his voyage home from Troy. The final scene on the left, near the handle, shows an old man being carried piggyback by a warrior, preceded by a young boy, both looking back on the destruction. None of the figures are named, but other examples of this distinctive composition allow a viewer to recognize the Trojan Aeneas carrying his father, Anchises, away from Troy.

To the right of the central scene, with Priam and Neoptolemos, are more unusual groups. A fully armed Greek warrior crouches on his knees behind his shield as he is attacked, not by a Trojan warrior, one of whom lies dead behind him, but by a Trojan woman wielding a large pestle. Although she is not labeled, the woman is usually identified as Andromache, the wife of Hektor; her name also means "man battler." The reversal of roles here offers a negative view of the Greek

warrior's character. Andromache will be taken from Troy as a slave of Neoptolemos, but the elderly woman behind her, sitting on a block, is being assisted by two Greek warriors. She is Aithra, the mother of Theseus, who was enslaved to Helen and taken to Troy, and is being rescued from the destruction by her Athenian grandsons, Akamas and Damophon. Her recovery provides a pendant to the escape of Aeneas and Anchises at the other end of the panorama.

The date of the vase, circa 475 BCE, is significant in considering this specific narrative, in that the vessel was likely made after the Persian destruction of Athens in 480. As John Boardman once proposed, it is possible to view these scenes through the eyes of a survivor of that real event.[5] The Persians had desecrated the sanctuaries of Athens and killed the few who had not fled the city ahead of the attack, but the Athenian navy had obliterated the Persian navy at the Battle of Salamis after the people had evacuated the city. As the Athenians restored their polis, one might see the recovery of Aithra and the escape of Aeneas, who became the ancestor of Romulus and Remus, and of Julius and Augustus Caesar, as showing that the conduct of a war has consequences.

We end our story with a quieter moment of the Trojan War: Achilles and Ajax playing a game (plates 11–13). The scene survives in more than 150 examples, and as Sheramy Bundrick has pointed out, this is the single most popular episode of the Trojan War saga except for the Judgment of Paris, starting in the workshop of Exekias about 540 BCE and spreading throughout Athens's Kerameikos over the next half century.[6] At its core, the composition shows two warriors focusing on a block and holding their hands above it; Athena is one regular addition to the scene. In rare instances, the figures are named (plate 11), and sometimes even scores are given.[7] It is not certain what game they are playing (or even whether a higher roll is necessarily winning), or if they are perhaps engaged in divination, but the activity attests to the close bond between these two Greek heroes (recall that Ajax would later recover Achilles's body, only to be denied the honor of receiving his armor). There is no surviving literary source that mentions this episode, and it could be that it was an invention of the vase painters in Athens, to show the warriors in one of the many moments when they were not fighting during their ten-year encampment outside Troy.

Pictures on pottery reached a broad and diverse audience in the ancient Mediterranean and convey some of the shared cultural values of the region. As we have seen, in appealing to vase consumers who were often far from the painters' workshops, artists relied on a visual language to engage with their viewers, using a combination of formulas and specific, unusual imagery to depict their narratives and envision the struggle at Troy and its epic cast.

STANSBURY-O'DONNELL

NOTES

1 Eleusis amphora: see fig. 58; Argos krater: Argos Archaeological Museum, C149; Aristonothos krater: Rome, Musei Capitolini, Castellani Collection 172. There is also an early Etruscan white-on-red pithos from 650–625 BCE with this scene: formerly Los Angeles, J. Paul Getty Museum, 96.AE.135.

2 *Iliad* 17.43–122. In the Homeric account, Menelaos and Hektor do not actually come face to face, which has led some scholars to conclude that the scene conveys another version of the narrative; see the references cited by Squire 2018, 5n8.

3 This ballot with pebbles occurs on a cluster of red-figure vessels datable to between 500 and 480 BCE and is without precedent in earlier literary sources. From what survives of a now-lost trilogy, we know that the Greek tragedian Aeschylus portrayed Ajax and Odysseus arguing their cases before their Greek comrades, and this performance may have inspired the painters. But the date of that trilogy remains uncertain, and the ballot episode may already have been in circulation by the end of the sixth century BCE, influencing playwright and vase painter alike (see Williams 1980).

4 The vase, called the Vivenzio Hydria, was found in 1797 in a tomb in Nola, near Naples, where it had been used as a cinerary urn. See Giulierini and Giacco 2019, 369.

5 Boardman 1976, 14–15.

6 Bundrick 2017; see also Mackay 2010, 331–39; Junker 2012, 192–96; Kunze 2022.

7 For instance, in what is the best-known example of the scene, on a black-figure amphora by Exekias of about 530 BCE, Achilles has the inscription "four" coming from his mouth, and Ajax "three" (written retrograde) (Museo Gregoriano Etrusco Vaticano, 344; BAPD 310395).

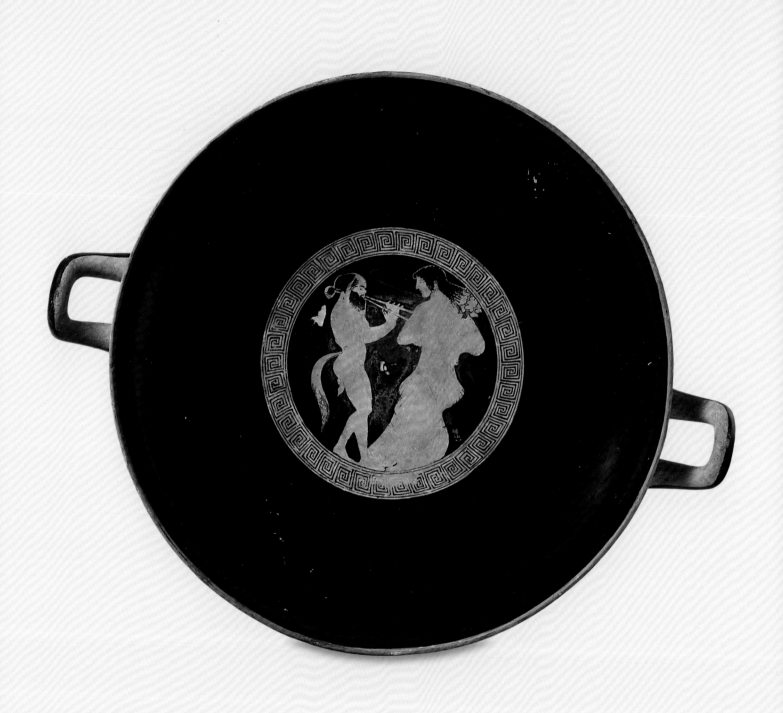

SATYRS

Guy Hedreen

Satyrs (also known as silens) are mythical hybrid creatures composed of the body of a male human and the ears and tail of a horse. Sometimes they also have the hooves, legs, or hairy coat of a horse. Satyrs are ubiquitous subjects on painted vases from East Greece, Etruria, South Italy, and especially Attica, first appearing around 600 BCE, and continuing to appear on vases, gems, jewelry, and even in sculpture well into the Roman period.

Satyrs have almost no presence in early Greek epic poetry. In this respect, they differ from another group of mythical hybrid creatures to whom they are closely related physiologically, the centaurs. Centaurs were protagonists or villains in several significant heroic narratives related in epic poetry. Satyrs play minor roles in three traditional stories about Dionysos, including the return of Hephaistos and the discovery of Ariadne, but there is no reference to those roles in early poetry, and the presence of satyrs in those stories may be the contribution of vase painters, who articulated the idea of satyrs as a *thiasos*, or entourage of the wine god.

In vase painting, satyrs are often highly sexually aroused. They regularly pursue their mythological female counterparts (the nymphs), are almost always rebuffed, and resort to masturbation with surprising frequency. In those ways, satyrs embody forms of male sexuality at odds with proper male society, which valorized self-control. Yet the point of view of the imagery appears to be less condemnatory than amused.

Satyrs were regularly impersonated in ritual masquerades. At Athens, one genre of dramatic performance was defined by a chorus of men dressed as satyrs. The plots of satyr plays, which became part of the theater festival of Dionysos by 500 BCE, were burlesques of traditional narratives, such as the story of Odysseus and Polyphemos (the subject of the only complete satyr play that survives today, Euripides's *Cyclops*). The question of how closely Athenian vase painting followed satyr plays is difficult to answer. An oil jar (plate 16) depicts a satyr holding a conversation with a sphinx. The image corresponds to earlier vase paintings of Oedipus answering the riddle of the Theban sphinx. That myth was also the subject of a lost satyr play by Aeschylus, *Sphinx*. Is the image on the vase a representation of a scene from the Aeschylean play? Or is it a visual spoof of the earlier vase paintings?

As much as any other type of figure in vase painting, the satyr invited vase painters to use free imagination to create new visual ideas about it. Consider the tondo of a drinking cup (opposite): compared to the explicit nudity and eroticism in the scene of men and women on the outside of this vessel, and compared to many other images of satyrs, the image on the inside of the cup—the satyr, concealing his genitalia between his legs, dancing politely with the modestly dressed nymph—is unexpectedly restrained. It is in fact difficult to write a definitive account of the nature of satyrs precisely because vase painters brought such originality to their representation.

OPPOSITE Satyr and nymph, interior of Wine Cup with Symposium Scene. Greek, made in Athens, ca. 480 BCE (see plate 3)

THE ADVENTURES OF WRINKLE FACE

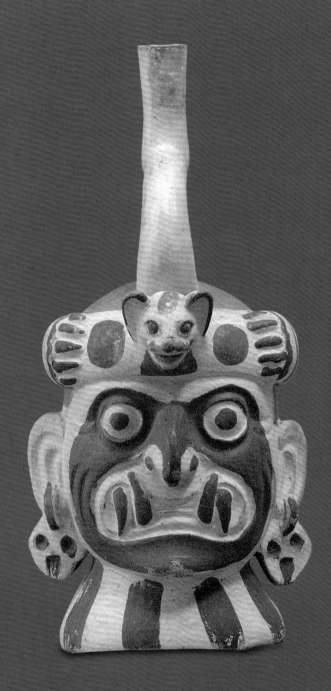

Julio Rucabado Yong

Moche visual art depicted and disseminated stories that, though now considered mythical or fantastic, in their day formed part of the core beliefs that supported the Moche way of seeing and understanding the world. This worldview stemmed from ideologies and religious thought that had preceded the development of Moche culture,[1] but only with the rise of the first states in northern coastal Peru would these beliefs begin to be presented as visual narratives.

These stories' complex plots, like those of many ancient epics, were organized into episodes featuring a variety of figures, from powerful hybrid creatures to human beings (living and dead), animals, plants, and objects. The scenes, filled with action, violence, and sex, were represented on hundreds of ceramic vessels, on temple walls, and in adornments finely crafted in metal, textiles, and wood, among other media. The Moche did not write down these stories, and the chronicles compiled during the colonial period offer no descriptions relating to the narrative cycles seen in Moche art. As a result, interpretation mainly falls to the systematic study of an extensive corpus of images,[2] produced in specific historical and cultural contexts within a multiethnic society and linked to religious and political functions.[3]

A central figure in the Moche tales is a hybrid creature, human in appearance but having certain zoomorphic attributes, mainly feline. The most prominent features of his wrinkle-covered face are sharp fangs and large, round eyes. He usually wears a feline-shaped headdress, which appears to represent an ocelot or an oncilla (fig. 62). From his ears hang serpents' heads. In several representations, he also wears other adornments, such as a large feather or bird's tail on his head and a two-headed serpent coiled around his waist. He is clad in a short

FIGURE 62 (OPPOSITE) Stirrup-Spout Vessel in the Form of the Head of Wrinkle Face. Moche, made in northern Peru, 300–600 CE. Terracotta, H: 27 cm (10 5/8 in.); W: 13 cm (5 1/8 in.); Diam: 16 cm (6 5/16 in.). Berkeley, California, Phoebe A. Hearst Museum of Anthropology, 4-3302

skirt or loincloth, as well as a T-shirt-type garment decorated with a double-step motif (see, for example, fig. 20; plates 18–21). In some episodes, he appears to be wearing other clothes, in particular a shirt covered with small, quadrangular metallic plates (see fig. 50, at far left). These changes of attire, as well as many of the character's gestures and actions, make sense, given the narrative nature of Moche art, and must be interpreted from that perspective, taking into account the conventions of representation in different media.[4]

Although we have a glossary of the Moche language, spoken by some of the groups that inhabited the north coast of Peru about fifteen hundred years ago,[5] we are unsure of the name by which this character was known in his day.[6] Researchers, applying various iconographic analyses, have used an array of names to distinguish him within the broad repertory of figures in Moche imagery: Ai Apaec,[7] Mellizo Terrestre (Terrestrial Twin),[8] Cara Arrugada (Wrinkle Face),[9] Quismique (the Moche word for "elder"),[10] Personaje Antropomorfo de Cinturones de Serpientes (Anthropomorphic Figure with Serpent Belts),[11] or Personaje F (Figure F).[12] Representations of flora, fauna, and other surrounding elements in the different scenes of this character's travel through the Andean landscape offer additional clues to his identity, as does his ability to shape-shift by acquiring the powers of his defeated enemy. Here, for the sake of simplicity, we will call him Wrinkle Face.

Stylistic diversity presents a challenge to identifying figures in Moche art. The images were produced in workshops located in the different valleys or regions in which the Moche political-religious ideology held sway for more than five hundred years. Over time, the number of figures and narrative episodes represented increased, and the imagery changed. Furthermore, between the seventh and ninth centuries CE, autonomous political units to the north of the administrative and ceremonial center at Huacas de Moche assimilated several representational conventions used in the Moche Valley and valleys to the south to depict the narrative cycle of Wrinkle Face. The use of

these images, especially in the Jequetepeque Valley, was directly linked to interregional political dynamics and the interests of local elites.

What follows is a summary, reconstructed from many ancient images, of the narrative cycle of Wrinkle Face, in what we term its southern and northern versions. We will take as our point of departure the disappearance of the Sun, an event that spurs Wrinkle Face to action, as he embarks on a long journey to the underworld to find the celestial body and bring it back to the world above.

A SOUTHERN VERSION OF A MOCHE MYTH

At nightfall, the Sun sets into the ocean and descends to the underworld, where it is trapped by the Owl, the great lord of darkness. Together with the Moon, and with the help of animated objects, the nocturnal bird organizes the capture and sacrifice of human prisoners (plate 17). The Moon, accompanied by the Tule Boat Man, transports the prisoners in reed boats to an island in the ocean, where the sacrifices are performed (see fig. 52). Some of the prisoners' blood is drunk from cups, while the rest is saved in pitchers to be brought back to the shore.

Amid the prevailing chaos, Wrinkle Face and his faithful companion, the anthropomorphic Iguana (see plates 18, 19), along with a little dog, set out on their journey to find the sun. To that end, Wrinkle Face tackles an anthropomorphic serpent that lives in the mountains. Once he has vanquished it and cut off its head (fig. 63), he flies on the back of a large condor down to the mouth of the river, at the edge of the sea. There he meets the Tule Boat Man, whom he fights and defeats in order to take his boat, the nets, and all the other fishing and navigation implements.

Wrinkle Face goes into the sea to hunt or fish, and there he combats various marine creatures, including a crab, a cormorant, a lobster, an octopus, a strombus (sea snail), a sea urchin, a jellyfish (or puffer fish?), another type of fish (armored catfish, bonito, or shark?), and a sea lion (see figs. 50, 64, 65).

FIGURE 63 Rollout drawing of Stirrup-Spout Vessel with Wrinkle Face Fighting an Anthropomorphic Serpent. Moche, made in northern Peru, 300–600 CE. Lima, Museo Nacional de Arqueología, Antropología e Historia del Perú. Drawing by Donna McClelland

FIGURE 64 Rollout drawing of Stirrup-Spout Vessel with Wrinkle Face Fighting Marine Creatures. Moche, made in northern Peru, 500–800 CE. London, British Museum, 1909,1218.120. Drawing by Donna McClelland

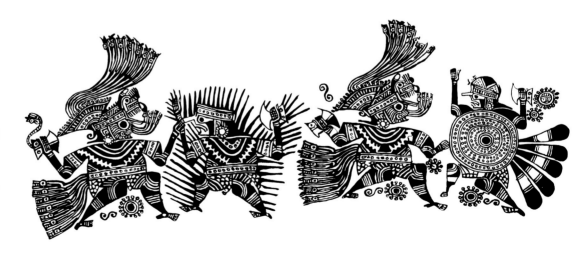

FIGURE 65 Rollout drawing of Stirrup-Spout Vessel with Wrinkle Face Fighting Marine Creatures. Moche, probably made in San José de Moro, La Libertad, Peru, 650–800 CE. Los Angeles, Fowler Museum at UCLA, X86.2880. Drawing by Donna McClelland

FIGURE 66 Rollout drawing of Stirrup-Spout Vessel with the Healing of Wrinkle Face. Moche, made in northern Peru, 500–800 CE. Berlin, Ethnologisches Museum, Staatliche Museen zu Berlin, V A 3188. Drawing by Wilhelm von den Steinen, after Kutscher 1954, pl. 75

FIGURE 67 Rollout drawing of Stirrup-Spout Vessel with Coca Ritual (Wrinkle Face at left). Moche, made in northern Peru, 500–800 CE. Stuttgart, Linden-Museum, Staatliches Museum für Völkerkunde, inv. no. 93 387. Drawing by Donna McClelland

FIGURE 68 Rollout drawing of Stirrup-Spout Vessel with Coca Ritual (Wrinkle Face at far right). Moche, made in northern Peru, 500–800 CE. Lima, Museo Larco, ML004112. Drawing by Donna McClelland

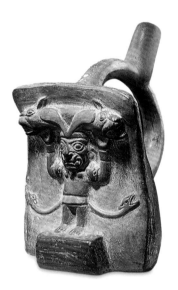

FIGURE 69 Bottle with Wrinkle Face with Serpent Belt beneath a Two-Headed Arch. Moche, made in northern Peru, 300–800 CE. Terracotta, H: 22 cm (8 ⅝ in.); W: 14.2 cm (5 ⁹⁄₁₆ in.); Depth: 17 cm (6 ¹¹⁄₁₆ in.). Museo de Arte de Lima, Donación Memoria Prado, IV-2.0-1086

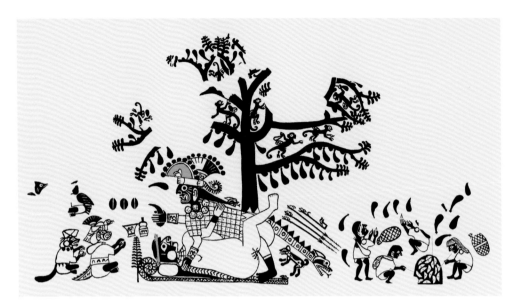

FIGURE 70 Rollout drawing of Ceramic Vessel with Wrinkle Face Copulating with the Moon. Moche, made in northern Peru, 500–800 CE. Private collection. Drawing by Donna McClelland

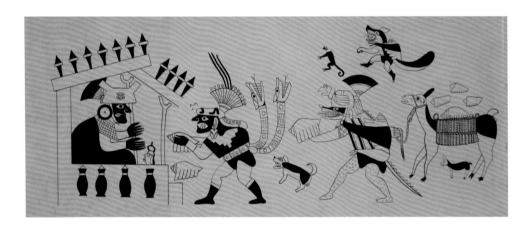

FIGURE 71 Rollout drawing of Stirrup-Spout Vessel with Presentation of Conch Shells Scene. Moche, made in northern Peru, 500–800 CE (see plate 21). Museo Larco Archives

These creatures take on anthropomorphic traits and put up a fight against Wrinkle Face. He wins most of these battles, though he ends up wounded and exhausted before being lifted out of the sea by some birds and Iguana, who carry him off to an island. There he is cared for by a healer owl, who uses bezoar stones and wraps the patient's body in spider silk until it is transformed into a cocoon, resembling a funerary bundle (see figs. 19, 66). Wrinkle Face is now ready to enter the land of the dead.

In his passage through the under-world, Wrinkle Face meets cadaverous men, women, and children who celebrate his arrival by dancing to the rhythm of drums and panpipes. This underground journey, from west to east, ends with his return to the surface as one reborn, lacking the attire and other elements that had previously distinguished him. His exit occurs at a remote spot in the east (perhaps the Amazon rainforest), where the sun usually appears each day. There he comes upon a group of foreign

warriors performing a ritual for the rains to begin. Wrinkle Face is invited to participate, receiving the warriors' garb and paraphernalia, which include sacks to hold coca leaves and small containers for white lime powder, as well as a feline-shaped pendant with metallic plates and a feline headdress (figs. 67, 68). In return, Wrinkle Face gives them trumpets made from the conch shells he obtained after defeating the strombus in his earlier sea crossing. In the middle of this celebration, a large two-headed serpent

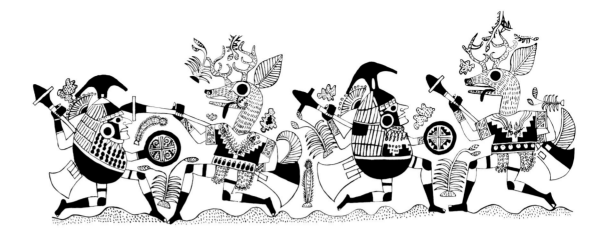

FIGURE 72 Rollout drawing of Stirrup-Spout Vessel with Bean Warriors Fighting Anthropomorphic Deer. Moche, made in northern Peru, 500–800 CE. Peru, Museo de Arqueología, Antropología e Historia de la Universidad de Trujillo. Drawing by Donna McClelland. After Golte 2009, fig. 9.13

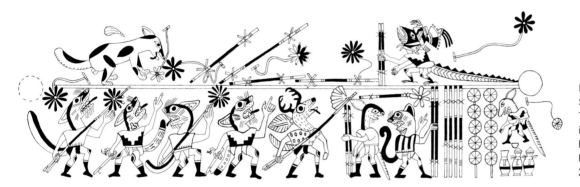

FIGURE 73 Rollout drawing of Stirrup-Spout Vessel with Flower-Throwing Scene. Moche, made in northern Peru, 500–800 CE. Private collection. Drawing by Madeleine Fang. After Golte 2009, fig. 10.3

appears like a rainbow in the sky. Wrinkle Face takes this creature in his hands and ties it around his waist (fig. 69). Thus, he acquires all the attributes by which he is commonly identified.

Wrinkle Face is brought before the Moon, with whom he has sex (fig. 70; see also figs. 18, 37, 38). In almost all the scenes that portray this encounter, on vessels produced with a press-mold technique, the great two-headed serpent (the same one that Wrinkle Face now wears around his waist) appears before the couple. It seems to represent the celestial water, transforming itself into a source of Wrinkle Face's fertilizing power. This union produces the tree *Guarea grandifolia,* whose fruit, *ulluchu,*[13] is harvested by the inhabitants of these distant lands, who are sometimes depicted as monkeys.

Wrinkle Face and his entourage continue their journey to the mountains, where they meet the lord Owl, to whom they present an offering of conch shells (fig. 71). Fights are organized between Wrinkle Face's troops, made up of lima-bean warriors (plate 22), and an army of deer-men under the command of the nocturnal bird (fig. 72).

At the battle's end, the lima beans are the winners. Meanwhile, warriors with feline headdresses help Wrinkle Face hunt deer. From the bodies of the deer they extract bezoar stones and blood, which they smear on flowers that are then thrown into the sky (fig. 73). This act helps ensure the first spring rains for the mountain villages. They offer human sacrifices on the mountaintops, with Wrinkle Face presiding over the event. The blood flows from on high like

the river water that will soon run down to fertilize the lands of the valley (fig. 74).

It is now time for the Sun to return to the surface. The Owl frees him from his subterranean prison and allows him to ascend a staircase woven by spiders. Having resumed his dominant place in the daytime world, the Sun demands the capture of all rebels. The Owl and the Moon are brought before him, and new battles are organized, this time between human warriors, in order to capture prisoners and obtain fresh blood to drink (fig. 75). Wrinkle Face participates in this celebration in honor of the Sun, while the nocturnal creatures deliver the liquid offering in cups (fig. 76).

Finally, the Moon is punished, and her inert body is turned over to vultures who peck at her genitals and pick out her left

FIGURE 74 Stirrup-Spout Bottle with Mountain Sacrifice. Moche, made in northern Peru, 500–800 CE. Terracotta, H: 20 cm (7⅞ in.); W: 13.7 cm (5⅜ in.); Diam: 18 cm (7 1/16 in.). Museo de Arte de Lima, Donación Colección Petrus y Verónica Fernandini, 2007.16.42

FIGURE 75 Flared Bowl with Warriors in Battle and Capturing Prisoners. Moche, made in northern Peru, 500–800 CE. Terracotta and pigment, Diam: 43.8 cm (17¼ in.). The Art Institute of Chicago. Gift of Edward and Betty Harris, 2004.1153

RUCABADO YONG

FIGURE 76 Rollout drawing of Stirrup-Spout Vessel with Battle, Sacrifice, and Blood Presentation Scenes. Moche, made in northern Peru, 500–800 CE. Lima, Museo Nacional de Antropología y Arqueología e Historia, C4382. Drawing by Donna McClelland

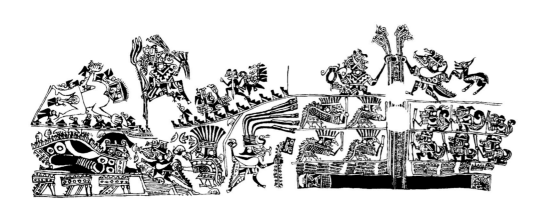

FIGURE 77 Rollout drawing of Stirrup-Spout Vessel with the Burial Theme. Moche, probably made in San José de Moro, La Libertad, Peru, 650–800 CE (see plate 26). Drawing by Donna McClelland

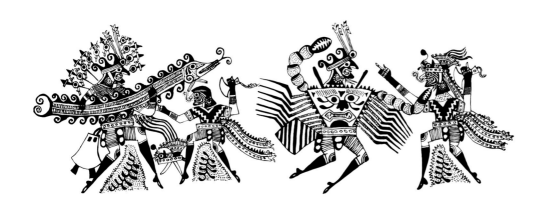

FIGURE 78 Rollout drawing of Stirrup-Spout Vessel with Wrinkle Face Fighting Marine Creatures. Moche, probably made in San José de Moro, La Libertad, Peru, 650–800 CE. Private collection. Drawing by Donna McClelland. In the scene on the left, Wrinkle Face's headdress has fallen at his feet.

eye. Wrinkle Face and Iguana capture these carrion birds, sacrificing one as part of a funerary offering dedicated to the Lady of the Night (see figs. 35, 77; plate 29). Following a long procession accompanied by musicians, the body of the Moon is placed in a coffin and enters the land of the dead; a retinue of hybrid beings and female ancestors observe its descent.

This narrative cycle continues with a time of stability, which, once again, ends as the great night nears and the dry period begins, when the Sun disappears into the horizon and everything starts over again.

All the scenes used to reconstruct this epic come from painted vessels, and from some murals found in ceremonial buildings. Most notable are the polychrome paintings inventoried at Huaca de la Luna, focusing on the mountain and the seafloor creatures.[14] Similar subjects are found at Huaca Cao Viejo, in the Chicama Valley. However, on the main platform at Pañamarca, an important bastion of Moche culture in the Nepeña Valley, the murals' narrative focuses as much on Wrinkle Face's sea battles as on the sacrifice and the presentation of the cup of blood to the Sun.[15]

A NORTHERN VERSION OF A MOCHE MYTH

The images found on hundreds of vessels in the Late Moche fineline style, which come from burials in an elite cemetery at San José de Moro, in the Jequetepeque Valley, present differences in the Wrinkle Face narrative, in both style and content. Depictions of the Moon and sea creatures are more frequently found here, and in several of the marine battle scenes, Wrinkle Face appears to be wounded by his opponents and stripped of his headdress, an act that conveys his defeat (fig. 78). Such an outcome is not recorded in the late narrative from the southern Moche territories, and these details appear to indicate the specific interests of the Moche elites in Jequetepeque. They emphasize the power of creatures belonging to the nocturnal and marine worlds, figures that were embodied by men and women who played an important political and religious role in this region.[16]

This northern version of the tale of Wrinkle Face has no stylistic precedents in local works before the sixth century CE. It has been suggested that the Late Moche fineline style derived from the southern Moche style, perhaps as a result of artisans migrating to the Jequetepeque Valley.[17] The migration north could have occurred during a specific moment of crisis, marked by drastic environmental changes related to the El Niño–Southern Oscillation. While the southern Moche territories were expanding farther south (toward the Santa, Nepeña, and Culebras Valleys), in the Jequetepeque Valley to the north, an independent polity was gaining power. This scenario of competing polities appears to reflect the diversification of the visual narratives and the differing prestige of their protagonists in each region.

FINAL CONSIDERATIONS

In the context of the formation of Moche culture and its political identity in the Moche Valley, Wrinkle Face becomes a model who guides the actions of leaders, warriors, and ritual officiants, presenting shared symbols and values that unite all community members. Similarly, the images of monstrous creatures that live in the mountains or near the sea represent the non-Moche groups residing in those settings, and Wrinkle Face's victories can be seen as a way of showing control or domination over foreign communities that settled in regions neighboring the Moche Valley.

In addition to the close correlation between the figures depicted in the story of Wrinkle Face and certain functions performed by members of the Moche elite,[18] the tales also seem to associate Wrinkle Face's journey with the cycles of nature, especially the sun's transit through the sky and the rivers' flow from mountain pools down to the vast Pacific Ocean. Some episodes appear to refer to the seasonal passage from wet to dry, the beginning and the end of the rainy season, as well as to other events in the lives and subsistence of the northern people. It is therefore possible that several of the rituals connected

to the story of Wrinkle Face took place on important dates of an agricultural calendar.[19]

Like many stories that come from various parts of the ancient world, the adventures of Wrinkle Face transcend their historical context, the Andean precolonial era. In the progression of episodes described above, we can recognize the archetypal outline of what Joseph Campbell famously called the "hero's journey,"[20] a story whose mythical structure alludes to the universal process of individuation, marked by a series of events or milestones in the biological and social life of a person who assumes the protagonist's role. Birth, struggles, obstacles, victories, defeats, sex, death, and regeneration are steps along the great path of life—the one traveled long ago by figures like Odysseus, Perseus, Hunahpu, Xbalanque, and Wrinkle Face.

NOTES

Translated from the Spanish by Rose Vekony.

1 Benson 1972, 15, 27–28; Alva 2015; Campana 2015.

2 Major studies, from different methodological perspectives, include Benson 1972; Donnan 1978; Schuler-Schöming 1979; Schuler-Schöming 1981; Hocquenghem 1987; Castillo 1989; Quilter 1990; Lieske 1992; Golte 1994; Quilter 1997; Makowski 2000; Bourget 2001; Larco Hoyle 2001; Makowski 2003; Giersz, Makowski, and Przadka 2005; Bourget 2006; Bourget 2008; Makowski 2008a; Uceda 2008; Wołoszyn 2008; Golte 2009; Benson 2012; Bock 2012; Wołoszyn 2021.

3 For religious and political functions, see Bawden 1996; Donnan 2010. On the multiethnic society, see Makowski 2008a; Rucabado 2016.

4 Makowski 1994; Quilter 1997.

5 Brüning (1924) 2004; Carrera (1644) 1939.

6 Gayoso Rullier 2014.

7 Larco Hoyle 2001.

8 Hocquenghem 1987; Makowski 1994.

9 Donnan 1978.

10 Golte 1994.

11 Castillo 1989.

12 Lieske 1992; Golte 1994. On the different names for this figure, see further Rucabado 2016, 36; Rucabado Yong 2020, 267; Trever 2022, 24.

13 Bussmann, Sharon, and Brown (2009) recognize the species *ulluchu* as the fruit depicted in the *Guarea grandifolia* tree and in other scenes of Moche art. Today this species is found in woodlands on the tropical plains and in cloud forest areas, regions far from the ancient Moche territory. See also McClelland 2008.

14 Note that these murals also more frequently depict the monstrous creatures that live in the mountains and the sea, sacred and liminal spaces at the beginning and end of a natural cycle marked by the sun's passage and the waters of the river. At Huaca de la Luna, the image of the anthropomorphic serpent predominates at the top of the main platform, while in the Patio of Rhombuses, in front of the temple's facade, a small shrine is dedicated to the sea creature resembling an anthropomorphic fish. A wall close by features a scene of jaguars painted on a blue ground—a direct reference to Wrinkle Face's being turned into a feline and entering the sea. The architecture and murals thus seem to re-create the sacred landscape, transforming the built space into a microcosm that provided an ideal stage for rituals re-creating the narrative cycle of Wrinkle Face.

15 Trever 2017.

16 These include the so-called priestesses of San José de Moro, who appear to have represented the moon. See further Castillo and Holmquist 2000; Castillo and Rengifo 2008; Castillo et al. 2008.

17 Castillo 2001.

18 We see this, for example, in the graves of men that have been excavated in Sipan, in the Lambayeque Valley (Alva and Donnan 1993), and in Ucupe, in the Zaña Valley (Bourget 2014), as well as in the graves of women at Huaca Cao Viejo, in the Chicama Valley (Mujica 2007), and San José de Moro, in the Jequetepeque Valley (Castillo 2001). The elite individuals in these burials wear clothing similar to that of figures on the painted pottery, and hold similar items. See Holmquist, this volume.

19 The suggestion of a relationship between an agricultural calendar and the narratives of Moche art is based on a comparison with the ceremonies and ritual practices of the Incas in Cuzco, described in various colonial sources (Hocquenghem 1987). The narrative sequence reconstructed by Hocquenghem differs from the one proposed in this essay.

20 J. Campbell 1949.

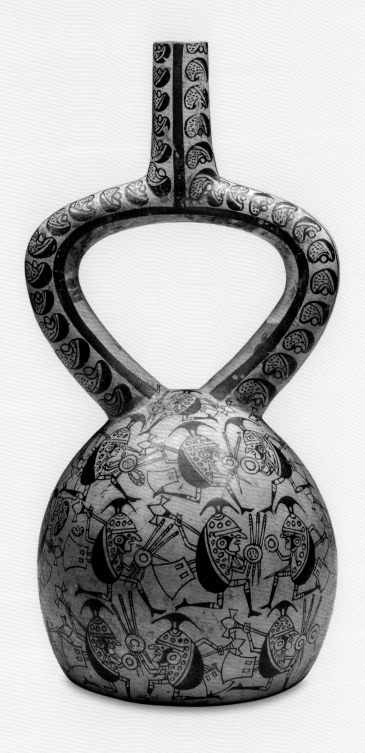

VIOLENT LEGUMES

Joanne Pillsbury

Moche artists frequently depicted hybrid creatures—beings that feature elements of more than one species—in mural painting, on sculpted vessels, and especially on finely painted ceramic bottles. Animals, and even vegetables, are shown in an upright posture, with human limbs in their correct relational positions, allowing them to walk, run, and wield weapons. Inanimate objects are also anthropomorphized: boats, bowls, weaving tools, and warrior regalia sprout arms and legs (plate 27), and restlessly engage in arm-to-arm combat or ritual processions. Such inventive amalgamations, existing outside a mundane, observed reality, were surely seen as uniquely powerful because of their compounded abilities. Among an array of possible uses, these fearsome composite creatures may have been considered protective figures on vessels destined to accompany the dead.

Composite creatures such as fox warriors, boasting the cunning and speed of the dog family, Canidae, in tandem with weaponry devised by humans, are perhaps easy to understand as superhuman beings of enhanced capabilities. Animated vegetables, somewhat less common, are more of a puzzle, particularly in the absence of contemporaneous texts that could aid the construction of meanings. Consideration of the composite's formal and botanical features, however, holds the potential to illuminate possible meanings for imaginative subjects such as bean warriors. On one stirrup-spout bottle (plate 22), pairs of armed legumes face off against each other across the chamber, with additional battle-ready beans behind them. The warriors' bean bodies are painted with designs suggesting the mottling seen on lima beans (*Phaseolus lunatus*), and the faces are rendered at the hilum of the bean, where it would have been attached to the plant's stalk during development. Each warrior is armored, wearing a conical helmet surmounted by a crescent-shaped finial and decorated with circular ear ornaments, and a prominently displayed backflap, a type of body armor suspended from the waist at the back of the wearer. Each bean warrior brandishes a war club in one hand, as if ready to strike, and carries a small, circular shield and darts in the other. Spindly legs, adorned with body paint, propel the beans forward, one knee elevated to indicate swift movement, a sense reaffirmed by the flying backflaps. The artist painted additional, not obviously animated, beans along the vessel's spout, but the idea that this bean-warrior army is an effective fighting force is abundantly clear.

Does the prevalence of beans relate to ideas of agricultural bounty, and, more broadly, abundance? Curiously, lima beans were not widely consumed in Moche times, despite their popularity as a foodstuff in both earlier and later periods. Some scenes depicting ritual specialists with beans suggest that they were used for divination, but more often the legume is shown anthropomorphized and weaponized. Lima beans can be toxic when raw, but they are also generative, and may have been seen as seeds from which warriors multiplied. Other properties, such as the predator-avoidance behavior of the lima bean plant itself, may have been noticed and considered significant. Lima bean plants are able to thwart attacks by herbivorous spider mites by attracting a type of carnivorous mite that is, in fact, the predator of the lima bean's predator. Tiny but mighty, beans may have been visual metaphors for a warrior's cunning and prowess, and a source of enduring, protective power.

OPPOSITE Stirrup-Spout Vessel with Lima Bean Warriors (plate 22)

THE JOURNEY OF THE MAYA MAIZE GOD

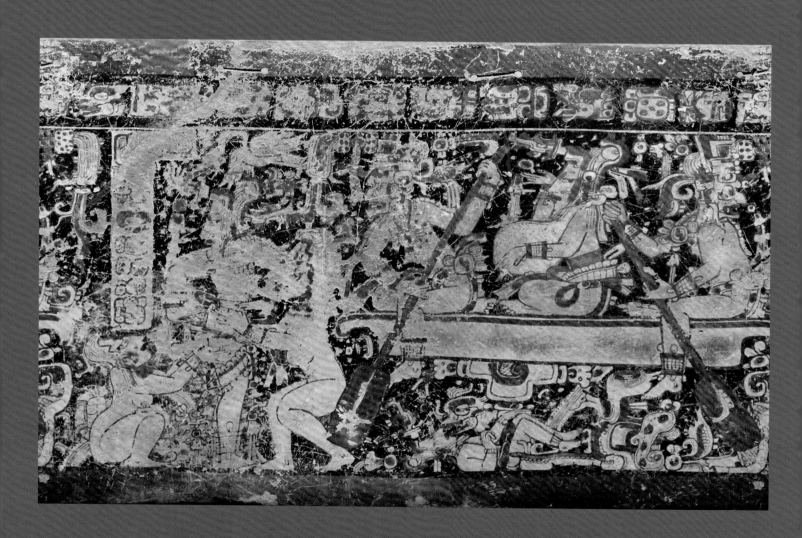

Oswaldo Chinchilla Mazariegos

For its original owners—likely members of the Mutul dynasty of the great city of Tikal, Guatemala—the Vase of the Paddlers was a cherished possession. They treasured it despite three vertical cracks on the vessel's rim, each repaired with string tied through twin perforations joined by a shallow groove across the crack (fig. 79). Their care is understandable; this is the work of a master painter who applied bold red lines on the vessel's light-buff surface, and wash in shades of red that enhanced details and created soft-pink textures. The artist then covered the designs with a resist material before adding black paint, to produce a striking visual contrast between the red-on-buff figures and the dark background.

There was another reason for cherishing the vase: it portrays episodes from an epic tale that explained the origin of sustenance, and, indeed, of all forms of abundance, embodied by the Maize God. Since the Late Preclassic period (300 BCE–250 CE), Maya artists depicted variants of this quest story in sculptures, mural paintings, and ceramic vessels and other portable objects. The Vase of the Paddlers stands out among this wealth of imagery not just for its beauty but also because it portrays three episodes of the saga, rather than just a single scene. The juxtaposition of episodes offers clues for reconstructing the progression of an epic that today remains only partially understood.[1]

Like students of ancient Greek and Moche art, Maya scholars struggle to understand the correspondences between narratives and images. The problem—also confronted by ancient Greek and Moche artists—was how to represent narratives with multiple participants and elaborate arguments in the restricted space provided by the walls of ceramic vessels. The purpose of the artists was not to explain stories that were familiar to their patrons. Instead, they illustrated key episodes, leaving out intervening

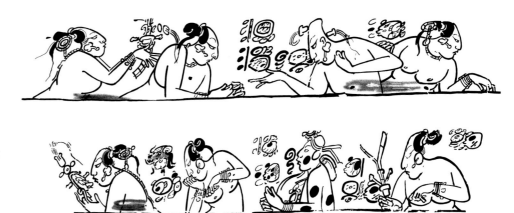

FIGURE 80 Rollout drawing of a Maya vessel, 650–800 CE (K1202). The upper and lower sections of this rollout drawing are part of a continuous frieze. Drawing by Oswaldo Chinchilla Mazariegos

and ancillary incidents. Solutions ranged from isolating discrete events to juxtaposing contiguous episodes to merging scenes into complex images that evoked several episodes at once. Some artists cramped numerous characters together, while others focused on the key participants, eliminating most others. Religious prescriptions, artistic preferences, and patrons' whims dictated the outcome, in addition to constraints imposed by the shapes and sizes of the vessels.

The designs of the Vase of the Paddlers are continuous, except for a partial division created by a hieroglyphic column with text that named a lord of the Mutul dynasty, now damaged and mostly unreadable. The rim text is a standard dedicatory phrase that identifies this as a vessel for drinking cacao and names its owner. Neither text offers clues about the vessel's mythical imagery. Three scenes can be discerned, each centered on a portrait of the Maize God—a youth with a very tall head, facing backward, crowned by an unruly crest of hair resembling a corncob. In the first scene, the Maize God is dancing in water, while two naked women reach out to his waist and buttocks. Water symbols around the squatting woman, a fish nibbling at her feet, and a waterfowl hovering above the dancing god denote the aquatic location of the scene. The god's contorted stance with the face and the feet turned in opposite directions shows that he is dancing.

In the next scene, the Maize God is sitting on a canoe. The vessel is manned by two

deities, associated with day and night, or with dawn and dusk, respectively, known as "the Paddlers" because of their role in the Maize God's myths.[2] The third scene happens below the canoe—that is, underwater. Here, the Maize God takes the form of a baby resting on the wide-open maw of a serpent. A fish nibbles at his nose, eager to consume the infant's nutritious flesh.

How do these scenes relate to one another, and how do they relate to ancient Maya myths about the origin of maize? The repetition of the key character (the Maize God) in the three scenes suggests temporal progression—a resource that was also employed by ancient Greek and Moche ceramic artists. Presumably, the three scenes correspond to episodes of a mythical narrative, but there is no textual source that transmits such a narrative as understood by the Classic-period Maya (250–850 CE). The extensive corpus of Mayan hieroglyphic inscriptions contains only brief references to the mythical deeds of the Maize God. Maya ceramic painters rarely wrote more than short captions naming the participants in scenes and offering terse remarks on their actions. Concise captions on a handful of vessels help us to understand the saga, but the interpretation rests mainly on the analysis of pictorial imagery.

The Maize God's encounter with women was a favorite subject for ancient Maya artists. In an early example, from the Late Preclassic mural paintings of San Bartolo, Guatemala,

FIGURE 79 Rollout photograph of Cylinder Vessel with the Death and Rebirth of the Maize God (Vase of the Paddlers). Maya, probably made in Tikal, Peten, Guatemala, 672–830 CE (see plate 32)

FIGURE 81 Drawing of incised designs on bone artifact from Burial 116, Tikal, Guatemala, ca. 734 CE. Drawing by Miss Annemarie Seuffert, Penn Museum, University of Pennsylvania

FIGURE 82 Drawing of incised designs on bone artifact from Burial 116, Tikal, Guatemala, ca. 734 CE. Drawing by Miss Annemarie Seuffert, Penn Museum, University of Pennsylvania

the Maize God adopts the dancing posture that he has on the Vase of the Paddlers, while approached by four young women.[3] This and other, similar representations are often interpreted as corresponding to the god's exaltation after his rebirth. But the opposite is indicated by the hieroglyphic captions on Late Classic–period (550–850 CE) codex-style vessels that show the Maize God encircled by as many as six naked or barely dressed women, waist-deep in water (fig. 80). The glyphs on these vessels contain the metaphorical expressions "enters the water" and "enters the road," which refer to the death of the Maize God. Some of the women have darkened eyes and other mortuary markers, suggesting deathly connotations.[4] In very explicit ways, artists linked the god's encounter with these women to his death.

This reading is coherent with the second scene of the Vase of the Paddlers. While riding the canoe, the Maize God touches his forehead with a wrist, extending the hand forward. The gesture conveys grief and sadness—the Maize God is weeping for his own death. He assumes the same position in parallel scenes that were delicately incised on bone artifacts recovered from the tomb of the great king Jasaw Chan K'awiil of Tikal (fig. 81). Here, four animal companions—iguana, monkey, parrot, and a furry mammal, perhaps a raccoon—share his grief, crying with wide-open mouths. The hieroglyphic captions of the Tikal bones date the event to the day 6 Ahk'ab 16 Saksihoom— a mythical date in the primordial past—and employ an undeciphered verb that, in war statements about the fall of cities or kings,

refers to ruin, fall, or sinking. Here, it refers to the Maize God, likening his mortuary journey to disastrous warfare.[5]

The painter of the Vase of the Paddlers omitted the animal passengers that received so much attention from the carver of the Tikal bones. Neither artist featured all the characters of the story. Both neglected a pair of young gods who joined the Maize God's saga: God S and God CH. This pair share the Maize God's youthful appearance, but unlike him, they are not handsome. One is covered with black pustules (see fig. 80), the other with jaguar-pelt patches, instead of the signs of shine that usually mark the Maize God's skin. They witness the Maize God's dealings with women but remain aloof and receive no attention from the ladies (see fig. 80). They do not dance or play instruments; their behavior

CHINCHILLA MAZARIEGOS

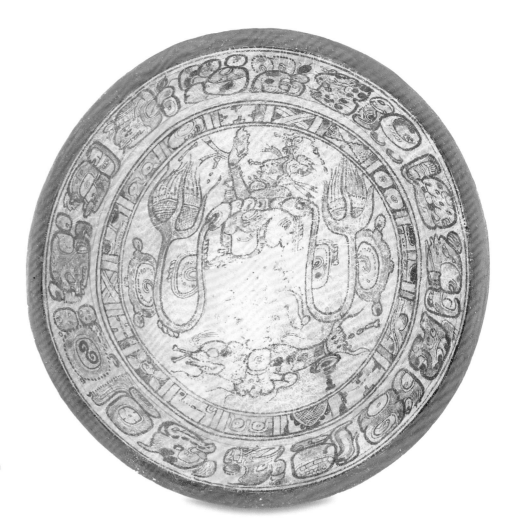

FIGURE 83 Codex-Style Plate Depicting the Watery Underworld. Maya, made in northern Peten, Guatemala, or southern Campeche, Mexico, 650–800 CE. Terracotta, Diam: 39.4 cm (15½ in.). Los Angeles County Museum of Art, Anonymous gift, 2010.115.5

is the opposite of the Maize God's playfulness. Yet they go along, sometimes walking while the Maize God rides the canoe. There is no indication that they died; this is a mortuary journey only for the Maize God. Sometimes Gods S and CH are together; sometimes only God S appears; and sometimes, as on the Vase of the Paddlers, neither of them appears. But their presence on other vessels shows that they partook in the entire journey.[6]

Further variations involve the canoe. On one of the Tikal bones, the vessel is animated with the shape of Yax Chit Juun Witz' Naah Kan, an aquatic serpent deity (fig. 82). This being has definite links with the Maize God, particularly in representations where both are marked as lunar deities.[7] The canoe is also animated in the Late Preclassic mural paintings of San Bartolo, where the Maize God

traverses dark waters in the quatrefoil-shaped body of a turtle (see fig. 4). Here, the turtle seems to double as a medium of transportation and as the destination of the journey, perhaps conflating two distinct narrative episodes. Inside the turtle, the Maize God is dancing and playing a drum, watched by two enthroned gods. One of them is an early form of Yax Chit Juun Witz' Naah Kan, the aquatic serpent deity. The other is Chahk, the powerful god of thunderstorms.[8]

The aim and destination of the Maize God's journey are elusive. Some vessels suggest an encounter with rain deities, probably a confrontation, though the rain gods also seem to act as helpers who enable the Maize God to come out of the turtle carapace. On one vessel, Gods S and CH watch, as if floating in water, while two rain gods wield an ax and a

handstone to crack the turtle carapace open, letting the Maize God out. Other representations accord Gods S and CH a more active role, pulling the Maize God's arms as if helping him to come out, or pouring water in the cleft.[9] Such scenes likely correspond to the Maize God's rebirth after death, like a maize plant sprouting from the earth.

The turtle is missing from the Vase of the Paddlers. Instead, the vase shows the Maize God as a baby in the maw of a serpent. Another variation shows the Maize God as a baby or a young man, emerging from the submerged rhizome of a water lily (fig. 83; plate 41). Are these episodes part of the same narrative, or do they correspond to versions in which the Maize God was reborn from a serpent or a water lily instead of a cleft turtle? All versions may have coexisted, but

FIGURE 84 Detail from a Maya cylinder vase, 750–770 CE. God CH holds up a plate that cradles the Maize God as a baby. God S carries a large bundle, while resting on an aquatic serpent. Museum of Fine Arts, Boston, 1988.1175. Drawing by Oswaldo Chinchilla Mazariegos

the question must be left unanswered, since the Vase of the Paddlers remains the lone artwork that ties one version of the Maize God's rebirth with the earlier episodes of his encounter with women, his death, and his journey across water.

Did the Maize God bring something back from his journey? He is often thought to have brought maize or other precious items, but, more precisely, it appears that he or his companion God S carried them all along the way. God S carries a bag or bundle during the Maize God's encounter with women, that is, at the time of his death (see fig. 80). A swollen bag is tied to the Maize God's neck on the Vase of the Paddlers. One vessel shows him carrying a bag of grains and a gourd, while emerging from the cleft turtle.[10] In another version of the Maize God's rebirth, the baby is resting on a plate held by God CH, while God S carries the outsize bundle (fig. 84). The hieroglyphic term *ikatz* marks this as a bundle and a container of precious items such as jade jewels. Conceivably, the grains of maize or other cultigens that the gods carried were as precious as jade.[11]

The narratives that were known to the painter of the Vase of the Paddlers and other Classic Maya artists are lost, except for fragments preserved in concise and often ambiguous hieroglyphic captions. But the myths of the origin of maize persisted in narratives and performances that were transmitted from parents to children in many parts of Mesoamerica. Some were recorded by Indigenous and Spanish writers in the early colonial period, and many persist today, especially in the Gulf Coast of Mexico. There are many variations, but the stories are generally about a young and mischievous boy, born from a prodigious union, who was rejected by his own relatives, beings of a former era who did not want people to prosper by planting the staple maize. In many versions, his grandmother or his mother killed him by drowning, but he came back to life—rescued by a turtle in some narratives—and overcame his opponents using trickery and magic. Then he undertook a journey to find the remains of his father, who had been killed in a remote place. To get there he passed a body of

water on the back of a turtle. A musician, he annoyed his enemies by playing instruments and dancing. In some versions, his foes were the storm gods. He defeated them and tamed them to produce the right amount of rain for him. He recovered his father's remains and tried to bring him back to life but failed; the father remained irrevocably dead.[12]

These stories share important details with the mythical episodes depicted in ancient Maya art: the god's young age, his death and rebirth in water, his journey across water, often aided by turtles, his love of music and dancing, his encounters with rain gods. But the narrative sequences differ, and the correspondences are partial. There are no ancient Maya representations of the Maize God's conflicts with his grandmother, a very widespread theme in colonial and modern narratives. The possibility that ancient Maya artists did not know this crucial component of the tale is doubtful; more likely, it was not a preferred pictorial subject for ceramic vessels.

Conversely, no colonial or modern narrative features the Maize God's encounter with young women. Such encounters appear, though, in narratives about the origin of the sun and the moon. The young god who is destined to become the moon enjoyed playing with women in streams or pools, a diversion that led to his defeat. This brings him close to the Maize God of the ancient Maya, whose affairs with women in water caused his demise. In agreement with his womanizing, the Maya Maize God had a lunar aspect. He is sometimes marked with a lunar sign and is also one of the deities named in associated with lunation cycles in Maya inscriptions.[13] By contrast, the companion of his journey God S shared the qualities of Mesoamerican solar gods: stark, stern, and sickly.

The overlapping origins of the sun, the moon, and maize were the gist of Mesoamerican creation myths.[14] The conflation is patent in the sixteenth-century text known as the *Popol Vuh*. This beautifully written narrative from the K'iche' Maya of highland Guatemala is sometimes taken as a model for interpreting ancient Maya representations, though a close examination reveals that correspondences between the gods of

CHINCHILLA MAZARIEGOS

ancient Maya art and the characters of the *Popol Vuh* are no closer than are the correspondences between the ancient tale of the Maize God and modern maize narratives from the Gulf Coast. Rather than a paradigm, the *Popol Vuh* offers an especially rich source for comparison with ancient Maya myths and modern versions of Mesoamerican mythology. The heroes of the *Popol Vuh*, Hunahpu and Xbalanque, are solar and lunar gods: they immolate themselves, and their ultimate destiny is to rise as luminaries. They also share the qualities of maize gods: they undertake a long journey to avenge their father, they die and come back to life, and their ashes are comparable to ground maize flour.

Many interpreters see Hun Hunahpu, the murdered father of Hunahpu and Xbalanque, as a counterpart of the Classic Maya Maize God. But, in parallel with narratives from the Gulf Coast and with modern Ch'orti' Maya myths, the destiny of Hun Hunahpu in the *Popol Vuh* is to remain irrevocably dead, despite his sons' attempt to bring him back to life.[15] This is a far cry from Classic Maya images of the Maize God coming back to life in full vigor from a cleft turtle, or as a tender baby in the maw of a serpent, as on the Vase of the Paddlers.

Maize—personified in a mischievous and magically gifted youth—triumphs over his opponents, to become the staple food for people. How he vanquished his own relatives, undertook a long journey to tame the wild gods of rain and thunder, and overcame death is the gist of modern maize narratives, which also delve into how he instituted the dances and rituals that people would perform for him. But he is not uniformly beneficent. Like a capricious child, he can withhold his benefits; to deliver them, he needs to be nurtured and indulged. Similar meanings are likely present in the fragments of the saga that have reached us in ancient Maya art and Mayan inscriptions. Rowing through primordial waters to his death, the Maize God embodies people's fear of losing the staple food; reborn as a baby or a vigorous youth, he holds the promise of abundance for those who remember him and celebrate his quest.

NOTES

1 The present discussion is based on Chinchilla Mazariegos 2017, 185–223. Other sources on the Maize God myths and iconography include Taube 1985; Braakhuis 1990; Quenon and Le Fort 1997; Taube 2009.

2 On the Paddler Gods, see Mathews 2001; Velásquez García 2010.

3 Saturno, Taube, and Stuart 2005.

4 Stuart 1998, 388.

5 Trik 1963; Schele and Miller 1986, 270. For readings of the "star war" verb, see Markianos-Daniolos 2021.

6 On Gods S and CH, see Taube 1992, 60–63, 115–19; Chinchilla Mazariegos 2017, 159–83; Chinchilla Mazariegos 2020; Chinchilla Mazariegos 2021.

7 On Yax Chit Juun Witz' Naah Kan, see Ishihara, Taube, and Awe 2006; Robertson 2011; Chinchilla Mazariegos 2022b.

8 Taube et al. 2010.

9 The vessel with rain gods cracking the turtle carapace is known from photographs by Nicholas Hellmuth in the Maya Ceramic Archive, Pre-Columbian Collection, Dumbarton Oaks Research Library and Collection, Washington, DC, LC.cb2.471. A vessel in the Museo de América, Madrid (1991/11/09), shows Gods S and CH pulling the arms of the Maize God as he emerges from a cleft turtle (Kerr ca. 2000, K4681).

10 Museum of Fine Arts, Boston, 1988.1178; Kerr ca. 2000, K0731.

11 Stuart 2006a.

12 Narratives of the origin of maize from the Gulf Coast can be found in, among other sources, Foster 1945; Elson 1947; Ichon 1973; González Cruz and Anguiano 1984; Münch Galindo 1992; Oropeza Escobar 2007.

13 On the Maize God's lunar aspect, see Chinchilla Mazariegos 2017, 202–7; Chinchilla Mazariegos 2022b.

14 Carlsen and Prechtel 1991; Tedlock 1996, 225–26.

15 On Ch'orti' myths, see Fought 1989; Hull 2009.

WAYOB AS SYMBOLS OF COLLECTIVE IDENTITY AND POWER

Iyaxel Cojti Ren

In the territory of the Maya, as in other parts of Meso-america, collective identity and the power of social groups can be represented through *wayob* (sing. *way*), beings who have the power to shift shapes. In Classic Maya, the word *way* means "to sleep," but it has been understood as a "co-essence,"[1] or a companion spirit of individuals or social groups. A cylinder vessel from the Ik'a' site of Motul de San José in Peten, Guatemala (opposite, top), depicts a group of *wayob* with their limbs flexed, indicating that they are dancing to music. One of them, named K'uh Til Hix (Sacred Tapir-Feline), plays a maraca and a long flute. Each appears with a hieroglyphic caption giving the *way*'s personal name and revealing the *way*'s power—for example, Tahn Bijil Chamiiy (Crossroad Death/Disease), K'ahk' (Fire), and Jatz'oom Akan (Striking Groan).[2] *Wayob* display particular attributes, including disembodied eyeballs and the *ahk'ab* (night, darkness) sign on their bodies, which link them with the underworld and the night. On Maya vessels, the most common *way* is the jaguar,[3] but other animals can be found. On a codex-style drinking vessel (opposite, bottom) are three *wayob*, named Amal (Toad), K'in Tahnal B'olay (Sun-Chested Predatory Creature), and Chijil Chan (Deer-Serpent), from whose jaws emerges the Deer God. The last two are connected with the emblem glyph, K'uhul Kaan Ajaw (Holy Snake Lord), used in Calakmul in the seventh and eighth centuries CE. Indeed, all the *wayob* on these two vessels are connected with emblem glyphs, and this has generated debate about whether the figures represent specific historical individuals, lineages, or polities.[4] An emblem glyph is a place-name and a title held by rulers and noblewomen who shared a place of origin and the ancestors who lived there. It is the most important identity marker of a social group.[5] Information from Indigenous texts and oral traditions of Mesoamerica after the Spanish invasion shows that shape-shifters can be linked not only to individuals but also to social groups and places, so they can also be markers of collective identity.

In the Maya highlands of Guatemala today, some terms used to identify these beings are *charakotel* or *q'isoma*, in Tz'utujil, and *win* or *nawal*, in K'iche'. The term *nawal* is a Nahua word that derives from *nawa*, "transform," plus *l*, the nominalized passive, to get "what has been transformed."[6] In oral tradition, shape-shifters are characterized as ritual specialists,[7] nocturnal, practitioners of anthropophagy,[8] and knowledgeable about how to communicate with local deities.[9] A person learns to shape-shift principally from family members or from individuals with whom they have a close relationship. Therefore, it is believed that there are families who can transform into specific animal shapes,[10] or that all members of a community are *nawal* people.[11]

In sixteenth-century CE documents written in K'iche', these shape-shifters are called *Aj pus Aj nawal*, or "enchanted person," and the power they hold *pus-nawal*, or "miraculous magic-spirit essence." *Pus-nawal* was an attribute of powerful rulers like Q'ukumatz (r. 1400–1425 CE), who could transform himself into multiple shapes, including a snake, a jaguar, an eagle, and a pool of blood.[12] His warriors appear as *nawal* people, implying that members of a group could share the power to transform. Warriors commonly transform themselves into jaguars, eagles, comets, and phantom fireballs.[13] Places could also have *nawal*. The *nawal* of a place is known as the owner or guardian of that location. For example, the confederation Nima' K'iche' identified the *sochoch* (rattlesnake) and *q'anti'* (viper) as the *nawal* of their settlement called Chi Ismachi' (1400–1524 CE).[14] In other parts of Mesoamerica, the interactions between the *nawal* of places can help to explain interethnic or sociopolitical relationships between towns.[15] The presence of multiple *wayob* connected with place-names on the Late Classic vessels illustrated here could represent the acknowledgment of multiple collective identities whose power could be expressed by the characteristics of their *wayob*.

Rollout photograph of Cylinder Vessel with *Wayob* Figures. Maya, probably made in Motul de San José, Peten, Guatemala, ca. 755 CE (see plate 38)

Rollout photograph of Cylinder Vessel depicting Otherworldly Toad, Jaguar, and Serpent. Maya, made in southern Campeche, Mexico, or northern Peten, Guatemala, 650–800 CE (see plate 37)

NOTES

1 Houston and Stuart 1989.

2 Just 2012, 128–30.

3 Stone and Zender 2011, 195.

4 Grube and Nahm 1994, 686.

5 Biro 2016.

6 L. Campbell 1983, 84.

7 González Pérez 2013, 33.

8 Moreno Zaragoza 2013, 56.

9 Martínez González 2011, 263, 367.

10 Martínez González 2011, 293.

11 González Pérez 2013, 39.

12 Sam Colop 2008, 198.

13 Christenson 2022, 108.

14 Recinos 2001, 44–45.

15 González Pérez 2013, 41, 49.

PLATES

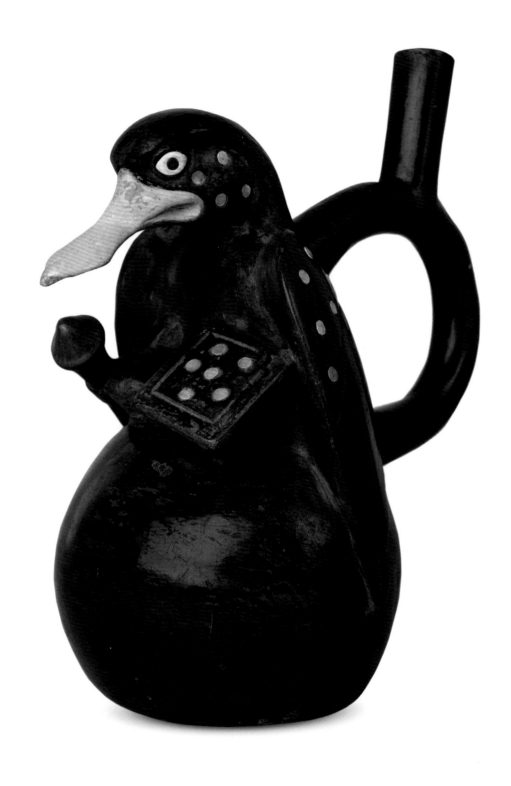

PLATE 1
Stirrup-Spout Vessel in the Shape of a Warrior Duck
Moche, made in Huacas de Moche, La Libertad, Peru, 500–650 CE

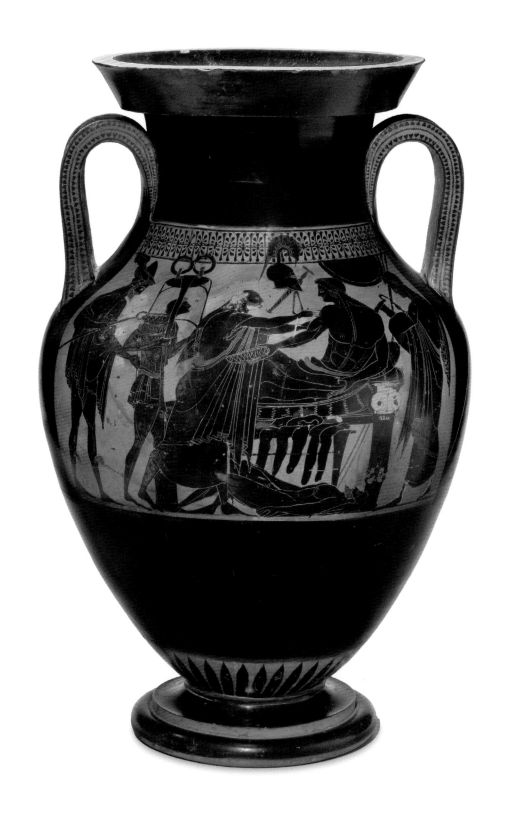

PLATE 2
Storage Jar with the Ransom of Hektor
Greek, made in Athens, ca. 520–510 BCE

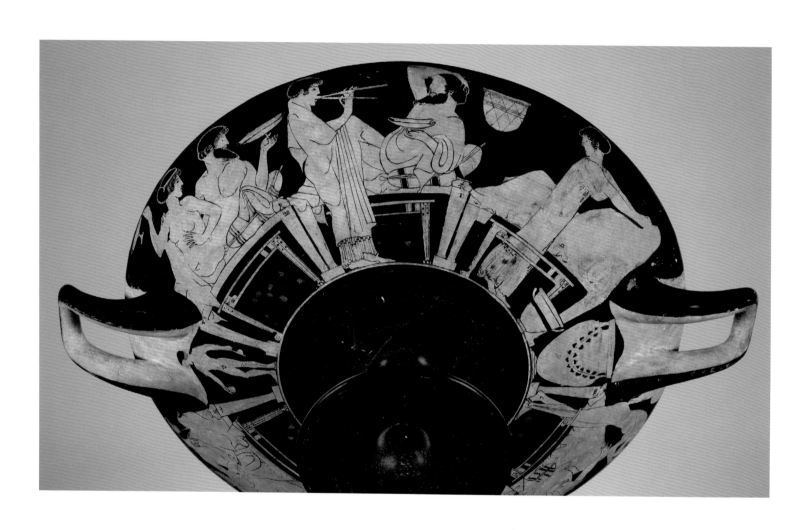

PLATE 3
Wine Cup with Symposium Scene
Greek, made in Athens, ca. 480 BCE

PLATE 4
Cylinder Vessel with Palace Scene
Maya, probably made in Peten, Guatemala, 750–790 CE

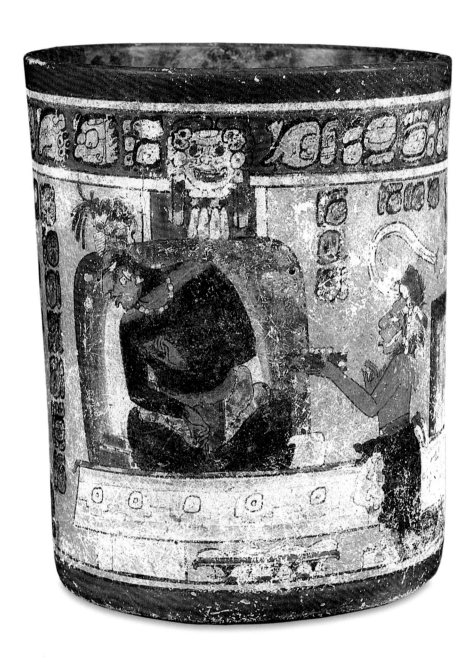

PLATE 5
Cylinder Vessel with Palace Scene

Maya, probably made in Motul de San José, Peten, Guatemala, ca. 650–750 CE

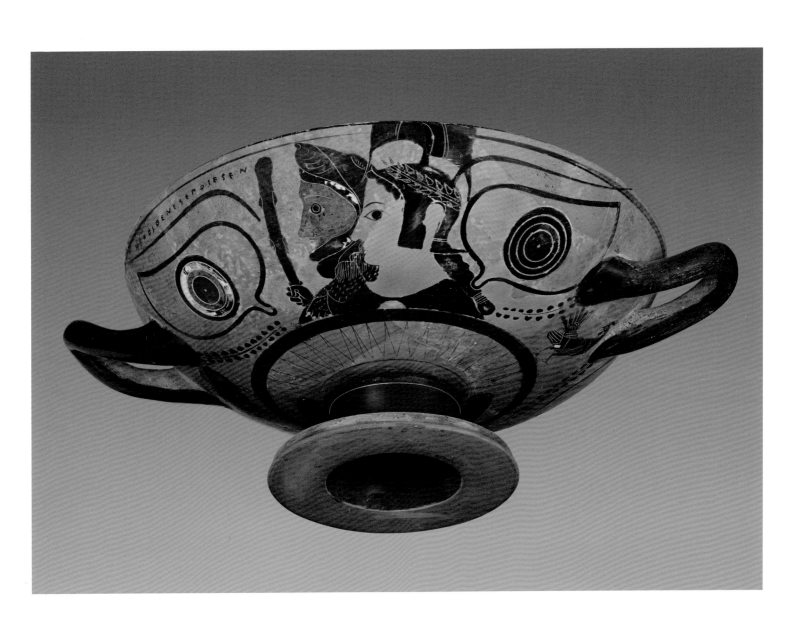

PLATE 6
Wine Cup with Herakles and Athena
Greek, made in Athens, ca. 530 BCE

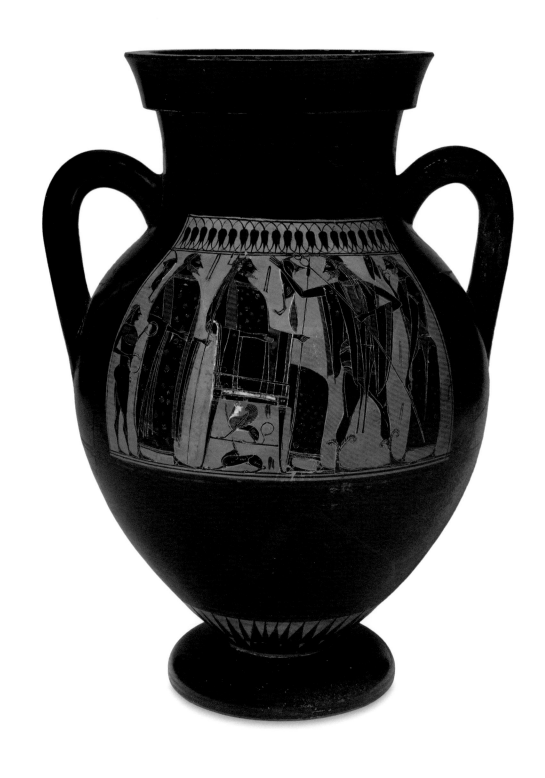

PLATE 7
Storage Jar with Gods and Attendants
Greek, made in Athens, 540–530 BCE

PLATE 8
Mixing Bowl with Theseus and Poseidon
Greek, made in Athens, 480–470 BCE

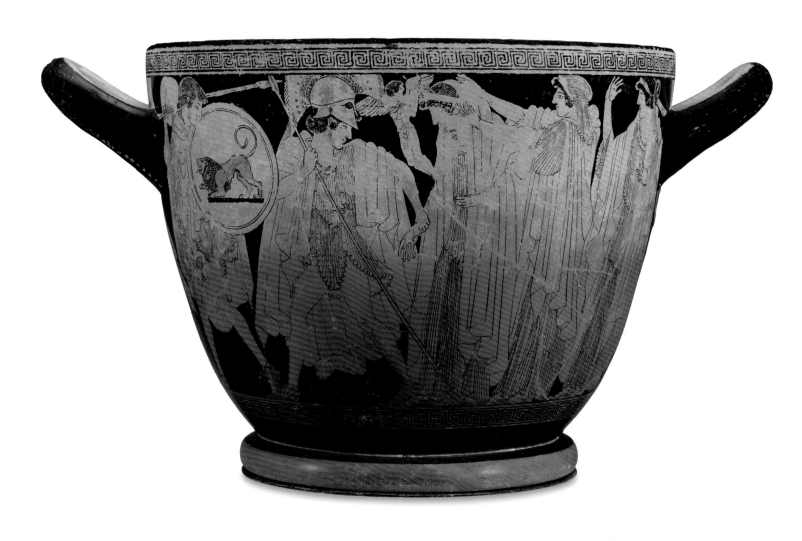

PLATE 9
Drinking Vessel with the Departure and Recovery of Helen
Greek, made in Athens, ca. 490 BCE

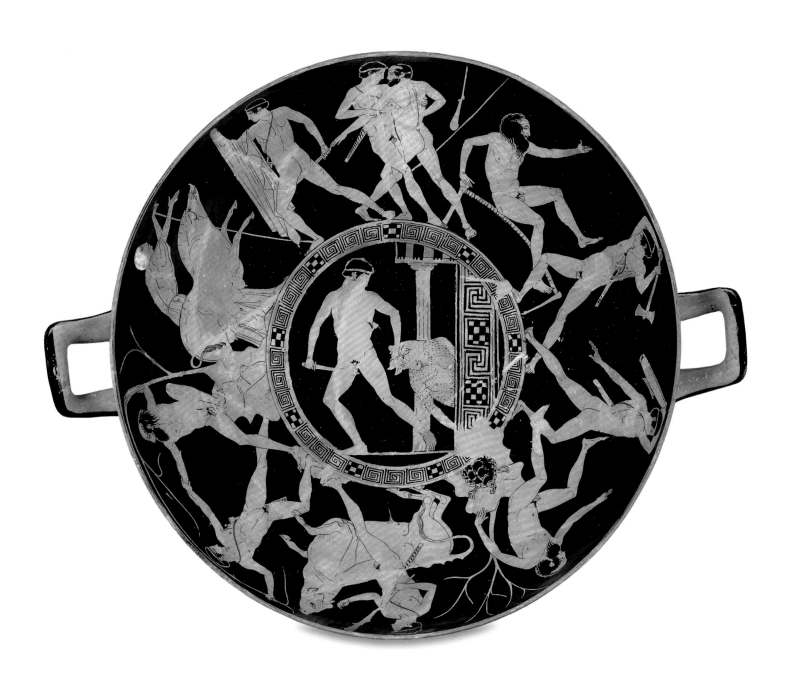

PLATE 10
Drinking Cup with the Deeds of Theseus
Greek, made in Athens, 440–430 BCE

PLATE 11
Mixing Bowl with Achilles, Ajax, and Athena
Greek, made in Athens, ca. 520–510 BCE

PLATE 12
Storage Jar with Achilles, Ajax, and Athena
Greek, made in Athens, ca. 510 BCE

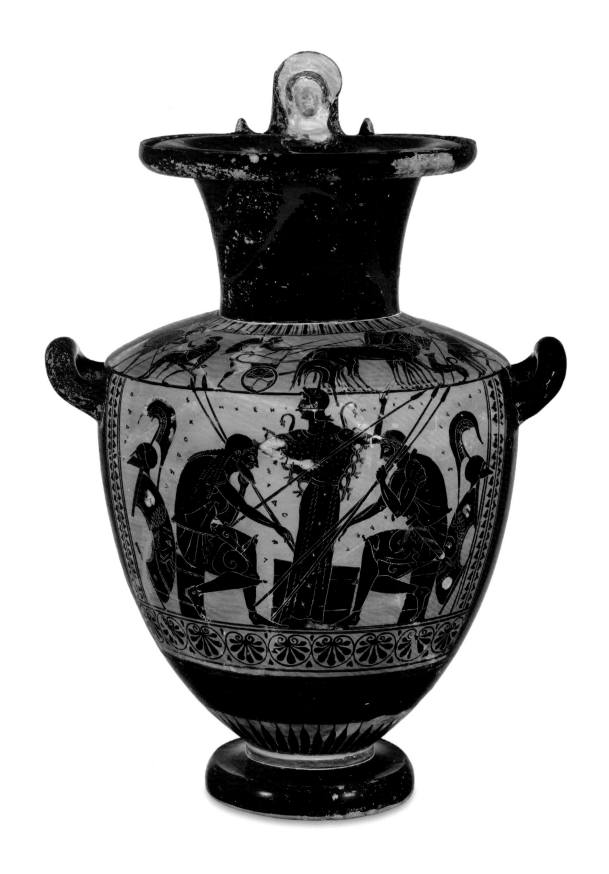

PLATE 13
Water Jar with Achilles, Ajax, and Athena
Greek, made in Athens, ca. 510 BCE

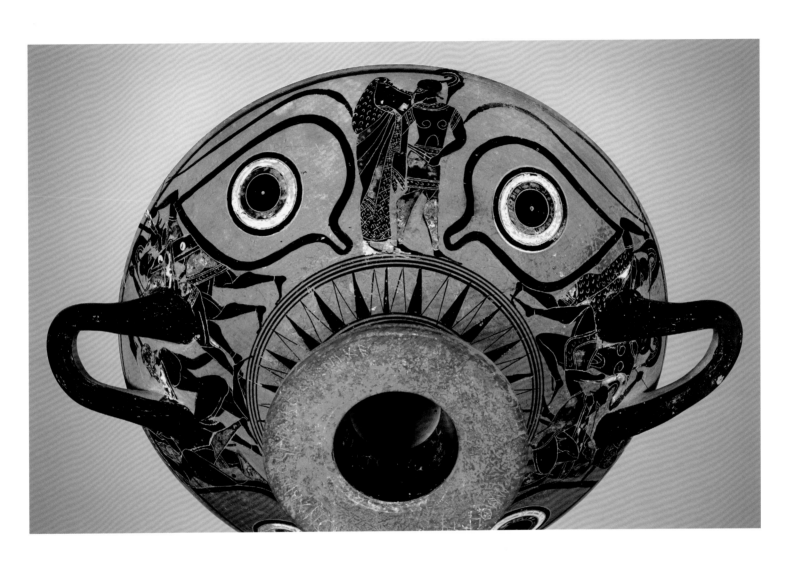

PLATE 14
Wine Cup with Menelaos and Helen and Battle Scenes
Greek, made in Athens, 540–530 BCE

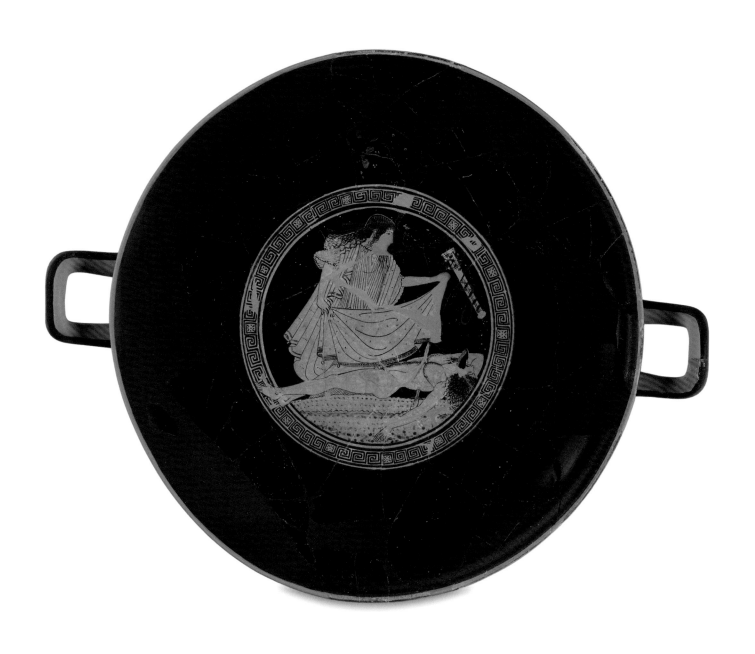

PLATE 15
Wine Cup with the Suicide of Ajax
Greek, made in Athens, 490–480 BCE

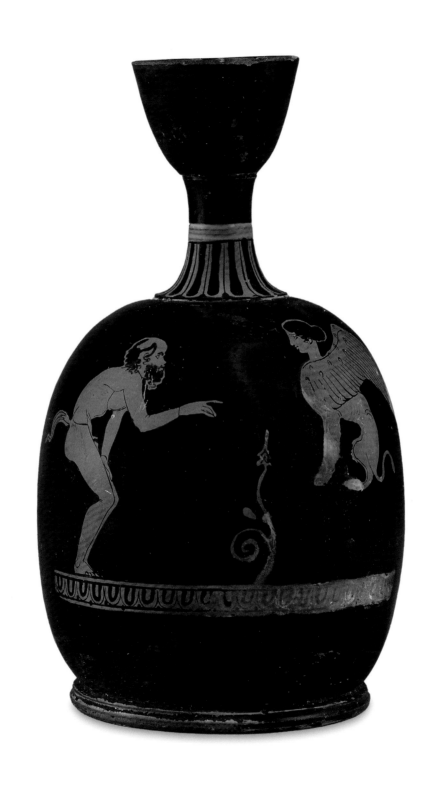

PLATE 16
Oil Jar with Satyr and Sphinx
Greek, made in Athens, 425–420 BCE

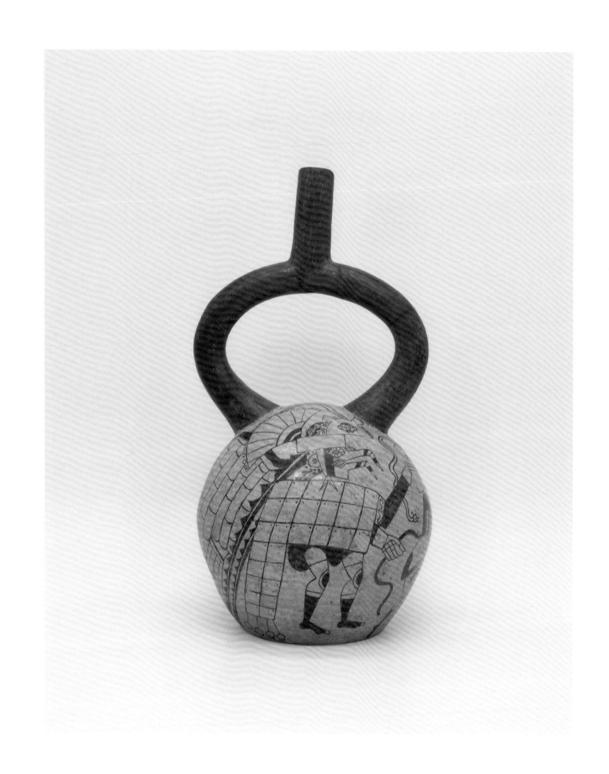

PLATE 17
Stirrup-Spout Vessel with Divinity and Captive
Moche, made in northern Peru, 500–700 CE

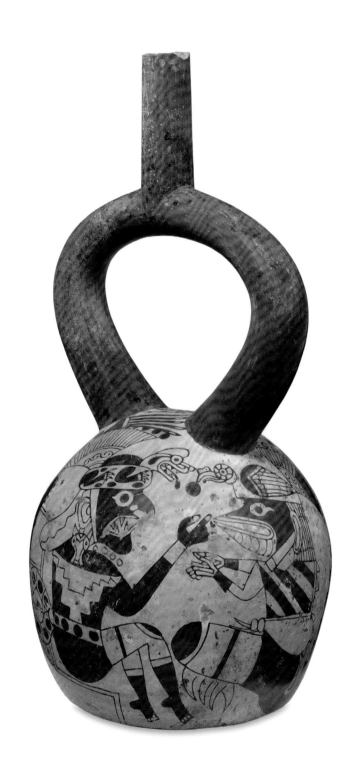

PLATE 18
Stirrup-Spout Vessel with Wrinkle Face and Iguana
Moche, made in northern Peru, 500–800 CE

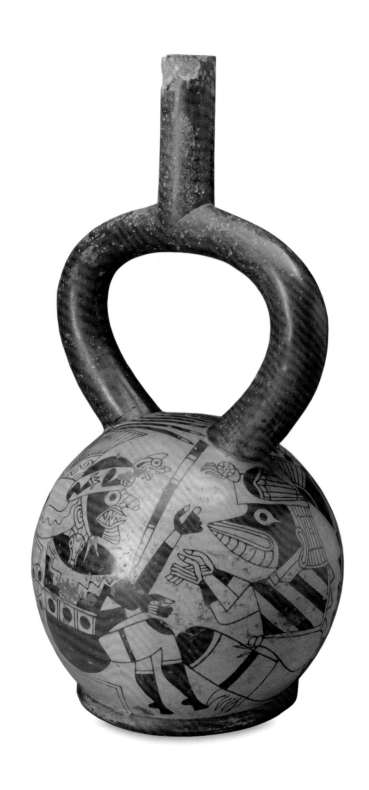

PLATE 19
Stirrup-Spout Vessel with Wrinkle Face and Iguana
Moche, made in northern Peru, 500–800 CE

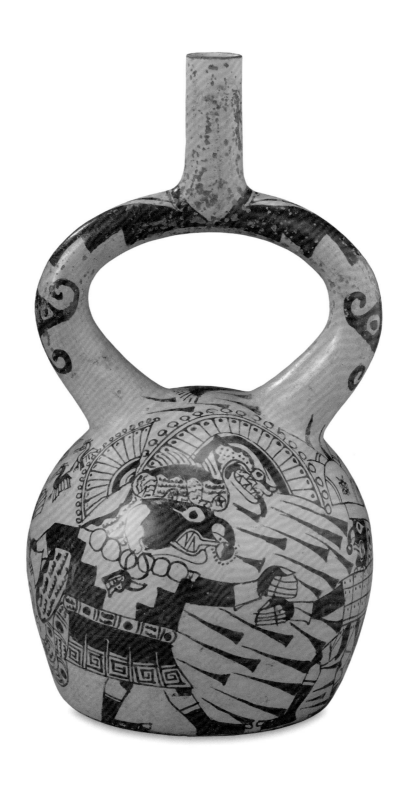

PLATE 20
Stirrup-Spout Vessel with Wrinkle Face Fighting Anthropomorphized Creatures
Moche, made in northern Peru, 500–800 CE

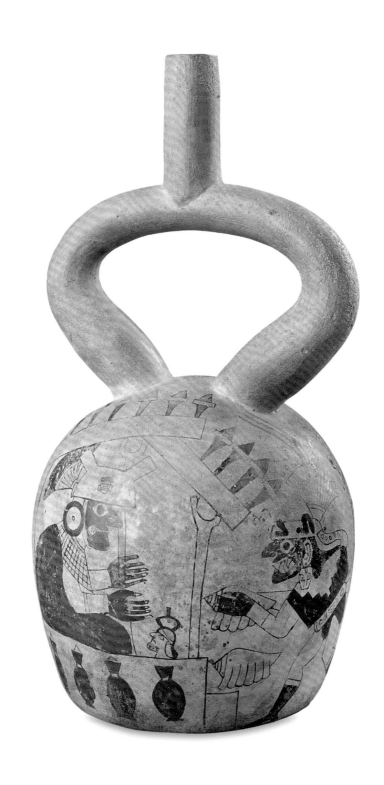

PLATE 21
Stirrup-Spout Vessel with Presentation of Conch Shells Scene
Moche, made in northern Peru, 500–800 CE

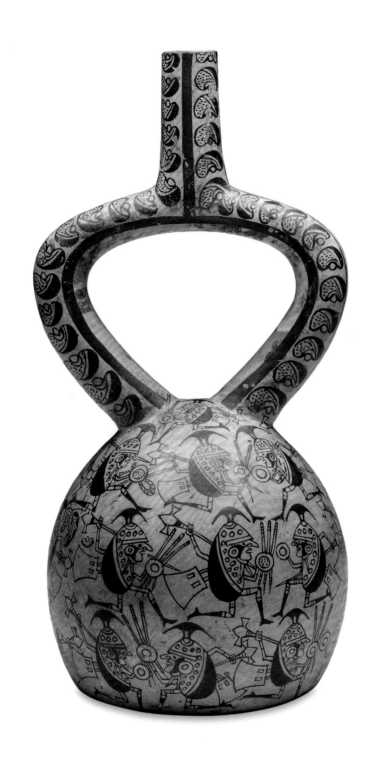

PLATE 22
Stirrup-Spout Vessel with Lima Bean Warriors
Moche, made in northern Peru, 650–800 CE

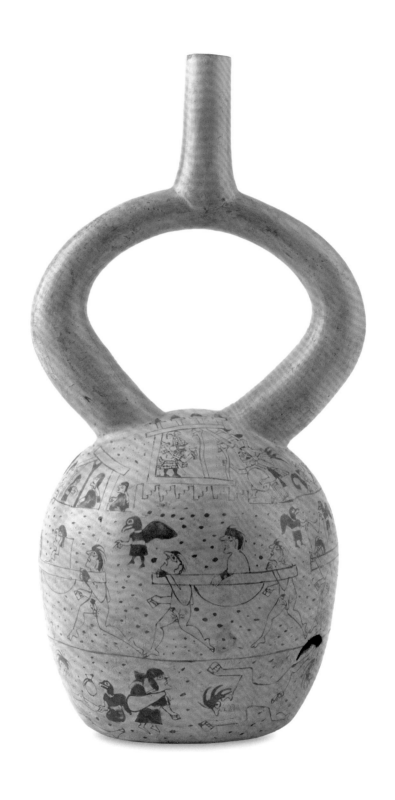

PLATE 23
Stirrup-Spout Vessel with Sacrifice and Presentation Scenes
Moche, made in northern Peru, 650–800 CE

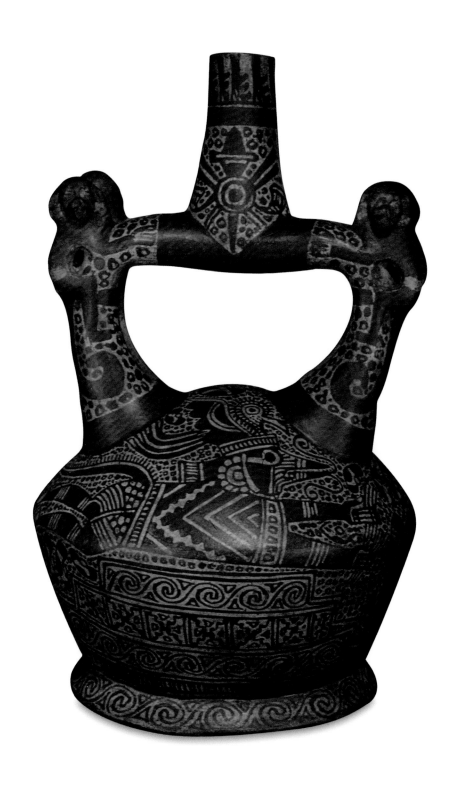

PLATE 24
Stirrup-Spout Vessel with Iguana and Wrinkle Face
Moche, probably made in San José de Moro, La Libertad, Peru, 650–800 CE

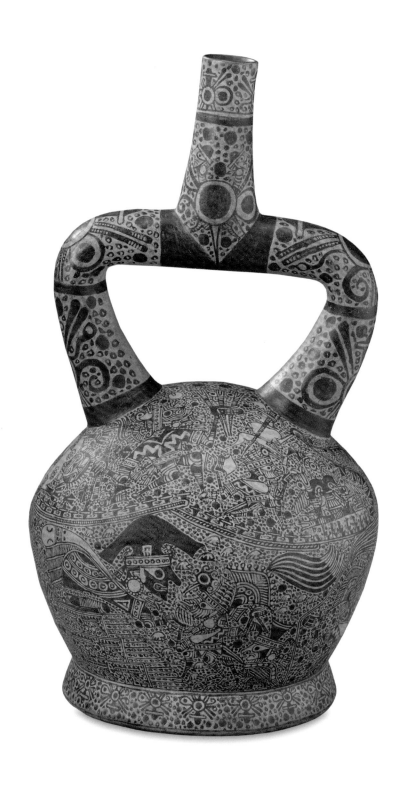

PLATE 25
Stirrup-Spout Vessel with the Burial Theme
Moche, probably made in San José de Moro, La Libertad, Peru, 650–800 CE

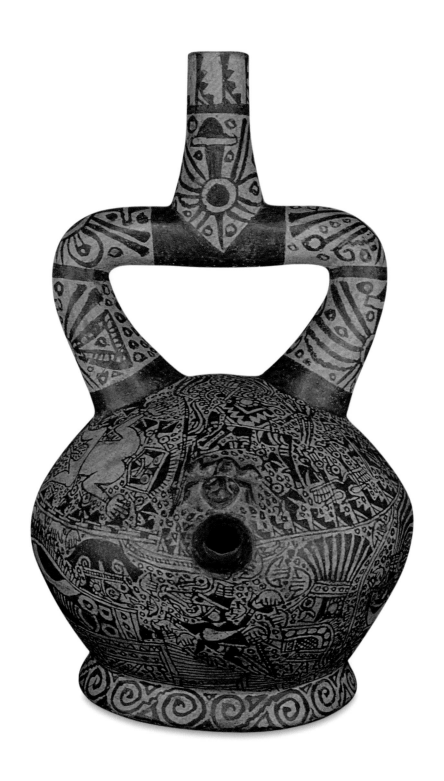

PLATE 26
Stirrup-Spout Vessel with the Burial Theme
Moche, probably made in San José de Moro, La Libertad, Peru, 650–800 CE

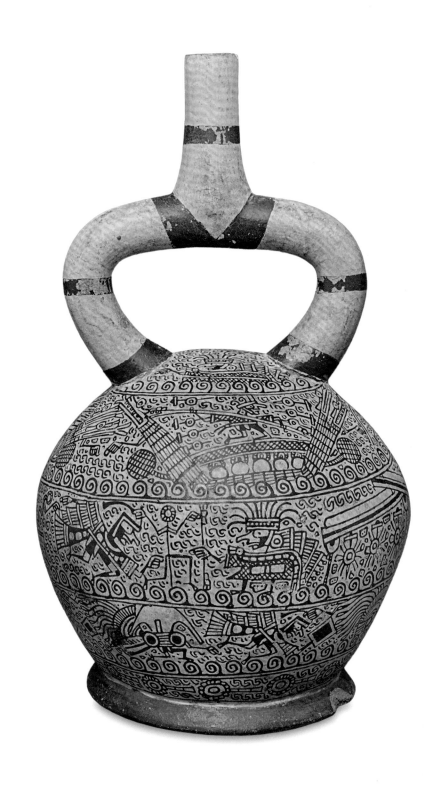

PLATE 27
Stirrup-Spout Vessel with Combat, Boats, and a Presentation Scene
Moche, probably made in San José de Moro, La Libertad, Peru, 650–800 CE

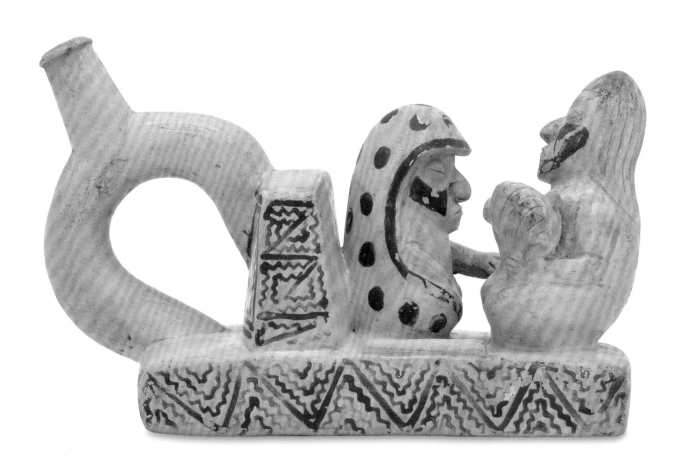

PLATE 28
Stirrup-Spout Vessel with Curer, Baby, and Mother
Moche, made in El Brujo, La Libertad, Peru, 300–450 CE

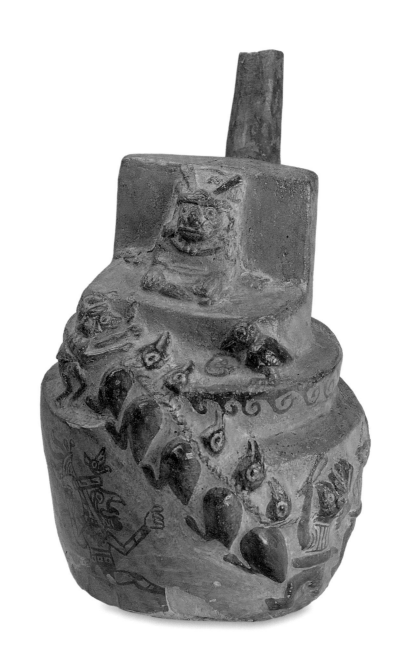

PLATE 29
Stirrup-Spout Vessel with Sacrifice of Vultures
Moche, made in northern Peru, 500–800 CE

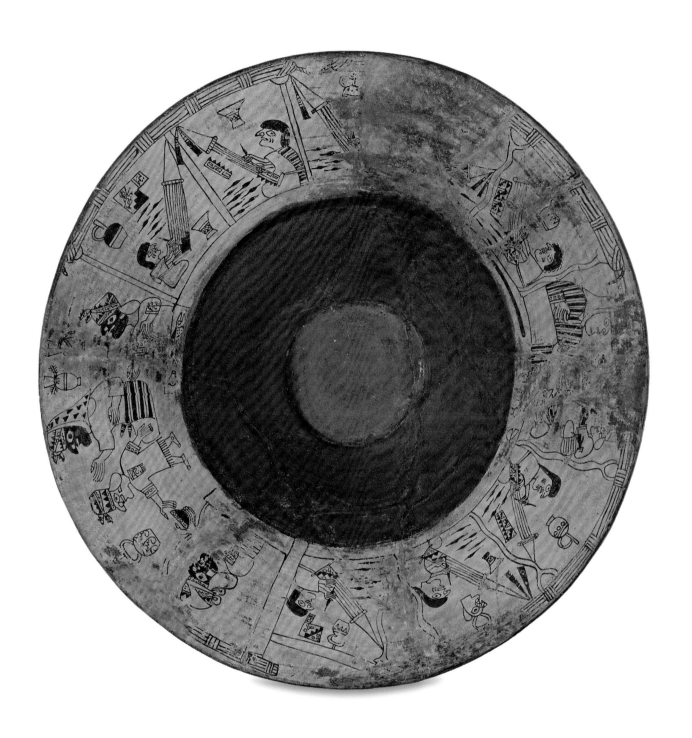

PLATE 30
Flared Bowl with Weavers
Moche, made in northern Peru, 500–800 CE

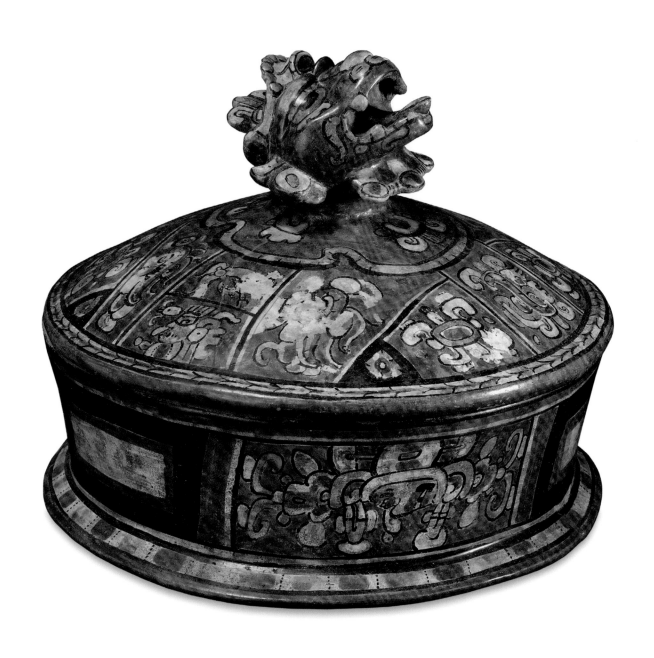

PLATE 31
Lidded Bowl with Handle in the Form of a Howler Monkey
Maya, made in El Zotz, Peten, Guatemala, 250–400 CE

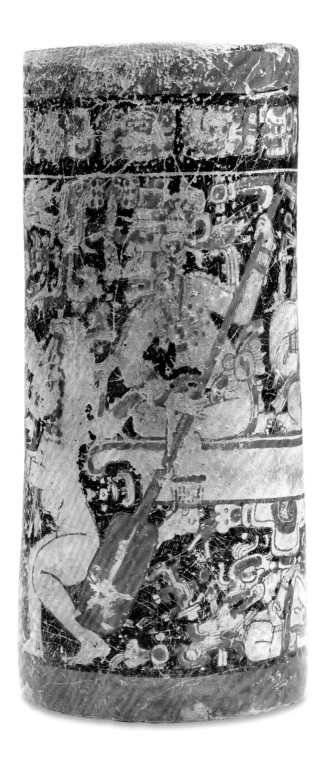

PLATE 32
Cylinder Vessel with the Death and Rebirth of the Maize God (Vase of the Paddlers)
Maya, probably made in Tikal, Peten, Guatemala, 672–830 CE

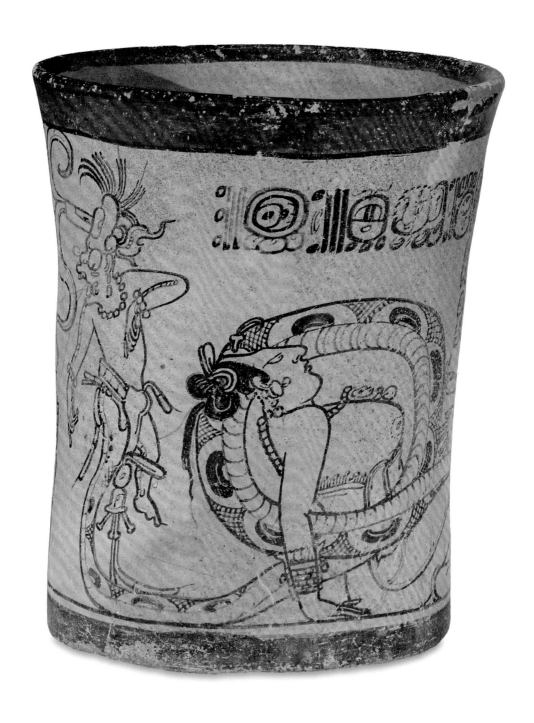

PLATE 33
Cylinder Vessel with Supernatural Birth Scene
Maya, made in southern Campeche, Mexico, or northern Peten, Guatemala, 650–800 CE

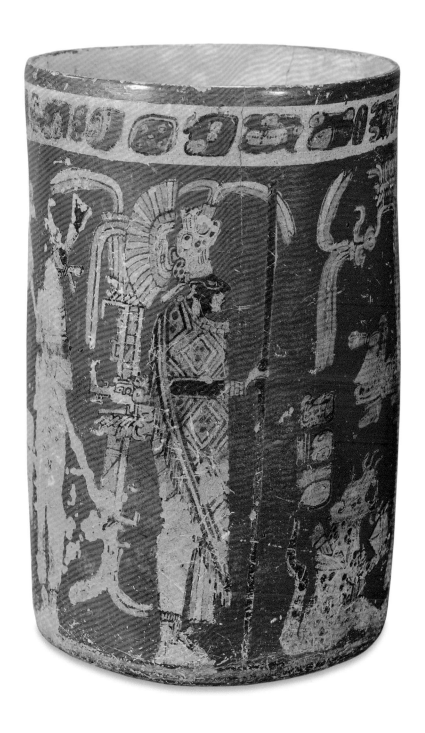

PLATE 34
Cylinder Vessel with Presentation Scene (Vase of the Initial Series)
Maya, probably made in El Zotz, Peten, Guatemala, 600–700 CE

PLATE 35
Cylinder Vessel with Maize God Dancers and Companion
Maya, made in Peten, Guatemala, 650–750 CE

PLATE 36
Cylinder Vessel with the Rebirth of the Maize God
Maya, probably made in southern Campeche, Mexico, or northern Peten, Guatemala, 650–800 CE

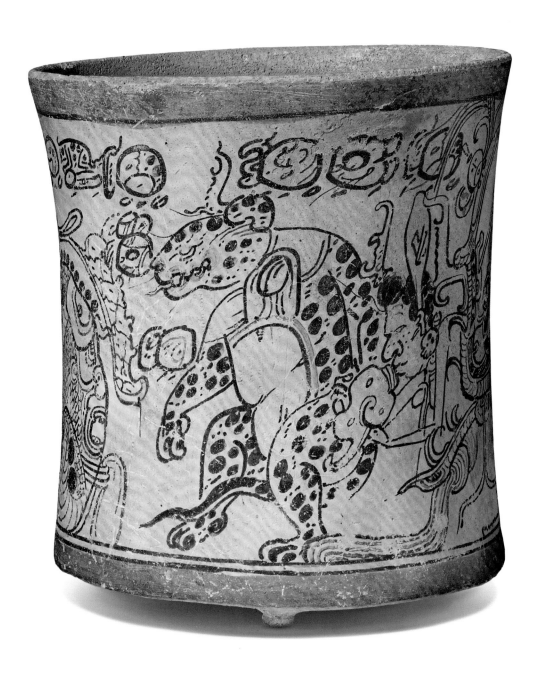

PLATE 37
Cylinder Vessel depicting Otherworldly Toad, Jaguar, and Serpent

Maya, made in southern Campeche, Mexico, or northern Peten, Guatemala, 650–800 CE

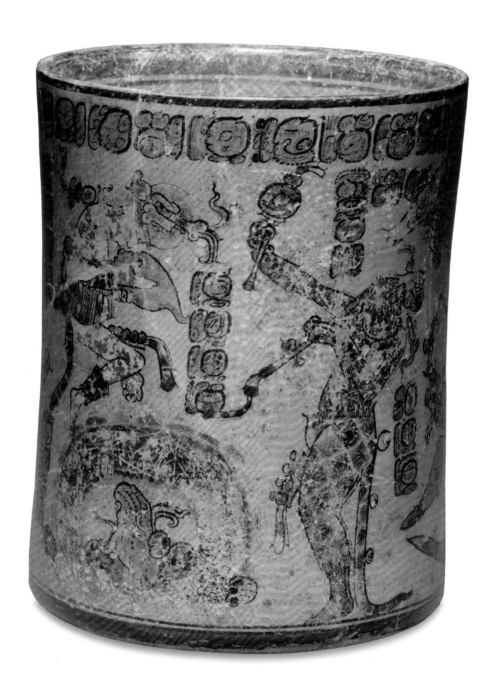

PLATE 38
Cylinder Vessel with *Way* Figures
Maya, probably made in Motul de San José, Peten, Guatemala, ca. 755 CE

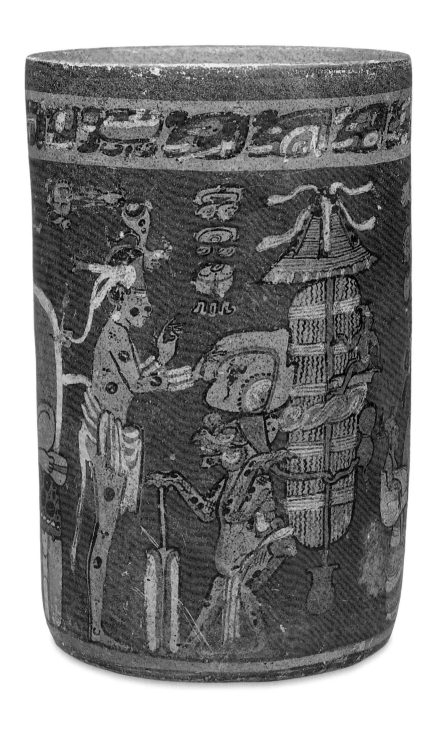

PLATE 39
Cylinder Vessel with the Maize God and other Supernaturals
Maya, probably made in El Zotz, Peten, Guatemala, 600–700 CE

PLATE 40
Plate with Maize God Dancer
Maya, made in Peten, Guatemala, 600–700 CE

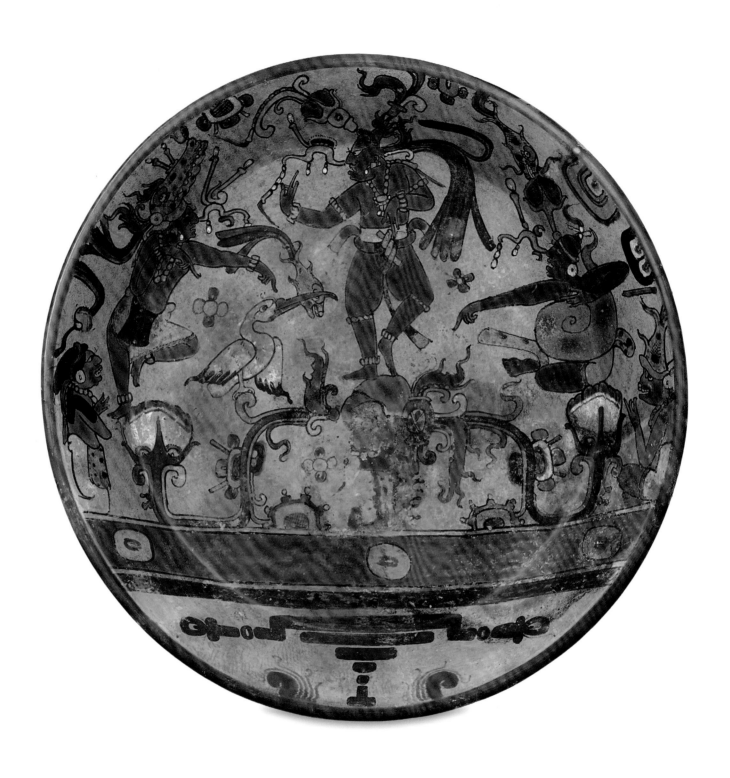

PLATE 41
Plate with the Rebirth of the Maize God
Maya, probably made in Peten, Guatemala, 600–800 CE

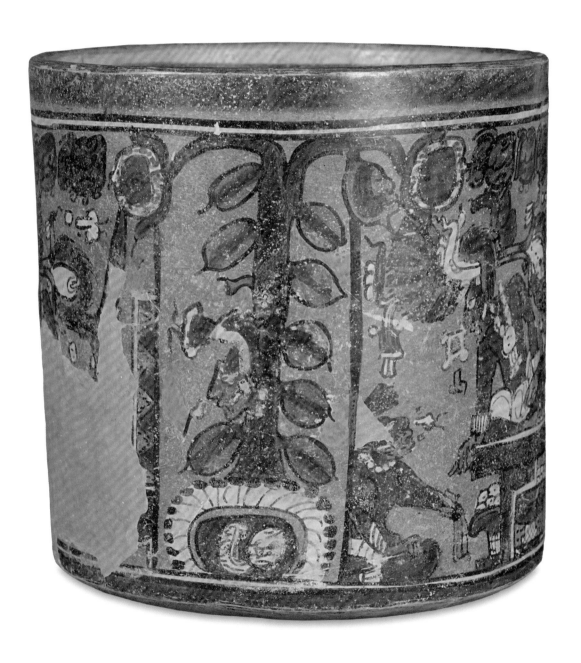

PLATE 42
Cylinder Vessel with Heads of the Maize God in Cacao Trees
Maya, probably made in Alta Verapaz, Guatemala, 600–800 CE

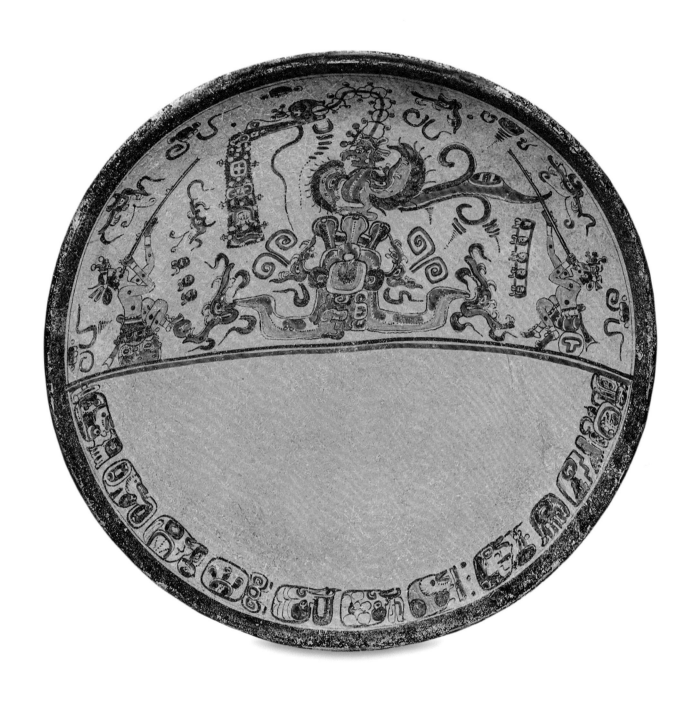

PLATE 43
Plate with Hunters Shooting a Supernatural Bird (Blom Plate)
Maya, made in Belize, Guatemala, or Mexico, 600–900 CE

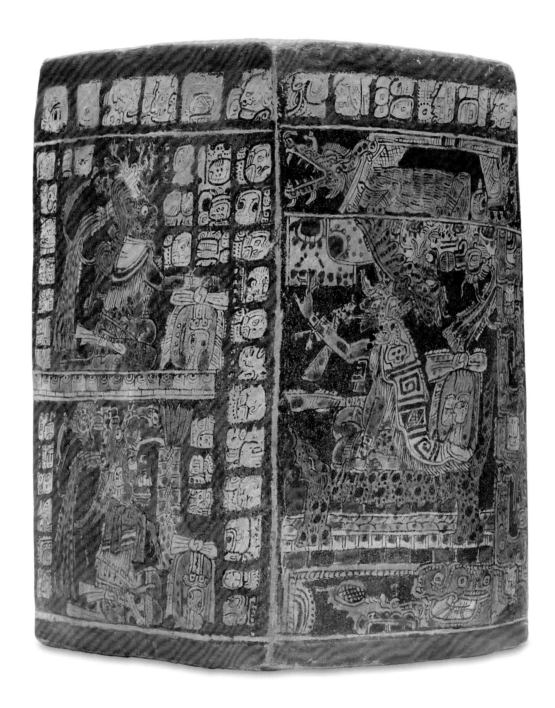

PLATE 44
Squared Vessel (Vase of the Eleven Gods)
Maya, probably made in Naranjo, Guatemala, 755–780 CE

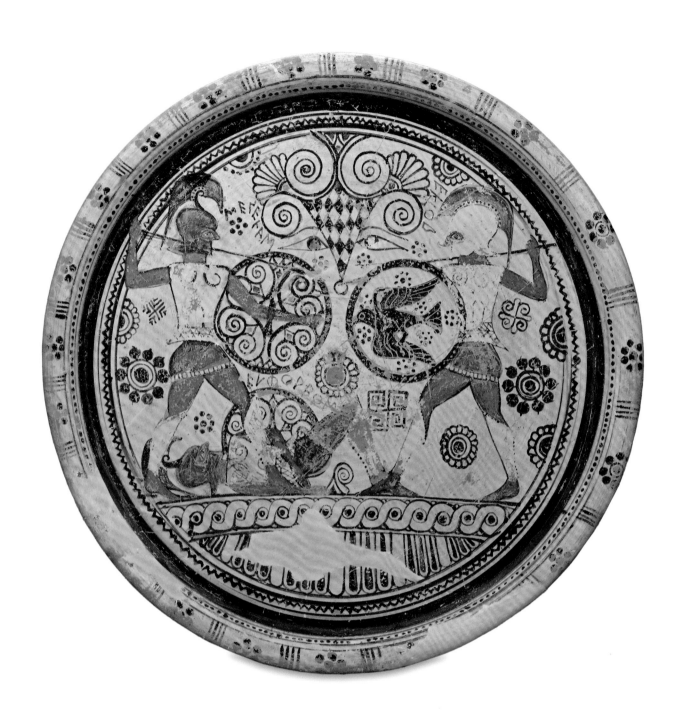

PLATE 45
Plate with Menelaos and Hektor Fighting over Euphorbos
East Greek, made on Kos, ca. 610–590 BCE

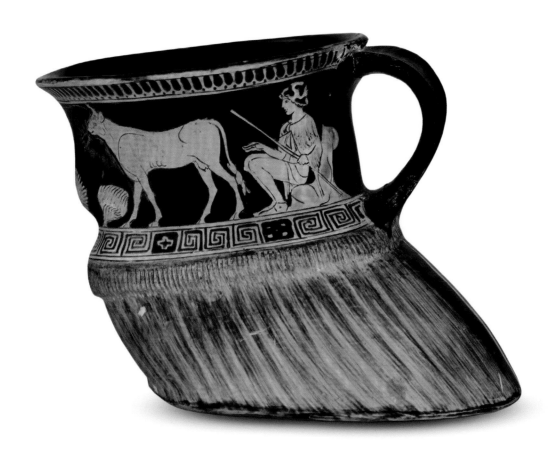

PLATE 46
Drinking Cup with a Shepherd and Cattle
Greek, made in Athens, 470–460 BCE

PLATE LIST

PLATE 1

Stirrup-Spout Vessel in the Shape of a Warrior Duck. Moche, made in Huacas de Moche, La Libertad, Peru, 500–650 CE. Terracotta, mother-of-pearl inlay, H: 23.5 cm (9¼ in.); W: 13.5 cm (5⁵⁄₁₆ in.); Depth: 22.5 cm (8⅞ in.). Found in Tomb 2, Platform I, Huaca de la Luna, Peru. Trujillo, Museo Santiago Uceda Castillo, PHL-PL.I-026

PLATE 2

Storage Jar with the Ransom of Hektor. Greek, made in Athens, ca. 520–510 BCE. Terracotta, H: 68.6 cm (27 in.); Diam (of body): 45 cm (17¹¹⁄₁₆ in.). Attributed to the Rycroft Painter. Toledo Museum of Art, Purchased with funds from the Libbey Endowment, Gift of Edward Drummond Libbey, 1972.54

PLATE 3

Wine Cup with Symposium Scene. Greek, made in Athens, ca. 480 BCE. Terracotta, H: 13.8 cm (5⁷⁄₁₆ in.); W (including handles): 41 cm (16⅛ in.). Signed by Hieron as potter and attributed to Makron as painter. Probably found at Vulci, Italy. New York, The Metropolitan Museum of Art, Rogers Fund, 1920, 20.246

PLATE 4

Cylinder Vessel with Palace Scene. Maya, probably made in Peten, Guatemala, 750–790 CE. Terracotta with post-fire pigment, H: 18.1 cm (7⅛ in.); Diam: 13 cm (5⅛ in.). Signed by Akan Suutz' as painter. Los Angeles County Museum of Art, Purchased with funds provided by Camilla Chandler Frost, M.2010.115.12

PLATE 5

Cylinder Vessel with Palace Scene. Maya, probably made in Motul de San José, Peten, Guatemala, ca. 650–750 CE. Terracotta with post-fire pigment, H: 20.3 cm (8 in.); Diam: 16.5 cm (6½ in.). Signed by Kuluub as painter. Washington, DC, Dumbarton Oaks Research Library and Collection, Pre-Columbian Collection, PC.B.564

PLATE 6

Wine Cup with Herakles and Athena. Greek, made in Athens, ca. 530 BCE. Terracotta, H: 11.4 cm (4½ in.); W (across handles): 34.4 cm (13½ in.). Signed by Nikosthenes as potter and attributed to the Painter of Villa Giulia 63613. Malibu, J. Paul Getty Museum, Villa Collection, 86.AE.170

PLATE 7

Storage Jar with Gods and Attendants. Greek, made in Athens, 540–530 BCE. Terracotta, H: 38.5 cm (15³⁄₁₆ in.); W (including handles): 27.5 cm (10¹³⁄₁₆ in.). Attributed to the Affecter as painter. Found in a tomb at Tarquinia, Italy. Cambridge, Massachusetts, Harvard Art Museums / Arthur M. Sackler Museum, Transfer from the Department of the Classics, Harvard University, Bequest of Henry W. Haynes, 1912, 1977.216.2244

PLATE 8

Mixing Bowl with Theseus and Poseidon. Greek, made in Athens, 480–470 BCE. Terracotta, H: 48.5 cm (19⅛ in.); W (including handles): 49 cm (19⁵⁄₁₆ in.). Attributed to the Harrow Painter. Found in a tomb in Ruvo, Italy. Cambridge, Massachusetts, Harvard Art Museums / Arthur M. Sackler Museum, Bequest of David M. Robinson, 1960.339

PLATE 9

Drinking Vessel with the Departure and Recovery of Helen. Greek, made in Athens, ca. 490 BCE. Terracotta, H: 21.5 cm (8⁷⁄₁₆ in.); W (including handles): 39 cm (15⅜ in.). Signed by Hieron as potter and Makron as painter. Found next to a tomb at the necropolis of Suessula, Italy. Museum of Fine Arts, Boston, Francis Bartlett Donation of 1912, 13.186

PLATE 10

Drinking Cup with the Deeds of Theseus. Greek, made in Athens, 440–430 BCE. Terracotta, H: 12.7 cm (5 in.); Diam: 33 cm (13 in.). Attributed to the Codrus Painter. Reportedly from Vulci, Italy. London, British Museum, 1850,0302.3

PLATE 11

Mixing Bowl with Achilles, Ajax, and Athena. Greek, made in Athens, ca. 520–510 BCE. Terracotta, H: 39.2 cm (15⁷⁄₁₆ in.); Diam: 46.5 cm (18⁵⁄₁₆ in.). Attributed to the Rycroft Painter. Toledo Museum of Art, Purchased with funds from the Libbey Endowment, Gift of Edward Drummond Libbey, 1963.26

PLATE 12

Storage Jar with Achilles, Ajax, and Athena. Greek, made in Athens, ca. 510 BCE. Terracotta, H: 45.3 to 45.8 cm (17¹³⁄₁₆ to 18¹⁄₁₆ in.); Diam (body): 30.4 cm (11¹⁵⁄₁₆ in.). Attributed to the Leagros Group. Malibu, J. Paul Getty Museum, Villa Collection, 86.AE.81

PLATE 13

Water Jar with Achilles, Ajax, and Athena. Greek, made in Athens, ca. 510 BCE. Terracotta, H: 54.1 cm (21^{5}/$_{16}$ in.); Diam (mouth): 24.8 cm (9¾ in.). Attributed to the Leagros Group. New York, The Metropolitan Museum of Art, Fletcher Fund, 1956, 56.171.29

PLATE 14

Wine Cup with Menelaos and Helen and Battle Scenes. Greek, made in Athens, 540–530 BCE. Terracotta, H: 12.6 cm (4^{15}/$_{16}$ in.); W (including handles): 37.2 cm (14⅝ in.). Reportedly from Taranto, Italy. New York, The Metropolitan Museum of Art, Rogers Fund, 1944, 44.11.1

PLATE 15

Wine Cup with the Suicide of Ajax. Greek, made in Athens, 490–480 BCE. Terracotta, H: 11.2 cm (4^{7}/$_{16}$ in.); W (across handles): 39.1 cm (15⅜ in.). Attributed to the Brygos Painter. Malibu, J. Paul Getty Museum, Villa Collection, 86.AE.286

PLATE 16

Oil Jar with Satyr and Sphinx. Greek, made in Athens, 425–420 BCE. Terracotta, H: 16.7 cm (6^{9}/$_{16}$ in.); Diam: 9.8 cm (3⅞ in.). Attributed to Polion. Malibu, J. Paul Getty Museum, Villa Collection, 86.AE.257

PLATE 17

Stirrup-Spout Vessel with Divinity and Captive. Moche, made in northern Peru, 500–700 CE. Terracotta, H: 27.7 cm (10⅞ in.); W: 15.5 cm (6⅛ in.); Depth: 14.8 cm (5^{13}/$_{16}$ in). Found in Burial 13-1995, on the west side of the ceremonial plaza at Huaca Cao Viejo, El Brujo, Peru. El Brujo, Museo Cao, EBBCE00000-36

PLATE 18

Stirrup-Spout Vessel with Wrinkle Face and Iguana. Moche, made in northern Peru, 500–800 CE. Terracotta, H: 22.9 cm (9 in.); Diam: 16.5 cm (6½ in.). New York, The Metropolitan Museum of Art, The Michael C. Rockefeller Memorial Collection, Purchase, Nelson A. Rockefeller Gift, 1961, 1978.412.70

PLATE 19

Stirrup-Spout Vessel with Wrinkle Face and Iguana. Moche, made in northern Peru, 500–800 CE. Terracotta, H: 31.1 cm (12¼ in.); Diam: 16.8 cm (6⅝ in.). The Art Institute of Chicago, Kate S. Buckingham Endowment, 1955.2265

PLATE 20

Stirrup-Spout Vessel with Wrinkle Face Fighting Anthropomorphized Creatures. Moche, made in northern Peru, 500–800 CE. Terracotta, H. 30.2 cm (11⅞ in.); Diam: 16 cm (6^{5}/$_{16}$ in.). Los Angeles, Fowler Museum at UCLA, Gift of Mr. and Mrs. Herbert L. Lucas, Jr., X86.3934

PLATE 21

Stirrup-Spout Vessel with Presentation of Conch Shells Scene. Moche, made in northern Peru, 500–800 CE. Terracotta, H: 29 cm (11^{7}/$_{16}$ in.); W: 15.2 cm (6 in.). Possibly found at Huaca del Sol, La Libertad, Peru. Lima, Peru, Museo Larco, ML013653

PLATE 22

Stirrup-Spout Vessel with Lima Bean Warriors. Moche, made in northern Peru, 650–800 CE. Terracotta, H: 25.9 cm (10^{3}/$_{16}$ in.); Diam: 13.2 cm (5^{3}/$_{16}$ in.). The Art Institute of Chicago, Kate S. Buckingham Endowment, 1955.2274

PLATE 23

Stirrup-Spout Vessel with Sacrifice and Presentation Scenes. Moche, made in northern Peru, 650–800 CE. Terracotta, H: 31.5 cm (12⅜ in.); Diam: 16 cm (6^{5}/$_{16}$ in.). New York, American Museum of Natural History, 1/907

PLATE 24

Stirrup-Spout Vessel with Iguana and Wrinkle Face. Moche, probably made in San José de Moro, La Libertad, Peru, 650–800 CE. Terracotta, H: 22.5 cm (8⅞ in.); Diam: 13 cm (5⅛ in.). Attributed to the Amano Painter. Los Angeles, Fowler Museum at UCLA, Gift of Mr. and Mrs. Herbert L. Lucas, Jr., X86.2873

PLATE 25

Stirrup-Spout Vessel with the Burial Theme. Moche, probably made in San José de Moro, La Libertad, Peru, 650–800 CE. Terracotta, H: 26.6 cm (10½ in.); Diam: 14.6 cm (5¾ in.). Los Angeles, Fowler Museum at UCLA, Gift of Mr. and Mrs. Herbert L. Lucas, Jr., X88.800

PLATE 26

Stirrup-Spout Vessel with the Burial Theme. Moche, probably made in San José de Moro, La Libertad, Peru, 650–800 CE. Terracotta, H: 21 cm (8¼ in.); Diam: 13 cm (5⅛ in.). Los Angeles, Fowler Museum at UCLA, Gift of Mr. and Mrs. Herbert J. Lucas, Jr., X88.801

PLATE 27

Stirrup-Spout Vessel with Combat, Boats, and a Presentation Scene. Moche, probably made in San José de Moro, La Libertad, Peru, 650–800 CE. Terracotta, H: 26.3 cm (10⅜ in.); Diam: 15.2 cm (6 in.). Lima, Peru, Museo Larco, ML013610

PLATE 28

Stirrup-Spout Vessel with Curer, Baby, and Mother. Moche, made in El Brujo, La Libertad, Peru, 300–450 CE. Terracotta, H: 10.8 cm (4¼ in.); W: 17.5 cm (6⅞ in.); Depth: 8.5 cm (3⅜ in.). Found in the tomb of the Señora de Cao at Huaca Cao Viejo, El Brujo, Peru. El Brujo, Museo Cao, EBBCE00000-59

PLATE 29

Stirrup-Spout Vessel with Sacrifice of Vultures. Moche, made in northern Peru, 500–800 CE. Terracotta, H: 19.6 cm (7¹¹⁄₁₆ in.); W: 13 cm (5⅛ in.); Depth: 18.2 cm (7³⁄₁₆ in.). Lima, Peru, Museo Larco, ML003115

PLATE 30

Flared Bowl with Weavers. Moche, made in northern Peru, 500–800 CE. Terracotta, H: 18.7 cm (7⅜ in.); Diam: 33.9 cm (13⅜ in.). London, British Museum, Am1913,1025.1

PLATE 31

Lidded Bowl with Handle in the Form of a Howler Monkey. Maya, made in El Zotz, Peten, Guatemala, 250–400 CE. Terracotta, lid H: 17 cm (6¹¹⁄₁₆ in.); W: 33 cm (13 in.); bowl H: 12 cm (4¾ in.); W: 32 cm (12⅝ in.). Found in the Temple of the Night Sun (Structure F8-1, Burial 9), El Zotz, Guatemala. Flores, Museo Regional Mundo Maya, Ministerio de Cultura y Deportes de Guatemala, 17.7.88.68a,b

PLATE 32

Cylinder Vessel with the Death and Rebirth of the Maize God (Vase of the Paddlers). Maya, probably made in Tikal, Peten, Guatemala, 672–830 CE. Terracotta, H: 22.7 cm (8¹⁵⁄₁₆ in.); Diam: 10.3 cm (4¹⁄₁₆ in.). Guatemala City, Colección del Museo Popol Vuh, Universidad Francisco Marroquín, 0368

PLATE 33

Cylinder Vessel with Supernatural Birth Scene. Maya, made in southern Campeche, Mexico, or northern Peten, Guatemala, 650–800 CE. Terracotta, H: 16.5 cm (6½ in.); Diam: 14.3 cm (5⅝ in.). Los Angeles County Museum of Art, Anonymous Gift, M.2010.115.3

PLATE 34

Cylinder Vessel with Presentation Scene (Vase of the Initial Series). Maya, probably made in El Zotz, Peten, Guatemala, 600–700 CE. Terracotta, H: 23.5 cm (9¼ in.); Diam: 15 cm (5⅞ in.). Found in Burial A2, Structure A-1, Uaxactun, Guatemala. Guatemala City, Museo Nacional de Arqueología y Etnología, Ministerio de Cultura y Deportes de Guatemala, 350

PLATE 35

Cylinder Vessel with Maize God Dancers and Companion. Maya, made in Peten, Guatemala, 650–750 CE. Terracotta, H: 16.2 cm (6⅜ in.); Diam: 7.6 cm (3 in.). Los Angeles County Museum of Art, Purchased with funds provided by Camilla Chandler Frost, M.2010.115.616

PLATE 36

Cylinder Vessel with the Rebirth of the Maize God. Maya, probably made in southern Campeche, Mexico, or northern Peten, Guatemala, 650–800 CE. Terracotta, H: 15.5 cm (6⅛ in.); Diam: 11.7 cm (4⅝ in.). Found in Tomb 1, Structure II-H, Calakmul, Mexico. Mexico City, Museo Nacional de Antropología, Secretaría de Cultura–Instituto Nacional de Antropología e Historia, 10-566398

PLATE 37

Cylinder Vessel depicting Otherworldly Toad, Jaguar, and Serpent. Maya, made in southern Campeche, Mexico, or northern Peten, Guatemala, 650–800 CE. Terracotta, H: 13 cm (5⅛ in.); Diam: 13.7 cm (5⅜ in.). Los Angeles County Museum of Art, Gift of the 2006 Collectors Committee, M.2006.41

PLATE 38

Cylinder Vessel with *Way* Figures. Maya, probably made in Motul de San José, Peten, Guatemala, ca. 755 CE. Terracotta, H: 20.4 cm (8¹⁄₁₆ in.); Diam: 16.3 cm (6⁷⁄₁₆ in.). Signed by Mo(?)-n Buluch Laj as painter. Princeton University Art Museum, Museum purchase, Fowler McCormick, Class of 1921, Fund, y1993-17

PLATE 39

Cylinder Vessel with the Maize God and other Supernaturals. Maya, probably made in El Zotz, Peten, Guatemala, 600–700 CE. Terracotta, H: 21.5 cm (8⁷⁄₁₆ in.); Diam: 15 cm (5⅞ in.). Princeton University Art Museum, Gift of Stephanie H. Bernheim and Leonard H. Bernheim, Jr. in honor of Gillett G. Griffin, 2005-127

PLATE 40

Plate with Maize God Dancer. Maya, made in Peten, Guatemala, 600–700 CE. Terracotta, Diam: 32.4 cm (12¾ in.). Found in Burial A3, Structure A-1, Uaxactun, Guatemala. Guatemala City, Museo Nacional de Arqueología y Etnología, Ministerio de Cultura y Deportes de Guatemala, 352

PLATE 41

Plate with the Rebirth of the Maize God. Maya, probably made in Peten, Guatemala, 600–800 CE. Terracotta, H: 11.4 cm (4½ in.); Diam: 37.5 cm (14¾ in.). Princeton University Art Museum, Museum purchase, Fowler McCormick, Class of 1921, Fund, 1997-465

PLATE 42

Cylinder Vessel with Heads of the Maize God in Cacao Trees. Maya, probably made in Alta Verapaz, Guatemala, 600–800 CE. Terracotta, H: 18 cm (7¹⁄₁₆ in.); Diam: 18.5 cm (7⁵⁄₁₆ in.). Guatemala City, Colección del Museo Popol Vuh, Universidad Francisco Marroquín, 0093

PLATE 43

Plate with Hunters Shooting a Supernatural Bird (Blom Plate). Maya, made in Belize, Guatemala, or Mexico, 600–900 CE. Terracotta, H: 44.5 cm (17½ in.); W: 44.5 cm (17½ in.); Depth: 7.3 cm (2⅞ in.). Found in a destroyed burial mound, Río Hondo, Quintana Roo, Mexico. Cancún, Museo Maya de Cancún, Secretaría de Cultura–Instituto Nacional de Antropología e Historia, 10-455136

PLATE 44

Squared Vessel (Vase of the Eleven Gods). Maya, probably made in Naranjo, Guatemala, 755–780 CE. Ceramic, postfire stucco, H: 24.5 cm (9⅝ in.); W: 16.5 cm (6½ in.); Depth: 16.2 cm (6⅜ in.). Signed by Lo' Took' Akan(?) Xok as painter. Los Angeles County Museum of Art, Anonymous Gift, M.2010.115.14

PLATE 45

Plate with Menelaos and Hektor Fighting over Euphorbos. East Greek, made on Kos, ca. 610–590 BCE. Terracotta, Diam: 39.4 cm (15½ in.). Found in a tomb at Kameiros, Rhodes. London, British Museum, 1860,0404.1

PLATE 46

Drinking Cup with a Shepherd and Cattle. Greek, made in Athens, 470–460 BCE. Terracotta, H: 10.3 cm (4¹⁄₁₆ in.). Attributed to a painter recalling the Brygos Painter. Reportedly from Salamis. New York, The Metropolitan Museum of Art, Fletcher Fund, 1938, 38.11.2

POSTSCRIPT

Megan E. O'Neil and David Saunders

What is the benefit of juxtaposing Greek, Moche, and Maya painted pottery, and what can we learn from doing so? The motivations for—and intricacies of—creating, using, and exchanging figure-decorated ceramics in these three disparate ancient cultures appear to arise from both shared and divergent human practices. Like many items of material culture from across human societies, these vessels were created and used in social contexts, not least those relating to food, drink, and communal interaction. But these are activities that do not, prima facie, require finely made and carefully painted vessels. The consumption of beverages, the storage of food, the pouring of libations—all can be (and were) accomplished using vessels without figural imagery, or with no decoration at all. So the production and use of figure-decorated pottery is a choice, made by people and communities as a way to impress or communicate with others, highlight their social status, or heighten a gathering's special nature. Furthermore, the display and exchange of vessels bearing narrative scenes pertaining to the creation of the world, the activities of gods and heroes, or the establishment of political entities or their power served to cultivate or reify individual and group identities. These themes were significant for whole societies or smaller groups within them.

When buried with the dead, the vessels—and the foods or liquids they may have held—served as offerings for the deceased, even nourishing them during their journeys after death. Again, more humble containers could have served (and did) as funerary goods, but the use of vessels bearing images of deities, ancestors, and culture heroes may have provided the dead and those mourning them with important cultural narratives to accompany the deceased—if not enable them—on those journeys. Furthermore, the offering of vessels to an ancestor or a god linked the living, the dead, and the divine, while gift giving among peers, whether within a polity or across polities, bound people and vessels in reciprocal relationships that could endure, both because of the memory of the exchange and because of the persistence of the physical object. When painted pots were bought and sold, as was the case with many Athenian painted vases, they may have lost connections to those involved in their production, but they acquired new ones in the course of their movement.

In their comparative study of the ancient Maya and Egyptians, Lynn Meskell and Rosemary Joyce begin, "It can be productive to ask the same questions about … very different places and times. This is not because we expect to discover any simple explanatory framework that transcends history. Rather, we believe that it is through a constant tacking between historical specificities that unexamined postulates are exposed."[1] By bringing together the figure-decorated pottery of the ancient Greeks, Moche, and Maya, we have subscribed to a similar principle, seeking to initiate fruitful encounters with material that might be unfamiliar, and fresh perspectives on what is well known. The narratives depicted on these vessels can engender a multiplicity of voices, and each pot has its own unique history, perhaps seen, handled, or used by numerous individuals. The picture worlds that we have explored here encompass many different readings and interpretations, and we look forward to the conversations initiated by their juxtaposition.

1 Meskell and Joyce 2003, 1.

BIBLIOGRAPHY

ABE AND ELSNER 2017
Abe, Stanley, and Jaś Elsner. "Introduction: Some Stakes of Comparison." In *Comparativism in Art History*, edited by Jaś Elsner, 1–15. Abingdon, UK: Routledge, 2017.

ADAMS 1999
Adams, Richard E. W. *Río Azul: An Ancient Maya City*. Norman: University of Oklahoma Press, 1999.

AIMI AND TUNESI 2017
Aimi, Antonio, and Raphael Tunesi. "Notas sobre unos nuevos grandes artistas de los Sagrados Hombres de Chatahn." *Glyph Dwellers* 54 (May 2017): 1–45. http://glyphdwellers.com/pdf/R54.pdf.

ALVA 1988
Alva, Walter. "Discovering the New World's Richest Unlooted Tomb." *National Geographic* 174, no. 4 (1998): 510–55.

ALVA 2001
Alva, Walter. "The Royal Tombs of Sipán: Art and Power in Moche Society." In Pillsbury 2001, 223–45.

ALVA 2015
Alva, Walter. "Los mochicas: Herederos del periodo formativo de la costa norte, y el renacimiento de los antiguos dioses." In *Chavín*, edited by Peter Fux, 207–11. Lima: Museo de Arte de Lima, 2015.

ALVA AND DONNAN 1993
Alva, Walter, and Christopher B. Donnan. *Royal Tombs of Sipán*. Exh. cat. Los Angeles: Fowler Museum of Cultural History, University of California, 1993.

ANTONOPOULOS, CHRISTOPOULOS, AND HARRISON 2021
Antonopoulos, Andreas P., Menelaos M. Christopoulos, and George W. M. Harrison, eds. *Reconstructing Satyr Drama*. Berlin: De Gruyter, 2021.

APPADURAI 1986
Appadurai, Arjun. "Introduction: Commodities and the Politics of Value." In *The Social Life of Things: Commodities in Cultural Perspective*, edited by Arjun Appadurai, 3–63. Cambridge: Cambridge University Press, 1986.

ARNOLD 1991
Arnold, Denise Y. "The House of Earth-Bricks and Inka-Stones: Gender, Memory, and Cosmos in Qaqachaka." *Journal of Latin American Lore* 17 (1991): 3–69.

ARNOLD ET AL. 2008
Arnold, Dean E., Jason R. Branden, Patrick Ryan Williams, Gary M. Feinman, and J. P. Brown. "The First Direct Evidence for the Production of Maya Blue: Rediscovery of a Technology." *Antiquity* 82 (2008): 151–64.

ARNOLD 2018
Arnold, Dean E. *Maya Potters' Indigenous Knowledge: Cognition, Engagement, and Practice*. Boulder: University Press of Colorado, 2018.

ARREDONDO LEIVA, AULD-THOMAS, AND CANUTO 2018
Arredondo Leiva, Ernesto, Luke Auld-Thomas, and Marcello Canuto. "La transformación de las instituciones religiosas y de gobierno del Preclásico Tardío al Clásico Temprano en las Tierras Bajas Mayas: Una visión desde el sitio El Achiotal, Petén, Guatemala." In *XXXI Simposio de investigaciones arqueológicas en Guatemala, 2017*, edited by Bárbara Arroyo, Luis Méndez Salinas, and Gloria Ajú Álvarez, 315–29. Guatemala City: Ministerio de Cultura y Deportes, Instituto de Antropología e Historia; Asociación Tikal, 2018.

ARRINGTON 2017
Arrington, Nathan. "Connoisseurship, Vases, and Greek Art and Archaeology." In Padgett 2017, 21–39.

BALACHANDRAN 2019
Balachandran, Sanchita. "Bringing Back the (Ancient) Bodies: The Potters' Sensory Experiences and the Firing of Red, Black and Purple Greek Vases." *Arts* 8, no. 2 (2019): 70.

BAWDEN 1995
Bawden, Garth. "The Structural Paradox: Moche Culture as Political Ideology." *Latin American Antiquity* 6, no. 3 (1995): 255–73.

BAWDEN 1996
Bawden, Garth. *The Moche*. Oxford: Blackwell, 1996.

BEARD 1991
Beard, Mary. "Adopting an Approach II." In *Looking at Greek Vases*, edited by Tom Rasmussen and Nigel Spivey, 12–35. Cambridge: Cambridge University Press, 1991.

BENSON 1972
Benson, Elizabeth. *The Mochica: A Culture of Peru*. New York: Praeger, 1972.

BENSON 2012
Benson, Elizabeth. *The Worlds of the Moche on the North Coast of Peru*. Austin: University of Texas Press, 2012.

BENTZ, GEOMINY, AND MÜLLER 2010
Bentz, Martin, Wilfred Geominy, and Jan Marius Müller, eds. *Tonart: Virtuosität antiker Töpfertechnik*. Exh. cat. Petersberg, Germany: M. Imhof, 2010.

BIRO 2016
Biro, Peter. "Emblem Glyphs in Classic Maya Inscriptions: From Single to Double Ones as a Means of Place of Origin, Memory and Diaspora." In *Places of Power and Memory in Mesoamerica's Past and Present: How Sites, Toponyms and Landscapes Shape History and Remembrance*, edited by Daniel Graña-Behrens, 123–58. Berlin: Mann, 2016.

BISHOP 1994
Bishop, Ronald L. "Pre-Columbian Pottery: Research in the Maya Region." In *Archaeometry of Pre-Columbian Sites and Artifacts: Proceedings of a Symposium Organized by the UCLA Institute of Archaeology and the Getty Conservation Institute, Los Angeles, California, March 23–27, 1992*, edited by David A. Scott and Pieter Meyers, 15–65. Marina del Rey, CA: Getty Conservation Institute, 1994.

BLOM 1950
Blom, Frans. "A Polychrome Plate from Quintana Roo." *Notes on Middle American Archaeology* 98 (1950): 405–6.

BOARDMAN 1976
Boardman, John. "The Kleophrades Painter at Troy." *Antike Kunst* 19 (1976): 3–18.

BOARDMAN 2001
Boardman, John. *The History of Greek Vases: Potters, Painters and Pictures*. London: Thames & Hudson, 2001.

BOCK 2012
Bock, Edward K. de. *Sacrificios humanos para el orden cósmico y la regeneración: Estructura y significado en la iconografía moche*. Edited by Luis Valle Álvares. Translated by César A. Gálvez Mora. Trujillo, Peru: Ediciones SIAN, 2012.

BONAVIA 1985
Bonavia, Duccio. *Mural Painting in Ancient Peru*. Translated by Patricia J. Lyon. Bloomington: University of Indiana Press, 1985.

BOONE 1996
Boone, Elizabeth Hill, ed. *Andean Art at Dumbarton Oaks*. Vol. 1. Washington, DC: Dumbarton Oaks, 1996.

BOURGET 2001
Bourget, Steve. "Rituals of Sacrifice: Its Practice at Huaca de la Luna and Its Representation in Moche Iconography." In Pillsbury 2001, 89–109.

BOURGET 2006
Bourget, Steve. *Sex, Death, and Sacrifice in Moche Religion and Visual Culture*. Austin: University of Texas Press, 2006.

BOURGET 2008
Bourget, Steve. "The Third Man: Identity and Rulership in Moche Archaeology and Visual Culture." In Bourget and Jones 2008, 263–88.

BOURGET 2014
Bourget, Steve. *Les rois mochica: Divinité et pouvoir dans le Pérou ancien.* Exh. cat. Paris: Somogy Éditions d'art; Geneva: MEG, 2014.

BOURGET AND JONES 2008
Bourget, Steve, and Kimberly L. Jones, eds. *The Art and Archaeology of the Moche: An Ancient Andean Society of the Peruvian North Coast.* Austin: University of Texas Press, 2008.

BRAAKHUIS 1990
Braakhuis, Edwin. "The Bitter Flour: Birth-Scenes of the Tonsured Maize God." In *Mesoamerican Dualism / Dualismo mesoamericano,* edited by Rudolf van Zantwijk, Rob de Ridder, and Edwin Braakhuis, 25–147. Utrecht: RUU-ISOR, 1990.

BRAINERD 1958
Brainerd, George W. *The Archaeological Ceramics of Yucatan.* Berkeley: University of California Press, 1958.

BRITTENHAM 2019
Brittenham, Claudia, ed. *Vessels: The Object as Container.* Oxford: Oxford University Press, 2019.

BRÜNING (1924) 2004
Brüning, Hans Heinrich. *Mochica Wörter-buch / Diccionario mochica: mochica-castellano, castellano-mochica.* Originally published in 1924. Lima: Universidad San Martín de Porres, 2004.

BUITRON-OLIVER 1995
Buitron-Oliver, Diana. *Douris: A Master-Painter of Athenian Red-Figure Vases.* Mainz am Rhein: Phillip von Zabern, 1995.

BUNDGAARD RASMUSSEN 2008
Bundgaard Rasmussen, Bodil. "Special Vases in Etruria: First- or Secondhand?" In Lapatin 2008, 215–24.

BUNDRICK 2017
Bundrick, Sheramy. "Altars, *Astragaloi,* Achilles: Picturing Divination on Athenian Vases." In *Gods, Objects, and Ritual Practice,* edited by Sandra Blakely, 53–74. Atlanta: Lockwood Press, 2017.

BUNDRICK 2019
Bundrick, Sheramy. *Athens, Etruria, and the Many Lives of Greek Figured Pottery.* Madison: University of Wisconsin Press, 2019.

BURDICK n.d.
Burdick, Catherine. "Notes on K7727." In Kerr ca. 2000. www.mayavase.com/7727/com7727.html.

BUSSMANN, SHARON, AND BROWN 2009
Bussmann, Rainer, Douglas Sharon, and William L. Brown. "Nombrando un fantasma: La búsqueda de la identidad de Ulluchu, una planta ceremonial no identificada de la cultura Moche en el norte del Perú." In *Medicina tradicional: Conocimiento milenario,* edited by Enrique Vergara Montero and Rafael Vásquez Guerrero, 171–82. Trujillo, Peru: Museo de Arqueología, Antropología e Historia, Facultad de Ciencias Sociales, Universidad Nacional de Trujillo, 2009.

CALLAGHAN 2014
Callaghan, Michael. "Maya Polychrome Vessels as Inalienable Possessions." *Archaeological Papers of the American Anthropological Association* 23, no. 1 (2014): 112–27.

CALVIN 2006
Calvin, Inga. "Between Text and Image: An Analysis of Pseudo-Glyphs on Late Classic Maya Pottery from Guatemala." PhD diss., University of Colorado, Boulder, 2006.

CAMPANA 2015
Campana, Cristóbal. *Iconografía del pensamiento andino.* Trujillo, Peru: Fondo Editorial, Universidad Privada Antenor Orrego, 2015.

J. CAMPBELL 1949
Campbell, Joseph. *The Hero with a Thousand Faces.* New York: Bollingen Foundation, 1949.

L. CAMPBELL 1983
Campbell, Lyle. "Préstamos lingüísticos en el Popol Vuh." In *Nuevas perspectivas sobre el Popol Vuh,* edited by Robert Carmack and Francisco Morales Santos, 81–86. Guatemala City: Editorial Piedra Santa, 1983.

CARLSEN AND PRECHTEL 1991
Carlsen, Robert S., and Martin Prechtel. "The Flowering of the Dead: An Interpretation of Highland Maya Culture." *Man* 26 (1991): 23–42.

CARRERA (1644) 1939
Carrera, Fernando de la. *Arte de la lengua yunga.* Originally published in 1644. San Miguel de Tucumán, Argentina: Instituto de Antropología, 1939.

CARTER 2015
Carter, Nicholas P. "Once and Future Kings: Classic Maya Geopolitics and Mythic History on the Vase of the Initial Series from Uaxactun." *PARI Journal* 15, no. 4 (2015): 1–15.

CASTILLO 1989
Castillo, Luis Jaime. *Personajes míticos, escenas y narraciones en la iconografía mochica.* Lima: Fondo Editorial, Pontificia Universidad Católica del Perú, 1989.

CASTILLO 2001
Castillo, Luis Jaime. "The Last of the Mochicas: A View from the Jequetepeque Valley." In Pillsbury 2001, 307–32.

CASTILLO AND HOLMQUIST 2000
Castillo, Luis Jaime, and Ulla Holmquist. "Mujeres y poder en la sociedad mochica tardía." In *El hechizo de las imágenes: Estatus social, género y etnicidad en la historia peruana,* edited by Narda Henríquez, 13–34. Lima: Fondo Editorial, Pontificia Universidad Católica del Perú, 2000.

CASTILLO AND RENGIFO 2008
Castillo, Luis Jaime, and Carlos Rengifo. "El género y el poder: San José de Moro." In Makowski 2008b, 165–81.

CASTILLO AND UCEDA 2008
Castillo, Luis Jaime, and Santiago Uceda. "The Mochicas." In *Handbook of South American Archaeology,* edited by Helaine Silverman and William H. Isbell, 707–29. New York: Springer, 2008.

CASTILLO ET AL. 2008
Castillo B., Luis Jaime, Julio Rucabado Y., Martín del Carpio P., Katiusha Bernuy Q., Karim Ruiz R., Carlos Rengifo Ch., Gabriel Prieto B., and Carole Fraresso. "Ideología y poder en la consolidación, colapso y reconstrucción del estado mochica del Jequetepeque: El Proyecto Arqueológico San José de Moro (1991–2006)." *Ñawpa Pacha* 29 (2008): 1–86.

CHAPDELAINE 2001
Chapdelaine, Claude. "The Growing Power of a Moche Urban Class." In Pillsbury 2001, 69–87.

CHIARINI 2018
Chiarini, Sara. *The So-Called Nonsense Inscriptions on Greek Vases: Between Paideia and Paidia.* Leiden: Brill, 2018.

CHINCHILLA MAZARIEGOS 2011
Chinchilla Mazariegos, Oswaldo. *Imágenes de la mitología maya.* Guatemala City: Museo Popol Vuh, Universidad Francisco Marroquín, 2011.

CHINCHILLA MAZARIEGOS 2017
Chinchilla Mazariegos, Oswaldo. *Art and Myth of the Ancient Maya.* New Haven, CT: Yale University Press, 2017.

CHINCHILLA MAZARIEGOS 2020
Chinchilla Mazariegos, Oswaldo. "Pus, Pustules, and Ancient Maya Gods: Notes on the Names of God S and Hunahpu." *PARI Journal* 21, no. 1 (2020): 1–13.

CHINCHILLA MAZARIEGOS 2021
Chinchilla Mazariegos, Oswaldo. "The Solar and Lunar Heroes in Classic Maya Art." In *The Myths of the Popol Vuh in Cosmology, Art, and Ritual,* edited by Holley Moyes, Allen J. Christenson, and Frauke Sachse, 251–67. Louisville: University Press of Colorado, 2021.

CHINCHILLA MAZARIEGOS 2022a
Chinchilla Mazariegos, Oswaldo. "Cosmic Struggles, Primeval Transgressions." In Chinchilla Mazariegos, Doyle, and Pillsbury 2022, 57–84.

CHINCHILLA MAZARIEGOS 2022b
Chinchilla Mazariegos, Oswaldo. "In the Court of the Moon Gods: Maya Lunar Myths and the Patrons of Glyph C." In Magaloni and O'Neil 2022, 429–43.

CHINCHILLA MAZARIEGOS, DOYLE, AND PILLSBURY 2022
Chinchilla Mazariegos, Oswaldo, James A. Doyle, and Joanne Pillsbury, eds. *Lives of the Gods: Divinity in Maya Art.* Exh. cat. New York: Metropolitan Museum of Art, 2022.

CHRISTENSON 2007
Christenson, Allen J., trans. *Popol Vuh: Sacred Book of the Quiché Maya People.* Mesoweb, 2007. https://www.mesoweb.com/publications/Christenson/PopolVuh.pdf. Electronic version of *Popol Vuh: The Sacred Book of the Maya.* Norman: University of Oklahoma Press, 2003.

CHRISTENSON 2022
Christenson, Allen J., trans. The *"Title of Totonicapán."* Louisville: University Press of Colorado, 2022.

CHUCHIAK 2006
Chuchiak, John F., IV. "De Extirpatio Codicis Yucatanensis: The 1607 Colonial Confiscation of a Maya Sacred Book; New Interpretations on the Origins and Provenience of the Madrid Codex." In *Sacred Books, Sacred Languages: Two Thousand Years of Ritual and Religious Maya Literature; Proceedings of the 8th European Maya Conference, Madrid, November 25–30, 2003*, edited by Rogelio Valencia Rivera and Geneviève Le Fort, 113–40. Markt Schwaben, Germany: Verlag Anton Saurwein, 2006.

CHUCHIAK 2010
Chuchiak, John F., IV. "Writing as Resistance: Maya Graphic Pluralism and Indigenous Elite Strategies for Survival in Colonial Yucatan, 1550–1750." *Ethnohistory* 57, no. 1 (2010): 87–116.

CLENDINNEN 1987
Clendinnen, Inga. *Ambivalent Conquest: Maya and Spaniard in Yucatan, 1517–1570.* Cambridge: Cambridge University Press, 1987.

COE 1973
Coe, Michael D. *The Maya Scribe and His World.* New York: Grolier Club, 1973.

COE 1978
Coe, Michael D. *Lords of the Underworld: Masterpieces of Classic Maya Ceramics.* Princeton, NJ: Princeton University Press, 1978.

COGGINS 1975
Coggins, Clemency Chase. "Painting and Drawing Styles at Tikal: An Historical and Iconographic Approach." PhD diss., Harvard University, 1975.

COGGINS 1998
Coggins, Clemency Chase. "United States Cultural Property Legislation: Observations of a Combatant." *International Journal of Cultural Property* 7, no. 1 (January 1998): 52–68.

COHEN 2006
Cohen, Beth. *The Colors of Clay: Special Techniques in Athenian Vases.* With contributions by Susan Lansing-Maish et al. Exh. cat. Los Angeles: J. Paul Getty Museum, 2006.

COJTÍ CUXIL 1996
Cojtí Cuxil, Demetrio. "The Politics of Maya Revindication." In *Maya Cultural Activism in Guatemala*, edited by Edward F. Fischer and R. McKenna Brown, 19–50. Austin: University of Texas Press, 1996.

COJTI REN 2006
Cojti Ren, Avexnim. "Maya Archaeology and the Political and Cultural Identity of Contemporary Maya in Guatemala." *Archaeologies* 2, no. 1 (2006): 8–19.

CONNELLY 2007
Connelly, Joan Breton. *Portrait of a Priestess: Women and Ritual in Ancient Greece.* Princeton, NJ: Princeton University Press, 2007.

CORDY-COLLINS 1977
Cordy-Collins, Alana. "The Moon Is a Boat! A Study in Iconographic Methodology." In Cordy-Collins and Stern 1977, 421–34.

CORDY-COLLINS 1983
Cordy-Collins, Alana. "Ancient Andean Art as Explained by Andean Ethnohistory: An Historical Review." In *Text and Image in Pre-Columbian Art: Essays on the Interrelationship of the Visual and Verbal Arts*, edited by Janet Catherine Berlo, 181–96. Oxford: B.A.R., 1983.

CORDY-COLLINS AND STERN 1977
Cordy-Collins, Alana, and Jean Stern, eds. *Pre-Columbian Art History: Selected Readings.* Palo Alto, CA: Peek Publications, 1977.

CUMMINS 2004
Cummins, Thomas B. F. "Silver Threads and Golden Needles: The Inca, the Spanish, and the Sacred World of Humanity." In *The Colonial Andes: Tapestries and Silverwork, 1530–1830*, edited by Elena Phipps, Joanna Hecht, and Cristina Esteras Martín, 2–15. Exh. cat. New York: The Metropolitan Museum of Art, 2004.

CUOMO DI CAPRIO 2017
Cuomo di Caprio, Ninina. *Ceramics in Archaeology: From Prehistoric to Medieval Times in Europe and the Mediterranean; Ancient Craftsmanship and Modern Laboratory Techniques.* Rome: "L'Erma" di Bretschneider, 2017.

DAVIDSON 1997
Davidson, James N. *Courtesans and Fishcakes: The Consuming Passions of Classical Athens.* London: HarperCollins, 1997.

DAVIS 1971
Davis, Natalie Z. "The Reasons of Misrule: Youth Groups and Charivaris in Sixteenth-Century France." *Past and Present* 50 (1971): 41–75.

DÍAZ DEL CASTILLO 1928
Díaz del Castillo, Bernal. *The Discovery and Conquest of Mexico, 1517–1521*, edited by Genaro García. Translated by A. P. Maudslay. London: George Routledge, 1928.

DIETRICH 2018
Dietrich, Nikolaus. "Viewing and Identification: The Agency of the Viewer in Archaic and Early Classical Greek Visual Culture." In *Gaze, Vision, and Visuality in Ancient Greek Literature*, edited by Alexandros Kampakoglou and Anna Novokhatko, 464–92. Berlin: De Gruyter, 2018.

DIETRICH AND SQUIRE 2018
Dietrich, Nikolaus, and Michael Squire, eds. *Ornament and Figure in Graeco-Roman Art: Rethinking Visual Ontologies in Classical Antiquity.* Berlin: Walter de Gruyter, 2018.

DILLON AND GARLAND 2013
Dillon, Matthew, and Lynda Garland. *The Ancient Greeks: History and Culture from Archaic Times to the Death of Alexander.* London: Routledge, 2013.

DOBKIN DE RIOS 1977
Dobkin de Rios, Marlene. "Plant Hallucinogens and the Religion of the Mochica—an Ancient Peruvian People." *Economic Botany* 31, no. 2 (1977): 189–203.

DONNAN 1965
Donnan, Christopher B. "Moche Ceramic Technology." *Ñawpa Pacha* 3 (1965): 115–34.

DONNAN 1975
Donnan, Christopher B. "The Thematic Approach to Moche Iconography." *Journal of Latin American Lore* 1, no. 2 (1975): 147–62.

DONNAN 1976
Donnan, Christopher B. *Moche Art and Iconography.* Los Angeles: University of California, Los Angeles, 1976.

DONNAN 1977
Donnan, Christopher B. "The Thematic Approach to Moche Iconography." In Cordy-Collins and Stern 1977, 407–20.

DONNAN 1978
Donnan, Christopher B. *Moche Art of Peru: Pre-Columbian Symbolic Communication.* Exh. cat. Los Angeles: Museum of Cultural History, University of California, Los Angeles, 1978.

DONNAN 1995
Donnan, Christopher B. "Moche Funerary Practice." In *Tombs for the Living: Andean Mortuary Practices,* edited by Tom D. Dillehay, 111–59. Washington, DC: Dumbarton Oaks Research Library and Collection, 1995.

DONNAN 2010
Donnan, Christopher B. "Moche State Religion: A Unifying Force in the Moche Political Organization." In Quilter and Castillo 2010, 45–67.

DONNAN 2011
Donnan, Christopher B. "Moche Substyles: Keys to Understanding Moche Political Organization." *Boletín del Museo Chileno de Arte Precolombino* 16, no. 1 (2011): 105–18.

DONNAN AND CASTILLO 1992
Donnan, Christopher B., and Luis Jaime Castillo. "Finding the Tomb of a Moche Priestess." *Archaeology* 45, no. 6 (1992): 38–42.

DONNAN AND MCCLELLAND 1979
Donnan, Christopher B., and Donna McClelland. *The Burial Theme in Moche Iconography.* Washington, DC: Dumbarton Oaks, 1979.

DONNAN AND MCCLELLAND 1999
Donnan, Christopher B., and Donna McClelland. *Moche Fineline Painting: Its Evolution and Its Artists.* Los Angeles: Fowler Museum, University of California, Los Angeles, 1999.

DOYLE 2016
Doyle, James A. "Creation Narratives on Ancient Maya Codex-Style Ceramics in the Metropolitan Museum." *Metropolitan Museum Journal* 51 (2016): 42–63.

EBBINGHAUS 2018
Ebbinghaus, Susanne, ed. *Animal-Shaped Vessels from the Ancient World: Feasting with Gods, Heroes, and Kings.* Exh. cat. Cambridge, MA: Harvard Art Museums, 2018.

ELIA 2001
Elia, Ricardo. "Analysis of the Looting, Selling, and Collecting of Apulian Red-Figure Vases: A Quantitative Approach." In *Illicit Antiquities: The Destruction of the World's Archaeological Heritage,* edited by Neil Brodie, Jennifer Doole, and Colin Renfrew, 145–53. Cambridge: McDonald Institute for Archaeological Research, 2001.

ELSON 1947
Elson, Ben. "The Homshuk: A Sierra Popoluca Text." *Tlalocan* 2, no. 3 (1947): 193–214.

EVANS 1997
Evans, Clifford. "Rafael Larco Hoyle (1901–1966)." In *The Spirit of Ancient Peru: Treasures from the Museo Arqueológico Rafael Larco Herrera,* edited by Kathleen Berrin, 15–19. Exh. cat. New York: Thames & Hudson, 1997.

FELCH AND FRAMMOLINO 2011
Felch, Jason, and Ralph Frammolino. *Chasing Aphrodite: The Hunt for Looted Antiquities at the World's Richest Museum.* Boston: Houghton Mifflin Harcourt, 2011.

FERRARI 2003
Ferrari, Gloria. "Myth and Genre on Athenian Vases." *Classical Antiquity* 22 (2003): 37–54.

FILLOY NADAL AND MARTÍNEZ DEL CAMPO LANZ 2010
Filloy Nadal, Laura, and Sofía Martínez del Campo Lanz. "El rostro eterno de K'inich Janaab' Pakal: La mascara funeraria." In *Misterios de un rostro maya: La máscara de funeraria de K'inich Janaab' Pakal de Palenque,* edited by Laura Filloy Nadal, 109–30. Mexico City: Instituto Nacional de Antropología e Historia, 2010.

FINEGOLD 2021
Finegold, Andrew. *Vital Voids: Cavities and Holes in Mesoamerican Material Culture.* Austin: University of Texas Press, 2021.

FOSTER 1945
Foster, George M. "Sierra Popoluca Folklore and Beliefs." In *University of California Publications in American Archaeology and Ethnology.* Vol. 42, no. 2, 177–250. Berkeley: University of California Press, 1945.

FOUGHT 1989
Fought, John. "Kumix, the Ch'orti' Hero." In *General and Amerindian Ethnolinguistics: In Remembrance of Stanley Newman,* edited by Mary Ritchie Key and Henry M. Hoenigswald, 461–68. Berlin: Mouton de Gruyter, 1989.

FREIDEL, SCHELE, AND PARKER 1993
Freidel, David, Linda Schele, and Joy Parker. *Maya Cosmos: Three Thousand Years on the Shaman's Path.* New York: William Morrow, 1993.

FRICKE AND FLOOD 2022
Fricke, Beate, and Finbarr Barry Flood. "Premodern Globalism in Art History: A Conversation." *Art Bulletin* 104, no. 4 (2022): 6–19.

FÜRTWANGLER AND REICHHOLD 1904
Fürtwangler, Adolf, and Karl Reichhold. *Griechische Vasenmalerei.* Vol. 1. Munich: F. Bruckmann, 1904.

GARCÍA BARRIOS AND CARRASCO VARGAS 2006
García Barrios, Ana, and Ramón Carrasco Vargas. "Algunos fragmentos cerámicos de estilo códice procedentes de Calakmul." *Los investigadores de la cultura maya* 14, no. 1 (2006): 126–36.

GARLAND 2001
Garland, Robert. *The Greek Way of Death.* 2nd ed. Ithaca, NY: Cornell University Press, 2001.

GAYOSO RULLIER 2014
Gayoso Rullier, Henry. "¿Por qué *Aiapaec* y *Chicopaec* no son nombres de dioses?" *Chungará: Revista de antropología chilena* 46, no. 3 (September 2014): 345–54. dx.doi.org/10.4067/S0717 -73562014000300003.

GERSTENBLITH 2013
Gerstenblith, Patty. "The Meaning of 1970 for the Acquisition of Archaeological Objects." *Journal of Field Archaeology* 38, no. 4 (2013): 364–73.

GERSTENBLITH 2019
Gerstenblith, Patty. "Provenances: Real, Fake, and Questionable." *International Journal of Cultural Property* 26 (2019): 285–304.

GIERSZ, MAKOWSKI, AND PRZADKA 2005
Giersz, Miłosz, Krzysztof Makowski, and Patrycja Przadka. *El mundo sobrenatural mochica: Imágenes escultóricas de las deidades antropomorfas en el Museo Arqueológico Rafael Larco Herrera.* Lima: Fondo Editorial, Pontificia Universidad Católica del Perú, 2005.

GILL 2018
Gill, David. "Returning Archaeological Objects to Italy." *International Journal of Cultural Property* 25 (2018): 283–321.

GIULIANI 2013
Giuliani, Luca. *Image and Myth: A History of Pictorial Narration in Greek Art.* Translated by Joseph O'Donnell. Chicago: University of Chicago Press, 2013.

GIULIERINI AND GIACCO 2019
Giulierini, Paolo, and Marialucia Giacco. *La collezione Magna Grecia*. Naples: Museo Archeologico Nazionale di Napoli, 2019.

GOLTE 1994
Golte, Jürgen. *Iconos y narraciones: La reconstrucción de una secuencia de imágenes moche*. Lima: Instituto de Estudios Peruanos, 1994.

GOLTE 2009
Golte, Jürgen. *Moche: Cosmología y sociedad; Una interpretación iconográfica*. Lima: Instituto de Estudios Peruanos, 2009.

GONZÁLEZ CRUZ AND ANGUIANO 1984
González Cruz, Genaro, and Marina Anguiano. "La historia de Tamakastsiin." *Estudios de cultura nahuatl* 17 (1984): 205–25.

GONZÁLEZ PÉREZ 2013
González Pérez, Damián. "De naguales y culebras: Entidades sobrenaturales y 'guardianes de los pueblos' en el sur de Oaxaca." *Anales de antropología* 47, no. 1 (2013): 31–55.

GORDON AND MASON 1925–43
Gordon, George Byron, and J. Alden Mason. *Examples of Maya Pottery in the Museum and Other Collections*. 3 vols. Philadelphia: University Museum, 1925–43.

GRANT 2006
Grant, Lynn A. *The Maya Vase Conservation Project*. Philadelphia: University of Pennsylvania Museum of Archaeology and Anthropology, 2006.

GRUBE 2004
Grube, Nikolai. "El origen de la dinastía Kaan." In *Los cautivos de Dzibanché*, edited by Enrique Nalda, 117–31. Mexico City: Instituto Nacional de Antropología e Historia, 2004.

GRUBE 2013
Grube, Nikolai. "The Parentage of 'Dark Sun' of Tikal." *Mexicon* 35 (December 2013): 130–33.

GRUBE AND KERR 1998
Grube, Nikolai, and Justin Kerr. "Two Sides of a Quadrangular Polychrome Classic Maya Vase." *Mexicon* 20, no. 1 (February 1998): 1–2.

GRUBE AND NAHM 1994
Grube, Nikolai, and Werner Nahm. "A Census of Xibalba: A Complete Inventory of *Way* Characters on Maya Ceramics." In Kerr and Kerr 1989–2000, vol. 4, 686–715.

GRUBE ET AL. 2012
Grube, Nikolai, Kai Delvendahl, Nicolaus Seefeld, and Beniamino Volta. "Under the Rule of the Snake Kings: Uxul in the 7th and 8th Centuries." *Estudios de cultura maya* 40 (2012): 11–49.

GRUBE ET AL. 2022
Grube, Nikolai, Elisabeth Wagner, Christian Prager, Marie Botzet, and Guido Krempel. "Pecking a New Stela: A Reading Proposal for Sign 1927st as T'OJ." *Textdatenbank und Wörterbuch des Klassischen Maya: Research Note* 26 (2022). https://classicmayan.org/portal/doc/215.

GUAMAN POMA DE AYALA 1615–16
Guaman Poma de Ayala, Felipe. *El primer nueva corónica y buen gobierno*, 1615–16. Royal Library, Copenhagen. The Guaman Poma Website. http://www.kb.dk/permalink/2006/poma/info/en/frontpage.htm.

HALL ET AL. 1990
Hall, Grant D., Stanley M. Tarka Jr., W. Jeffrey Hurst, David S. Stuart, and Richard E. W. Adams. "Cacao Residues in Ancient Maya Vessels from Rio Azul, Guatemala." *American Antiquity* 55, no. 1 (1990): 138–43.

HASAKI 2021
Hasaki, Eleni. *Potters at Work in Ancient Corinth: Industry, Religion, and the Penteskouphia Plaques*. Princeton, NJ: Princeton University Press, 2021.

HASAKI AND BENTZ 2020
Hasaki, Eleni, and Martin Bentz, eds. *Reconstructing Scales of Production in the Ancient Greek World: Producers, Processes, Products, People; Panel 3.4*. Vol. 8 of *Archaeology and Economy in the Ancient World*. Heidelberg: Propylaeum, 2020.

HEDREEN 1992
Hedreen, Guy M. *Silens in Attic Black-Figure Vase-Painting: Myth and Performance*. Ann Arbor: University of Michigan Press, 1992.

HEDREEN 1994
Hedreen, Guy M. "Silens, Nymphs, and Maenads." *Journal of Hellenic Studies* 114 (1994): 47–69.

HEDREEN 1996
Hedreen, Guy M. "Image, Text, and Story in the Recovery of Helen." *Classical Antiquity* 15, no. 1 (1996): 152–84.

HEDREEN 2001
Hedreen, Guy M. *Capturing Troy: The Narrative Functions of Landscape in Archaic and Early Classical Greek Art*. Ann Arbor: University of Michigan Press, 2001.

HEDREEN 2016a
Hedreen, Guy. *The Image of the Artist in Archaic and Classical Greece: Art, Poetry, and Subjectivity*. Cambridge: Cambridge University Press, 2016.

HEDREEN 2016b
Hedreen, Guy M. "'So-and-so καλή': A Reexamination." In Yatromanolakis 2016, 53–72.

HELMKE, HOGGARTH, AND AWE 2018
Helmke, Christophe, Julie A. Hoggarth, and Jaime J. Awe. *A Reading of the Komkom Vase Discovered at Baking Pot, Belize*. San Francisco: Precolumbia Mesoweb Press, 2018.

HELMKE AND NIELSEN 2009
Helmke, Christophe, and Jesper Nielsen. "Hidden Identity and Power in Ancient Mesoamerica: Supernatural Alter Egos as Personified Diseases." *Acta Americana* 17, no. 2 (2009): 49–98.

HEWITT 1999
Hewitt, Erika A. "What's in a Name? Gender, Power, and Classic Maya Women Rulers." *Ancient Mesoamerica* 10 (1999): 251–62.

HIRX AND O'NEIL 2022
Hirx, John W., and Megan E. O'Neil. "Building the Ceramic Vessel." In Magaloni and O'Neil 2022, 33–49.

HOCQUENGHEM 1987
Hocquenghem, Anne Marie. *Iconografía mochica*. Lima: Fondo Editorial, Pontificia Universidad Católica del Perú, 1987.

HOUSTON 1994
Houston, Stephen D. "Literacy among the Precolumbian Maya: A Comparative Perspective." In *Writing without Words: Alternative Literacies in Mesoamerica and the Andes*, edited by Elizabeth H. Boone and Walter D. Mignolo, 27–49. Durham, NC: Duke University Press, 1994.

HOUSTON 2009
Houston, Stephen D. "A Splendid Predicament: Young Men in Classic Maya Society." *Cambridge Archaeological Journal* 19, no. 2 (2009): 149–78.

HOUSTON 2012
Houston, Stephen D. "Painted Vessel." In Pillsbury et al. 2012, 314–21.

BIBLIOGRAPHY

HOUSTON 2016
Houston, Stephen D. "Crafting Credit: Authorship among Classic Maya Painters and Sculptors." In *Making Value, Making Meaning: Techné in the Pre-Columbian World*, edited by Cathy L. Costin, 391–431. Washington, DC: Dumbarton Oaks Research Library and Collection, 2016.

HOUSTON 2018
Houston, Stephen D. *The Gifted Passage: Young Men in Classic Maya Art and Text*. New Haven, CT: Yale University Press, 2018.

HOUSTON 2021
Houston, Stephen D. "Queenly Vases." *Maya Decipherment*, 2021. https://mayadecipherment.com /2021/04/30/queenly-vases/.

HOUSTON 2022
Houston, Stephen D. "Day, Night." In Chinchilla Mazariegos, Doyle, and Pillsbury 2022, 85–107.

HOUSTON AND MATSUMOTO 2019
Houston, Stephen D., and Mallory E. Matsumoto. "Molded Meaning." *Res: Anthropology and Aesthetics* 71–72 (2019): 1–5.

HOUSTON, ROBERTSON, AND STUART 2000
Houston, Stephen D., John Robertson, and David S. Stuart. "The Language of Classic Maya Inscriptions." *Current Anthropology* 41, no. 3 (2000): 321–56.

HOUSTON AND SCHERER 2020
Houston, Stephen D., and Andrew Scherer. "Maya Creatures IV: Why Do Dogs Dress Up?" *Maya Decipherment*, 2020. https://mayadecipherment.com /2020/07/07/maya-animalia-or-why -do-dogs-dress-up/.

HOUSTON AND STUART 1989
Houston, Stephen D., and David S. Stuart. *The Way Glyph: Evidence for "Co-essences" among the Classic Maya*. Washington, DC: Center for Maya Research, 1989.

HOUSTON AND TAUBE 1987
Houston, Stephen D., and Karl Taube. "'Name-Tagging' in Classic Mayan Script." *Mexicon* 9, no. 2 (May 1987): 38–41.

HOUSTON AND TAUBE 2008
Houston, Stephen D., and Karl Taube. "Meaning in Early Maya Imagery." In Taylor 2008a, 127–44.

HULL 2009
Hull, Kerry. "The Grand Ch'orti' Epic: The Story of the Kumix Angel." In Le Fort et al. 2009, 131–40.

HULL 2010
Hull, Kerry. "An Epigraphic Analysis of Classic-Period Maya Foodstuffs." In *Pre-Columbian Foodways: Interdisciplinary Approaches to Food, Culture, and Markets in Ancient Mesoamerica*, edited by John E. Staller and Michael Carrasco, 235–55. New York: Springer, 2010.

HURWIT 2015
Hurwit, Jeffrey M. *Artists and Signatures in Ancient Greece*. Cambridge: Cambridge University Press, 2015.

ICHON 1973
Ichon, Alain. *La religión de los Totonacas de la Sierra*. Mexico City: Instituto Nacional Indigenista, 1973.

IOZZO 2018
Iozzo, Mario. "Hidden Inscriptions on Athenian Vases." *American Journal of Archaeology* 122 (2018): 397–410.

ISHIHARA, TAUBE, AND AWE 2006
Ishihara, Reiko, Karl A. Taube, and Jaime J. Awe. "The Water Lily Serpent Stucco Masks at Caracol, Belize." In *Archaeological Investigations in the Eastern Maya Lowlands: Papers of the 2005 Belize Archaeology Symposium*, edited by John Morris et al., 213–23. Belmopan, Belize: Institute of Archaeology, National Institute of Culture and History, 2006.

JACKSON 2008
Jackson, Margaret. *Moche Art and Visual Culture in Ancient Peru*. Albuquerque: University of New Mexico Press, 2008.

JUNKER 2012
Junker, Klaus. *Interpreting the Images of Greek Myths*. Translated by Annemarie Künzl-Snodgrass and Anthony Snodgrass. Cambridge: Cambridge University Press, 2012.

JUST 2009
Just, Bryan. "Mysteries of the Maize God." *Record of the Princeton University Art Museum* 68 (2009): 3–15.

JUST 2012
Just, Bryan. *Dancing into Dreams: Maya Vase Painting of the Ik' Kingdom*. With contributions by Christina T. Halperin, Antonia E. Foias, and Sarah Nunberg. Exh. cat. Princeton, NJ: Princeton University Art Museum, 2012.

KALTSAS AND SHAPIRO 2008
Kaltsas, Nikolaos, and H. Alan Shapiro, eds. *Worshipping Women: Ritual and Reality in Classical Athens*. Exh. cat. New York: Alexander S. Onassis Public Benefit Foundation in collaboration with the National Archaeological Museum, Athens, 2008.

KARTTUNEN 1994
Karttunen, Frances. *Between Worlds: Interpreters, Guides and Survivors*. New Brunswick, NJ: Rutgers University Press, 1994.

KÉI 2018
Kéi, Nikolina. "Beneath the Handles of Attic Vases." In Dietrich and Squire 2018, 143–66.

KENNEDY 2014
Kennedy, Rebecca Futo. *Immigrant Women in Athens: Gender, Ethnicity, and Citizenship in the Classical City*. New York: Routledge, 2014.

KERR ca. 2000
Kerr, Justin. *Maya Vase Database: An Archive of Rollout Photographs Created by Justin Kerr*. www.mayavase.com.

KERR AND KERR 1989–2000
Kerr, Justin, and Barbara Kerr. *The Maya Vase Book: A Corpus of Rollout Photographs of Maya Vases*. 6 vols. New York: Kerr and Associates, 1989–2000.

KNIGHT 2013
Knight, Vernon James, Jr. *Iconographic Method in New World Prehistory*. Cambridge: Cambridge University Press, 2013.

KOCKELMAN 2009
Kockelman, Paul. "Inalienable Possessions as Grammatical Category and Discourse Pattern." *Studies in Language* 33 (2009): 25–68.

KOONS 2012
Koons, Michele L. "Moche Geopolitical Networks and the Dynamic Role of Licapa II, Chicama Valley, Peru." PhD diss., Harvard University, 2012.

KOVACEVICH 2017
Kovacevich, Brigitte. "The Value of Labor: How the Production Process Added Value to Pre-Columbian Maya Jade." In *The Value of Things: Prehistoric to Contemporary Commodities in the Maya Region*, edited by Jennifer P. Mathews and Thomas H. Guderjan, 17–29. Tucson: University of Arizona Press, 2017.

KREMPEL AND MATTEO 2012
Krempel, Guido, and Sebastian Matteo. "Painting Styles of the North-Eastern Petén from a Local Perspective: The Palace Schools of Yax We'en Chan K'inich, Lord of Xultun." In *Proceedings of the 1st Cracow Maya Conference: Archaeology and Epigraphy of the Eastern Central Maya Lowlands*, edited by Christophe Helmke and Jarosław Źrałka. Special issue, *Contributions in New World Archaeology* 3 (2012): 135–72.

KUNZE 2022
Kunze, Christian. "Der Alltag der Heroen: Zur Brettspielervase des Exekias." In *Exekias und seine Welt: Tagung an der Universität Zürich vom 1.–2. März 2019*, edited by Christoph Reusser and Martin Bürge, 71–94. Rahden, Germany: Verlag Marie Leidorf, 2022.

KUTSCHER 1954
Kutscher, Gerdt. *Nordperuanische Keramik*. Berlin: Mann, 1954.

LA FOLLETTE 2017
La Follette, Laeticia. "Looted Antiquities, Art Museums and Restitution in the United States since 1970." *Journal of Contemporary History* 52, no. 3 (2017): 669–89.

LANGRIDGE-NOTI 2015
Langridge-Noti, Elizabeth M. "'To Market, to Market': Pottery, the Individual, and Trade in Athens." In *Cities Called Athens: Studies Honoring John McK. Camp II*, edited by Kevin F. Daly and Lee Ann Riccardi, 165–95. Lewisburg, PA: Bucknell University Press, 2015.

LAPATIN 2008
Lapatin, Kenneth, ed. *Papers on Special Techniques in Athenian Vases*. Los Angeles: J. Paul Getty Museum, 2008.

LARCO HOYLE 1948
Larco Hoyle, Rafael. *Cronología arqueológica del norte del Perú*. Buenos Aires: Sociedad Geográfica Americana, 1948.

LARCO HOYLE 2001
Larco Hoyle, Rafael. *Los mochicas*. 2 vols. Lima: Museo Arqueológico Rafael Larco Herrera, 2001.

LEAR AND CANTARELLA 2008
Lear, Andrew, and Eva Cantarella. *Images of Ancient Greek Pederasty: Boys Were Their Gods*. London: Routledge, 2008.

LE FORT ET AL. 2009
Le Fort, Geneviève, Raphaël Gardiol, Sebastian Matteo, and Christophe Helmke, eds. *The Maya and Their Sacred Narratives: Text and Context in Maya Mythologies*. Markt Schwaben, Germany: Verlag Anton Saurwein, 2009.

LIESKE 1992
Lieske, Bärbel. *Mythische Bilderzählungen in den Gefäßmalereien der alterperuanischen Moche-Kultur: Versuch einer ikonographischen Rekonstruktion*. Bonn: Holos, 1992.

LISSARRAGUE 1992
Lissarrague, François. "*Graphein*: Écrire et dessiner." In *Image en jeu: De l'antiquité à Paul Klee*, edited by Christian Bron and Effy Kassapoglou, 189–203. Lausanne: Institut d'archéologie et d'histoire ancienne, Université de Lausanne; Yens-sur-Morge: Éditions Cabédita, 1992.

LISSARRAGUE 1999
Lissarrague, François. "Publicity and Performance: *Kalos* Inscriptions in Attic Vase-Painting." In *Performance Culture and Athenian Democracy*, edited by Simon D. Goldhill and Robin Osborne, 359–73. Cambridge: Cambridge University Press, 1999.

LISSARRAGUE 2013
Lissarrague, François. *La cité des satyres: Une anthropologie ludique (Athènes VIe–Ve siècles avant J.-C)*. Paris: École des hautes études en sciences sociales, 2013.

LISSARRAGUE 2015
Lissarrague, François. "Ways of Looking at Greek Vases." In *A Companion to Ancient Aesthetics*, edited by Pierre Destrée and Penelope Murray, 237–47. Malden, MA: Wiley-Blackwell, 2015.

LOOPER 2002
Looper, Matthew G. "Ancient Maya Women-Men (and Men-Women): Classic Rulers and the Third Gender." In *Ancient Maya Women*, edited by Traci Ardren, 171–202. Walnut Creek, CA: AltaMira Press, 2002.

LOOPER, REENTS-BUDET, AND BISHOP 2009
Looper, Matthew G., Dorie Reents-Budet, and Ronald L. Bishop. "Dance on Classic Maya Ceramics." In *To Be Like Gods: Dance in Ancient Maya Civilization*, by Matthew G. Looper, 113–50. Austin: University of Texas Press, 2009.

LYNCH 2011
Lynch, Kathleen M. *The Symposium in Context: Pottery from a Late Archaic House near the Athenian Agora*. Princeton, NJ: Princeton University Press, 2011.

MACKAY 2010
Mackay, E. Anne. *Tradition and Originality: A Study of Exekias*. Oxford: Archaeopress, 2010.

MAGALONI AND O'NEIL 2022
Magaloni, Diana, and Megan E. O'Neil, eds. *The Science and Art of Maya Painted Ceramic Vessels: Contextualizing a Collection*. Los Angeles: Los Angeles County Museum of Art, 2022. https://archive.org/details/maya-painted-ceramic-vessels.

MAKOWSKI 1994
Makowski, Krzysztof. "Los señores de Loma Negra." In *Vicús*, edited by Krzysztof Makowski, Christopher B. Donnan, Iván Amaro Bullón, Luis Jaime Castillo, Magdalena Diez Canseco, Otto Elésperu Revoredo, and Juan Antonio Murra Mena, 83–141. Lima: Banco de Crédito del Perú, 1994.

MAKOWSKI 2000
Makowski, Krzysztof. "Las divinidades en la iconografía mochica." In *Los dioses del antiguo Perú*, by Krzysztof Makowski et al., vol. 1, 137–78. Lima: Banco de Crédito del Perú, 2000.

MAKOWSKI 2003
Makowski, Krzysztof. "La deidad suprema en la iconografía mochica: ¿Cómo definirla?" In *Moche: Hacia el final del milenio*, edited by Santiago Uceda and Elías Mujica, vol. 1, 343–81. Lima: Fondo Editorial, Pontificia Universidad Católica del Perú, 2003.

MAKOWSKI 2008a
Makowski, Krzysztof. "Poder e identidad étnica en el mundo moche." In Makowski 2008b, 55–76.

MAKOWSKI 2008b
Makowski, Krzysztof, ed. *Señores de los reinos de la luna*. Lima: Banco de Crédito del Perú, 2008.

MAKOWSKI 2022
Makowski, Krzysztof. "¿Uno (Aiapaec) o muchos? El debate sobre el panteón moche / One Deity (Aiapaec) or Many? The Debate on the Moche Pantheon." In *Dioses y creencias del Perú prehispánico / Gods and Beliefs of Prehispanic Peru*. Vol. 1, *Costa y sierra norte / Coast and the Northern Andes*, by Krzysztof Makowski, 293–491. Lima: Ernst & Young Consultores, 2022.

MANNACK 2014
Mannack, Thomas. "Beautiful Men on Vases for the Dead." In *Athenian Potters and Painters III*, edited by John H. Oakley, 116–24. Oxford: Oxbow Books, 2014.

MANNACK 2016
Mannack, Thomas. "*Hipparchos kalos*." In Yatromanolakis 2016, 43–52.

MARKIANOS-DANIOLOS 2021
Markianos-Daniolos, Dimitrios. "JOM: A Possible Reading for the 'Star War' Glyph?" *Textdatenbank und Wörterbuch des Klassischen Maya: Research Note* 25, 2021. https://doi.org/10.20376/IDIOM-23665556.21.rn025.en.

MARTIN 2006a
Martin, Simon. "Cacao in Ancient Maya Religion: First Fruit of the Maize Tree and Other Tales from the Underworld." In *Chocolate in Mesoamerica: A Cultural History of Cacao*, edited by Cameron McNeil, 154–83. Gainesville: University Press of Florida, 2006.

MARTIN 2006b

Martin, Simon. "On Pre-Columbian Narrative: Representation across the Word-Image Divide." In *A Pre-Columbian World*, edited by Mary E. Miller and Jeffrey Quilter, 55–96. Washington, DC: Dumbarton Oaks Research Library and Collection, 2006.

MARTIN 2008

Martin, Simon. "Wives and Daughters on the Dallas Altar." Mesoweb, 2008. www.mesoweb.com/articles/martin /Wives&Daughters.pdf.

MARTIN 2015

Martin, Simon. "The Old Man of the Maya Universe: A Unitary Dimension to Ancient Maya Religion." In *Maya Archaeology 3*, edited by Charles Golden, Stephen D. Houston, and Joel Skidmore, 186–227. San Francisco: Precolumbia Mesoweb Press, 2015.

MARTIN AND SKIDMORE 2012

Martin, Simon, and Joel Skidmore. "Exploring the 584286 Correlation between the Maya and European Calendars." *PARI Journal 13*, no. 2 (2012): 3–16.

MARTÍNEZ DE VELASCO CORTINA 2014

Martínez de Velasco Cortina, María Alejandra. "Cerámica funeraria maya: Las vasijas matadas." Master's thesis, Universidad Nacional Autónoma de México, 2014.

MARTÍNEZ GONZÁLEZ 2011

Martínez González, Roberto. *El nahualismo*. Mexico City: Universidad Nacional Autónoma de México, Instituto de Investigaciones Históricas, 2011.

MATHEWS 2001

Mathews, Peter. "Notes on the Inscription on the Back of Dos Pilas Stela 8." In *The Decipherment of Ancient Maya Writing*, edited by Stephen D. Houston, Oswaldo Chinchilla Mazariegos, and David S. Stuart, 394–415. Norman: University of Oklahoma Press, 2001.

MCCLELLAND 2008

McClelland, Donna. "*Ulluchu*: An Elusive Fruit." In Bourget and Jones 2008, 4–65.

MCCLELLAND, MCCLELLAND, AND DONNAN 2007

McClelland, Donna, Donald McClelland, and Christopher B. Donnan. *Moche Fineline Painting from San José de Moro*. Los Angeles: Cotsen Institute of Archaeology, University of California, Los Angeles, 2007.

MCEWAN 1997

McEwan, Colin. "Whistling Vessels from Pre-Hispanic Peru." In *Pottery in the Making*, edited by Ian Freestone and David Gaimster, 176–81. London: British Museum Press, 1997.

MERCER 1897

Mercer, Henry C. *The Kabal; or, Potter's Wheel of Yucatan*. Philadelphia: H. C. Mercer, 1897.

MERWIN AND VAILLANT 1932

Merwin, Raymond E., and George C. Vaillant. *The Ruins of Holmul, Guatemala*. Cambridge, MA: Peabody Museum Press, 1932.

MESKELL AND JOYCE 2003

Meskell, Lynn, and Rosemary Joyce. *Embodied Lives: Figuring Ancient Maya and Egyptian Experience*. London: Routledge, 2003.

MILLER 1989

Miller, Mary Ellen. "The History of the Study of Maya Vase Painting." In Kerr and Kerr 1989–2000, vol. 1, 128–45.

MILLER 2019

Miller, Mary Ellen. "Molding Maya Practice: Standardization and Innovation in the Making of Jaina Figurines." *Res: Anthropology and Aesthetics 71–72* (2019): 40–51.

MILLER 2022

Miller, Mary Ellen. "The Trouble with Sets: Renewing the Contexts of Maya Vases." In Magaloni and O'Neil 2022, 445–55.

MILLER AND MARTIN 2004

Miller, Mary Ellen, and Simon Martin. *Courtly Art of the Ancient Maya*. Exh. cat. San Francisco: Fine Arts Museums of San Francisco; New York: Thames & Hudson, 2004.

MONTANARO 2007

Montanaro, Andrea Celestino. *Ruvo di Puglia e il suo territorio: Le necropoli*. Rome: "L'Erma" di Bretschneider, 2007.

MONTEJO 2022

Montejo, Victor. "Indigenous Threatened Heritage in Guatemala." In *Cultural Heritage and Mass Atrocities*, edited by James Cuno and Thomas G. Weiss, 264–77. Los Angeles: Getty Publications, 2022. https://www.getty.edu/publications /cultural-heritage-mass-atrocities /part-2/15-montejo/.

MORENO ZARAGOZA 2013

Moreno Zaragoza, Daniel. "*Xi'bajob y wäyob*: Espíritus del mundo subterráneo; Permanencia y transformación del nahualismo en la tradición oral ch'ol de Chiapas." Master's thesis, Universidad Nacional Autónoma de México, 2013.

MUJICA 2007

Mujica, Elias, ed. *El Brujo: Huaca Cao, centro ceremonial moche en el valle de Chicama*. Lima: Fundación Wiese, 2007.

MÜNCH GALINDO 1992

Münch Galindo, Guido. "Acercamiento al mito y sus creadores." *Anales de antropología 29* (1992): 285–99.

MURRAY, CHORGHAY, AND MACPHERSON 2020

Murray, Sarah C., Irum Chorghay, and Jennifer MacPherson. "The Dipylon Mistress: Social and Economic Complexity, the Gendering of Craft Production, and Early Greek Ceramic Material Culture." *American Journal of Archaeology 124* (2020): 215–44.

NEER 1998

Neer, Richard T. "Imitation, Inscription, Antilogic." *Mètis: Anthropologie des mondes grecs anciens 13* (1998): 17–38.

NEER 2002

Neer, Richard T. *Style and Politics in Athenian Vase-Painting: The Craft of Democracy, ca. 530–460 B.C.E.* Cambridge: Cambridge University Press, 2002.

NEER 2012

Neer, Richard T. *Greek Art and Archaeology: A New History, c. 2500–c. 150 B.C.E.* New York: Thames & Hudson, 2012.

NEILS 1987

Neils, Jenifer. *The Youthful Deeds of Theseus*. Rome: Bretschneider, 1987.

NEILS AND ROGERS 2021

Neils, Jenifer, and Dylan K. Rogers. *The Cambridge Companion to Ancient Athens*. Cambridge: Cambridge University Press, 2021.

NEWMAN ET AL. 2015

Newman, Sarah, Stephen D. Houston, Thomas Garrison, and Edwin Román. "Outfitting a King." In *Temple of the Night Sun: A Royal Tomb at El Diablo, Guatemala*, by Stephen Houston et al., 85–179. San Francisco: Precolumbia Mesoweb Press, 2015.

NOBLE 1988

Noble, Joseph V. *The Techniques of Painted Attic Pottery*. Rev. ed. London: Thames & Hudson, 1988.

NØRSKOV 2002

Nørskov, Vinnie. *Greek Vases in New Contexts*. Aarhus, Denmark: Aarhus University Press, 2002.

NUNBERG 2012

Nunberg, Sarah. "New Insights from Conservation and Materials Analysis of Maya Vases at Princeton." In Just 2012, 220–36.

OAKLEY 2004

Oakley, John H. *Picturing Death in Classical Athens: The Evidence of the White Lekythoi*. Cambridge: Cambridge University Press, 2004.

OAKLEY 2013
Oakley, John H. *The Greek Vase: Art of the Storyteller.* Los Angeles: J. Paul Getty Museum, 2013.

OAKLEY 2020
Oakley, John H. *A Guide to Scenes of Daily Life on Athenian Vases.* Madison: University of Wisconsin Press, 2020.

OAKLEY AND SINOS 1993
Oakley, John H., and Rebecca H. Sinos. *The Wedding in Ancient Athens.* Madison: University of Wisconsin Press, 1993.

O'NEIL 2018
O'Neil, Megan E. *Forces of Nature: Ancient Maya Arts from the Los Angeles County Museum of Art.* Exh. cat. With contributions by Anthony J. Meyer and Michelle Rich. Beijing: Cultural Relics Press, 2018.

O'NEIL 2022a
O'Neil, Megan E. *The Maya.* London: Reaktion, 2022.

O'NEIL 2022b
O'Neil, Megan E. "Shaped Pots, Painted Surfaces: The Artistry of Ancient Maya Potters and Painters." In Magaloni and O'Neil 2022, 415–27.

O'NEIL AND HIRX 2022
O'Neil, Megan E., and John W. Hirx. "Insights into Maya Ceramic Techniques with Digital X-radiography." In Magaloni and O'Neil 2022, 27–31.

OROPEZA ESCOBAR 2007
Oropeza Escobar, Minerva. "Mitos cosmogónicos de las culturas indígenas de Veracruz." In *Relatos ocultos en la niebla y el tiempo: Selección de mitos y estudios*, edited by Blas Román Castellón Huerta, 163–259. Mexico City: Instituto Nacional de Antropología e Historia, 2007.

PADGETT 2017
Padgett, J. Michael, ed. *The Berlin Painter and His World.* Exh. cat. Princeton, NJ: Princeton University Art Museum, 2017.

PALEOTHODOROS 2004
Paleothodoros, Dimitris. *Epictétos.* Leuven: Éditions Peeters; Namur: Société des études classiques, 2004.

PANOFSKY 1939
Panofsky, Erwin. *Studies in Iconology: Humanistic Themes in the Art of the Renaissance.* New York: Oxford University Press, 1939.

PAPADOPOULOS 2003
Papadopoulos, John K. *Ceramicus Redivivus: The Early Iron Age Potters' Field in the Area of the Classical Agora.* Princeton, NJ: Princeton University Press 2003.

PEVNICK 2010
Pevnick, Seth D. "ΣΥΡΙΣΚΟΣ ΕΓΡΦΣΕΝ: Loaded Names, Artistic Identity, and Reading an Athenian Vase." *Classical Antiquity* 29 (2010): 222–49.

PEVNICK 2021
Pevnick, Seth D. "Lykos Kalos: Beyond Youthful Beauty." *Hesperia* 90, no. 4 (2021): 641–83.

PILLSBURY 2001
Pillsbury, Joanne, ed. *Moche Art and Archaeology in Ancient Peru.* Washington, DC: National Gallery of Art, 2001.

PILLSBURY AND TREVER 2008
Pillsbury, Joanne, and Lisa Trever. "The King, the Bishop, and the Creation of an American Antiquity." *Ñawpa Pacha* 29 (2008): 191–219.

PILLSBURY ET AL. 2012
Pillsbury, Joanne, Reiko Ishihara-Brito, Miriam Doutriaux, and Alexandre Tokovinine, eds. *Ancient Maya Art at Dumbarton Oaks.* Washington, DC: Dumbarton Oaks Research Library and Collection, 2012.

PLANT 2022
Plant, Ian. "Melõsa and Her Prize: The Victory of a Woman in Ancient Greece." *Gender and History.* https://onlinelibrary.wiley.com/doi/10.1111/1468-0424.12639

POLLITT 1987
Pollitt, Jerome J. "Pots, Politics, and Personifications in Early Classical Athens." *Yale University Art Gallery Bulletin* 40, no. 1 (1987): 8–15.

POMEROY ET AL. 2020
Pomeroy, Sarah B., Stanley M. Burstein, Walter Donlan, Jennifer Tolbert Roberts, David Tandy, and Georgia Tsvoula, eds. *A Brief History of Ancient Greece: Politics, Society and Culture.* 4th ed. New York: Oxford University Press, 2020.

QUENON AND LE FORT 1997
Quenon, Michel, and Geneviève Le Fort. "Rebirth and Resurrection in Maize God Iconography." In Kerr and Kerr 1989–2000, vol. 5, 884–99.

QUILTER 1990
Quilter, Jeffrey. "The Moche Revolt of the Objects." *Latin American Antiquity* 1, no. 1 (March 1990): 42–65.

QUILTER 1997
Quilter, Jeffrey. "The Narrative Approach to Moche Iconography." *Latin American Antiquity* 8, no. 2 (1997): 113–33.

QUILTER 2002
Quilter, Jeffrey. "Moche Politics, Religion, and Warfare." *Journal of World Prehistory* 16, no. 2 (2002): 145–95.

QUILTER 2010a
Quilter, Jeffrey. "Moche: Archaeology, Ethnicity, Identity." *Bulletin de l'Institut français d'études andines* 39, no. 2 (2010): 225–41.

QUILTER 2010b
Quilter, Jeffrey. *The Moche of Ancient Peru: Media and Messages.* Cambridge, MA: Peabody Museum Press, 2010.

QUILTER 2020
Quilter, Jeffrey. "Moche Mortuary Pottery and Culture Change." *Latin American Antiquity* 31, no. 3 (2020): 538–57.

QUILTER 2021
Quilter, Jeffrey. "Moche Pottery: Forms, Functions, and Social Change." *Ñawpa Pacha* 41, no. 2 (2021): 187–209.

QUILTER 2022
Quilter, Jeffrey. "Moche Representational Art." In *Image, Thought, and the Making of Social Worlds*, edited by David Wengrow, 139–62. Heidelberg: Propylaeum, 2022.

QUILTER AND CASTILLO 2010
Quilter, Jeffrey, and Luis Jaime Castillo, eds. *New Perspectives on Moche Political Organization.* Washington, DC: Dumbarton Oaks Research Library and Collection, 2010.

RECINOS 2001
Recinos, Adrián. *Crónicas indígenas de Guatemala.* Guatemala City: Academia de Geografía e Historia de Guatemala, 2001.

REEDER 1995
Reeder, Ellen D., ed. *Pandora: Women in Classical Greece.* Exh. cat. Baltimore: Trustees of the Walters Art Gallery, 1995.

REENTS-BUDET 1989
Reents-Budet, Dorie. "Narrative in Classic Maya Art." In *Word and Image in Maya Culture: Explorations in Language, Writing, and Representation*, edited by William F. Hanks and Don S. Rice, 189–97. Salt Lake City: University of Utah Press, 1989.

REENTS-BUDET 1994
Reents-Budet, Dorie. *Painting the Maya Universe: Royal Ceramics of the Classic Period.* Exh. cat. Durham, NC: Duke University Press in association with Duke University Museum of Art, 1994.

REENTS-BUDET 1998
Reents-Budet, Dorie. "Elite Maya Pottery and Artisans as Social Indicators." *Archaeological Papers of the American Anthropological Association* 8, no. 1 (1998): 71–89.

REENTS-BUDET AND BISHOP 2012
Reents-Budet, Dorie, and Ronald L. Bishop. "Classic Maya Painted Ceramics: Artisans, Workshops, and Distribution." In Pillsbury et al. 2012, 288–99.

REENTS-BUDET AND BISHOP 2023
Reents-Budet, Dorie, and Ronald L. Bishop. "Between a Rock and a Hard Spot: Museum Collections and Mesoamerican Archaeology." Paper presented at the 88th Annual Meeting of the Society for American Archaeology, Portland, OR, April 2, 2023.

REENTS-BUDET ET AL. 2012
Reents-Budet, Dorie, Stanley Guenter, Ronald L. Bishop, and M. James Blackman. "Identity and Interaction: Ceramic Styles and Social History of the Ik' Polity, Guatemala." In *Motul de San José: Politics, History, and Economy in a Classic Maya Polity*, edited by Antonia E. Foias and Kitty F. Emery, 67–93. Gainesville: University Press of Florida, 2012.

RENGIFO AND ROJAS VEGA 2008
Rengifo, Carlos, and Carol Rojas Vega. "Talleres especializados en el conjunto arqueológico Huacas de Moche: El carácter de los especialistas y su producción." In *Arqueología mochica: Nuevos enfoques*, edited by Luis Jaime Castillo, Hélène Bernier, Gregory Lockard, and Julio Rucabado, 325–39. Lima: Fondo Editorial, Pontificia Universidad Católica del Perú, and Instituto Francés de Estudios Andinos, 2008.

RESTALL 1997
Restall, Matthew. *The Maya World: Yucatec Culture and Society.* Stanford, CA: Stanford University Press, 1997.

RESTALL 1998
Restall, Matthew. *Maya Conquistador.* Boston: Beacon Press, 1998.

RICE 2009
Rice, Prudence M. "Late Classic Maya Pottery Production: Review and Synthesis." *Journal of Archaeological Method and Theory* 16, no. 2 (2009): 117–56.

RICHTER 1923
Richter, Gisela M. A. *The Craft of Athenian Pottery: An Investigation into the Technique of Black-Figured and Red-Figured Athenian Vases.* New Haven, CT: Yale University Press, 1923.

RICHTER AND MILNE 1935
Richter, Gisela M. A., and Marjorie Milne. *Shapes and Names of Athenian Vases.* New York: Plantin Press, 1935.

ROBERTSON 2011
Robertson, Merle Greene. "The Celestial God of Number 13." *PARI Journal* 12, no. 1 (Summer 2011): 1–6.

ROSAS 2017
Rosas, Marco. "La cultura mochica: Confrontando el modelo estatal con una perspectiva andina." In *Repensar el antiguo Perú: Aportes desde la arqueología*, edited by Rafael Vega Centeno, 183–213. Lima: IEP-PUCP, 2017.

ROSSI, SATURNO, AND HURST 2015
Rossi, Franco D., William A. Saturno, and Heather Hurst. "Maya Codex Book Production and the Politics of Expertise: Archaeology of a Classic Period Household at Xultun, Guatemala." *American Anthropologist* 117, no. 1 (2015): 116–32.

ROSSI AND STUART 2020
Rossi, Franco D., and David S. Stuart. "Stela 30: A New Window into Eighth Century Xultun." *Mexicon* 42 , no. 1 (February 2020): 12–15.

ROTROFF 2020
Rotroff, Susan. "New Contextual Evidence for the Introduction of Red-Figure." In *Innovations and Inventions in Athens c. 530 to 470 BCE: Two Crucial Generations*, edited by Marion Meyer and Gianfranco Adornato, 115–23. Vienna: Phoibos, 2020.

ROTROFF 2021
Rotroff, Susan. "The Ceramic Industry." In *The Cambridge Companion to Ancient Athens*, edited by Jenifer Neils and Dylan K. Rogers, 269–81. Cambridge: Cambridge University Press, 2021.

RUCABADO 2016
Rucabado, Julio. "(Re) Construyendo identidades: Los mochicas y sus vecinos." In *Moche y sus vecinos: Reconstruyendo identidades*, edited by Cecilia Pardo and Julio Rucabado, 22–55. Lima: Museo de Arte de Lima, 2016.

RUCABADO YONG 2020
Rucabado Yong, Julio. "Los otros, los 'no-Moche': Reflexiones en torno a la formación y representación de identidades colectivas." In *El arte antes de la historia: Para una historia del arte andino antiguo*, edited by Marco Curatola, Cecile Michaud, Joanne Pillsbury, and Lisa Trever, 259–90. Lima: Fondo Editorial, Pontificia Universidad Católica del Perú, 2020.

RUSSELL AND JACKSON 2001
Russell, Glenn S., and Margaret A. Jackson. "Political Economy and Patronage at Cerro Mayal, Peru." In Pillsbury 2001, 159–75.

SAM COLOP 2008
Sam Colop, Luis Enrique, trans. *Popol Wuj: Traducción al español y notas.* Guatemala City: Fundación Cholsamaj, 2008.

SANSONE 2017
Sansone, David. *Ancient Greek Civilization.* 3rd ed. Chichester, UK: John Wiley and Sons, 2017.

SAPIRSTEIN 2013
Sapirstein, Phillip. "Painters, Potters, and the Scale of the Attic Vase-Painting Industry." *American Journal of Archaeology* 117 (2013): 493–510.

SAPIRSTEIN 2020
Sapirstein, Phillip. "Productivity of Athenian Vase-Painters and Workshops." In Hasaki and Bentz 2020, 81–96.

SATURNO, TAUBE, AND STUART 2005
Saturno, William A., Karl A. Taube, and David S. Stuart. *The Murals of San Bartolo, El Petén, Guatemala.* Pt. 1, *The North Wall.* Barnardsville, NC: Center for Ancient American Studies, 2005.

SAUNDERS, TRENTELMAN, AND MAISH 2021
Saunders, David, Karen Trentelman, and Jeffrey Maish. "Collaborative Investigations into the Production of Athenian Pottery." In *New Approaches to Ancient Material Culture in the Greek and Roman World: Twenty-First Century Methods and Classical Antiquity*, edited by Catherine L. Cooper, 124–35. Leiden: Brill, 2021.

SCHELE AND MILLER 1986
Schele, Linda, and Mary Ellen Miller. *The Blood of Kings: Dynasty and Ritual in Maya Art.* Exh. cat. Fort Worth, TX: Kimbell Art Museum, 1986.

SCHELLHAS 1904
Schellhas, Paul. *Representations of Deities of the Maya Manuscripts*, translated by Selma Wesselhoeft and A. M. Parker. 2nd ed. Cambridge, MA: Peabody Museum of Archaeology and Ethnology and Harvard University, 1904.

SCHREIBER 1999
Schreiber, Toby. *Athenian Vase Construction: A Potter's Analysis.* Malibu, CA: J. Paul Getty Museum, 1999.

SCHULER-SCHÖMING 1979
Schuler-Schöming, Immina von. "Die 'Fremdkrieger' in Darstellungen der Moche–Keramik: Eine ikonographische Studie." *Baessler-Archiv*, n.s., 27 (1979): 135–213.

SCHULER-SCHÖMING 1981
Schuler-Schöming, Immina von. "Die sogenannten Fremdkrieger und ihre weiteren ikonographischen Bezüge in der Moche-Keramik." *Baessler-Archiv*, n.s., 29 (1981): 207–39.

SERVADEI 2005
Servadei, Cristina. *La figura di Theseus nella ceramica attica: Iconografia e iconología del mito nell'Atene arcaica e classica.* Bologna: Ante quem, 2005.

SHAPIRO 1994
Shapiro, H. Alan. *Myth into Art: Poet and Painter in Classical Greece.* London: Routledge, 1994.

SHARON AND DONNAN 1974
Sharon, Douglas, and Christopher B. Donnan. "Shamanism in Moche Iconography." In *Ethnoarchaeology*, edited by Christopher B. Donnan and C. William Clewlow Jr., 49–77. Los Angeles: Institute of Archaeology, University of California, 1974.

SHEPARD 1956
Shepard, Anna O. *Ceramics for the Archaeologist*. Washington, DC: Carnegie Institution of Washington, 1956.

SHESHEÑA 2010
Sheseña, Alejandro. "Los nombres de los naguales en la escritura jeroglífica maya: Religión y lingüística a través de la onomástica." *Journal of Mesoamerican Languages and Linguistics* 2, no. 1 (2010): 1–30.

SHIMADA 2010
Shimada, Izumi. "Moche Sociopolitical Organization: Rethinking the Data, Approaches, and Models." In Quilter and Castillo 2010, 70–82.

SILVER 2009
Silver, Vernon. *The Lost Chalice: The Epic Hunt for a Priceless Masterpiece*. New York: William Morrow, 2009.

SIMON 1997
Simon, Erika. "Silenoi." *Lexicon Iconographicum Mythologiae Classicae* 8 (1997): 1108–33.

SLATER 1999
Slater, Niall W. "The Vase as Ventriloquist: *Kalos*-Inscriptions and the Culture of Fame." In *Signs of Orality: The Oral Tradition and Its Influence in the Greek and Roman World*, edited by Anne MacKay, 143–61. Leiden: Brill, 1999.

SMALL 2003
Small, Jocelyn Penny. *The Parallel Worlds of Classical Art and Text*. Cambridge: Cambridge University Press, 2003.

DE SMET 1985
De Smet, Peter A. G. M. *Ritual Enemas and Snuffs in the Americas*. Amsterdam: Centrum voor Studie en Documentatie van Latijns Amerika, 1985.

SMITH 1932
Smith, A. Ledyard. "Two Recent Ceramic Finds at Uaxactun." *Contributions to American Archaeology* 2, no. 5: 1–25. Washington, DC: Carnegie Institution of Washington, 1932.

SNODGRASS 1998
Snodgrass, Anthony. *Homer and the Artists: Text and Picture in Early Greek Art*. Cambridge: Cambridge University Press, 1988.

SNODGRASS 2000
Snodgrass, Anthony. "The Uses of Writing on Early Greek Painted Pottery." In *Word and Image in Ancient Greece*, edited by N. Keith Rutter and Brian A. Sparkes, 22–34. Edinburgh: Edinburgh University Press, 2000.

SQUIRE 2009
Squire, Michael. *Image and Text in Graeco-Roman Antiquity*. Cambridge: Cambridge University Press, 2009.

SQUIRE 2016
Squire, Michael. "Introductory Reflections: Making Sense of Ancient Sight." In *Sight and the Ancient Senses*, edited by Michael Squire, 1–35. London: Routledge, 2016.

SQUIRE 2018
Squire, Michael. "'To haunt, to startle, and way-lay': Approaching ornament and figure in Graeco-Roman art." In Dietrich and Squire 2018, 1–41.

STAMPOLIDIS AND OIKONOMOU 2014
Stampolidis, Nikolaos, and Stavroula Oikonomou, eds. *Beyond: Death and Afterlife in Ancient Greece*. Exh. cat. Athens: Museum of Cycladic Art and Onassis Foundation, 2014.

STANSBURY-O'DONNELL 1999
Stansbury-O'Donnell, Mark. *Pictorial Narrative in Ancient Greek Art*. Cambridge: Cambridge University Press, 1999.

STANSBURY-O'DONNELL 2011
Stansbury-O'Donnell, Mark. *Looking at Greek Art*. Cambridge: Cambridge University Press, 2011.

STANSBURY-O'DONNELL 2015
Stansbury-O'Donnell, Mark. *A History of Greek Art*. Chichester, UK: John Wiley and Sons, 2015.

STISSI 2012
Stissi, Vladimir. "Giving the Kerameikos a Context: Ancient Greek Potters' Quarters as Part of the Polis Space, Economy and Society." In *"Quartiers" artisanaux en Grèce ancienne: Une perspective méditer-ranéenne*, edited by Arianna Esposito and Giorgos M. Sanidas, 201–30. Villeneuve d'Ascq: Presses universitaires du Septentrion, 2012.

STISSI 2016
Stissi, Vladimir. "Minor Artisans, Major Impact?" In *Töpfer Maler Werkstatt: Zuschreibungen in der griechischen Vasenmalerei und die Organisation antiker Keramikproduktion*, edited by Norbert Eschbach and Stefan Schmidt, 54–68. Munich: Verlag C. H. Beck, 2016.

STISSI 2020
Stissi, Vladimir. "From Counting Pots to Counting People: Assessing the Scale of Athenian Pottery Production and Its Impact on Workshop Staff." In Hasaki and Bentz 2020, 97–108.

STOCKETT 2005
Stockett, Miranda K. "On the Importance of Difference: Re-envisioning Sex and Gender in Ancient Mesoamerica." *World Archaeology* 37, no. 4 (2005): 566–78.

STONE AND ZENDER 2011
Stone, Andrea, and Marc Zender. *Reading Maya Art: A Hieroglyphic Guide to Ancient Maya Painting and Sculpture*. New York: Thames & Hudson, 2011.

STUART 1998
Stuart, David S. "'The Fire Enters His House': Architecture and Ritual in Classic Maya Texts." In *Function and Meaning in Classic Maya Architecture*, edited by Stephen D. Houston, 373–425. Washington, DC: Dumbarton Oaks Research Library and Collection, 1998.

STUART 2005
Stuart, David S. "Glyphs on Pots: Decoding Classic Maya Ceramics." In *Sourcebook for the 29th Maya Meetings at Texas*, n.p. Austin: University of Texas, 2005.

STUART 2006a
Stuart, David S. "Jade and Chocolate: Bundles of Wealth in Classic Maya Economics and Ritual." In *Ritual Acts of Wrapping and Binding in Mesoamerica*, edited by Julia Guernsey and F. Kent Reilly, 127–44. Barnardsville, NC: Boundary End Archaeology Research Center, 2006.

STUART 2006b
Stuart, David S. "The Language of Chocolate: References to Cacao on Classic Maya Drinking Vessels." In *Chocolate in Mesoamerica: The Cultural History of Cacao*, edited by Cameron McNeil, 184–201. Gainesville: University Press of Florida, 2006.

TAPLIN 2007
Taplin, Oliver. *Pots and Plays: Interactions between Tragedy and Greek Vase-Painting of the Fourth Century B.C.* Los Angeles: J. Paul Getty Museum, 2007.

TASCHEK AND BALL 1992
Taschek, Jennifer T., and Joseph W. Ball. "Lord Smoke-Squirrel's Cacao Cup: The Archaeological Context and Socio-Historical Significance of the Buenavista 'Jauncy Vase.'" In Kerr and Kerr 1989–2000, vol. 3, 490–97.

TAUBE 1985
Taube, Karl A. "The Classic Maya Maize God: A Reappraisal." In *Fifth Palenque Round Table, 1983*, edited by Virginia M. Fields, 171–81. San Francisco: Pre-Columbian Art Research Institute, 1985.

TAUBE 1992
Taube, Karl A. *The Major Gods of Ancient Yucatan*. Washington, DC: Dumbarton Oaks Research Library and Collection, 1992.

TAUBE 2009
Taube, Karl A. "The Maya Maize God and the Mythic Origins of Dance." In Le Fort et al. 2009, 41–52.

TAUBE ET AL. 2010
Taube, Karl A., William Saturno, David S. Stuart, and Heather Hurst. *The Murals of San Bartolo, El Petén, Guatemala*. Pt. 2, *The West Wall*. Barnardsville, NC: Boundary End Archaeology Research Center, 2010.

TAYLOR 2008a
Taylor, Paul, ed. *Iconography without Texts*. London: Warburg Institute, 2008.

TAYLOR 2008b
Taylor, Paul. Introduction to Taylor 2008a, 1–14.

TEDLOCK 1996
Tedlock, Dennis, ed. and trans. *Popol Vuh: The Mayan Book of the Dawn of Life*. New York: Touchstone Books, 1996.

TOKOVININE AND BELIAEV 2013
Tokovinine, Alexandre, and Dmitri Beliaev. "People of the Road: Traders and Travelers in Ancient Maya Words and Images." In *Merchants, Markets, and Exchange in the Pre-Columbian World*, edited by Kenneth G. Hirth and Joanne Pillsbury, 169–200. Washington, DC: Dumbarton Oaks Research Library and Collection, 2013.

TOPPER 2012a
Topper, Kathryn. "Approaches to Reading Attic Vases." In *A Companion to Women in the Ancient World*, edited by Sharon L. James and Sheila Dillon, 141–52. Malden, MA: Wiley-Blackwell, 2012.

TOPPER 2012b
Topper, Kathryn. *The Imagery of the Athenian Symposium*. Cambridge: Cambridge University Press, 2012.

TOSTO 1999
Tosto, Vincent. *The Black-Figure Pottery Signed "Nikosthenesepoiesen."* Amsterdam: Allard Pierson Museum, 1999.

TREVER 2017
Trever, Lisa. *The Archaeology of Mural Painting at Pañamarca, Peru*. Washington, DC: Dumbarton Oaks Research Library and Collection, 2017.

TREVER 2022
Trever, Lisa. *Image Encounters: Moche Murals and Archaeo Art History*. Austin: University of Texas Press, 2022.

TRIK 1963
Trik, Aubrey S. "The Splendid Tomb of Temple I at Tikal, Guatemala." *Expedition* 6, no. 1 (1963): 2–18.

TURNER 2015
Turner, Andrew D. *Sex, Metaphor, and Ideology in Moche Pottery of Ancient Peru*. Oxford: Archaeopress, 2015.

UCEDA 2008
Uceda, Santiago. "The Priests of the Bicephalus Arc: Tombs and Effigies Found in Huaca de la Luna and Their Relation to Moche Rituals." In Bourget and Jones 2008, 153–78.

UCEDA AND ARMAS 1998
Uceda, Santiago, and José Armas. "An Urban Pottery Workshop at the Site of Moche, North Coast of Peru." In *Andean Ceramics: Technology, Organization, and Approaches*, edited by Izumi Shimada, 91–110. Philadelphia: University of Pennsylvania Museum of Archaeology and Anthropology, 1998.

UCEDA, MORALES, AND MUJICA 2016
Uceda, Santiago, Ricardo Morales, and Elías Mujica. *Huaca de la Luna: Templos y dioses moches*. Lima: World Monuments Fund Perú, 2016.

VALDÉS 2006
Valdés, Juan Antonio. "Management and Conservation of Guatemala's Cultural Heritage: A Challenge to Keep History Alive." In *Art and Cultural Heritage: Law, Policy, and Practice*, edited by Barbara T. Hoffman, 94–99. Cambridge: Cambridge University Press, 2006.

VELÁSQUEZ GARCÍA 2009
Velásquez García, Erik. "Reflections on the Codex Style and the Princeton Vessel." *PARI Journal* 10, no. 1 (2009): 1–16.

VELÁSQUEZ GARCÍA 2010
Velásquez García, Erik. "Los dioses remeros mayas y sus posibles contrapartes nahuas." In *The Maya and Their Neighbors: Internal and External Contacts through Time*, edited by Laura van Broekhoven, Rogelio Valencia Rivera, Benjamin Vis, and Frauke Sachse, 115–31. Markt Schwaben, Germany: Verlag Anton Saurwein, 2010.

VELÁSQUEZ GARCÍA AND GARCÍA BARRIOS 2018
Velásquez García, Erik, and Ana García Barrios. "El título *Chatahn winik* en la sociedad maya del periodo clásico." In *El gobernante en Mesoamérica: Representaciones y discursos del poder*, edited by María Elena Vega Villalobos and Miguel Pastrana Flores, 39–84. Mexico City: Instituto de Investigaciones Históricas, Universidad Nacional Autónoma de México, 2018.

VILLING 2021
Villing, Alexandra. "Cross-cultural Communication in Context: East Greek 'Egyptianising' Vessels in 6th Century BC Egypt." In *Griechische Vasen als Medium für Kommunikation: Ausgewählte Aspekte*, edited by Claudia Lang-Auinger and Elisabeth Trinkl, 277–94. Vienna: Verlag der Österreichischen Akademie der Wissenschaften, 2021.

VOGT AND STUART 2005
Vogt, Evon Z., and David S. Stuart. "Some Notes on Ritual Caves among the Ancient and Modern Maya." In *In the Maw of the Earth Monster: Mesoamerican Ritual Cave Use*, edited by James E. Brady and Keith M. Prufer, 155–85. Austin: University of Texas Press, 2005.

WAGNER-DURAND, FATH, AND HEINEMANN 2019
Wagner-Durand, Elisabeth, Barbara Fath, and Alexander Heinemann, eds. *Image—Narration—Context: Visual Narration in Cultures and Societies of the Old World*. Heidelberg: Propylaeum, 2019.

WATSON AND TODESCHINI 2007
Watson, Peter, and Cecilia Todeschini. *The Medici Conspiracy: The Illicit Journey of Looted Antiquities from Italy's Tomb Raiders to the World's Greatest Museums*. New York: Public Affairs, 2007.

WEBSTER 1972
Webster, Thomas B. L. *Potter and Patron in Classical Athens*. London: Methuen, 1972.

WEISMANTEL 2012
Weismantel, Mary. "Obstinate Things." In *The Archaeology of Colonialism: Intimate Encounters and Sexual Effects*, edited by Barbara L. Voss and Eleanor Conlin Casella, 303–20. Cambridge: Cambridge University Press, 2012.

WEISMANTEL 2021
Weismantel, Mary. *Playing with Things: Engaging the Moche Sex Pots*. Austin: University of Texas Press, 2021.

WILLIAMS 1980

Williams, Dyfri. "Ajax, Odysseus and the Arms of Achilles." *Antike Kunst* 23 (1980): 137–45.

WILLIAMS 2009

Williams, Dyfri. "Picturing Potters and Painters." In *Athenian Potters and Painters II*, edited by John H. Oakley and Erika Simon, 306–17. Oxford: Oxbow Books, 2009.

WILLIAMS 2013

Williams, Dyfri. "Greek Potters and Painters: Marketing and Movement." In *Pottery Markets in the Ancient Greek World (8th–1st Centuries B.C.): Proceedings of the International Symposium Held at the Université libre de Bruxelles, 19–21 June 2008*, edited by Athena Tsingarida and Didier Viviers, 39–60. Brussels: CReA-Patrimoine, 2013.

WILLIAMS 2017

Williams, Dyfri. "Beyond the Berlin Painter: Toward a Workshop View." In Padgett 2017, 144–87.

WOŁOSZYN 2008

Wołoszyn, Janusz. *Los rostros silenciosos: Los huacos retrato de la cultura moche.* Lima: Fondo Editorial, Pontificia Universidad Católica del Perú, 2008.

WOŁOSZYN 2021

Wołoszyn, Janusz. *Enemy—Stranger—Neighbour: The Image of the Other in Moche Culture.* Oxford: Archaeopress, 2021.

YAN 2002

Yan, Yunxiang. "Unbalanced Reciprocity: Asymmetrical Gift Giving and Social Hierarchy in Rural China." In *The Question of the Gift: Essays across Disciplines*, edited by Mark Osteen, 6–84. London: Routledge, 2002.

YATROMANOLAKIS 2016

Yatromanolakis, Dimitrios, ed. *Epigraphy of Art: Ancient Greek Vase-Inscriptions and Vase-Paintings.* Oxford: Archaeopress, 2016.

ZAPHIROPOULOU 2006

Zaphiropoulou, Photini N. "Geometric Battle Scenes on Vases from Paros." In *Pictorial Pursuits: Figurative Painting on Mycenaean and Geometric Pottery; Papers from Two Seminars at the Swedish Institute at Athens in 1999 and 2001*, edited by Eva Rystedt and Berit Wells, 271–77. Stockholm: Svenska Institutet i Athen, 2006.

ZEVALLOS QUIÑONES 1994

Zevallos Quiñones, Jorge. *Huacas y huaqueros en Trujillo durante el virreinato, 1535–1835.* Trujillo, Peru: Editora Normas Legales, 1994.

ILLUSTRATION CREDITS

Plate 1: Museo Santiago Uceda Castillo

Plates 2, 11: Toledo Art Museum / Photo: Richard Goodbody, New York

Plates 3, 13, 14, 18, 46; figs. 6, 11, 57; page 110: www.metmuseum.com, CC0

Plates 4, 33, 37; figs. 3, 25c, 83: www.lacma.org, CC0

Plate 5; fig. 25b: © Dumbarton Oaks, Pre-Columbian Collection, Washington, DC

Plates 7, 8; fig. 47: © President and Fellows of Harvard College

Plate 9; figs. 46, 55, 59: Photo: © 2024 Museum of Fine Arts, Boston

Plates 10, 30, 45: © The Trustees of the British Museum

Plates 17, 28: Ministerio de Cultura, Museo Nacional de Arqueología, Antropología e Historia del Perú, Lima / Museo Cao

Plate 19: The Art Institute of Chicago / Art Resource, NY

Plates 20, 25: Fowler Museum at UCLA / Photo: Donald Cordy

Plate 21: Museo Larco, Lima—Perú, ML013653

Plate 22; figs. 2, 20, 75; page 122: www.artic.edu, CC0

Plate 23: American Museum of Natural History, Courtesy of the Division of Anthropology

Plates 24, 26; fig. 53: Photo: Christopher Donnan / Moche Archive, Dumbarton Oaks, Trustees for Harvard University, Washington, DC

Plate 27: Museo Larco, Lima—Perú, ML013610

Plate 29: Museo Larco, Lima—Perú, ML003115

Plates 31, 40: © Authorized reproduction Ministerio de Cultura y Deportes de Guatemala / Museum de Arqueología y Etnología / Photo: Jorge Pérez de Lara

Plate 32: Colección del Museo Popol Vuh, Universidad Francisco Marroquín, Guatemala / Photo: Jorge Pérez de Lara

Plate 34: © Authorized reproduction Ministerio de Cultura y Deportes de Guatemala / Museo de Arqueología y Etnología / Photo: Bridgeman Images

Plate 35; figs. 24, 26a, 27, 31, 54; page 131 (bottom): Digital Image © 2024 Museum Associates / LACMA / Licensed by Art Resource, NY

Plate 36: © D. R. Secretaría de Cultura-INAH-MEX. Archivo Digital de las Colecciones del Museo Nacional de Antropología / INAH-CANON

Plates 38, 39, 41; fig. 25a; page 131 (top): Princeton University Art Museum / Art Resource, NY

Plate 42: Colección del Museo Popol Vuh, Universidad Francisco Marroquín, Guatemala / Photo: Eduardo Sacayón

Plate 43; fig. 26b: © D. R. Secretaría de Cultura-INAH-MEX / Ignacio Guevara

Plate 44: Photo courtesy Ancient Americas at LACMA (ancientamericas.org) / Photo: Yosi Pozeilov

Fig. 4: © Heather Hurst

Figs. 5, 17; figs. 35, 48–50, 52, 63–65, 67, 68, 70, 72, 76–78: Drawing by Donna McClelland / Moche Archive, Dumbarton Oaks, Trustees for Harvard University, Washington, DC

Fig. 7: © Secretaría de Cultura – INAH-FN-MEX-MID 77_20140827-134500:416098

Figs. 8, 14, 21: David Fuller

Fig. 9: ©searagen / 123RF.com

Fig. 10: Wikimedia Commons, CC BY-SA 2.0 / Photo: Dronepicr

Fig. 12: Ephorate of Antiquities of Athens-Ancient Agora / Ancient Agora Excavations / American School of Classical Studies / © Hellenic Ministry of Culture / Organization of Cultural Resources Development (H.O.C.RE.D.)

Fig. 15: Sébastien Lecocq / Alamy Stock Photo

Fig. 16: Image courtesy of Fundación Augusto N. Wiese

Fig. 18: Photo: Andrew D. Turner

Fig. 19: Gift of Friends of the Museum, 1916. Courtesy of the Peabody Museum of Archaeology and Ethnology, Harvard University, 16-62-30/F728

Figs. 22, 33, 40, 41, 43: Photo: Justin Kerr / Justin Kerr Maya Archive, Dumbarton Oaks, Trustees for Harvard University, Washington, TC

Fig. 23: Diego Grandi / Alamy Stock Photo

Fig. 28: With kind permission by Prof. Dr. N. Grube

Fig. 29: © Authorized reproduction Ministerio de Cultura y Deportes de Guatemala / Museo de Arqueología y Etnología / Courtesy of the Penn Museum, image #165114

Fig. 30: © Authorized reproduction Ministerio de Cultura y Deportes de Guatemala / Museo de Arqueología y Etnología / Photo: Justin Kerr / Justin Kerr Maya archive, Dumbarton Oaks, Trustees for Harvard University, Washington, DC

Fig. 32: With kind permission by Nicholas Hellmuth

Figs. 34, 37: Drawing by Andrew D. Turner

Fig. 36: National Museums in Berlin, Ethnological Museum / Claudia Obrocki

Fig. 38: Museo Larco, Lima—Perú, ML004358

Fig. 39: Ministerio de Cultura del Perú - Museo Nacional de Arqueología, Antropología e Historia del Perú

Fig. 42: Colección del Museo Popol Vuh, Universidad Francisco Marroquín, Guatemala / Photo: Nicholas Hellmuth

Fig. 44: With kind permission by Prof. C. Helmke

Fig. 56: Princeton University, CC0

Fig. 58: Wikimedia Commons, CC BY-SA 4.0

Fig. 60: Scala / Art Resource, NY

Fig. 61: Williams College Archives and Special Collections

Fig. 62: © Phoebe A. Hearst Museum of Anthropology and the Regents of the University of California / Catalogue numbers: 4-3302, 4-3273, 4-3272

Fig. 66: Illustration by Wilhelm von den Steinen

Fig. 69: Museo de Arte de Lima / Photo: Daniel Giannoni

Fig. 71: Museo Larco, Lima—Perú, ML013653

Fig. 73: Drawing by Madeleine Fang / Moche Archive, Dumbarton Oaks, Trustees for Harvard University, Washington, DC

Fig. 74: Museo de Arte de Lima / Donación Petrus Fernandini / Photo: Daniel Giannoni

Fig. 79: Colección del Museo Popol Vuh, Universidad Francisco Marroquín, Guatemala / Photo: Justin Kerr

Figs. 80, 84: Drawing by Oswaldo Chinchilla Mazariegos

Figs. 81, 82: Drawings by Miss Annemarie Seuffert / Courtesy of the Penn Museum, image numbers: 63-5-83, 63-5-87

INDEX

This publication is issued on the occasion of the exhibition *Picture Worlds: Greek, Maya, and Moche Pottery*, on view at the J. Paul Getty Museum at the Getty Villa, Malibu, from April 10 to July 29, 2024, and the Michael C. Carlos Museum, Emory University, Atlanta, Georgia, from September 14 to December 15, 2024.

The exhibition is made possible through generous support from Jeffrey P. Cunard and the Getty Patron Program, and from Charles and Ellen Steinmetz in honor of Professor Christopher B. Donnan.

Published by the J. Paul Getty Museum, Los Angeles

Getty Publications
1200 Getty Center Drive, Suite 500
Los Angeles, California 90049–1682
getty.edu/publications

Rachel Barth, *Project Editor*
Jane Bobko, *Manuscript Editor*
Dani Grossman, *Designer*
Victoria Gallina, *Production*
Nancy Rivera, *Image and Rights Acquisition*

Distributed in the United States and Canada by the University of Chicago Press

Distributed outside the United States and Canada by Yale University Press, London

Printed in China

Library of Congress Cataloging-in-Publication Data
Names: Saunders, David, editor. | O'Neil, Megan E. (Megan Eileen), editor. | J. Paul Getty Museum, host institution, issuing body. | Michael C. Carlos Museum, host institution.
Title: Picture worlds : storytelling on Greek, Moche, and Maya pottery / edited by David Saunders and Megan E. O'Neil ; with contributions by Oswaldo Chinchilla Mazariegos, Iyaxel Cojti Ren, Guy Hedreen, Ulla Holmquist, Stephen Houston, Kathleen M. Lynch, Joanne Pillsbury, Jeffrey Quilter, Carlos Rengifo, Julio Rucabado, Mark Stansbury-O'Donnell, Andrew D. Turner, Elena Vega.
Description: Los Angeles : J. Paul Getty Museum, [2024] | Published on the occasion of the exhibition Picture Worlds: Greek, Maya, and Moche Pottery, on view at the J. Paul Getty Museum at the Getty Villa, Malibu, from April 10 to July 29, 2024, and the Michael C. Carlos Museum, Emory University, Atlanta, Georgia, from September 14 to December 15, 2024. | Includes bibliographical references and index. | Summary: "An introduction to and comparative study of the painted pottery of ancient Greece, Moche, and Maya"—Provided by publisher.
Identifiers: LCCN 2023036896 (print) | LCCN 2023036897 (ebook) | ISBN 9781606069059 (paperback) | ISBN 9781606069066 (adobe pdf)
Subjects: LCSH: Pottery, Ancient—Greece—Exhibitions. | Pottery, Ancient—Peru—Exhibitions. | Pottery, Ancient—Mexico—Exhibitions. | Pottery, Ancient—Central America—Exhibitions. | Pottery, Greek—Exhibitions. | Mochica pottery—Exhibitions. | Maya pottery—Exhibitions. | Painted pottery—Exhibitions. | Narrative art—Exhibitions.
Classification: LCC NK3800 .P53 2024 (print) | LCC NK3800 (ebook) | DDC 738.09—dc23/eng/20231120
LC record available at https://lccn.loc.gov/2023036896
LC ebook record available at https://lccn.loc.gov/2023036897

Front cover: Mixing Bowl with Theseus and Poseidon, 480–470 BCE (at left, detail, plate 8); Stirrup-Spout Vessel with Presentation of Conch Shells Scene, 500–800 CE (top right, detail, plate 21); Plate with Maize God Dancer, 600–700 CE (bottom right, detail, plate 40)

Back cover (top to bottom): Drinking Cup with a Shepherd and Cattle, 470–460 BCE (plate 46); Stirrup-Spout Vessel in the Shape of a Warrior Duck, 500–650 CE (plate 1); Lidded Bowl with Handle in the Form of a Howler Monkey, 250–400 CE (plate 31)

Page 3 (left to right): Oil Jar with Satyr and Sphinx, 425–420 BCE (plate 16); Stirrup-Spout Vessel with Sacrifice of Vultures, 500–800 CE (plate 29); Cylinder Vessel with Maize God Dancers and Companion, 650–750 CE (plate 35)

Pages 22–23 (left to right): Storage Jar with Achilles, Ajax, and Athena, ca. 510 BCE (detail, plate 12); Drinking Cup with a Shepherd and Cattle, 470–460 BCE (plate 46); Drinking Cup with the Deeds of Theseus, 440–430 BCE (detail, plate 10)

Pages 40–41 (left to right): Stirrup-Spout Vessel with Presentation of Conch Shells Scene, 500–800 CE (detail, plate 21); Stirrup-Spout Vessel with the Burial Theme, 650–800 CE (detail, plate 25); Flared Bowl with Combat Scenes, 500–800 CE (detail, fig. 36)

Pages 58–59 (left to right): Plate with the Rebirth of the Maize God, 600–800 CE (detail, plate 41); Cylinder Vessel with the Maize God and other Supernaturals, 600–700 CE (detail, plate 39); Plate with Maize God Dancer, 600–700 CE (detail, plate 40)

Illustration Credits
Every effort has been made to contact the owners and photographers of illustrations reproduced here whose names do not appear in the captions or in the illustration credits on page 199. Anyone having further information concerning copyright holders is asked to contact Getty Publications so this information can be included in future printings.

MIX
Paper | Supporting responsible forestry
FSC® C008047